Thomas McGovern

# Alpha
# Teach Yourself
# Black & White
# Photography

in **24** hours

**ALPHA**

A Pearson Education Company

# Alpha Teach Yourself Black & White Photography in 24 Hours

## Copyright © 2003 by Thomas McGovern

International Standard Book Number: 0-02-864392-5

Library of Congress Catalog Card Number: 2002108506

*Printed in the United States of America*

First printing: 2002

04  03  02      4   3   2

**Note:** This publication contains the opinions and ideas of its author. It is intended to provide helpful and informative material on the subject matter covered. It is sold with the understanding that the author and publisher are not engaged in rendering professional services in the book. If the reader requires personal assistance or advice, a competent professional should be consulted.

The author and publisher specifically disclaim any responsibility for any liability, loss or risk, personal or otherwise, which is incurred as a consequence, directly or indirectly, of the use and application of any of the contents of this book.

## Trademarks

All terms mentioned in this book that are known to be or are suspected of being trademarks or service marks have been appropriately capitalized. Alpha Books and Pearson Education, Inc., cannot attest to the accuracy of this information. Use of a term in this book should not be regarded as affecting the validity of any trademark or service mark.

For marketing and publicity, please call: 317-581-3722

The publisher offers discounts on this book when ordered in quantity for bulk purchases and special sales.

For sales within the United States, please contact: Corporate and Government Sales, 1-800-382-3419 or corpsales@pearsontechgroup.com

Outside the United States, please contact: International Sales, 317-581-3793 or international@pearsontechgroup.com

**ACQUISITIONS EDITOR**
Mike Sanders

**DEVELOPMENT EDITOR**
Tom Stevens

**PRODUCTION EDITOR**
Katherin Bidwell

**COPY EDITOR**
Catherine Schwenk

**INDEXER**
Heather McNeill

**PRODUCTION**
John Etchison
Becky Harmon

**COVER DESIGNER**
Charis Santillie
Douglas Wilkins

**BOOK DESIGNER**
Gary Adair

**MANAGING EDITOR**
Jennifer Chisholm

**PRODUCT MANAGER**
Phil Kitchel

**PUBLISHER**
Marie Butler-Knight

*This book is dedicated to those who taught me and to those I teach.*

*My teachers:*

*Fred W. McDarrah*

*Arnold Kramer*

*John Gossage*

*Eileen Cowin*

*Linda Kroff*

*Joseph Santarromana*

*Kim Abeles*

*The photography students at
California State University,
San Bernardino*

# Overview

# Contents

# Introduction

In this book you will find the information to fully understand and execute the black and white photographic process. I have been making pictures for more than 25 years and have had the honor to teach many beginning photography students. I approach the subject with the assumption that you know nothing about photography, your camera, or picture making. I have tried to be as clear as possible and to take the complex issues, both technical and creative, and present them in an understandable and accessible way.

In our era of sophisticated digital technology, it is interesting that so many people are drawn to the basic process of black and white photography. One obvious reason is that you can process the film and make the prints yourself (of course, you do something like that with digital), but more important is the intangible, almost indescribable feeling that you get from beautiful black and white photographs. They have a timeless quality that is less representational than color photography, and they emphasize the inherent vision of the photographer. I believe it is for this reason, the suggestion of the artistic vision behind the camera, that the black and white process is alive and well in our time of instant imagery and seamless digital manipulation. Also, the well-crafted object is less common in our culture, so the satisfaction of making a beautiful print from your own negative is a rather unique and fulfilling experience.

Thank you for choosing *Alpha Teach Yourself Black and White Photography in 24 Hours*.

## EXTRAS

Last but not least, this book has a lot of miscellaneous cross-references, tips, shortcuts, and warning sidebar boxes. Here's how they stack up:

**GO TO** ▶
This sidebar cross-references you to another point in the book to learn more about a particular topic.

### JUST A MINUTE

Just a Minute sidebars offer advice or teach an easier way to do something.

### TIME SAVER

Time Saver sidebars give you a faster way to do something.

### PROCEED WITH CAUTION

Proceed with Caution sidebars are warnings about potential problems and help you steer clear of trouble.

These are quick references to direct you toward further reading and examples in other sources.

### STRICTLY DEFINED

Strictly Defined sidebars offer definitions of words you may not know.

# About the Author

**THOMAS MCGOVERN** has been a photographer for more than 25 years. So far, his work has been in 18 solo and more than 35 group exhibitions and is represented in the permanent collections of the Brooklyn Museum of Art, the Baltimore Museum of Art, and the Museum of Fine Arts, Houston, among others. He has worked as a freelance editorial photographer for *The Village Voice, The New York Times,* and *New York Newsday.* While he has photographed countless subjects over the years, his proudest accomplishment is "Bearing Witness (to AIDS)," a 10-year project on the AIDS crisis that was published in 1999 by Visual AIDS/A.R.T. Press. He is currently photographing professional wrestlers and is an assistant professor of art at California State University, San Bernardino.

# Acknowledgments

I have a lot of people to thank for helping me with this book. First is my wife, Renate, who allowed me to shamelessly neglect her for three months. I promise I will make it up to you!

Thanks to Fred W. McDarrah for all his help and advice over many years and for introducing me to my agent. Thanks to my agent, Sheree Bykofsky, for taking care of business.

Thanks to Wendy De Rycke, Bob Burns, and Jan Wilhelm of Ilford Photo Products for generously supplying film and paper; Glenn Weinfeld at Fuji for supplying film and press photos; Eileen Southard at Nikon; Ralph Hagenauer at Leitz; Marie Smith at Vivitar; Ray Vitiello at Mamiya; Phill Braydon at Minolta, and the folks at Hasselblad and Pentax, all for supplying press photos of their fine products.

Thanks to the photographers who contributed to this book, Matthew Richardson, Tony Maher, Ian Spanier, Sant Khalsa, Leta Schmidt, Phil Marquez, Stephanie Keith, Eric Nelson, and my illustrator, Mike Hollenbeck.

Thanks to my editors, Tom Stevens, Mike Sanders, Catherine Schwenk, and Kathy Bidwell, for their hard work and attention to detail.

# Part I

# Understanding Your Equipment and Using It

# Hour 1
# The Camera

LESSON PLAN:

In this hour, you learn how cameras work and how to control their various functions.

- Identify camera parts and features
- Adjust the aperture and shutter
- Use the self-timer
- Load and unload your film

Manual and automatic cameras have many of the same functions, and because the manufacturer determines how they are controlled, you should have, or try to obtain, the manual for your individual camera. Camera manuals are usually available from the manufacturer and some are available online.

## IDENTIFY CAMERA PARTS

All cameras are basically light-tight boxes that hold light sensitive film. They have a lens to focus the image on the film and each lens has an adjustable opening, called the *aperture*. All cameras also have an adjustable *shutter*, a curtain that opens for a certain amount of time when the picture is taken.

### STRICTLY DEFINED

An **aperture** is a hole, and in photography, it is the hole in a lens. This is an adjustable hole that when opened (to make larger) or closed down (to make smaller) controls how much light comes into the camera.

The **shutter** is a curtain inside the camera that opens for an adjustable amount of time, letting light fall onto the film.

A camera has a body and lens that can usually be removed to accommodate different lenses, as seen in the following figure of the Nikon FM2.

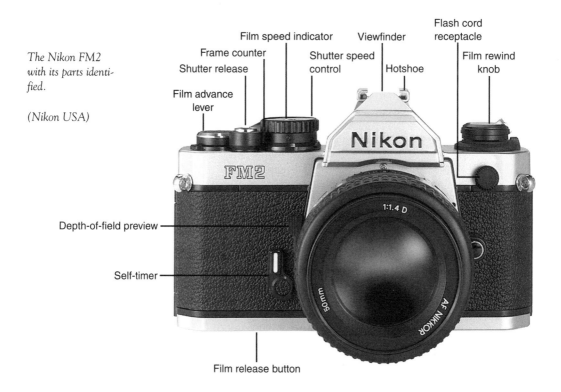

*The Nikon FM2 with its parts identified.*

*(Nikon USA)*

Film speed indicator
Frame counter
Shutter release
Film advance lever
Shutter speed control
Viewfinder
Hotshoe
Flash cord receptacle
Film rewind knob

Depth-of-field preview
Self-timer
Film release button

GO TO ▶
For more on lenses, see Hour 2.

The following figure of a lens shows the focus ring, aperture ring, and a scale to indicate in feet and meters where focus is. Most lenses also have a scale to help you determine the amount of depth of field (discussed later in this hour) with each aperture.

The Nikon FM10 shown in the second figure is an inexpensive manual camera that I recommend to my beginning students. It comes with a 35mm to 70mm zoom lens and sells for around $250.

Focus ring    Exact focus    Distance scale

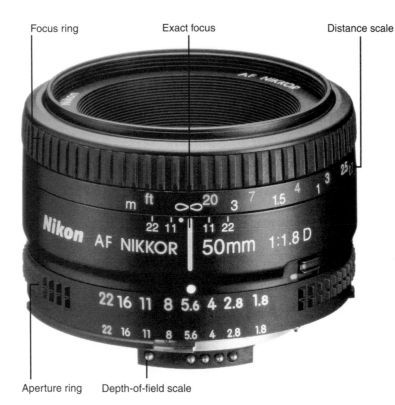

*The 50mm lens with its parts identified.*

*(Nikon USA)*

Aperture ring    Depth-of-field scale

*The Nikon FM10 is an inexpensive manual camera.*

*(Nikon USA)*

## THE CAMERA BODY AND SHUTTER

Open your camera back and see where the film is loaded. The film canister is loaded on the left; in the middle is the shutter and on the right is the film take-up spool. Your shutter may resemble a cloth curtain or a series of ultra thin plates. Never touch the shutter or try to open it with your finger. If a shutter is malfunctioning, take your camera to a repair shop.

When you take a picture, the shutter opens for an amount of time called the *shutter speed,* which is set by the shutter speed control. Let's look at the shutter for a moment. Remove your lens if possible (not necessary) and set your shutter speed control to B (more about shutter speeds and what B means shortly). Wind your film advance lever and while looking into the open back of the camera, push and hold the shutter release button. You will see the shutter open, and it will remain open as long as you hold the shutter release down. You can see that the shutter is simply a curtain that opens to expose the film. Release the shutter release and set the shutter speed to 1, and again wind the film advance and push the shutter release. The shutter will open and remain open for one second, then automatically close. Do this with all the shutter speeds and you will get a feel for how the shutter works.

Note that the shutter is positioned in front of where the film will be. This type of shutter is called a focal plane shutter because it is at the place of focus. In later hours we will discuss other types of shutters as well.

**PROCEED WITH CAUTION**

Never put your finger into the shutter or try to open or close it with your finger or other object. It is a very delicate mechanism and should only be touched by a trained camera repairperson.

Look at the numbers on the shutter speed control knob. Most cameras will have one letter, B, and then numbers 1, 2, 4, 8, 15, 30, 60, 125, 250, 500, 1000. Perhaps your camera has 2000 and even 4000, or yours may also have a T setting. These settings indicate how long the shutter stays open, and are mostly fractions of a second:

- B stands for bulb, which means that the shutter stays open as long as your finger holds the shutter release down.
- T stands for time and means that the shutter will open when you press the release and remain so until you press the release again, allowing very long exposure times.

Numbers 1 and up are fractions of a second and indicate the denominator (the bottom number) in a fraction. Mentally, put the number one over any shutter speed and that is how long it remains open. Setting 1 is one second ($\frac{1}{1}$), 2 is half a second ($\frac{1}{2}$), 4 is a quarter second ($\frac{1}{4}$), and so on. A setting of 1000 is a one-thousandth of a second exposure. So now you understand that the shutter is basically a curtain on a timer that can stay open indefinitely (on T setting) or for any fraction of a second down to $\frac{1}{1000}$—or even less depending on your camera.

As you may have noticed, each shutter speed is double or half the one before and after it. A shutter speed of $\frac{1}{60}$ is half the amount of time of a shutter speed of $\frac{1}{30}$ and double the amount of time of a shutter speed of $\frac{1}{125}$. This formula is consistent throughout the various shutter speeds and, consequently, the amount of light that enters the camera is halved or doubled with each consecutive shutter speed.

In the following figure of a strip of negatives, the five frames range from being too light, to just right, and then too dark. They were shot at five different shutter speeds, demonstrating that each shutter speed allows twice or half the amount of light as the one before or after it. The frame in the middle is the one with the correct exposure.

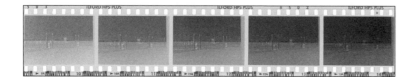

*You can see here that of the five frames, two are too light, two are too dark, and the middle one is just right.*

*(Matthew Richardson)*

The timed shutter speed openings have two primary functions—allowing a certain amount of light into the camera to properly expose the film and allowing you to either freeze moving objects or create blur.

It is obvious that more light comes into the camera the longer the shutter is open, and less light comes in the shorter the time the shutter is open. This is called the exposure time. The other function, controlling and allowing blur, is a bit less obvious. A one second exposure (1 on your shutter speed control knob) seems like a pretty short amount of time, but in terms of picture taking,

it is a very long time. You will probably use a one second exposure on very few occasions, because if anything in the lens's field of vision moves while the shutter is open, the object will be rendered blurry.

Look around you and see what stays totally still for one second. Trees move gently in the breeze, and even if you try to stay still, you probably move a tiny bit. Inanimate, steady objects are the only things that remain totally still for one second. Another factor is that if the photographer is holding the camera in her hand, she is moving slightly, even when trying very hard to stay still. Therefore, when taking a picture, you want to choose a shutter speed that produces the results you want. If you want things crisp and sharp in your photograph, you want to use a shutter speed that is fast enough to freeze any movement. Conversely, if you want some blur, you choose a slower shutter speed that allows movement to be seen. The slower the shutter speed, the more movement will be seen. The faster the shutter speed, the less movement will be seen.

**JUST A MINUTE**

Unsure how fast of a shutter speed you need to get crisp pictures? The general rule of thumb is to use a shutter speed that is approximately the same as the focal length of your lens. So if you're using a 50mm lens (a lens with a 50mm focal length), a $\frac{1}{60}$ shutter speed is good. If you're using a 300mm lens, use a $\frac{1}{250}$ shutter speed.

A very general rule for beginners is to use a shutter speed of $\frac{1}{60}$ of a second (60 on your shutter speed control knob) with wide-angle and normal lenses (discussed in the next section), and a shutter speed equivalent to the focal length of longer lenses. For example, with a 135mm lens, use a $\frac{1}{125}$ shutter speed, with a 250mm lens, use a $\frac{1}{250}$ shutter speed. (Types of lenses—that is, their focal length—are discussed in the next section.)

We have discussed the shutter speed control knob, and you have now used the shutter release as well. Let's return to the other features on the camera body:

- The film advance lever advances the film before each exposure and cocks the shutter. If your film was not advanced, you would get many exposures on a single piece of film, creating a confusing mess (or an interesting abstract image, depending on what you wanted).

- The film speed indicator lets you tell the camera's light meter how sensitive your film is and helps you to choose the proper exposure.

- The viewfinder is what you look through to see what the camera sees and what you want to make a picture of.

- The hotshoe is where you attach a portable camera flash. It is called a hotshoe because it has an electrical contact point that tells the flash when to fire.

- The self-timer allows you to be away from the camera and have it take a picture.

- The depth-of-field preview lets you see how much will be in focus in the actual picture (depth of field will be discussed in the next section on lenses).

- The film rewind knob is for returning your roll of film to its light tight canister after exposure, and the film rewind release button unlocks the camera's internal sprockets so that the film can travel backward into the canister.

- The flash cord receptacle is used to plug your camera flash into when the hotshoe (which does not need a cord) is not being used.

- Finally, the frame counter tells you how many pictures you have exposed.

**GO TO** ▶
For more on the light meter, see Hour 4.

## THE LENS AND APERTURE

Your lens is made from numerous glass elements and is one of the most important factors in getting a sharp, well-focused photograph. Because it is an optical device, it is important that it be treated gently and kept clean and in good operating condition. Look at your lens and identify its parts as shown in the following figure. There is a front and a back, with the back being attached to the camera. Around its barrel are a few movable rings. The one nearest the front of the lens adjusts the focus, and the ring closer to the back of the lens adjusts the aperture. As stated earlier, the aperture is the hole in the lens. When the lens is mounted on your camera, you can see the distance scale which tells you where focus is (in feet and meters) as well as which aperture is chosen.

**GO TO** ▶
Your lens is the most important factor in getting sharp and well-focused images. Keep your lens clean from fingerprints and dirt for best performance. See Hour 8 for the discussion of how to care for your lens.

*Look closely at your camera's lens and identify its parts with the help of this drawing.*

*(Mike Hollenbeck)*

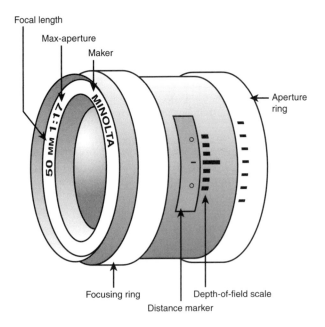

Focal length
Max-aperture
Maker
Aperture ring
Focusing ring
Depth-of-field scale
Distance marker

## FOCAL LENGTH

Look at the rim of the front of the lens and you will see some numbers. They tell you the *focal length* of the lens and its maximum aperture. There might also be a number indicating the diameter of the lens if you want to buy a screw-on filter.

### STRICTLY DEFINED

The **focal length** of a lens indicates its angle of view, and there are three types:

- A wide-angle lens gives you a wide point of view, which is very helpful when taking pictures in a confined space where you want to show the surroundings. It makes things appear smaller, like looking through the wrong side of binoculars. Wide-angle lenses are those with a focal length less than 50mm and long lenses are those greater than 50mm.

- A normal lens gives you an angle that is approximately what the naked eye sees. On a 35mm camera the normal lens is 50mm.

- A long focal length lens, or telephoto lens, typically 135mm and longer, gives you a narrow angle of view and is like using a telescope—it brings far things closer.

**FYI**
Lenses are defined by their focal length and maximum aperture. A lens listed as 50mm *f/2* means that it is a 50mm lens with a maximum aperture of *f/2*. Zoom lenses, those with variable focal lengths (enabling you to switch between normal, wide, and telephoto focal lengths without changing lenses), are listed with the minimum and maximum lengths followed by the maximum apertures for those lengths, such as 28mm to 70mm, *f/3.5* to *f/4.5*, respectively.

When you see lenses listed in an advertisement, the focal length and maximum aperture are listed. For example, 50mm *f/2* would mean a 50mm lens with a maximum aperture of *f/2*. On a camera like that shown in the first figure in this hour, 50mm is the normal lens. The 50mm lens on a 35mm camera mimics the angle and point of view of the human eye. For cameras that take a film larger than 35mm roll film, the normal lens is larger, too. Lenses that are shorter than 50mm (35mm, 28mm, and lower) are wide angle, giving an increasingly wider area of view in your picture; and as stated before, they also make things appear smaller. Lenses for 35mm cameras with a focal length over 50mm (80mm, 105mm, 135mm, and longer) are considered long lenses and bring far things closer.

## Zoom Lenses

There are lenses that have variable focal lengths called zoom lenses. Many new cameras now come equipped with these lenses that range from 35mm (wide angle) to 70mm (short telephoto) or an even greater range. These lenses cover everything in between as well, and reduce the need for carrying multiple lenses in your camera bag.

## Focusing Systems and Focus

Focus is a primary function of your lens. Most cameras will use the *single lens reflex*, or SLR, focusing system. This means that there is one lens that both takes the picture and through which you focus. Inside the camera body there is a mirror that reflects the image into a prism and into the camera viewfinder. When you twist the focus ring, the scene comes into focus.

**STRICTLY DEFINED**

**Single lens reflex,** or SLR, is a focusing system that lets you look through the camera lens to focus your picture.

Another focusing system is called a rangefinder. In this system you do not look through the lens but through a small window next to the lens. Focusing is done by aligning a semi-transparent "ghost" image found in the center of the viewfinder. When the focus ring on the lens is turned, the ghost image moves into alignment with the real image. When the two are matched up, focus is complete. The following photograph shows a Leica M7 rangefinder camera.

### STRICTLY DEFINED

A **rangefinder** is a focusing system in which you look through a small window near the lens and align a semi-transparent "ghost" image with the object being focused on.

*The Leica M series rangefinder camera has been around since 1954 and was modeled off of their earliest rangefinder, which was introduced in 1925.*

*(Leica Camera Group)*

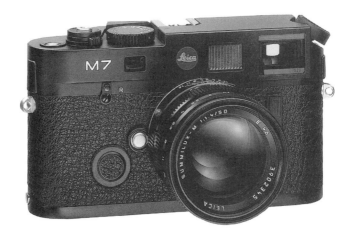

If you have an autofocus camera, disable that function and manually focus. The focus ring, usually the thin ring nearest the front of your lens, allows you to determine where exact focus is. This is accomplished by adjusting the distance between the front and rear glass elements in your lens. With the lens on your camera, look at objects near and far, and focus the lens. (This may seem obvious but most beginning photographers will have quite a few pictures that are not in focus.) Look carefully at what you are focusing on and gently twist the focus ring until the object appears crisp.

Your lens probably has a device built into it to help you do this. Look through your lens—in the center there may be a barely noticeable ring or two. Point your lens at something with vertical lines so that you see it in that center area and slowly twist the focus ring. As the object comes into

focus, its vertical lines will line up. When it is not in focus, its vertical lines will not line up. Your camera's focusing device may be different from this so check your camera manual if it is not obvious.

Holding your camera properly will help you get pictures that are well focused. The following figure shows you how to hold a camera so that your left hand controls the focus and your right hand is ready to release the shutter when the picture is just right.

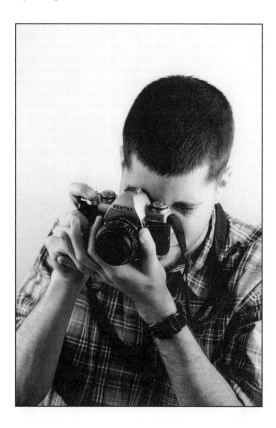

*Your pictures will come out better if you hold your camera correctly. Steady and focus the camera with your left hand while cocking and releasing the shutter with your right.*

*(Matthew Richardson)*

## DEPTH OF FIELD

The lens aperture is the opening in your lens and as mentioned earlier in this hour, it can be adjusted from a small hole to a large hole. Obviously, a small hole lets less light into your camera, and a large hole lets in more. This is similar to the adjustable shutter that can let more or less light in, too. But just as the shutter has another function, controlling blur, so does the aperture. The size of the aperture controls *depth of field*.

**STRICTLY DEFINED**

**Depth of field** is how much (from close to far away) is in focus in your photograph. Pictures taken with a large aperture have less depth of field than those taken with a small aperture.

The following figures show the difference between shallow and great depth of field. You can see in the first of the two following figures that with shallow depth of field, the chess pieces in front and back are not in focus, only the ones in the middle. But in the second figure, all of the pieces from near to far are in focus.

*With the lens wide open, the depth of field is only at exact focus, which is the center of the chessboard. The pieces in front and behind are out of focus.*

*(Tony Maher)*

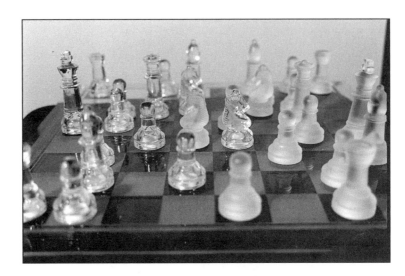

*With the lens stopped down, there is a lot of depth of field as shown here, where all the pieces, front to rear, are in focus.*

*(Tony Maher)*

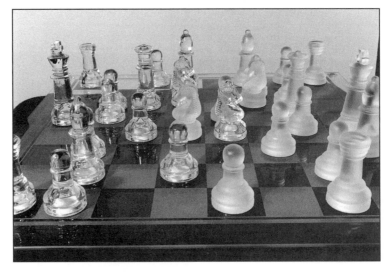

Depth of field is how much, from foreground to background, is in focus in your photograph. This is separate but related to what you have actually focused on. For example, you focus on a friend who is 10 feet from you. His dog is 8 feet away from you and his girlfriend is 14 feet away. Since you focused on your friend, it makes sense that the dog, which is nearer, and the girlfriend, who is farther, will not be in focus; but depth of field can bring all three into focus in your final picture. When the aperture is made smaller, the field of focus becomes deeper. This is an optical effect that happens when rays of light pass through a small opening. The result is that things both near and far all appear to be in focus. With your camera lens, this is a gradual effect. When your lens is wide open, there is very little depth of field; that is, only what you have focused on is sharp. As you stop your lens down (make the hole smaller), more and more things in front of and behind your exact focus become sharp. Controlling depth of field is an important creative tool in making interesting pictures.

## F-Stops

F-stops are the numbers used to indicate a given aperture. These numbers range from $f/1.0$ to $f/64$, with the smaller number representing a large lens opening or aperture and the larger number representing a small lens opening. The lens on your 35mm camera will typically have most of the following f-stops: 2.0, 2.8, 4, 5.6, 8, 11, 16, and 22. These numbers represent the size of the aperture in terms of a fraction. An $f/2$ aperture, for example, is a hole ½ the size of the lens, an $f/2.8$ aperture is 1/2.8 the size of the lens, and an $f/16$ is ¹⁄₁₆ the size of the lens. You do not really need to know this information, but it will help you remember that the larger the f-number, the smaller the hole. Also, any f-stop allows the same amount of light into the camera regardless of the lens used. So $f/5.6$ on a wide-angle lens lets the same amount of light into a camera as $f/5.6$ on a telephoto lens. The benefit of this consistency will become clear in Hour 4.

As you close your lens down, the amount of light between each f-stop is exactly half the previous one. So when you stop your lens down from $f/2$ to $f/2.8$, you are reducing the light coming into the camera by one half. This is true with each f-stop, and the opposite is true when you open the lens—each greater f-stop (larger hole) lets in twice as much light as the previous, smaller one. So opening your lens from $f/5.6$ to $f/4$ is doubling the amount of light entering the camera. This is exactly the same formula we discussed earlier in regard to the amount of light between shutter speeds. Increasing the shutter

speed cuts the light in half and decreasing the shutter speed (longer time) doubles the amount of light. The amount of light entering the camera between *f*-stops and shutter speeds is proportionally the same.

The following figure demonstrates that the light between each aperture is cut in half as the aperture closes. It may not look like that when you look into your lens, but it is true.

*As this drawing demonstrates, each smaller aperture cuts the amount of light entering the camera in half.*

*(Mike Hollenbeck)*

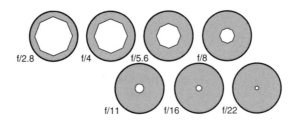

f/2.8　f/4　f/5.6　f/8

f/11　f/16　f/22

## JUST A MINUTE

The amount of light between each aperture or *f*-stop is exactly half or double the ones on either side of it. This is also true for shutter speeds—each shutter speed lets in half as much or double the amount of light as the ones on either side of it. And the amount of light between each *f*-stop and each shutter speed is proportionally the same.

The adjustable aperture allows for a certain amount of light to enter the camera and is indicated through *f*-stops. And the adjustable shutter also allows for a certain amount of light to enter the camera, and is indicated through shutter speeds. In Hour 4, we will discuss how the coordination between these two functions gives you a well-exposed photograph.

## SELF-TIMER

The self-timer is a great tool that allows the shutter to be released automatically. Most cameras will have a self-timer, and you should consult your manual for the exact location and operation of the one on your camera. This gives you the opportunity to make self portraits and include yourself in photographs of groups. The self-timer is essentially a timer that activates the shutter release. When using it, you will need to adjust your focus and set your aperture and shutter for correct exposure, and probably have your camera on a tripod or other steady surface. Depending on your camera, the self-timer may beep increasingly faster or may flash a little light increasingly faster to indicate when the shutter will be released.

## LOADING AND UNLOADING FILM

Closely examine a roll of 35mm film. It comes in a long strip that is rolled in a light-tight canister. When you open an unused (hereinafter referred to as unexposed) roll of film, there will be an inch or two of film protruding from the metal canister, called the film leader. The canister has a spool protruding about ⅜ of an inch from one end—this is the bottom of the canister.

To load film in your camera, follow these steps:

1. Open the back of your camera and place the film canister in the left side with the canister bottom (with protruding spool) facing the base of the camera. You may need to lift the film rewind lever to get the film canister to fall into place.

2. Push the rewind lever back down once the film is in the camera—you may need to twist the lever slightly so it fits into the top of the canister.

3. Pull the film leader across the shutter as shown in the following figure (being careful not to disturb the shutter) and over the spool with sprocket teeth. The sprocket holes in the film should line up with the sprocket teeth on the spool.

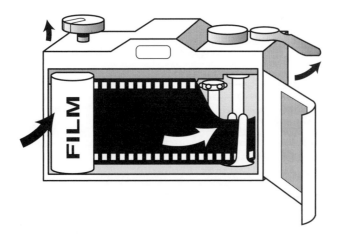

*To load your film, pull it across the shutter and feed into the take-up spool as shown here. Then advance the film until it is securely on the take-up spool.*

*(Mike Hollenbeck)*

4. Then slide the film leader into the take-up spool. It should fit snugly into the take-up spool.

5. With the camera back still open, advance the film with the film advance lever, making sure the film is indeed advancing and going onto the take-up spool.

6. Release the shutter and do this again.

7. Now your film should be wrapped around the take-up spool and you can close the camera back.

It is very important that the film is actually being advanced and wrapping around the take-up spool, otherwise you will not get any pictures.

**PROCEED WITH CAUTION**

Be sure your film is actually advancing when loaded. A trick to ensure this is to twist the rewind knob clockwise until taut once you've loaded the film and closed the camera back. As you advance the film for each picture, you will see the rewind knob rotate, indicating that the film is advancing.

A good trick to ensure that the film is advancing is to twist the rewind knob once you've loaded the film and closed the camera back. Then every time you advance the film, the knob will rotate, indicating that the film is actually advancing. Improperly loaded film is a very common problem with beginning photographers, so do this carefully. Once your film has been properly loaded, advance the film until the frame counter reads 1 (your first exposure).

If you have an automatic camera, this procedure may be done for you. If you have an automatic camera, do the following:

1. Open the camera back and drop the film in.

2. Pull the leader across the shutter and over the toothed sprocket.

3. Lay the film leader over the take-up spool and close the camera back.

Depending on the model, the camera will grab the film and pull it onto the take-up spool and show a number 1 on the frame counter. If the film does not load properly, the frame counter will show a zero. If so, just follow the procedure again until the frame counter shows a number 1.

**PROCEED WITH CAUTION**

When you are ready to remove a roll of exposed film from your camera, be sure to push the rewind release button, located on the bottom of most cameras. This will unlock the toothed spindle that prevents the film from accidentally rewinding and let you rewind the film without damage.

Let's pretend you have just shot a roll of film and are now ready to remove it. If you just try rotating the film rewind knob clockwise, it will not move. Remember that toothed sprocket inside the camera? That holds the film and prevents it from rolling backwards, which is what needs to happen to rewind the film. To rewind and remove a roll of film, take the following steps:

1. Push the small film rewind release button located on the bottom of the camera to release the toothed sprocket. This unlocks the sprocket and allows you to rewind the film back into the film canister.

2. Gently rewind the film—try not to do this very quickly, as static electricity can build up and create tiny sparks and marks on your film.

3. Rewind the film so the leader goes all the way into the film canister. Otherwise you may mistake an exposed roll of film for one that is not.

So now you know your camera's controls and basic functions, how the shutter and aperture control the amount of light entering the camera, and how to load and unload your film. You are now ready for a more in-depth discussion of lenses, focal lengths, and apertures.

# Hour 2
# Lenses and Filters

## Chapter Summary

**LESSON PLAN:**

In this hour, I discuss the wide variety of lenses available for 35mm cameras, their particular properties and functions, and how to go about choosing a lens for various applications.

- Choose the lens that best suits your needs and budget
- Identify the three basic lens types
- Learn how to pre-focus your lens and use lens hoods to obtain the sharpest picture possible
- Distinguish the differences between some commonly used color filters and their effects

Lenses are obviously one of the most important components of your camera and primarily effect focus, sharpness, and perspective in your pictures. As such, the look and feel of your photograph is greatly affected by the lens you use. There are scores of lenses to choose from, and finding the right lens for your application will greatly improve your pictures.

The following discussion builds on Hour 1's information about lenses but goes into much greater detail so that you will have the knowledge to choose the lens that best suits your needs and budget. While a camera store will gladly sell you any and every lens, by educating yourself, you will be able to make the right choices for your photographic style and budget.

## Choosing a Lens

When you buy a camera, one of the most confusing and costly decisions is which lens to buy. If you have access to a good camera store or if you shop online, there are hundreds of lenses to choose from, ranging from a few hundred to many thousands of dollars, so choosing the best lens for you is an important decision. As discussed in Hour 1, focal length is how long the lens is. Shorter lenses are called *wide angle* and give your images a broad scope of view; *normal lenses* are those that approximate the scale seen with the naked eye; and telephoto lenses are those that act like a telescope, bringing far things closer in your pictures. By understanding these three basic lens types, you already have a good foundation to understand more about lenses.

Lenses are made up of many glass elements. Each element must be precision-ground to exact specifications concerning magnification, color, and smoothness, and be free from any imperfections in the glass. Each element has a coating as well, which helps the lens transmit light without distortion. The contrast in your pictures, that is, the crisp darkness of the shadows and clarity of the highlights, is greatly affected by the coating on lenses. If this coating becomes worn or chipped, the picture quality is adversely affected. These precision elements are fitted into a tube (the lens housing) exactly parallel to each other and must remain so for good picture quality. The following figure shows how these glass elements fit precisely together for good optics.

*This drawing shows the intricate internal composition of a lens.*

(Mike Hollenbeck)

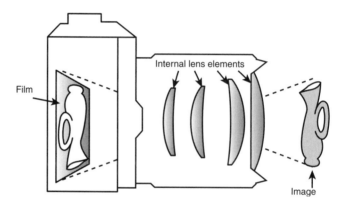

Although a lens of any quality, including a cheap plastic one, will let you make a picture, the image quality will be affected. Older photographers swear that old-time lenses gave them the best pictures and bemoan all the new ones with their triple coatings, lightweight design, and variable focal lengths. The truth is that lenses are optically better than ever. Technology and globalization have made them more precise and brought the cost down, and there is a wider variety than ever before.

The following figure shows three of the most commonly used lenses for 35mm photography: the wide-angle 24mm, the normal 50mm, and the telephoto 105mm. The 105mm is considered the ideal lens for portraiture.

**24mm lens**

**50mm lens**

**105mm lens**

*Three very popular lenses: the wide-angle 24mm, the normal 50mm, and the short telephoto 105mm.*

*(Nikon USA)*

## WIDE-ANGLE LENSES

As you learned in Hour 1, the 50mm lens gives approximately the same point of view and scale as the human eye for 35mm cameras, and is therefore called a normal lens. As lens focal length is reduced, the angle of view widens, so lenses with a focal length less than 50mm are called wide angle. Typically available wide-angle lenses are the 35mm, 28mm, 24mm, 20mm, 18mm, 16mm, and even 14mm. The 35mm lens gives a moderately wide view that increases with the shorter focal lengths. The 28mm gives a wide view and 24mm is a very wide view. I use my 24mm lens when needing to include the surrounding area in a tight space, such as a small office. A 20mm or 18mm lens could be used to show the interior of an elevator and the 16mm and 14mm lenses are even more extreme, creating a distorted perspective. These last two lenses are referred to as fish-eye lenses due to their very large and rounded outer element. The following three figures show the same scene shot with three different lenses, demonstrating how a longer lens creates a narrower angle of view and brings far things closer.

*Distortion* is a natural occurrence when using wide-angle lenses. The wider the angle, the more distortion; and the closer to an object, the more distortion as well. For instance, you would probably not use a 28mm lens, which is very wide, to take a portrait of one person. It would create a lot of distortion, making your subject's nose appear very large and his or her ears very small. It might, however, be useful for making a group portrait of 10 or more people in a medium-size office. Each person would be far enough away to minimize the distortion, and the wide angle would allow for everyone to be in the picture.

This shows the wide-angle effect of the 28mm lens.

(Tony Maher)

Here's the same scene with the normal 50mm lens.

(Tony Maher)

*And the same scene again, but with the telephoto 100mm lens.*

*(Tony Maher)*

**STRICTLY DEFINED**

**Distortion** is the unnatural perspective given to objects seen through wide-angle lenses. The wider the angle, the more distortion. Also, the closer the object, the more pronounced the effect. Longer lenses have little or no distortion.

The best way to get a feel for how wide a lens you need is through experience. Go to your camera store and try some out and ask friends if you can try theirs out. Don't be afraid of the distortion, you will be able to see it when you look through your camera and can decide whether it works for you or not. The following two figures show the distortion from a 28mm lens versus the lack of distortion from a 100mm lens.

*This photo shows distortion from using the 28mm lens for a portrait.*

*(Tony Maher)*

*Here you can see the lack of distortion from using a short telephoto 100mm lens.*

*(Tony Maher)*

One of the best advantages of a wide-angle lens is that it lets you get close to your subjects and still include their surroundings. This is extremely useful for making pictures of people in action and going about their lives, because the photographs give the context the person is working in. Photojournalists typically rely on wide-angle lenses unless a subject is far away. The following two figures show the advantage of shooting with a wide-angle lens instead of a normal lens in a location.

*With a normal lens, the scene is claustrophobic.*

*(Tony Maher)*

*With a wide-angle lens, the photographer can capture the context of the pool hall.*

*(Tony Maher)*

## TELEPHOTO LENSES

Telephoto lenses are those that are longer than the normal lens for your camera format. Short telephoto lenses include 70mm, 80mm, and 105mm lenses, while 135mm and longer are telephoto. Longer telephoto lenses include 180mm, 200mm, and 300mm. There are even longer lenses for specialty photography such as sport and police surveillance. A telephoto brings far things near and is invaluable when photographing wildlife and for photojournalism. Unlike wide-angle lenses, long lenses do not distort, so they are the lens of choice for many portrait photographers. Their main characteristic is a flattening of the scene, creating the illusion that things in the distance are close to each other, when in fact they are not.

So we see that wide, normal, and telephotos each have properties that are important considerations when you make your choices on which lenses to buy and which lenses to use to create the pictures you want. As you can imagine, photographers prefer to have all lenses available to them for creative purposes.

## ZOOM LENSES

This is where *zoom lenses* come in. Zoom lenses are those that have multiple focal lengths in a single unit and are the most popular lenses for this reason. Most cameras for beginners now come with a zoom lens, whereas in the old days cameras came equipped with a normal 50mm lens. Technology has made the optical sharpness and reliability of zoom lenses very good, but

strictly speaking, the best single focal length lenses are considered to have better optical quality than most zoom lenses. In reality, though, most photographers will never be able to see any difference between the picture quality of zooms and single focal length lenses, so the issue of whether or not to use one is mostly one of personal preference. The biggest drawback for zoom lenses is that they are larger than fixed-focal lenses and their maximum aperture is not as great. (This drawback is discussed shortly.)

### STRICTLY DEFINED

**Zoom lenses** are those with variable focal lengths in one unit. For example, a 35mm to 70mm zoom lens is able to provide both wide-angle and telephoto angles of view and everything in between. This is obviously a great advantage for many photographers and saves you from buying a lot of lenses. Older zoom lenses typically do not have great optics but those made today are very good.

A zoom lens has a range of focal lengths. For example, a zoom lens may be able to give you a wide-angle shot from the 28mm perspective and increase its focal length to up to 70mm, giving you a short telephoto effect. The way you change the focal length is usually by twisting the lens barrel. As you twist it, a number on the lens indicates which focal length you are at. This is a continuous effect, allowing any length lens within its range. The following figure shows a 24mm to 70mm zoom lens with the chosen focal length, 50mm, indicated by the white mark.

*This is a 24mm to 70mm zoom lens. The ribbed ring is twisted to change the focal length of the lens and the white marker shows which focal length has been chosen.*

*(Nikon USA)*

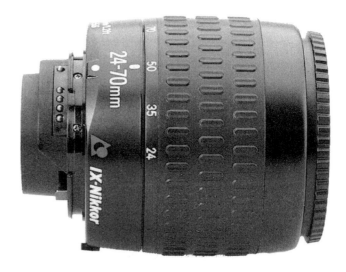

The following list includes some zoom lenses and their effects:

- 17mm to 35mm is a very wide-angle zoom. 17mm is a fish-eye lens and produces images with definite distortion. As you zoom out (increasing the focal length) you will see the point of view through the lens narrowing. This is great since you can see exactly what the lens sees and the effect it produces. The 35mm focal length is moderately wide but without much distortion.

- 24mm to 50mm is a good general-purpose lens, affording you the advantages of the very wide 24mm up to the normal 50mm.

- 24mm to 120mm is a very large range and could conceivably be the only lens you need, from a wide angle all the way up to a telephoto.

- 28mm to 80mm is a popular range and is very reasonably priced.

- 28mm to 105mm, same as above but slightly longer maximum length. 105mm is considered by many to be the perfect portrait lens length.

- 70mm to 210mm is a nice telephoto zoom, great for portraits and nature photography.

## ZOOM VS. FIXED-FOCAL-LENGTH LENSES

So why doesn't everyone just use a few zooms and get rid of their fixed-focal-length lenses? For one thing, zooms are larger and often heavier than fixed lenses, and most zooms do not have as high optical quality as fixed. But as I mentioned, most photographers will not be able to see the difference. Choosing zoom over fixed mostly has to do with personal preference. Many people learned photography with fixed lenses, so they are more comfortable with them. Many artists feel that relying too much on a zoom hurts their personal artistic vision.

FYI   You might think that with the availability of zoom lenses nobody would use a fixed-focal-length lens, but that's not true. While zooms are great, fixed-focal-length lenses can have a larger maximum aperture, making them better suited to low light photography.

In the history of photography, few of the great pictures have been made with long lenses. As a teacher, I find my students relying too much on the power of their zoom lenses when they should be getting closer to their subjects. A zoom lens encourages them to be lazy and gives them rather dull pictures. And as we have discussed, different focal lengths produce different and sometimes subtle effects that may be lost on the beginning photographer

who is being dazzled by the ability of his or her lens. But the bottom line is that zooms are highly valuable tools and you should try them out and decide what you like best.

However, the best reason for choosing a fixed lens over a zoom lens is *lens speed*. Lens speed is the maximum aperture available from your lens, and zooms offer smaller maximum apertures than fixed lenses. If you need lens speed, that is, a wide aperture for photographing under low light conditions, a zoom will not be useful. Remember back in Hour 1 when we discussed that the *f*-stop number is essentially a fraction? A setting of *f/2* indicates that the hole is ½ the size of the lens. Well, if your zoom is 28mm to 105mm, an aperture of *f/2* would need to be ½ the size of the lens's maximum focal length, 105mm. This would require a very large diameter lens.

### STRICTLY DEFINED

**Lens speed** is the term used to describe the maximum aperture of a lens. Generally, a lens with *f/2* or larger (smaller number) opening is considered fast.

Let's consider some zoom lenses and their maximum apertures to illustrate this point. As mentioned in Hour 1, lenses are listed by their focal length(s) followed by their maximum aperture(s). The Nikon 24mm to 50mm, *f/3.3* to *f/4.5*, respectively, means that the zoom has focal lengths from 24mm to 50mm and the maximum apertures are *f/3.3* at the 24mm length and *f/4.5* at the 50mm length. Why the difference? Because each lens has a maximum aperture that is a fraction of the focal length, and when the length of the lens is increased, the maximum aperture does not. So *f/3.3* is 1/3.3 the size of the 24mm lens. But when you zoom out to 50mm, the aperture cannot get any bigger, so the fraction is decreased. The hole in the lens remains constant, whereas the length of the lens is variable. This limitation of lens speed is probably the most important reason for choosing a fixed-focal-length lens.

Fixed lenses with an aperture of *f/2* or greater are considered fast lenses. They have a larger diameter than slower lenses and cost more to purchase. If you never shoot under low light conditions or always use a flash when you do, you may not need a fast lens. However, creative photography requires a certain amount of preparedness, and great picture opportunities often arise in dimly lit situations when using a flash would spoil the ambiance and disturb the subjects. In the following figure, a photograph taken inside a church, I was able to capture the ambiance of the scene without using a flash and disturbing the worshipers.

*I used a super fast 50mm f/1.2 lens to capture the joyful worship of these churchgoers. A zoom lens would have required using a flash, which would have interrupted the service.*

*(Thomas McGovern)*

## TELECONVERTERS

An economical device that allows a fixed-focal lens of more than one length is called a *teleconverter*. It is a hollow tube that fits in between the lens and camera and basically doubles the focal length of a lens. So a normal 50mm lens with a teleconverter becomes a 100mm lens. This is a great gadget to have in your camera bag to quickly adapt your existing lenses into telephotos. The teleconverter is nothing more than a hollow tube, so it is light and easy to carry and it costs a lot less than a good quality zoom lens. Since it moves the lens farther from the film, you need to compensate your exposure (discussed in Hour 4).

### STRICTLY DEFINED

A **teleconverter** is a hollow tube that is attached between the lens and camera body that increases the focal length of a lens. They come in different magnifications and generally double or triple a lens's length. A 2× teleconverter on a 50mm lens increases the focal length to 100mm.

As discussed earlier, depth of field is how much, from foreground to background, is in focus in your photograph. This effect is caused by the aperture, and when the lens is wide open, there is little depth of field. When the lens is closed down (smaller aperture) there is greater depth of field (see Hour 1).

But depth of field is also determined by the focal length of a lens. Wider lenses have much more depth of field than longer lenses. This is a gradual effect: As the focal length increases, the depth of field decreases. If you use a fixed-focal-length lens, there is a depth-of-field scale on the lens barrel.

The following figure shows a lens barrel with the depth-of-field scale on a 24mm wide-angle lens. The center line above the distance scale indicates where exact focus is—in this case the lens is focused to around 4 feet. On either side of the center line are aperture numbers pointing to how much more will be in focus when using a given aperture. For example, the following diagram shows that exact focus is 4 feet away. If the lens is wide open at *f*/2.8, only objects 4 feet away will be sharp. But when the lens is closed down to *f*/16, the scale indicates those things as close as 2 feet and as far as infinity (∞) will also be in focus. As you continue to use your lenses of various focal lengths, you will become comfortable with how much depth of field you can expect. A general rule of thumb is that depth of field, no matter how great, is distributed ⅓ in front of exact focus and ⅔ behind, because depth of field increases as the distance from the camera increases.

*This illustration shows the depth-of-field scale on a 28mm lens. The center line shows where exact focus is but the small lines on either side show how much more is in focus with each aperture.*

(Mike Hollenbeck)

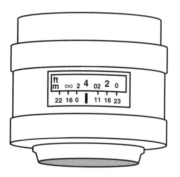

**FYI** How much depth of field do you get with a lens? It depends on the focal length, the aperture, and the distance the object is from the camera. Generally, depth of field is distributed ⅓ in front of exact focus and ⅔ behind exact focus. Look at your lens barrel to determine how much depth of field you get in a given situation.

The preceding figure shows how much depth of field you get on a 28mm lens, so now let's look at the depth of field on an 85mm lens. The following figure shows the 85mm lens focused to 20 feet. When the 85mm lens is wide open, only objects at 20 feet are in focus. When the lens is stopped down to

$f/16$, the scale indicates those things only as close as 15 feet and as far as ∞ will be in focus. As you can see, the amount of depth of field at $f/16$ with the 85mm lens is considerably less than with the wide, 28mm lens. All lenses, regardless of their focal length, will have more depth of field behind their exact focus than in front because depth of field increases with distance.

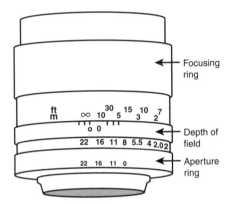

*This illustration shows how much less depth of field the 85mm lens has compared with the previous image of the 24mm lens. The 24mm lens has a range from 2 feet to ∞ at $f/16$, but the 85mm lens has a range from 15 feet to ∞.*

*(Mike Hollenbeck)*

This handy depth-of-field scale is not available on zoom lenses because their focal length is variable, and therefore, their depth of field changes with each focal length.

## Pre-Focus Using the Depth-of-Field Scale

The depth-of-field scale can also be used to pre-set your focus and to set focus for maximum depth of field. This is particularly useful when the pictures must be made quickly and focusing each time would miss the action or alert the subject. I have often used this technique when doing street photography; that is, walking down the street taking spontaneous pictures of fast-moving street life. If you know how far away your subject is or will be, simply adjust your focus so that the center line indicates the proper distance, and you are ready to photograph. When used for street photography when you don't know what or how far your subject will be, you can use depth of field and pre-set your focus to allow for sharp pictures within a given range. The following figure shows how to pre-focus the lens for spontaneous shooting without having to focus.

*This illustration shows you how to set the lens for maximum depth of field and for pre-focusing within a given range.*

*(Mike Hollenbeck)*

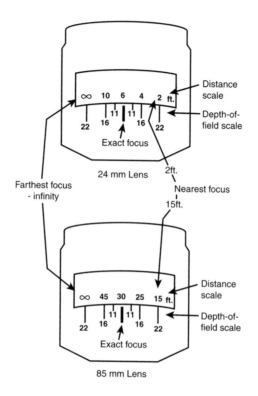

Here's how it is done:

1. Take a general light reading (discussed in Hour 4) of where you are going to be photographing and determine what your aperture will be.

2. Attempt to use the smallest aperture possible. Rotate the focus ring so that infinity (∞) lines up with the farthest distance for your aperture indicated on your depth-of-field scale.

3. Look to see what the nearest distance focus will be.

4. When you shoot, everything from the nearest distance to infinity (∞) will be in sharp focus, without having to manually focus the lens.

## LENS HOODS

Lens hoods are an important accessory for all lenses and help produce sharp images with good contrast. They are attached to the front of the lens and shade sunlight from falling directly on the front lens element, which will cause *sun spots* and *flaring*. Lens hoods help prevent this common problem and are recommended for all lenses.

STRICTLY DEFINED

**Sun spots** are those octagonal-shaped spots that appear in pictures when light falls directly on a lens. **Flaring** occurs when a bright light near the lens or edge of the picture causes a washed out area in the picture.

Because wide-angle lenses have a broader field of vision than normal or telephoto lenses, each lens hood is made specifically for the focal length of a lens. Be sure the lens hood you buy is for the right lens. When a lens hood that is for a 50mm lens is used on a 28mm lens, the pictures will have some vignetting or dark edges caused by the lens hood being too narrow for the wide lens. If a lens hood for a 28mm lens was used on a 50mm lens, it would not be as effective in blocking errant light, nor would it interfere with the picture.

**FYI** A lens hood is an important but often overlooked bit of equipment. It helps shield the lens from direct light that will cause flare and sun spots, which reduce the overall contrast in your pictures.

Lens hoods can be made of metal and therefore rigid, or they can be rubber and flexible. Both work fine; however, the metal lens hoods really protect your lens much more than rubber, but on the other hand, the rubber ones fold flat and fit more easily into your camera bag.

Zoom lenses can accommodate lens hoods, but the hood must either be for the widest focal length or adjustable, depending on which focal length the lens is set at.

## Lens Filters for Creative and Technical Uses

Filters are typically used in front of the lens (the end farthest from the camera) and have many uses—from those that have creative and technical effects to those that are protective. Because they fit over the lens, it is essential that they are optically superior and clean, otherwise they will adversely affect your photographs.

Filters come in glass that screw onto the front of the lens and plastic ones that fit into a holder that is mounted to the lens. There are also loose filters that can be taped to the lens. Glass filters are generally more expensive but much more durable than plastic filters. Plastic filters are all right if you use them infrequently, but if used often or carelessly, they become scratched and unusable.

The most commonly used filters are UV and skylight filters. They have little or no effect on your pictures because they remove ultraviolet light, which the human eye does not see, but they are used by most photographers to protect their lenses. If the filter becomes broken or gets dirty, it's easier and less expensive to replace or clean than buying a new camera lens.

Filters for black and white photography essentially filter the light, and in doing so, have an effect on the look of your photograph. Color filters make objects of the same color lighter in tone and objects opposite in color darker, so a red filter makes red things brighter and green and blue things darker. Remember this and you will understand how to use them. This is useful when trying to create a contrast between objects in a picture that are the same tone but different color. Imagine red strawberries on a dark green plate. The tones are very similar and the black and white photograph renders their tone the same. By using the red filter, the strawberries become brighter and the plate becomes darker, creating a nice separation between the two.

The following are some commonly used color filters with their numeric designation for black and white photography and their effects:

- Yellow filters (#8) are used to make the blue sky darker in black and white photographs. Film is sensitive to blue light and so skies are often rendered very white in photographs. A yellow filter makes the sky darker and gives much better separation between the sky and clouds. It also helps reduce the bluish haze in landscapes. In the following figures, you can see the difference in the sky between the image with no filter and that with the yellow filter that darkens the sky.

- Dark yellow (#15) and orange filters do the same as the yellow, only more so. These filters are especially useful for landscape photography to cut the bluish haze in the distance.

- Red filters (#25) are used to make red objects appear lighter and blue and green objects appear darker. The effect is much greater than with the yellow filter. A red filter will make the sky appear very dark or black. The red filter shot in the third figure that follows makes the sky even darker than with the yellow filter. It also gives the picture more contrast.

- Greenish yellow filters (#11) are used to lighten foliage and enhance pale skin tones.

- Neutral density filters (ND) reduce the amount of light coming into the camera and allow for larger apertures or slower shutter speeds in bright lighting conditions.

- Polarizing filters (Polarizing) reduce reflections and glare—useful when photographing on water or at the beach and for photographing through glass. Polarizing filters are made of two filters and can be rotated, increasing or decreasing their effect to varying degrees. The fourth figure that follows shows the effect of the polarizing filter in reducing glare from the passing traffic.

- UV and skylight filters (1A or UV) absorb ultraviolet light and have no effect on black and white photographs. These are used to protect the camera lens from damage and dirt.

*This was taken using no filter.*

*(Tony Maher)*

*This was taken using a yellow filter.*

*(Tony Maher)*

*This was taken using a red filter.*

*(Tony Maher)*

*This was taken using a polarizing filter.*

*(Tony Maher)*

The following are some filters used for more dramatic effects:

- Close-up filters screw onto the lens and allow for very close focusing. They often come in a set of three, varying in magnification. When attached, you can only focus on very near objects and need to remove the filter to focus normally. These work very well and are an inexpensive way to enjoy macro photography.

**JUST A MINUTE**

When you are ready to do some close-up photography, buy a set of close-up filters instead of investing in a macro lens. Close-up filters work well and only cost about $30, whereas a macro lens will be a few hundred dollars.

- Split range filters are used when you want a close foreground subject and distant background subject both sharp, and when manipulating the depth of field cannot accomplish this. Half of the filter is a close-up and the other half is clear. Position the foreground subject to one side of your frame and rotate the close-up side of the filter to the same side. When the picture is made, the close-up subject is in focus and the background subject on the opposite side of the picture is, too.
- Starburst filters create a star pattern from points of light such as a headlight or lamp.
- Soft focus filters reduce the apparent sharpness of a picture. This effect is sometimes used to hide skin blemishes and wrinkles in portraits.

Now you have a strong command of lenses, their various focal lengths, depth-of-field characteristics, and pictorial effect. As we've just discussed, filters are great tools with which to manipulate tonal relationships and enhance your final photograph. Now we will go into a detailed discussion of black and white film and how it works.

# HOUR 3
# Black and White Film

**LESSON PLAN:**

In this hour, you learn about black and white film. Because film is what captures and holds your image, it is essential for you to understand its properties, the way it records light, and the options available for creative control.

- How black and white film works
- ISO and ASA numbers and film speed
- How developers differ
- How to push and pull film

Film is light sensitive. We have learned in the previous hours about the shutter and aperture that let light into the camera, and in this hour we begin to learn why those controls are necessary. Anyone who has bought film knows that there is a large selection to choose from, and here we discuss those different films and their individual characteristics, taking the mystery out of which film to choose for a photo shoot.

## HOW FILM WORKS

The 35mm black and white film is made up of a long roll of flexible cellulose and polyester, called the *base*. On this base is a gelatin coating called the *emulsion*. In the emulsion are silver halides, also called silver salts, that when exposed to light are converted into metallic silver. As seen in the following figure, the silver halides float in the emulsion that is adhered to the clear flexible base.

### STRICTLY DEFINED

The **film base** is a flexible support made from cellulose and polyester upon which a gelatin emulsion is coated. The **emulsion** contains silver halides (also called silver salts) that become tiny particles of metallic silver when exposed to light and treated with a chemical developer.

*Photographic film consists of a clear polyester base coated with a gelatin emulsion. Within the emulsion are light-sensitive silver halides that convert into metallic silver when exposed to light.*

*(Mike Hollenbeck)*

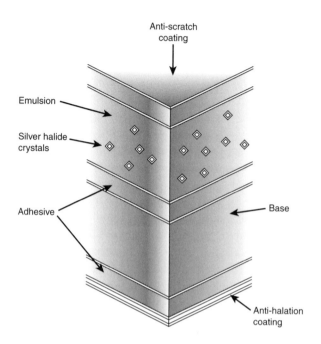

So black and white film is basically a plastic base coated with a light-sensitive emulsion of silver salts. In the camera, light coming through the aperture and shutter falls onto the film emulsion, creating a latent image. This means that the image is there but unseen until the film is *developed*, by using chemicals that help the silver halides convert into tiny particles of metallic silver. In your photograph you can see these tiny particles, which are the film *grain*. The crispness of your photographic image is determined by the size of these particles of grain and whether they have a sharp or soft edge. The properties of grain are determined by which film is used, the amount of exposure (how much light they get), and how they are developed.

### STRICTLY DEFINED

**Developer** is the chemical used to process film that converts a latent film image (made of silver halides) into metallic silver. The tiny particles of metallic silver seen in a photograph are called **grain.**

When light falls onto film, the silver halides are activated and begin converting into tiny particles of metallic silver. This is a chemical occurrence found in nature. Once converted, the tiny particles of metallic silver appear as black specks. The more light that falls onto the film, the more of this conversion takes place and the more black specks build up, making the film

darker. This accumulation of silver is referred to as *density*, a gradual effect that produces an image with smooth transitions between highlights and shadows. The camera lens focuses an image, made of light, onto the film; and in areas with bright light, say a sky, the film builds up a lot of silver and becomes darker. In the same image, the part of the image with less light, say a shadow, builds up less silver and remains lighter.

**STRICTLY DEFINED**

**Density** is how much silver is present in a negative. A dense negative is one that is dark from a lot of silver and a thin negative is one that is mostly clear, with very little silver.

Because film is the source from which your pictures are made, it is essential that the exposure be sufficient to capture the information on the film, or your image will lack in detail and resolution. In the following figure you can see the *highlight* (dark) and shadow (light) areas of the negative. If there is no detail in the shadow areas, that part of the picture will be black.

**GO TO** ▶
Exposure, or how much light falls onto your film, is discussed in Hour 4.

*The light areas in the negative correspond to the shadows in the photograph and the dark areas in the negative correspond to the highlights in the picture.*

*(Tony Maher)*

**STRICTLY DEFINED**

**Highlights** are the areas of the negative that are dark and therefore correspond to the bright areas in a photographic print.

Film that has not been used is referred to as unexposed. Once exposed to light, it is referred to as exposed film. Once it has been developed, it is called a negative, because the areas that receive a lot of light become black and the areas that do not remain clear or become a soft gray. As seen in the preceding figure, negatives are tonally reversed from positive images, hence the name.

## ISO, ASA, and Exposure

ISO and ASA numbers, which mean the same thing, indicate how sensitive film is to light, referred to as *film speed*. The higher the ISO or ASA number, the more sensitive film is and the faster the film speed. This means that the conversion from silver halides to black specks of metallic silver happens with less light.

### STRICTLY DEFINED

**Film speed** is how sensitive any given film is to light and indicated by the ISO or ASA number; the higher the number, the more sensitive the film.

ISO stands for International Standards Organization and is the worldwide organization that sets the numeric standards for rating film speed. ASA is the older, American version that also created standards for film speed. The numbers designated by ISO and ASA are exactly the same and the terms are interchangeable. Previously, there was a different standard and numeric designation for film made or distributed in Europe called DIN. DIN and ASA had different standards and so ISO unified the system and now the worldwide standard is the ISO number. Older photographers will still use the term ASA, and either ASA or ISO is correct because their numbers are the same.

The manufacturers, Kodak, Ilford, Fuji, Agfa, and the rest, create many different films at many different film speeds, or ISOs. Each film has a unique characteristic that will be useful under specific photographic circumstances or is made for different purposes. There are all-purpose films for most picture taking needs and others for very specialized purposes, to create certain effects or produce certain results. Understanding these differences and what they do will help you choose the film best suited for your needs.

Film speed can generally be characterized as slow, medium, fast, or high speed:

- Slow-speed films are those with an ISO of 100 or less. They are made to operate under bright light conditions or with long exposures.

- Medium-speed films are those with ISOs above 100 and below 400. These films are good for "normal" conditions of daytime, outdoor light.
- Fast-speed films are those with an ISO of 400 and up to 1600. These films are made for lower light conditions and indoor use.
- High-speed films are ISO 1600 and 3200 and produce excellent results in very low light conditions, at night, and under artificial lights.

Besides speed, these various films generally have different characteristics in regard to the size of their grain and sharpness of the photographs they produce. I say generally because the film developer greatly affects these characteristics, which will be discussed later in this hour.

## SLOW-SPEED FILMS

Slow-speed films generally produce pictures with small grain. As stated earlier, grain is the tiny particles of metallic silver that make up a photograph, and so the smaller the grain, the smoother the overall appearance of the photographic image. Slower film is generally sharper, producing prints that appear crisp and well focused. Again, I say "generally" because the developer is also a big factor.

Sharpness in photographs is a matter of a few factors. First of all, the lens must focus the image sharply onto the film. Then the film must be able to translate that image into a sharp print. The ability of the film's grain to show sharpness is due to two factors, resolution and acutance. *Resolution* is the ability of the film to determine very fine detail. *Acutance* is the edge sharpness of the individual specks of grain. As you can see in the following figure, which has been greatly enlarged, ISO 100 film has very fine, sharp grain.

Slow films are often chosen when a photograph is being made in a studio, where the photographer has a great deal of control over the light. They are also used when photographing in bright outdoor light, for landscapes and architecture. They work well for portraiture if the light is strong enough because the grain is so small and tightly clumped that it produces a picture with smooth and even skin tones.

*Slow film (that is, film with a low ISO number) has finer, tight grain, as in this extreme enlargement.*

*(Tony Maher)*

## MEDIUM-SPEED FILMS

Medium-speed films are good for using during the day outdoors and with an electronic flash. They have a grain pattern similar to slow films and produce smooth, even tones of gray.

 **FYI** ISO 400 film is extremely versatile and can be used in bright or dim light. The newest versions of this fast film, Ilford's Delta 400 and Kodak's TMAX 400, have very small and tight grain and can produce sharp pictures under most lighting conditions.

## FAST-SPEED FILMS

Fast film is very versatile and can be used indoors or outdoors with good results. Many professional photographers and photojournalists use ISO 400 film both outside during the day and inside. The grain of many new 400-speed films is very tight and small. This is particularly true of Kodak TMAX 400 film and Ilford Delta 400 film. Both look as sharp and have grain as tight as the older version of slow film. Both of these films are extremely flexible, and depending on how they are exposed and developed, can be used for most photography with natural light, artificial light, or electronic flash. The following figure is an enlargement showing the moderate, coarser grain that is typical of 400-speed film.

*Here is an extreme enlargement from ISO 400 film in which the grain is larger than in the previous photo of ISO 100 film.*

*(Tony Maher)*

## High-Speed Films

High-speed films are best used under low light conditions. Because they are extremely sensitive to bright light, they are not recommended for use outdoors during the day unless it is very overcast and dark. They work best under low light either indoors with artificial light or outside at night. Their very high speed is also useful for action shots when you want to use a fast shutter speed to freeze action or when a long lens is used. They do not work well with an electronic flash because they are so sensitive to bright light. As you can see in the following figure, these high-speed films produce a much larger, more noticeable grain than 400-speed film or slower. For this reason they are not used in portrait photography unless large grain is an effect you are looking for. Kodak TMAX 3200, Ilford Delta 3200, and Fuji Neopan 1600 are all high-speed films that produce excellent results under low light conditions.

*This enlargement shows the much larger grain that is typical with high-speed film.*

*(Tony Maher)*

### Choosing the Right Speed

So when you choose a film, think about the lighting conditions you are going to be photographing under. If you photograph under many different conditions, you should have a variety of films to choose from. I buy 20 rolls of film at a time and keep them in a plastic container in the refrigerator. I remove and let them warm up to room temperature before exposure. Depending on what I am shooting and when, I carry various films in my camera bag.

**FYI** As film speed increases, so does the appearance of grain. This is not a hard-and-fast rule as the conditions of exposure and development are also factors, but generally, slower film produces pictures with less apparent grain while faster films do the opposite.

Some typical film speeds are:

- ISO 25 is very slow film and will have very fine grain and sharpness. Kodak Technical Pan claims to be for extreme enlargements and resolution. It works best with their Technidol film developer. Agfa's Agfapan 25 can be used with any of their developers.
- ISO 50 is similar to ISO 25 film, very slow, generating fine grain and sharpness. Ilford's Pan F Plus works well with any of their developers.

- ISO 100 and 125 films have fine grain and sharpness at moderate speed. They are great for using outdoors during the day and under bright light. Kodak's TMAX 100, Ilford's PF4 and Delta 100, and Agfapan 100 are all excellent films that work well with practically any developer.

- ISO 400 films are the most widely used and versatile. Kodak's Tri-X and TMAX 400, Ilford's HP5 Plus, Delta Pro 400, Agfa's Agfapan 400, and Fuji's Neopan 400 give excellent results under all light conditions and are compatible with any developer. The major difference is that Tri-X, HP5, Agfapan 400, and Neopan 400 are older technology films that have a bit more noticeable grain. The newer technology films work better when you need to push film speed (discussed later in this hour).

- ISO 1600 and 3200 films are great for low light conditions and indoor use. Kodak's TMAX 3200, Ilford's Delta 3200, and Fuji's Neopan 1600 work well with many developers. TMAX and Delta are new technology films that respond very well to pushing film speeds up to ISO 25,000! This characteristic makes them indispensable for low light and special applications.

- Chromogenic films are a type of black and white film that is made to be processed the same way as conventional color film. This film can be processed by any lab or one-hour photo finisher that does color film; however, it does not develop well in traditional black and white film developers. Kodak's TMAX CN400 and Ilford's XP2 are black and white chromogenic films. I would not recommend using these films because the image is made up of dyes instead of the tiny particles of silver as in conventional black and white films. These films typically have lower contrast and sharpness than conventional films. Be careful not to buy this film by mistake when you think you are getting conventional black and white film.

## How Film Speeds Relate to Each Other

In Hour 1, I said that each consecutive f-stop and shutter speed lets in twice as much or half as much light as the one preceding it, depending on whether you are opening or closing the lens, or speeding up or slowing down the shutter. There is also a way to determine how much faster one film is than another. Doubling the ISO number is equivalent to one f-stop, so ISO 100 film is one stop faster, or more sensitive, than ISO 50 film. ISO 400 film is two stops faster than ISO 100 film (100 doubled is 200 and equals one stop, 200 doubled is 400 and equals another stop). So ISO 3200 is how many stops faster

than ISO 400 film? Well, 400 doubled is 800 (first stop), 800 doubled is 1600 (second stop) and 1600 doubled is 3200 (third stop). So ISO 3200 film is three stops faster than IS0 400 film.

### PROCEED WITH CAUTION

Never leave your film in your car in the summer or near a heat source.

Film is sensitive to heat and radiation. Slow films have a higher resistance to both while high-speed films are very sensitive. Film that becomes too warm will have uneven grain structure, low contrast, or poor sharpness. Radiation occurs in nature and usually has little effect on film, but airport x-ray machines produce moderate levels of radiation and will damage high-speed films. ISO 400 and slower films are not usually affected, but 1600 and 3200 films are pretty susceptible to radiation damage. You can buy a lead-lined bag in most camera stores to prevent your film from being damaged by x-ray radiation, but airport security will need to be informed of this. You can also put your film in a clear plastic bag (perforated so condensation does not form) and ask the security personnel to "hand check" your film. Take your film out of the box so they can see that it is indeed photographic film.

## Various Film Developers and Their Characteristics

As already mentioned, different film developers produce different results in your photographs. Now that you have an idea of how film works, their speeds as designated by the ISO, and some of their general characteristics, let's look at some common film developers and how they affect films.

Film developers are chemicals that accelerate the process of converting silver halides into metallic silver. When light hits the silver halides, this process begins, but happens rather slowly. Film developer makes this process happen much more quickly and to a greater extent. Theoretically, film will develop an image without using developer but the process would take a much larger amount of light over a longer period of time.

As with most chemical processes, temperature affects how quickly the action takes place. Film developer is made to work at various temperatures but optimally at 68° Fahrenheit (20° Celsius).

There are general-purpose, high-energy, and fine-grain film developers. General-purpose developers will give good results with most films, high-energy developers are good for boosting contrast and for pushing film speed, and fine-grain developers do just that. Because fine grain helps produce sharp images, most film developers say they produce fine grain. But not all developers give the same results, and some produce negatives with higher or lower contrast and varying degrees of optimal sharpness and appearance of grain. Some developers come in powder form and must be mixed with water; others come as a liquid. Some can be used full strength while others must be diluted. Dilutions can vary to produce subtle results. When diluted, the amount of time for which the film is developed must increase.

The following are some popular film developers:

**GO TO** ▶
The complete film developing procedure will be discussed in detail in Hour 15.

- Kodak D-76 is an all-purpose powdered developer that works well with most films. It must be mixed with water before using. It can be used full strength or diluted 1:1, 1:2, or 1:3. Of course, as chemicals are diluted, their action is reduced, thereby increasing developing times. D-76 typically produces negatives with noticeable but even grain and give good acutance, or sharp-edged grain, which produces sharp pictures.

- Kodak HC 110 is a liquid developer that can be mixed many ways to produce different results. HC 110 is called a high-energy developer and is known for producing negatives with strong contrast. If you have shot pictures under low contrast light, HC 110 would be a good developer to help boost the film's contrast or to push film speed. The grain produced is noticeable but even and has good acutance.

- Kodak Technidol liquid film developer is made for use with Kodak Technical Pan film, a slow-speed, super-fine-grain film. And, it produces the best results when used with this film.

- Kodak TMAX liquid developer is specifically made for use with Kodak TMAX films but is also a very good general film developer. It is easy to mix and use, very versatile, and gives good sharpness and fine grain.

- Agfa Rodinal is a classic, fine-grain, super-sharp film developer. It has been around a long time and is the favorite of many photographers. It is highly diluted before use and works well with most films.

- Ilford ID-11 is an all-purpose powdered film developer comparable to Kodak's D-76. It works well with all films and gives good, uniform grain and sharpness.

- Ilford Microphen is a powdered, high-energy film developer that provides fine grain and is good for boosting contrast and for pushing film speed such as Kodak's HC 110.
- Ilford Perceptol is a powdered developer used for extra-fine grain and has longer development times for greater control.

You will notice that practically all developers claim they are fine-grain developers, but some do it better than others do. Some developers work best with certain films and some will produce sharper images than others will. It is best to start out with a developer that is made for your film and see the results. The more you develop film and share experiences with other photographers, the better understanding you will have of which film-developer combinations you like.

## How to Adjust Film Speed/Pushing and Pulling

When you buy your film, you are choosing it based primarily on its ISO or film speed. As mentioned earlier, film speed is how sensitive to light the given film is. This has been determined by the manufacturer and is designated by the ISO; the higher number designation means more sensitivity. But the ISO is a general level of sensitivity that can be altered with varying degrees of success. You can use a film rated at ISO 400 and expose it at higher or lower levels than what the manufacturer calls for. When you choose to expose the film as if it was rated higher, it is called *pushing* and when you rate the film lower, it is called *pulling*.

### STRICTLY DEFINED

**Pushing** means that you are rating film at a higher ISO than what the manufacturer calls for, and **pulling** means that you are rating it at a lower ISO. Pulling works very well, but pushing often results in no shadow detail and enhanced grain.

Why would you push or pull film? One reason would be if you need a faster or slower film but don't have it handy. Another would be if you have done this before and like the effect. When film is made, the manufacturer has created different emulsions that are tested and receive an ISO rating, but their ratings are at the highest end of the film sensitivity. For this reason, some photographers feel that any given ISO is actually too high and therefore choose to cut their ISO in half.

Pulling means that if your film is rated 400, you would actually expose it at 200. That would be giving the film twice as much light as the manufacturer suggests and therefore the developing time would need to be reduced. The outcome of pulling is usually very good shadow detail, fine grain, and a wide range of gray tones.

Pushing the film means the opposite. If your film is 400, you expose it as if it were rated 800 or even 1600. The result would be less shadow detail but good highlights. Contrast is increased and so is graininess.

Pulling usually gives very good results with no loss of image quality. What's great about pulling is that the shadows have very good exposure because you are overexposing the film, allowing more light to fall onto the film from the shadow areas. To prevent the highlights from getting too dense, you reduce your developing time.

Pushing doesn't work as well because the film is already rated at its highest level by the manufacturer, but some films do this better than others. Kodak's TMAX 3200 and Ilford's Delta 3200 are designed for just this purpose. They work great at their designated ISO (3200) but also work well when pushed. I have pushed both films two stops (rating them at 12,800) with excellent results. But there are limits to everything, and shadow detail suffers and grain size increases when any film is pushed.

## Bulk Loading

To save money, you can bulk load your film. Instead of buying it in pre-packaged canisters, you can buy it in 100-foot rolls and load it yourself into reusable canisters. If you shoot a lot of the same film and need to save money, bulk loading can cut your film cost in half or more. You can buy a convenient bulk loader into which you put the 100-foot roll of film. The bulk loader is a light-tight box that lets you do the loading of your film in the light and has a counter so you know how many frames will be on each roll. The following figure shows a bulk loader.

*This bulk film loader holds a 100-foot roll of film that can be loaded into reusable film canisters, saving you a lot of money.*

*(Matthew Richardson)*

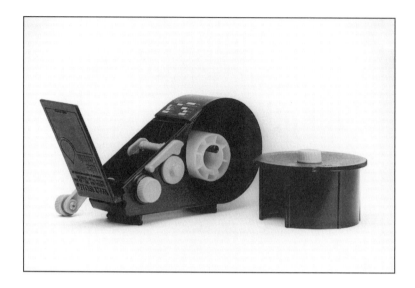

Now you know how film works, have a deeper understanding of film speed, and know how to determine which film to choose for your photographic needs. We will now take the next step and discuss how you go about metering the light to get a well-exposed negative.

# Hour 4

# Using a Light Meter

## Chapter Summary

**LESSON PLAN:**

In this hour, I put together all of the information from the preceding hours so that you can begin making pictures.

- How to use an exposure meter
- How to use different hand-held incident meters
- How to use a camera meter
- How to use gray cards

As stated earlier, the lens aperture and the shutter each let a certain amount of light into your camera, and the ISO indicates your film's sensitivity to that light. So how do we set the aperture and shutter? The exposure meter, also called a light meter, gives us the answer.

## Operating an Exposure Meter

An exposure meter is an amazing device. It has photo-electric cells that convert light into electricity. The more intense the light, the more electricity is produced. It reads the intensity of light in a given situation and produces a series of *f*-stops and shutter speeds for you to choose from.

**JUST A MINUTE**

When using any exposure meter, the first thing to do is set the ISO for the film you are using. All meters need to know this information before they can give you a reading.

The first thing you must do is tell the meter how sensitive your film is. This is done by setting the meter for your film's ISO. It does not matter if you have the cheapest or most expensive meter, one that is built into the camera or hand held. The meter cannot give you an accurate reading until it knows which film speed you are using.

## How They Work

There are a few types of meters that read different kinds of light. Meters that are built into cameras as well as many hand-held meters read *reflected* light—that is, the

light that is bouncing off your subject. When you point your camera at an object, the light reflected goes into the camera and activates the photoelectric cell in the camera's meter, which produces a *light reading*. Depending on how your particular meter works, the light reading indicates which *f*-stop or shutter speed to set your camera at. Or your meter may simply indicate that for whatever settings your camera is at, the amount of reflected light is too strong, too weak, or just right for a well-exposed negative.

**STRICTLY DEFINED**

**Exposure meters** that are built into your camera read reflected light, the light bouncing off the subject and entering the camera. The meter will give you a light reading, which indicates what aperture and shutter speed will produce a well-exposed negative.

## How to Use It

Go out with your camera and see how this works by following these steps:

1. Set your shutter speed to $\frac{1}{60}$ of a second. As mentioned in Hour 1, this is the slowest speed recommended when the camera is hand held with a wide-angle or normal lens. If you are using a longer lens, set your shutter to the speed nearest the focal length of the lens. If you are using a 135mm lens, set the shutter to $\frac{1}{125}$.

2. Now point your camera at your subject and activate your meter. Depending on your camera, this may be done by pressing the shutter release partially or turning a knob. Most modern camera exposure meters are activated by pressing the shutter release button halfway down. A series of lights will be activated, a needle will move, or numbers will be illuminated.

3. While the meter is activated and the camera is pointed at the subject, gently turn the aperture ring until the meter indicates correct exposure. If you are not sure how your meter indicates correct exposure, consult your camera manual.

My Nikon FM2 produces a series of lights to indicate correct exposure. If the light is a minus sign (–), it means that there is not enough light to get a well-exposed negative. Opening the lens to a larger aperture corrects this. If the light in the camera is a plus sign (+), it means there is too much light, which is corrected by closing the lens to a smaller aperture. Correct exposure is indicated by a zero (0) on my camera. If I get a – or +, I simply rotate the aperture ring until I get a zero (0).

Other brands of cameras have other methods to tell you this. Some will have a needle, others have lights, and still others use numbers. Read your camera manual for your specific exposure meter system. In the following figure are three typical exposure meter displays. They all basically provide the same information: correct exposure, overexposure, and underexposure.

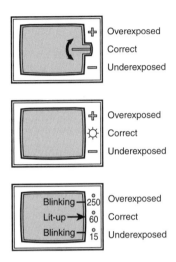

Here are three different in-camera exposure meter displays. While every camera is unique, they all give you the same basic information: underexposure, overexposure, and correct exposure.

(Mike Hollenbeck)

My Mamiya's built-in camera meter has two lights. One is stationary and indicates the shutter speed that the camera is set at. The other light blinks and indicates which shutter speed I would need to set my camera at to get a well-exposed negative for whatever aperture is set on the camera. By rotating the aperture ring, the blinking light can be lined up with the stationary light, indicating good exposure. Remember from Hour 1 that the amount of light between each aperture and shutter is the same, so you can move either the aperture or shutter control to get the lights to line up.

Once you see how your camera indicates correct exposure, you can take the picture. Go back and review the information about shutter speeds and apertures if necessary, remembering to use a fast shutter speed to prevent blur. If you are photographing under very bright conditions, your meter may indicate that even with the lens closed all the way down, there is still too much light. Simply increase the shutter speed to correct this. If your meter indicates that there is not enough light even with your lens wide open, you will need to slow the shutter speed down below ⅟₆₀, but this may produce blur in your picture. This can be overcome by using a faster film (higher ISO) or by using a tripod to hold the camera steady.

**GO TO** ▸

For more on tripods see Hour 8.

## How to Overcome the Shortcomings

Your camera's exposure meter is probably very good, and if you follow it, your pictures will come out well-exposed most of the time—but why not always? The meter is reading the light reflected from your subject. The reading it gives you is to adjust the amount of light reflected from the subject to produce *middle gray*. Middle gray is half white and half black, 50 percent of each. Middle gray has a reflective rate of 18 percent; that means it absorbs 82 percent of the light that falls on it and reflects 18 percent back. All exposure meters are designed to give you a reading that will produce this middle gray.

Depending on the camera, meters can take readings from the entire picture area or a small portion of the picture area. Older cameras usually have a rather wide angle of view, meaning that everything you see through your camera's viewfinder is being seen by the meter. For instance, if there is a lot of sky in a landscape picture, the meter is averaging the brightness of the sky with the medium tones of the ground. This works pretty well most of the time, with some exceptions that will be discussed shortly.

Newer cameras often have a "center-weighted" meter. This means that the meter is taking its reading from the center of the picture you want to take. A great advantage to this type of meter is that you can point the camera at something that is approximately middle gray and take a reading, then recompose your photograph and take the picture. In the preceding example with a lot of sky in a landscape, you could point your camera at the ground to get a reading, then recompose so that the bright sky would not be a factor in the light reading. This center-weighted meter is especially good for portraiture, when the picture's main interest will be a person's face.

Many cameras have a center-weighted meter. This means that the center of the viewing area is where the light reading is taken from. This is a great feature that helps you get good exposure, even in a backlit situation.

Once you know this you can determine when to follow your meter and when to ignore its readings. Imagine photographing someone standing in front of a bright wall as in the following figure. The meter is simply trying to average the overall scene to middle gray and the bright background is forcing the meter to make the bright wall dark. The person standing in front of the wall consequently is made very dark.

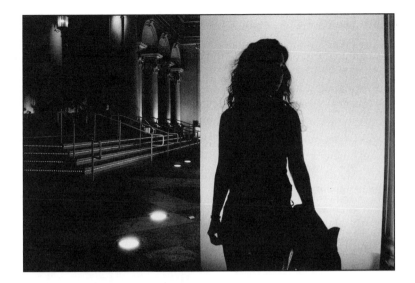

*The exposure meter was followed and it tries to render the white background middle gray, producing a silhouetted figure.*

*(Tony Maher)*

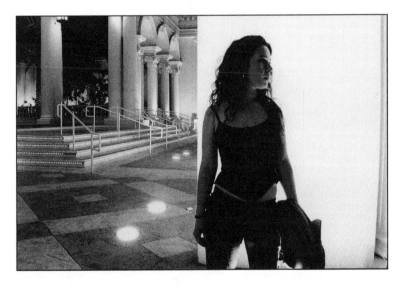

*This time the photographer opened up the lens two stops to let more light in and give better exposure to the skin tone and brighten the whites.*

*(Tony Maher)*

The preceding figure shows that the photographer recognized that the bright wall would render his model too dark, so he opened up the lens two stops to let more light in to better expose his subject. When he did so, the light meter indicated he was overexposing the film. But he understood that to get a well-exposed subject he would need to overexpose the background.

The more you use your camera's exposure meter the more comfortable you will become using and reading it, and the more adept you will be at knowing when to override its readings.

## USING HAND-HELD, INCIDENT LIGHT METERS

One way to get around the shortcomings of your camera's exposure meter is to use a hand-held meter that reads *incident* light, the light landing on a subject, not the light reflected into the camera. An incident reading is more accurate because it is not dependent on the light or dark tones in the scene but only reads the intensity of the light that is actually illuminating the subject. The following figure demonstrates the difference between a reflective and incident reading, and why the incident reading is more accurate.

### STRICTLY DEFINED

While **reflected light readings** measure the light bouncing off a subject and are therefore subject to error due to the tone of things in the scene, an **incident light reading** measures the intensity of the light falling onto the subject and is therefore more accurate.

*This shows the difference between an incident and reflective reading, and why one is more accurate. The incident reading measures the intensity of the light, not the light being reflected into the camera.*

*(Mike Hollenbeck)*

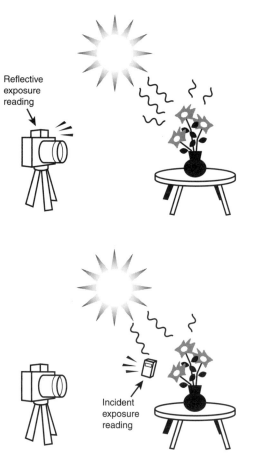

Reflective exposure reading

Incident exposure reading

## USING THE SEKONIC STUDIO DELUXE II

The Sekonic Studio Deluxe II (shown in the following figure) is a popular exposure meter that will give you an accurate incident reading. To use it, follow these steps:

1. As with all meters, set the ISO first.

2. Hold the meter up so the light falling on the white module is the same intensity as the light falling on your subject. If you are making a portrait, hold the meter in front of the person's face. Be sure the white module, which takes the reading, is pointed toward the camera.

3. Activate the meter by pressing the center button, and release. The red needle will swing and take continuous readings while the button is held and will be locked in place when released. The red needle indicates the strength of the light and points to a number.

4. Rotate the outer ring until the black pointer is at the same number as the red needle. Then simply read what aperture is indicated for your shutter speed.

Note that the meter gives you a full range of apertures and shutter speeds to choose from. When you are taking a reading outside in bright light, there is a perforated slide that must be inserted behind the white module. This allows for accurate readings in either dim or very bright lighting conditions.

This meter costs around $250 and will last a lifetime.

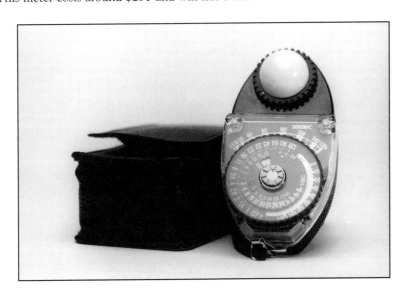

*The Studio Deluxe is a classic and durable meter that takes an incident reading.*

*(Matthew Richardson)*

## USING THE SEKONIC FLASHMATE AND MINOLTA FLASHMATE V

The Sekonic Flashmate and Minolta Flashmate V (shown in the following figure) are electronic meters with advanced features. They can read the natural available light like your camera's meter, and they can also read the light from a flash. Both meters are electronic, so the batteries need to be fresh and care must be taken to keep them dry. Unlike the sturdy meter we just discussed, most electronic meters are damaged easily if dropped.

*These exposure meters can read ambient light as well as the light output by electronic flashes. These are both very sensitive and work well in the studio and in the field.*

*(Matthew Richardson)*

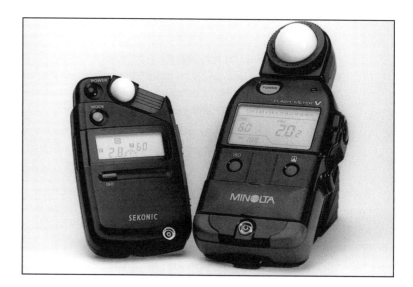

Just like camera meters, flash meters all have a different way of telling you pretty much the same thing. With the Sekonic Flashmate, begin by pushing the power switch. Then select the ISO by holding the ISO button while activating the up and down keys on the side of the meter. This meter has two different modes that you must choose from. The modes are for an *ambient* reading or a *flash* reading.

### STRICTLY DEFINED

**Ambient light** is the continuous light existing in a given situation. Sunlight and artificial lights produce ambient light. Ambient light is what is read by your camera's light meter.

A **flash** is the light produced by an electronic flash and occurs for a tiny fraction of a second. A special flash meter is used to read the intensity of light made by a flash.

Let's begin by taking an ambient reading with the Sekonic Flashmate. Take the following steps:

1. Push the mode button until an icon of the sun appears on the display. This indicates that the meter is ready to take an ambient reading.

2. Set the shutter speed on the meter to the same as your camera's. The shutter speed on the meter is the number by the letter *T*, indicating time. Use the up and down keys on the side of the meter to set your shutter speed. Now you are ready to take an ambient reading.

3. Hold the meter so the light falling on the white module is the same intensity as the light falling on your subject as in the following figure. If it is a portrait, hold the meter in front of the person's face and point the white module toward the camera lens.

4. Push the reading button above the up and down keys on the side of the meter. If you hold the reading button, the meter continuously reads the light. For most photographs, simply hold the reading button for a second and the display produces your reading.

Once done, the meter indicates what aperture to set your camera at for the given shutter speed. Your aperture will appear next to the letter *F*, indicating *f*-stop. Next to the number will be a series of dashes. Each dash represents $\frac{1}{10}$ of an *f*-stop, so be sure not only to read the large number, say 5.6, but to count the number of dashes, too. If there are 5 dashes, set your camera to 5.6 and $\frac{1}{2}$. That means closing the aperture another $\frac{1}{2}$ stop down toward *f*/8. If the number of dashes is only one or two, you don't need to worry, but by the third dash, you will want to begin closing the lens a bit. If you want to see what the aperture for different shutter speeds would be, simply push the up and down keys and as the shutter number changes, so will the aperture.

GO TO ▶

For more on camera flashes and how they work, see Hour 5.

Now let's try setting the meter to take a flash reading. Because the light produced by a flash is not constant, but a short, powerful burst of light, a special mode is required to get a light reading. Take the following steps:

1. As before, turn the power on and set the ISO.

2. Push the mode button until a lightning bolt icon appears. This is the universal sign for a flash. You again set the shutter speed, but when using a flash you need to use a shutter speed that is synchronized with the flash. This synch speed is the fastest shutter speed you can use with a flash. Most cameras synch at $\frac{1}{60}$ or slower, but many cameras also have higher synch speed. This will be discussed in detail in Hour 5.

3. Now hold the flash meter in front of the subject with the white module pointed toward the camera lens.

4. Depress the reading button and then fire the flash. The meter will produce an *f*-stop number and dashes to indicate correct exposure.

*Here the photographer is taking an incident reading with a hand-held meter.*

*(Matthew Richardson)*

## USING SPOT METERS

Besides the ambient and flash meters, there are also *spot meters*. Spot meters take a light reading from a very narrow range of focus. The typical meter built into your camera has an angle of view of around 30 degrees. A spot meter has a much narrower angle of view, 10 degrees, 5 degrees, or even an ultra narrow 1 degree. This allows you to locate a very small area within your picture and take a reading from that area alone, producing a highly accurate exposure. Some electronic flash meters have a flash attachment, making them capable of taking ambient, flash, and spot readings.

## OPERATING CAMERA METERS

Let's go back to built-in meters and look at some of the sophisticated modes available on newer cameras.

Aperture priority mode lets you set the *f*-stop you want and the meter tells you which shutter speed will produce a well-exposed negative. This mode is useful when depth of field is a priority. Larger apertures have little depth of field, and smaller apertures have more depth of field.

Shutter priority mode lets you set the shutter speed, and the meter tells you which aperture will produce a well-exposed negative. This mode is useful when freezing action or showing blur is a priority. Fast shutter speeds can stop action and freeze the subject; slow shutter speeds can show blur on moving subjects.

Programmed or fully automatic mode makes the decisions for you. Depending on the camera, this mode may select a fast enough shutter speed to freeze action, and may even be able to know when you've changed to telephoto lenses to keep the shutter fast enough to prevent blur.

## READING FOR MIDDLE GRAY

Because your exposure meter reads for middle gray, it is a good idea to get acquainted with that tone of gray. To do that, you can purchase a *gray card*— an inexpensive and worthwhile investment.

---

**STRICTLY DEFINED**

A **gray card** is a piece of cardboard with a middle gray, 18 percent reflective surface. All exposure meters are calibrated to give you a reading of this tone.

---

By getting comfortable with seeing middle gray, you can make better exposure judgments and know when to follow or disregard your meter readings. As mentioned before, your meter takes all the tones from a given scene and produces a reading that averages the light and dark areas to a middle gray reading. The most accurate reading of any scene would be the one that is of a middle gray subject. If the reading is coming from a brighter subject, the meter will darken it to middle gray. If the reading is coming from a darker subject, it will lighten it to middle gray.

Look through your camera at many possible picture-taking scenes and you will immediately see that a wide range of tones are present. If you can detect

something that is middle gray in a scene, that would be a good thing to take your reading from. This is essentially what your incident meter does, produces a reading of middle gray from the light landing on your subject.

If you don't have an incident meter, you can use your inexpensive gray card to help you get the best exposure. Here's what you do:

1. Once you have a subject ready to photograph, hold the gray card in front of it or hold it so the light landing on it is the same intensity of the light landing on your subject.

2. Hold the card close enough to your camera so that the entire viewing area is filled with the gray card, and then take a reading. Your exposure is now set to produce a middle gray from the light source, not the variable tones in your picture scene, producing a well-exposed negative.

If you don't have a gray card handy, just watch closely for excessively bright elements in your picture area, particularly something like a bright light near or behind your subject. A classic example of your meter giving you a poorly exposed subject is *backlighting*. We saw this demonstrated in the earlier picture of the woman in front of the bright wall.

**STRICTLY DEFINED**

**Backlighting** occurs when a bright light is behind your subject. This is a difficult situation for a light meter because it is trying to average the tone to produce middle gray and the backlight makes the meter think the scene is bright, usually producing an underexposed foreground subject.

If you look carefully at each photograph you are about to make, you will detect these problems before you make the picture.

Here are some solutions to the classic backlighting problem:

- Open the lens one or two stops to give a better exposure to the foreground subject. When unsure how much to open the lens, bracket your exposures. This means to take a few pictures of the scene with different exposures, so at least one comes out well.
- Move close and take a reading off just the foreground subject, then move back and recompose and take the picture.
- Use a flash to expose the foreground subject.
- Move the light from behind the subject.
- Move the subject away from the background light.

We have covered a lot of material, and I am sure that you are now well prepared to go out and make well-exposed photographs. But there are many instances when the available light is not enough to produce a good negative or when a supplemental light is desired, so in the next chapter we will discuss using your electronic flash.

# HOUR 5

# Camera Flashes

## CHAPTER SUMMARY

**LESSON PLAN:**

In this hour, I discuss how camera flashes work.

- Learn how flashes work
- Learn about flash powers, brands, and your needs
- Supplement existing light
- Create dramatic and interesting effects

A camera flash is a portable unit that emits a burst of light. Most flashes are small to medium-size, lightweight, and fit easily into your camera bag. Most will operate off a few common batteries, and many can be attached to powerful rechargeable batteries. Some flashes are relatively powerful while others are not, and some are basically foolproof and dedicated for a certain camera or brand while many others can be used with any camera.

## HOW A FLASH WORKS

Flash units come in different strengths. This means that a stronger flash puts out a brighter light and can illuminate subjects farther away. Flash power is indicated by a *guide number* with the higher number indicating a more powerful unit. Most photographers probably don't know what their flash guide number is, and it really doesn't matter until you are comparing different flashes and need to know which is more powerful.

### STRICTLY DEFINED

**Guide numbers** indicate how powerful a flash is. The larger the number, the more light a unit can produce. A more powerful unit can illuminate a subject that is farther away.

Basically, the larger the flash unit the more powerful it is. However, you may not need a large, powerful unit except in very rare situations, so don't feel you need a big flash to make good pictures.

An electronic flash, also called a strobe, has a tube filled with gas that produces a bright burst of light when an electrical current flows into it. The tube is basically the light bulb. Flashes often use common household batteries and can be outfitted with more powerful rechargeable batteries—some even have an A/C connector.

**PROCEED WITH CAUTION**

When using a flash on an automatic mode, be sure to first set the flash for the ISO of the film you are using. The auto mode will determine correct exposure, but just like an exposure meter, it must first know your film's ISO.

The burst of light from a flash is for a very short duration, from $\frac{1}{1000}$ of a second to $\frac{1}{30,000}$ of a second, and even shorter. Two of the greatest advantages of using a flash are that the light can be very strong, illuminating things far away, and that due to the extremely short duration, it can freeze moving subjects.

## Using a Flash

Modern flashes are very easy to use but are often confusing for beginning photographers. When they are not used properly the results can be disappointing, and many beginning photographers give up after some early disastrous results. So let's go over the basics of today's flashes.

Almost all, if not every, camera flash has some automatic settings. By camera flash I am talking about the portable units that have a foot that slides into your camera's hotshoe. When using the automatic settings, the flash gives you an *f*-stop number to set your camera at, and each time it fires (flashes), the flash can read the amount of light output and adjust itself for the given *f*-stop. Amazingly, this all happens in a tiny fraction of a second.

Because the flash is creating the exposure for the film, the first thing you need to do is tell the flash how sensitive your film is. Do this by setting the ISO on the flash unit. Once you have set the ISO, the flash, depending on the make and model, will have a series of modes for you to select from. There will probably be a few automatic settings and at least one manual setting. Let's first discuss the automatic settings.

**TIME SAVER**

Using a flash on auto mode is easy:

1. Set the ISO on the flash.

2. Choose an automatic mode.

3. Read the flash's scale to find the right aperture for the auto mode selected. Better flashes will let you choose from numerous *f*-stops, but lesser flashes will tell you which you must use.

4. Set your lens aperture to that *f*-stop.

5. Take the picture.

If your flash has an automatic exposure mode (as almost all of them do), there is a photosensitive eye on the front of the unit that reads the amount of light output. Next to this eye there will be a switch or knob that allows you to choose which auto setting you want. Some large units may have this auto mode switch on the back. The choices basically allow you to choose how much light the flash is going to put out, corresponding to an *f*-stop number. So which number to choose? Remember our discussion back in Hour 1 on depth of field? The smaller the aperture, the more depth of field, and vice versa. This is one reason for choosing a certain aperture—you may want more or less depth of field and the flash is letting you decide. The more powerful and expensive units give you more options, which is a good reason to buy a better flash.

## THE VIVITAR 285

Let's look at the Vivitar 285 flash shown in the following figure. This is a very good and powerful flash, selling for about $110. On the front is the photosensitive eye and sensor module (used to adjust the power levels and *f*-stops), and on the side is the ISO setting. On the ISO dial you will see four different colors, above which is a series of *f*-stop numbers. On the sensor module there is a window-display color marker that corresponds to a color on the ISO guide. As you twist this module, other colors appear—yellow, red, blue, and purple. Each of these colors corresponds to a color on the ISO guide and indicates the proper aperture for exposure.

*This is a very powerful and relatively small flash. Don't rely on those little flashes built into your camera—they are not that powerful, and all your flash pictures look the same. Hand-held flashes are more powerful and a lot more versatile.*

*(Vivitar)*

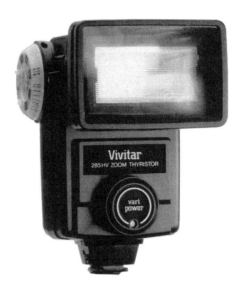

When you want to take a picture, always first set the ISO, then choose the *f*-stop you want and set your lens. (The Vivitar 285 lets you choose your aperture first and then set the flash output. Cheaper flashes will give you fewer choices and tell you what aperture to use.) Then look at the ISO guide on the side of the flash to see which color corresponds to that aperture, and rotate the module on the front to the same color. Now your aperture and flash power level are coordinated and your picture will come out well exposed. This is true whether you are close to or far from your subject within a given range. As you take the picture, the flash fires and the light bounces off of the subject and the sensor module takes a light reading and adjusts the flash output to correctly expose your film. This is all done within a split second and works very well.

Although the details of each flash will differ, this is the formula that most flashes operate on:

1. Set your power mode.
2. Read a scale to find the right aperture.
3. Set your camera accordingly and take your picture.

Check your flash manual for the specific circumstances and limitations of your unit. For instance, on the Vivitar 285 with ISO 400 film, the yellow mode says to set the aperture to $f$-4. When you read the manual, you'll find that the limits of range for that mode are 6 to 60 feet with a 50mm lens. If you want to photograph something closer than 6 feet, you will need to use another mode. On the blue and purple modes you can get as close as 2 feet. Read your flash instruction manual thoroughly.

**FYI** When using a flash on manual mode, determine the flash to subject distance, and then read the flash's distance scale to determine the correct $f$-stop for your film's ISO.

Another way to use your flash is on the manual mode. The manual mode puts out the same amount of light every time, so you will need to set your aperture depending on how far or close your subject is. As always, set the ISO on your flash or find your ISO on the flash's distance scale, usually located on the back of the unit. When you are ready to take a picture, find the distance from the subject to the flash. You can either estimate this or use the distance scale located on your lens (see Hour 2). Next, read the distance scale on the flash for which aperture to set your camera at, and take the picture. As your flash-to-subject distance changes, you will need to consult your distance scale and readjust your aperture.

## THE VIVITAR 2000

Let's look at a less expensive flash to see how it works. The little Vivitar 2000, shown in the following figure, is okay, very small and lightweight, and sells for about $25. The photosensitive eye and the exposure mode switch are located on the front. The flash gives you three exposure options: green mode to the left, manual mode in the center, and red mode to the right. On the back of the camera is a distance and auto mode aperture scale. Find your film's ISO on the scale and follow it across to the green and red $f$-stop numbers. For ISO 400 film, the green number is 11 and the red number is 5.6. This lets you choose either aperture to shoot by simply setting the mode switch to either color and then setting your lens to the indicated $f$-stop. Your pictures will be properly exposed when using the auto modes up to the maximum distance on the scale. If you want to use the manual mode, set the front switch to M, as shown in the following figure, and find your flash-to-subject distance. Read the distance scale for your film's ISO and subject distance to determine the proper $f$-stop and take the picture.

While every flash unit is different, the procedure and theory will be similar to the process just described.

*This flash is pretty typical of small, inexpensive units. It has two automatic and one manual mode. Simply find your film ISO on the back, read the corresponding f-stop for whichever mode you've chosen, and set your lens.*

*(Matthew Richardson)*

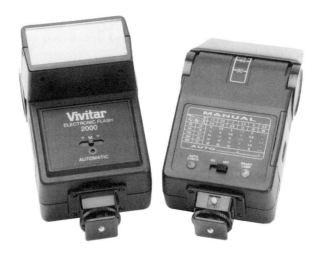

Some other flash features are a manual firing button and an auto exposure light. The manual firing button lets you set off the flash without having to push your shutter release and consequently waste film. The auto exposure light is used when you are not sure if the flash can reach your subject. To use this feature, have your flash set to an auto mode and press the manual fire button. If the auto exposure light comes on, the flash is telling you that for the aperture recommended, the flash put out enough light. In the preceding figure, the light is on the back and called Auto Check. This is a great feature to use when photographing something far away or using a bounce flash (discussed later in this hour).

**FYI** Flashes with an automatic mode also have a sufficient light indicator to tell you if the flash was able to expose the subject properly. When the flash fires, the light will glow for a few seconds, indicating that the flash output was sufficient for the subject's distance.

Using your exposure meter with your flash is easy, too. We discussed this procedure in Hour 4, but here is a review of the steps:

1. Indicate the ISO on your meter.
2. Set the meter to flash mode.
3. Hold the meter in front of the subject with the meter's white module pointed toward the camera lens.
4. Activate the meter and fire the flash.

The meter will display the correct *f*-stop.

## CAMERA SYNCH SPEEDS

You will notice that the discussion of film exposure with the flash has only mentioned apertures and not shutter speeds. When taking pictures without a flash under existing light, the aperture and shutter speeds are coordinated to get proper exposure, but with a flash, the aperture is the only function that controls exposure. This is due to the extremely short duration of the burst of light coming from the flash. The burst can range from $\frac{1}{30,000}$ of a second to $\frac{1}{1,000}$ of a second. But you do need to set your shutter speed to one that will be synchronized with the flash.

The *synch speed* is the fastest shutter speed that you can use with a flash. The flash fires when the shutter reaches its full opening, and if you are above the camera's synch speed, the flash will fire when the shutter is not completely open, resulting in a photograph with only partial flash exposure. If you look at your shutter speed dial, there will be an indication of the synch speed. This may be shown by highlighting the shutter speed number in red or by a lightning bolt. You can shoot with that speed or slower, but as seen in the following two figures, faster speeds will result in only part of the frame being exposed.

### PROCEED WITH CAUTION

When using a flash, be sure to set your shutter to a flash synch speed. The synch speed is the fastest shutter speed you can use with a flash. Any slower speed is okay, too, but faster speeds will result in only partial illumination of the subject.

*This photo shows the flash being used at a proper synch speed. The entire frame is illuminated.*

*(Tony Maher)*

*This photo was done with the shutter speed faster than the flash synch speed, resulting in the left part of the frame not being illuminated.*

*(Tony Maher)*

## FLASH EXPOSURE USING GUIDE NUMBERS

Before the advent of flashes with auto modes, photographers used the flash's guide number to determine correct exposure. Oldtimers were very good at using this method, and some continue to do so even with auto mode flashes, feeling that this method is more accurate. To determine exposure this way,

divide the guide number by the distance between the flash and subject, and that is your f-stop. So if you are using a flash with a guide number of 100 and shooting a subject that is 12 feet away (100 divided by 12 is 8.333), your exposure would be at f-8. If you want to use this method, be sure your flash is on manual mode.

## CHOOSING A FLASH FOR DIFFERENT PURPOSES

Now you have a basic idea of how flashes work and how to use them. Flashes come in a wide variety, and you want to have one or more for different uses. Many cameras come with small, built-in flashes. I am not a big fan of these little units, but many work just fine for subjects that are relatively close to the camera. Obviously, a tiny built-in flash has much less power than a larger, external unit, but the trade-off in power may be reasonable if you need a very portable and lightweight system. When making pictures of one or two people at a range from 3 to 10 feet, a built-in flash is fine. An advantage to them is that they are dedicated to your camera, meaning that the camera and flash were made for each other and coordinate the exposure, reducing the chance of error. The biggest limitation is their lower power, so you will probably not get well-exposed pictures from subjects farther than 15 feet away. You are also stuck with the flash being either just above the camera lens or when turning the camera for a vertical shot, on the side, producing very monotonous lighting and repetitious shadows. Many good cameras that have built-in flashes will let you use an external flash, too, making them much more versatile.

**FYI** Those little flashes built into many cameras are okay for close-up subjects but if you need to photograph a group of people, fill a room with light, or shoot something far away, you will probably need a more powerful external flash.

If you are going to be photographing large groups of people, or taking pictures outside or in a cavernous banquet hall, a more powerful flash will be required. The Vivitar 285, mentioned previously in this hour, is a quite powerful unit that I use for practically all my flash photography.

Another consideration is whether you are going to be using a normal, wide, or telephoto or zoom lens. Flashes typically come with a normal head, meaning that their angle of light will cover a normal lens's viewing area. If you use a wide lens with a flash, the picture will show the falloff of the light, meaning that the center of the picture will receive the flash but the edges will not. This is corrected by using an attachment over the flash head that

spreads the light over a wider area. The Vivitar 285 has a built-in adjustable head for this purpose. Conversely, if you are photographing with a telephoto lens, the flash may not be powerful enough to throw the light all the way to your subject. Again, better flashes like the 285 have adjustable heads that can accommodate telephoto lenses, giving you a much better exposure for far-away subjects. So choosing a flash that is powerful enough to illuminate your subject or wide enough to accommodate your lens is an important decision.

## FLASH TECHNIQUES

Using a flash effectively and creatively is a great way to enhance your photography. A typical problem in photographs done with a flash is that the pictures appear very flat, as seen in the following figure. Because the flash is just above and close to the lens, very little shadow is produced. Shadows are how we tell the depth of something, and they help define the surface characteristics of objects. This effect is controlled by the direction and quality of the light. It may seem that flashes just send out a burst of light, but you can greatly control the direction, intensity, and other qualities of that light pretty easily. Practice the following techniques and you will impress yourself and your friends with how good your pictures look. When done well, flash techniques make your picture look much more professional.

*This shows how the on-camera flash flattens the foreground subject and adds a shadow under the chin.*

*(Tony Maher)*

Flash photography often produces pictures that appear flat, with little or no sense of depth. This is due to the flash being near the camera lens, which minimizes shadows. Shadows help us discern depth. Try holding your flash off of the camera and pointing it at the subject to add shadows and therefore suggest depth.

## HAND-HELD, OFF-THE-CAMERA FLASH

We know that the direction of light creates shadows. By simply taking your flash off the camera you can adjust the shadows produced and make much more interesting photographs. One bit of equipment you will need to do this is a synch cord. With your flash attached to the hotshoe on the camera, the flash fires automatically when the shutter reaches maximum opening. When you use the flash off camera, you need a synch cord. Synch cords can be long or short. I have two: a 6-foot cord for holding my flash off camera and a longer one for placing my flash on a light stand (discussed shortly).

To use the off-camera technique, simply have the synch cord attached to the flash and camera and hold the flash off to the side or above the subject when photographing. You can move the flash around and try it at practically any angle, from directly above the subject, to the side of the subject, to directly below. This gives more directional shadows and better defines the subject. You can do this in either manual or auto-flash exposure modes. You can see the directional shadows in the off-camera flash shot in the following figure.

*Here the photographer held the flash off to the side, producing a shadow on the right side of the subject.*

*(Tony Maher)*

## THE BOUNCE FLASH

As you can see in the following figure, another great looking technique is bounce flash. Direct flash produces a harsh shadow, whether the unit is on or off the camera, but bounce flash produces a much softer shadow and more even, natural illumination.

*This shows the more subtle effect of a bounce flash, creating a natural looking illumination.*

*(Tony Maher)*

**JUST A MINUTE**

Try using the bounce flash technique. When indoors with a white ceiling, turn your flash head up to a 60-degree angle and make the picture. The light will bounce off the ceiling and produce a soft and natural illumination.

You can use bounce flash either on or off the camera. Normally, the flash head is pointed directly at the subject, but when using a bounce flash you point the head up at the ceiling or at a nearby wall. For this technique to be effective, you need to be indoors with a normal to low ceiling or wall that is white or light in tone. The photosensitive eye of the flash should be facing the subject when you take the picture in automatic mode. When the flash goes off, the light hits the ceiling or wall and creates a soft light with mild shadows. This is a beautiful technique for portraiture and the light is flattering. This also works well for group photography because the light is distributed more evenly throughout the room, allowing the people in the foreground and background to have similar illumination.

**JUST A MINUTE**

Flash photography can be very frustrating for beginners. After reading this hour, try all the techniques discussed and learn to use them. Your pictures will be greatly improved and you will be a much better, more versatile photographer.

Bounce flash can be used with a bounce card, too. A bounce card is a piece of white cardboard that is attached to the flash head as shown in the following figure. Point the flash head up toward the ceiling and the bounce card will be sticking up behind the flash head. When the flash fires, the same bounce effect previously discussed is achieved, but the bounce card also reflects some of the light straight ahead onto the subject. This technique gives a nice overall, even light with a bit more to the foreground subject. This also works well outside when there is no wall or ceiling to bounce off of.

**TIME SAVER**

You can buy a bounce card, but it is easy to make your own from cardboard, attaching it to the flash head with a rubber band. Just make sure the side that reflects light is white.

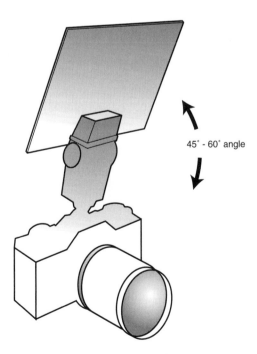

45° - 60° angle

*The flash with a bounce card is one of the best flash techniques. The bounce off the card helps illuminate the foreground, and the bounce off the ceiling helps illuminate the background.*

*(Mike Hollenbeck)*

### THE HANDKERCHIEF

Another softer lighting technique is to simply put a handkerchief or other thin white cloth or tissue over the flash head. The flash is then diffused, creating a much softer and more flattering light.

### OFF-CAMERA FLASH WITH A LIGHT STAND

Off-camera flash can also be done using a light stand for even more versatility. Get a light stand, available at most any camera store. There is a big difference in price and quality, so shop around for the one that fits your budget and needs. I have used an inexpensive stand made by Smith Victor for many years. You will also need to get a device to attach your flash to the stand, a variety of which are also available at camera stores in many price ranges. Simply attach your flash to the light stand and choose auto or manual modes. Decide whether you want a direct flash for harder shadows or a bounce flash for softer shadows. You can use the bounce card or handkerchief technique as well, and you will obviously need to use your long synch cord, too. This technique enables you to both move the flash to extreme angles for interesting lighting effects and move around your subject while shooting.

### OFF-CAMERA FLASH WITH AN UMBRELLA

Using an off-camera flash with an umbrella will give you the most flattering soft light and is like the sophisticated lighting used in a photo studio. You'll need the lighting stand and the attaching device, but also buy yourself an umbrella to attach to the lighting stand. Point the flash into the umbrella and take the picture.

### MULTIPLE FLASHES

Go all the way, using two or three flashes on stands around your subject and you'll have a very sophisticated lighting set up. I recommend using your flash on manual mode with multiple units and using a flash meter to determine your exposure. But how do you get more than one flash to fire simultaneously? By using a device called a slave. A slave is a small unit that plugs into a flash. When a flash goes off nearby, the slave triggers the flash it is attached to. You can use any number of slaves on multiple flashes with or without umbrellas or bounce cards, indoor or outside.

## FLASH FILL

Flash fill is using your flash outdoors or in very bright lighting conditions to soften shadows and illuminate subjects that may be in a shadow. This is typically used when photographing people outside during the day in bright sunlight, as in the following figure. Without a flash under these conditions, the subject's face has deep shadows under the eyes, nose, and mouth—effects that are unappealing and look amateurish.

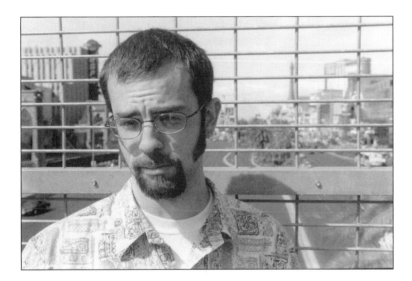

*This portrait was done in the middle of the day under harsh bright light, resulting in dark, heavy shadows.*

*(Tony Maher)*

The following figure shows how the flash fills in the deep shadows for a well-exposed portrait even in the harshest light. News photographers and photojournalists often use the flash-fill technique because they have to photograph whenever an occasion arises regardless of the lighting situation.

**JUST A MINUTE**

We've all taken portraits outside on a sunny day and got pictures with deep shadows under the eyes that are very unattractive. Next time use a flash fill that illuminates the shadows and makes the face bright and flattering on sunny days.

*This time the photographer used a flash fill to illuminate the subject and fill in the shadows.*

*(Tony Maher)*

Let's assume you are outside making a portrait. To use flash fill, take these steps:

1. Because you will be using your flash, be sure that your shutter speed is in synch with your flash (probably ¹⁄₆₀ or so).
2. Take a light reading of your subject.
3. Set the aperture.
4. Set your flash output to the same aperture.
5. Take the picture.

The result will be a well-exposed background and a well-exposed subject with a bright face and minimal shadows. This is a very popular technique and looks great. Look closely at magazines and you will often see this used. You can experiment with this by underexposing the ambient reading by one stop, making the background a bit darker and the foreground subject pop out from the picture.

The flash-fill technique works best when you have a flash with multiple auto settings to choose from, because you never know which aperture your meter will tell you to set your camera at. Also, some better cameras have higher synch speeds that really help you find a good aperture and shutter relationship.

## OPEN FLASH

Open flash is another great technique that makes your pictures look very professional and is similar to flash fill but used with slower shutter speeds and lets you create some blur. This is great to use in nightclubs or nighttime parties:

1. Choose the aperture you want for shallow or deep depth of field.

2. Set your camera and flash for this aperture.

3. Point your camera toward the subjects and watch your ambient light reading.

4. Because you're in a dark place, your reading will indicate that you need to open the lens or slow the shutter speed to get a good exposure. Because you are using a flash and your flash exposure is controlled by the aperture, leave the *f*-stop alone and begin slowing down the shutter speed. I keep slowing down the shutter speed until the meter says I have good exposure, and then I increase the shutter speed by two stops. For example, if my ambient reading says *f*-5.6 at a one-second exposure, I would increase the shutter speed two stops to ¼ second. By doing this, the ambient exposure is two stops less than the flash exposure.

When the picture is made, the flash will illuminate the subjects and the shutter will remain open long enough to give some detail in the dark background. If the subject is moving, there will be some blur but not enough to override the flash, because the ambient exposure is two stops weaker than the flash exposure.

### JUST A MINUTE

Open flash is a great technique for getting a little blur in pictures done at night or under very low light conditions. Try this technique next time you are at a party or club and you will be impressed with how interesting your pictures look with a bit of blur suggesting movement.

The idea behind open flash is that as the shutter speed slows down below ¹⁄₃₀ of a second, the flash exposure needs to be the dominant light source. The flash freezes the action, and the less intense ambient light fills in the background. I recommend a two-stop difference between the flash and ambient exposures for very long shutter speeds of ¼ or slower and a one-stop difference for exposures of ¹⁄₁₅ and ⅛. ¹⁄₃₀ and faster can be used at full exposure between ambient and flash. The amount of blur in your picture will be determined by the exposure time and how close to full exposure the ambient light is. The closer to full exposure, the more blur at slower speeds.

In the following figure, the ambient exposure was two stops under full exposure. This helped lighten the background and give a little blur. In the second following figure, the ambient exposure gave full exposure, and because the shutter speed was so slow, the picture has too much blur.

*In this photo the ambient exposure was enough to lighten the background and produce a small amount of blur.*

*(Tony Maher)*

*In this photo the ambient exposure with a slow shutter speed gave full exposure to the negative. Because the shutter speed was so long, the picture has too much blur.*

*(Tony Maher)*

Both flash-fill and open-flash techniques are about balancing the exposure from two sources, the existing or ambient light and the flash. In flash fill the two sources are balanced, meaning that the exposure from the existing light and electronic flash are about equal. In open flash, the strobe light is the stronger of the two sources because the existing light is very dim and requires a slow shutter speed, which, if used alone, would produce too much blur.

Now you understand how to use your flash on manual and automatic modes, as well as some great advanced techniques. Being able to effectively and creatively use your flash is a major accomplishment that most amateurs never learn, so at this point you are already better educated than many beginning photographers.

# HOUR 6

# Medium-Format Cameras

## CHAPTER SUMMARY

**LESSON PLAN:**

In this hour, I build on the material covered in the previous hours and specifically address how the technical and aesthetic considerations for medium-format cameras are similar to and different from 35mm cameras.

- What medium-format cameras are
- The purpose of medium-format cameras
- Examine the various models
- Medium-format effects on photographs

Once you've begun to master the 35mm camera, the medium-format camera is a natural extension of the same principles, but because of the larger negative size, the pictures have some real advantages. Medium-format cameras are widely used by professional magazine and commercial photographers, and once you use one, you will appreciate their unique characteristics.

## WHAT IS MEDIUM FORMAT?

*Medium format* is the general category for a variety of cameras that use 120 and 220 film. Just as with 35mm cameras, the film size is what designates this category.

### STRICTLY DEFINED

**Medium format** designates the cameras that use 120 and 220 film: 120 is a short roll, producing 10 (TM) to 15 exposures, depending on the width of the frame; 220 is twice as long, producing 20 to 30 exposures. Medium-format film and cameras are often referred to as 2¼ inch or 6 cm, which is the width of medium-format film.

Rolls of 120 and 220 film are 2¼ inches wide and come wrapped in paper. The numbers 120 and 220 are the designations of the length of the film, with 120 a short roll (producing 12, 2¼ × 2¼ frames) and 220 a long roll (producing 24 frames). All medium-format films come in the 120 length, and a limited number of them are available in the 220 length. Unlike 35mm films that come wound in a metal canister, the 120 and 220 films are wrapped in paper.

**PROCEED WITH CAUTION**

 The paper wrapper on 120 and 220 films is not as light tight as a metal canister, so care should be taken when loading and unloading medium-format films. Never load or unload medium-format film in direct sunlight; find subdued light or shade the film with your body when loading and unloading.

Any and all cameras that use these films are called medium format. Some folks also refer to these as roll-film cameras—a confusing term because 35mm cameras also use roll film.

There are a variety of cameras in this category that produce negatives of different sizes on the 120 and 220 film, and the following figure shows the relative sizes of these formats.

*In this illustration you can see that even though all of these medium formats are on the same 120 film, the width of the frame varies from format to format.*

*(Mike Hollenbeck)*

The following are the most commonly available medium-format negatives:

- 6 cm × 4.5 cm, also called 2¼ × 1¾. The negative is 6 cm or 2¼ inches high by 4.5 cm or 1¾ inches long. This is a great format for magazine photography since most publications are approximately these dimensions.
- 6 cm × 6 cm, also called 2¼ × 2¼. The negative is square and this is the most common of the medium-format sizes. The square format was originally intended for commercial photography because it could be cropped to any size, but now most photographers use the square in its entirety.
- 6 cm × 7 cm, also called 2¼ × 2¾. The negative is slightly rectangle, and many popular cameras offer this format.

- 6 cm × 8 cm, also called 2¼ × 3¼. Something in between the 6 × 7 and 6 × 9 formats. I only know of one widely available camera that uses this format but some photographers feel this is the ideal format and have had cameras custom made.

- 6 cm × 9 cm, also called 2¼ × 3½. This is the same proportion as the 35mm frame, a ratio of 1:1.5. Works well for landscape photography.

**FYI** Medium format gives you the freedom and flexibility of small-format photography with the advantages of a larger negative. Most medium-format cameras are easy to carry and hold and are made to be used without a tripod.

When you see medium-format cameras listed, their format will be, too. For example, the Mamiya 645AF has a 6 cm × 4.5 cm frame size and the AF stands for autofocus. The Fuji GW690 has a 6 cm × 9 cm frame size.

## THE ADVANTAGES OF MEDIUM FORMAT

The obvious advantage of medium-format photography is the larger negative size. A 6 cm × 6 cm negative is about 3½ times larger than the 35mm negative. This means that the 6 cm negative has a lot more information captured and can make much larger photographs with less enlargement, producing sharper pictures with less apparent grain.

If you were to take the same picture with the 35mm and 2¼ film, the differences would be striking, with a lot more detail and sharpness from the larger negative. This is a big advantage for commercial photography when image quality is paramount and when large blow-ups are desired. The tiny specks of grain in both films is the same, but because the medium format doesn't have to be as magnified as much as 35mm to get a big photograph, the appearance of those bits of grain is less noticeable.

## TYPES OF MEDIUM-FORMAT CAMERAS

There are many types of medium-format cameras. Because they are generally professional quality, they are made to high standards, come with many accessories not found in 35mm cameras, and cost more.

Here are some popular medium-format cameras, their general uses, and some interesting accessories:

- Hasselblad is considered one of the finest cameras made. Their lenses are all superior quality and the camera bodies are mechanical and all

metal. The design has remained practically unchanged for decades, so many older accessories are still usable on the latest models. This is the classic studio camera and works best on a tripod, but some photographers do street work with it. Accessories include many different lenses, from wide-angle to telephoto, and interchangeable camera backs, enabling the photographer to change films or frame sizes in mid roll. Just insert a dark slide to protect the film from exposure and remove the film back. The new film back is attached and the photographer keeps shooting. This way you can shoot color and black and white simultaneously. The film backs can make negatives in the 6 cm × 4.5 cm or 6 cm × 6 cm formats and can be had in the 120 or 220 lengths. The viewfinding prisms can be changed from a waist level finder to an eye level finder and can accommodate many different screens that help make focusing easier. The following figure shows the classic Hasselblad 503CW.

*This is the classic studio camera that has a large variety of lenses to choose from. The Hasselblad also has numerous prisms for the viewfinder, and interchangeable backs.*

*(Hasselblad USA)*

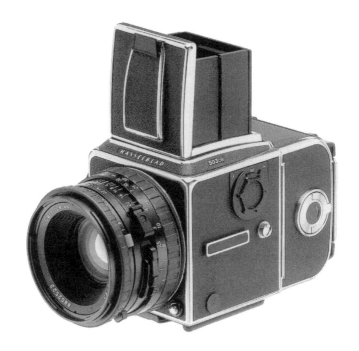

- The Mamiya RB67, shown in the following figure, and the RZ67 are very similar to the Hasselblad in design and accessories. These are professional studio cameras with a large selection of lenses, film backs, and prisms. A nice difference is that they can make 6 cm × 4.5 cm, 6 cm × 6 cm, and 6 cm × 7 cm format negatives.

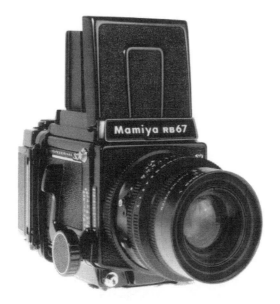

*The Mamiya is modeled after the Hasselblad, with many of the same features such as interchangeable backs, lenses, and prisms.*

*(Mamiya America Corp.)*

- The Bronica SQ, ETR, and GS cameras are also similar in design to the Hasselblad, and each offers a different maximum frame size. The SQ shoots a 6 cm × 6 cm, the ETR a 6 cm × 4.5 cm, and the GS a 6 cm × 7 cm. All have a large selection of lenses and accessories available.
- The Pentax 67, shown in the following figure, is a large single lens reflex camera, very similar to most 35mm cameras. It is easy to hold and carry, and works very well on the street or in the studio. You hold and use it just like a small camera, so it's a very popular model. It has a large number of lenses from super-wide fish eye to telephoto.

*As you can see, this is pretty similar to many 35mm SLR cameras, easy to use, and great for spontaneous as well as studio photography.*

*(Pentax)*

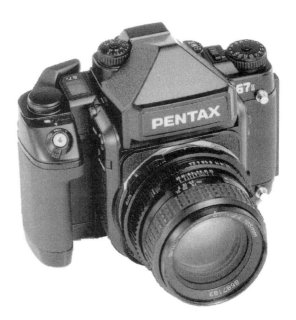

- The Fuji GA645, shown in the following figure, GW670, and GW690 are all hand-held rangefinder cameras. Back in Hour 1 we mentioned the rangefinder focusing system in which you do not focus through the lens, as with an SLR, but through a side rangefinder. A great advantage to this system is that there are fewer moving parts and no mirror (as with SLRs) having to move in the camera body, making these cameras very lightweight and quiet. These cameras are great for outdoor and spontaneous use as well as in the studio. Their main disadvantage is that there are fewer accessories and they cannot focus as close-up as an SLR. These rangefinders are made for spontaneous and street photography, unlike the studio cameras discussed previously.

*This is a very compact medium-format rangefinder camera that also has autofocus and exposure modes.*

*(Fuji)*

- As you can see, the Mamiya 7 II is very similar to the Fuji cameras.

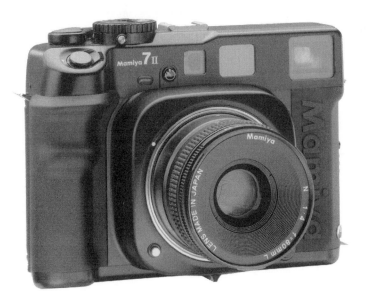

*This is also a rangefinder camera; it's lightweight and very easy to handle. Unlike the Hasselblad or Mamiya RB, this camera does not have interchangeable backs or prisms but does have three different lenses to choose from, including a close-up adapter.*

*(Mamiya America Corp.)*

- The Fuji GX617, shown in the following figure, is a panoramic camera producing a 6 cm × 17 cm negative (2¼ inches × 6¾ inches). This huge negative is great for landscape photography and reminiscent of the old-fashioned cameras used for photographing large groups of people.

*This camera produces a 6 cm × 17 cm negative—really huge! It also has almost a 1:3 image proportion for landscape photography.*

*(Fuji)*

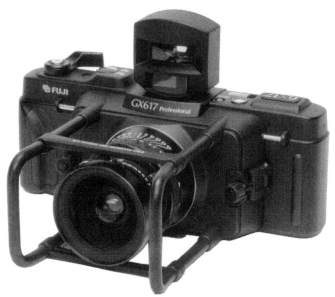

- The Holga is a plastic toy camera that many photographers like to use. Forget about good optics and just go with what you get with the Holga. The plastic lens and super simple construction produce fuzzy pictures with odd distortions that many people find fun and interesting. There are a lot of fine art photographers who like this camera and a number of websites devoted to modifying them for creative results. This camera costs about $15.

- There is also a breed of medium-format cameras called twin lens. They have two lenses, one above the other. When framing a picture, you look through the top lens. The bottom lens is the one that takes the picture. Popular twin-lens cameras are the Roleiflex and Mamiya 330.

## MEDIUM-FORMAT LENSES

Because most medium-format cameras are made for professional photography, their lenses are generally very high quality, and, therefore, they cost quite a bit more than most 35mm lenses. However, there are many other characteristics that are different, too.

The first is lens speed. (Remember this means the size of the largest aperture.) The larger the maximum aperture, the faster the lens, and consequently, the more light that comes into the camera. A big advantage of fast lenses is that you can take pictures under low light conditions with faster shutter speeds.

Each f-stop on a lens represents a proportion of the focal length. F/2 means the aperture is ½ the size of the focal length of a lens. Because medium-format negatives are larger, the focal length of the lenses is larger; therefore, to produce a fast lens, the lens has to be made bigger.

When you look at medium-format lenses, you see that only a few open to f-2.8. More commonly their maximum aperture is f-3.5 and 4. Therefore, shooting under low light conditions is not as easy as with 35mm cameras and lenses.

Because the negative is larger, and therefore the lens is, too, the normal lens on a medium-format camera is not 50mm but closer to 80mm. Once you have become accustomed to knowing the angle of view of lenses for your 35mm camera, you will see that this information is really different for the medium format. The following table shows some basic conversions to help you understand the differences.

| Medium-Format Lens | 35mm Equivalent |
| --- | --- |
| 30mm (super wide-angle fisheye) | 16mm (fisheye lens) |
| 40mm (very wide angle) | 24mm (very wide angle) |
| 50mm (wide angle) | 28mm (wide angle) |
| 60mm (wide angle) | 35mm (wide angle) |
| 80mm (normal lens) | 50mm (normal lens) |
| 135mm (short telephoto lens) | 80mm (short telephoto) |
| 250mm (telephoto lens) | 135mm (telephoto lens) |

## MEDIUM-FORMAT LENSES WITH SHUTTERS

Practically all lenses for medium-format cameras have built-in *leaf* shutters. Unlike the shutters in 35mm cameras that are located at the plane of focus

and called focal plane shutters, leaf shutters are built into the lens. And unlike focal plane shutters that open from left to right or top to bottom, leaf shutters open from the center out. They are called leaf shutters because of their design, which uses thin metal leaves that open and close in a similar manner to the thin metal leaves that adjust lens aperture.

**STRICTLY DEFINED**

**Leaf shutters** are those built into a lens. They open from the center outward and allow synchronization with an electronic flash at all shutter speeds.

An advantage to leaf shutters is that they allow flash synchronization at all shutter speeds, giving the photographer a lot more choices when using flash fill during the day. They also reduce the number of moving parts inside the camera body, making the overall camera less prone to breakdown and camera shake. Camera shake occurs when the internal movements of the camera create vibrations and blur or shake in a picture. This built-in shutter is another reason why medium-format lenses are more expensive.

## DEPTH OF FIELD WITH MEDIUM-FORMAT LENSES

Remember from Hour 2 that depth of field is the range of objects, from near to far, that are in focus in a picture. A smaller aperture allows more depth of field; the larger the aperture, the less depth of field. Also recall that the focal length of the lens also effects depth of field. Longer lenses have less depth of field at any given *f*-stop than shorter lenses.

That means that medium-format lenses, which are longer than 35mm lenses, also have less depth of field. Once you have come accustomed to the amount of depth of field with your 35mm lenses, you will need to adjust to the shallower depth of field in medium-format lenses. A good way to help get used to this is to remember the focal length of the lens you are using. It is the focal length that determines how much depth of field you will get at any given aperture. Just because an 80mm lens is normal on a medium-format camera doesn't mean it has any more depth of field than an 80mm lens on a 35mm camera. Normal, wide, and telephoto are relative to the size of the negative, but focal length is not relative. It is a physical description regardless of the negative size.

And now that you have an idea of what medium-format cameras are and how they work, we will look at large-format cameras in the next hour.

# HOUR 7

# Large-Format Cameras

## CHAPTER SUMMARY

**LESSON PLAN:**

Now that we have discussed medium-format cameras, let's go all the way and talk about large-format photography, the ultimate photographic experience.

- The two basic styles of large-format cameras
- The purpose of large-format cameras
- A look at various models
- Their effects on photographs

Large-format cameras are, by definition, big. All but a few specialty models will require a tripod to hold the camera during use. The equipment and methods are the basic stuff of making pictures, with little or no automation. The camera design has not changed since the nineteenth century. And because the negatives are even larger than those created in medium-format photography, some of the general principles we have discussed will be repeated.

Large format is also the choice for many photographic specialists such as food photographers, architectural photographers, still-life photographers, and many portrait and landscape photographers. About the only thing you can't do with large format is to photograph spontaneously on the street, because of the large camera and time-consuming procedure.

## TYPES OF LARGE-FORMAT CAMERAS

*Large-format* cameras are those using 4 × 5–inch film and larger. There are models for 5 × 7–inch, 8 × 10–inch, and even 11 × 14–inch and 20 × 24–inch film.

### STRICTLY DEFINED

**Large-format photography** is that using 4 × 5–inch and larger film. The cameras are the same basic design as those made 150 years ago. One of the greatest advantages to large-format photography is that the large negative gives a very sharp and detailed photograph.

As you can see from the following figure, the camera design is very simple, which is certainly part of the charm of working with large format. The basic design is a box with a lens and a ground-glass back. The box sits on a tripod, and the film is held in film holders and inserted into the camera when ready to make a picture. The focus is done by opening the lens and focusing the image onto a piece of ground glass attached to the back of the camera. This must be done under a dark focusing cloth, just like you have seen in old movies or old photographs. Once focused, the film holder is placed in front of the ground glass and the exposure is made.

*The view camera is a very simple piece of equipment with a lens, bellows, and camera back.*

*(Mike Hollenbeck)*

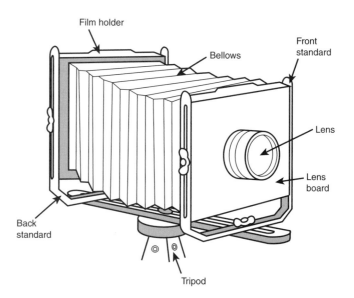

The basic design of a large-format camera is as follows: The lens is attached to the front *standard*, which is connected to the rear standard by a flexible, light-tight bellows. The front and rear standards are on a rail or track that lets them move forward and backward. This movement is how the lens is focused. The rear standard has a ground-glass insert. This is a piece of glass that has been etched on one side, making it translucent but not transparent. When the lens is opened, the light passing through it falls onto the ground glass and you can see the image. Because there are no mirrors or prisms, as in hand-held cameras, the image is upside down. (SLR cameras have a mirror that flips the image right side up for easy viewing.) This is a function of lenses, and when you use a large-format camera, this is something you have to get used to.

**STRICTLY DEFINED**

A **standard** is the front or rear plate of a large-format camera. The front standard holds the lens, and the rear (or back) standard holds the film. Each standard moves independently, and they are connected by a flexible, light-tight bellows.

Because the focusing takes a few moments and requires the photographer to be under a dark cloth, a sturdy tripod is needed to hold the camera.

## VIEW CAMERAS

Large-format cameras come in two basic styles, *view cameras* and *field cameras*. View cameras are made for studio use and offer a variety of camera movements. They typically have a monorail upon which the front and rear standards can slide while connected to each other by a bellows. The front and back standards on view cameras can rise and fall vertically and tilt forward and backward and swing from side to side. These movements allow for an amazing amount of control of focus and perspective in the photograph, and make these cameras ideal for complex studio photography. View cameras are usually rather heavy and cumbersome to carry. Photographers use a hard camera case to transport view cameras.

**STRICTLY DEFINED**

**View cameras** are large-format models that have many camera movements allowing for a large degree of control of focus and perspective. They are made for studio photography.

**Field cameras** are large-format models that have fewer movements, are made to be lightweight and portable, and are designed for outdoor photography.

## FIELD CAMERAS

Field cameras are very similar to view cameras but are designed for photographing outdoors, especially landscape photography. But they do not have the degree of movements that view cameras have and therefore are more limited in adjusting for perspective. They are made to be lightweight and compact (usually carried in a backpack or small camera bag), but still require a tripod.

There are some hand-held large-format cameras that use $4 \times 5$ film—some were made for news photographers in the 1930s to the 1950s. The most popular one is the Speed Graphic, and some contemporary photographers have

bought these old models and fitted them with new lenses. There are useful accessories for these old cameras that make using them more convenient—such as holders that carry multiple sheets of film and even a focusing system that projects two beams of light for nighttime photography.

## LARGE-FORMAT FILM

The film for large-format cameras does not come in rolls like 35mm or medium-format film. It comes in individual cut sheets of various sizes. These cut sheets must be loaded into light-tight film holders. A film holder is a thin, two-sided box. One piece of film can be loaded into each side, allowing two exposures per film holder. Each side of the film holder has a dark slide, a removable plate that protects the film from light until it is ready for exposure.

## CHARACTERISTICS OF LARGE-FORMAT NEGATIVES

Because medium-format negatives appear sharper and with more detail than 35mm negatives, you can imagine how much more information is available on large-format negatives. The dramatic increase in detail, resolution, and sharpness is one of large-format photography's greatest assets.

A $4 \times 5$ negative has 13 times the surface area of a 35mm negative, and an $8 \times 10$ negative has 58 times more surface. It is the larger negative area that allows the larger format to create photographs of amazing clarity and sharpness, as illustrated in the following figure.

Because the negatives are so large, many photographers, especially those using $8 \times 10$ and larger, do not make enlargements but *contact prints*.

### STRICTLY DEFINED

**Contact prints** are photographs made by placing the negative directly against the photography paper. Because the negative is not enlarged, this produces a photograph exactly the same size as the negative, with excellent sharpness and detail.

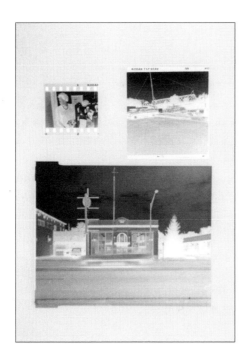

*As you can see, the 4 × 5 negative (bottom) is considerably larger than the medium-format negative (top right) and huge in comparison to the 35mm negative (top left). The larger size is what gives large-format photographs their amazing sharpness and detail.*

*(Matthew Richardson)*

## HOW TO USE LARGE-FORMAT CAMERAS

You can buy many of the same films that you use in your 35mm camera. Besides your camera, you will need the following:

- Tripod
- Film
- Film holders
- Focusing cloth
- Loupe
- Cable release
- Exposure meter

### LOADING THE FILM

Go into a darkroom or closet or bathroom at night and wait a few minutes to be sure the room is totally dark. The film comes in sheets cut for your film back and must be loaded in total darkness.

1. Lay out your film holders.

2. Remove the dark slide that will keep your film from being exposed to light. I stack the dark slides and opened film holders next to each other and have the box of film ready.

3. Dust out the inside of each film holder and their slides. Dust that is on the film during exposure will leave a black speck on your film, so it is very problematic when loading film holders. Film can be purchased already loaded in "ready packs" to avoid this problem.

4. When you are ready to load, know where the holder, slides, and film are and turn off the lights.

5. Open the film box and inside foil packet and remove a sheet of film.

6. As seen in the following figure, there are notches cut into one edge of the film. These indicate which side is the emulsion and which must face outward when loaded into the film holder. You know which side is emulsion when the notches are on the top right of the film. Gently slide the film emulsion side out into the holder and insert the dark slide as shown in the following figure. Do this until you have loaded as much film as you are going to need.

*Large-format cameras use sheet film that must be loaded into film holders. The notches indicate which side is the emulsion, and which must face the camera lens. When the notches are at the top right, the emulsion is facing you.*

(Mike Hollenbeck)

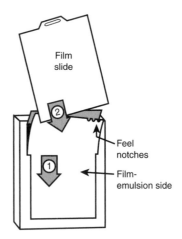

Film slide

Feel notches

Film-emulsion side

**FYI** Large-format photography takes a lot more time than 35mm and medium-format photography. Consequently, you shoot much more slowly and use less film. Because the procedure requires more time and set-up, your pictures are generally more accurately composed and lit.

## TAKING THE PHOTOGRAPH

Now you are ready to photograph. Take the following steps:

1. Set the front and rear standard in zero position, as shown in the following figure. This means that the front and rear standards are parallel to each other and perpendicular to the ground. I recommend using a level, found at any hardware store, to help do this. You will certainly be using a tripod, as seen in the figure below, and many better tripods have bubble levels built into them for this purpose. In this position the camera functions pretty much like conventional cameras.

*The view camera is great for both studio and field use. It has extensive movements to control focus and perspective and can be outfitted with a wide variety of lenses. It is rather heavy, though, and bulky to carry.*

*(Matthew Richardson)*

2. Set the aperture to the widest opening (the smallest *f*-stop number).

3. Open the lens by moving a small switch on its side. Once done, you can get under the dark focusing cloth and see the image on the ground glass. The image is upside down on the ground-glass surface.

4. Take a few minutes to look at your image and make adjustments for composition and focus. Focus should be done with the rear standard. As you move it farther from the front standard, objects closer to the camera come into focus. Very close objects require the front and rear standards to be far apart.

5. When you are done composing and focusing, be sure to close the lens.

6. Use your exposure meter to obtain a light reading now that the scene is composed and focused.

7. Set your camera lens for the aperture and shutter speed. Again, be sure the lens is closed before you do this.

8. Attach a cable release and cock the shutter. The cable release is a flexible cord that screws into the shutter release. This lets you trip the shutter without actually touching the camera, which could cause camera movement and blur your picture.

9. Take the picture, and you are ready for the next exposure or to develop your film.

## CAMERA MOVEMENTS ON VIEW CAMERAS

As already mentioned, view cameras have a variety of movements. These movements are used for creative control of the photographic image. There is a front standard that holds the lens and a rear standard that holds the film. Generally, the front standard affects focus, and the rear standard affects perspective. Both standards can rise and fall (meaning go up and down) and tilt (lean forward or backward) and swing (move left or right on a vertical axis). Here are some of those movements and their effects.

- Rise and fall of the front standard is useful for photographing objects or buildings that are just out of the picture area. Imagine standing in front of a building and that the top is just out of the picture area. By raising the front standard, the top of the building will come into the picture.

- Rise and fall of the rear standard does the same thing but in reverse, because lenses invert images, turning them upside down. So if you wanted more of the top of the building in your picture, you could lower the back standard, thereby showing more of what is at the top of the picture.

- Tilting the front standard creates a unique focus that is only available on cameras with tilt. With a rigid body camera, the lens and film plane are always parallel, and the focus is always parallel to them. Depth of field expands or contracts from this parallel plan. But when the lens plane, the front standard, is not parallel to the film plane, neither is the plane of focus. This effect is called the *Scheimpflug Principle*.

**STRICTLY DEFINED**

The **Scheimpflug Principle** states that when the lens and film are not parallel, neither will be parallel to the plane of focus. Focus will be where the lens and film planes intersect, cutting through the image at an angle.

For example, if the film plane is perpendicular to the floor and you tilt the lens plane so that it intersects at the same place on the floor, the plane of focus now runs along the floor. Said another way, extend an imaginary line from the lens plane until it meets an extended imaginary line from the film plane and that intersection is where the plane of focus is. The following figure shows a view camera at zero position where the plane of focus is normal and shows the horizontal plane of focus that occurs when the lens plane is tilted.

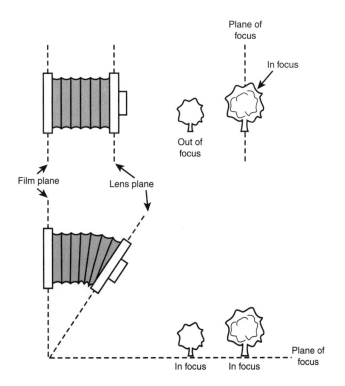

*With the lens and film planes parallel, the plane of focus is also parallel, just like with a hand-held camera. But when the lens plane is tilted, the plane of focus changes from being a vertical plane to a horizontal plane. This horizontal plane of focus is placed where the lens and film planes intersect. This effect is called the Scheimpflug Principle.*

*(Mike Hollenbeck)*

- Tilting the back standard creates a change in perspective. A common use for this is photographing tall buildings. If the top of the building is too tall to be in the photograph, you can raise the front standard. But

if that is not enough, you will need to tilt the whole camera up, as you would with a hand-held camera. But doing this creates converging lines, that is, the sides of the building appear to converge as they go up. This can be corrected with a view camera by tilting the back standard to be parallel with the building. The whole camera is still pointed up but the back standard is now parallel to the tall building, making it appear natural.

- Front swing also uses the Scheimpflug Principle to control focus and the focal plane. Let's say you are at a 45-degree angle to a long wall and you want the entire wall in focus. The front standard can be swung so that the lens plane and the film plane intersect at the wall. Now the plane of focus will be the entire long wall.

- Back swing controls the perspective and can be used to control horizontal line convergence. Just as keeping the back standard parallel to the tall building corrects for converging lines, swinging the back to be parallel to a horizontal wall corrects for converging lines.

Remember, always start with your view or field camera at zero position, with the front and rear standards parallel to each other and perpendicular to the ground. Then you can make these movements and see the effect on the ground glass.

## CAMERA MOVEMENTS ON FIELD CAMERAS

Field cameras are made to be lightweight and portable. This makes them ideal for landscape photography where you probably have to walk a distance from your car and need a camera that is easy to carry. Field cameras are typically made of lightweight wood and fold up to fit into small camera bags and backpacks. The one shown in the following figure is the Calumet Wood Field XM, made from lightweight cherry wood. You still need a tripod, but some manufacturers make strong, light tripods for this use.

Field cameras work pretty much the same as view cameras, but they offer a much more limited range of movements. However, when photographing nature outdoors, there is generally less need for the extensive tilts and swings offered by view cameras. Otherwise, their operation is the same:

1. After setting up the camera, open the lens.
2. Use a dark cloth to focus and compose the image.
3. Close the lens when done.

4. Take a light reading.

5. Set your lens.

6. Insert a film holder.

7. Remove the dark slide.

8. Use a cable release to take the picture.

*The field camera does not have as many movements as the view camera but is very lightweight and can be folded for easy transportation to remote locations. This particular model is made of cherry wood.*

*(Matthew Richardson)*

## BELLOWS EXTENSION

As you focus on very close objects, the bellows expands. As the bellows expands, the light passing through it dims before hitting the film and you must compensate or you will get an underexposed negative. Under most circumstances, you do not need to worry about bellows extension, only when focusing on very near objects.

### PROCEED WITH CAUTION

When using a view or field camera, you need to be aware of bellows extension. When the bellows extends beyond the focal length of the lens, you must open the lens some to compensate or your film will be underexposed.

The rule is that as long as the bellows is expanded no more than the focal length of the lens, there is no need to compensate. But as the bellows extends more than the focal length of the lens, you need to open the lens or slow the shutter to get adequate exposure.

How do we know when to compensate? I carry a ruler to check the bellows extension. First convert your lens's focal length into inches (or use a ruler with mm and cm). 25 mm equals 1 inch, so a 150mm lens is equal to 6 inches. Then measure the bellows extension. If it is 6 inches or less, no compensation is needed. If it is more, here is the formula to know how much to compensate:

$$\frac{\text{Bellows extension}^2}{\text{Lens focal length}^2} = \text{compensation factor}$$

If my bellows is extended 8 inches with a 150mm (6-inch) lens, here's my formula and compensation factor:

$$\frac{8 \times 8 = 64}{6 \times 6 = 36}, \text{ which gives me a factor of 1.8}$$

This means I would open my lens or slow down the shutter speed 1¾ stops for good exposure. If you are put off by the math, you can open the lens one stop for every inch the bellows is extended beyond the focal length.

## LARGE-FORMAT LENSES

Large-format lenses have built-in leaf shutters. Remember from our discussion of medium-format cameras that leaf shutters open from the center out, not from side to side or top to bottom like focal plane shutters. This means that you can use a large-format lens at any shutter speed with a flash.

Because the negative is larger, the lenses must be larger too. The normal lens on a 35mm camera is 50mm, and the normal lens on a medium format camera that produces a 6 cm × 6 cm negative is 80mm. For a 4 cm × 5 cm negative, the normal lens is 150mm.

Now you have a good understanding of all camera types, various models, and how they work. As you have learned, the basic principles of photography remain constant even when the equipment changes. I encourage you to try different camera models and formats to find the one(s) you like best. In the next hour, we will discuss how to go about finding good quality new and used equipment.

# HOUR 8

# Buying New and Used Equipment

## CHAPTER SUMMARY

**LESSON PLAN:**

In this hour, I discuss buying new and used equipment, which is great, but there are so many cameras and accessories that it can be both overwhelming and confusing even for experienced photographers.

- Learn tips for buying new equipment
- Learn tips for buying used equipment
- Understand how to care for your photographic equipment
- Identify some useful accessories

Remember that camera stores are in the business of selling you equipment, so their advice may be less than objective. However, many camera store employees love photography and can give you sound advice.

Used equipment is a great way to go. I have purchased many used lenses, tripods, and cameras over the years. When a piece of equipment goes off the market, used is the only way to buy it. Camera manufacturers target goods for the mass market, and you may be looking for something that is very specialized or quirky that has long since been discontinued.

Once you have some ideas of what your actual needs are, how you will use the equipment, and a good basic understanding of what to look for, you can purchase new and used equipment with confidence—and keep photographic equipment salespeople from selling you the store.

## CHOOSING AND SELECTING NEW EQUIPMENT

Most of us prefer buying new equipment for the obvious reason that we don't want to buy someone else's problems. Whether it is a car or camera, the feeling is that new equipment has the latest features and improvements and is less likely to break down. But hundreds of new products are introduced each year, and the only guide to which is right for you may be the manufacturer's marketing brochure or the camera store salesperson, both of whom's motives are suspect.

**PROCEED WITH CAUTION**

When buying a new camera, be wary of models with lots of bells and whistles. You pay extra for those features and if you cannot override them, they may inhibit your creative choices.

The first step is to talk to friends, visit the camera store, talk to their employees, and do not buy anything immediately. Doing some research is a big advantage to purchasing something that is affordable and, most important, useful for your picture taking needs.

**PROCEED WITH CAUTION**

Do some shopping around before you buy equipment. Check websites for general pricing information and ask other photographers about their experiences. Camera store employees can be a great resource, but remember that they are there to sell you something.

The web is a great resource tool and every manufacturer has a website with product information. Some will send you a catalog with their entire product line as well. Read the product descriptions and think about the type of photography you are interested in.

**GO TO** ▶
See Appendix B for photographic equipment, supplies, and resources.

If you are just beginning, getting a camera that is flexible is a good idea. By flexible I mean can it accommodate accessories from other companies, such as flashes and lenses? I would also advise being cautious about buying equipment with too many bells and whistles. An array of fancy features is a sure sign of a camera designed to seduce an uninformed buyer. They may be sexy to look at, but very few photographers actually use all those features and they can add a great deal of confusion and maintenance problems.

Here are some tips for buying new equipment:

- Look for a basic camera that has both manual and automatic features. Ask the salesperson if the auto modes can be easily overridden. This will immediately separate your choices, and as you have already learned, creative use of your shutter and aperture require you being able to make the decisions.

- Can the camera accommodate standard flash units? At least one manufacturer that I know of limits your flash choices to their models only. This forces you to buy their brand, severely limiting your choices and particularly your options to swap and borrow a friend's equipment or to pick up good deals when they arise.

- Keep the fancy bells and whistles to a minimum. Expensive amateur cameras are overstocked with features you will never use if you know how to use your camera's other functions. Many of these features are designed for those who do not know how to use a light meter correctly or have a limited understanding of the effects of aperture and shutter controls. By reading and using this book, you are learning how to make the creative choices that these features try to control automatically.

### PROCEED WITH CAUTION

 Don't get tempted by super-long zoom lenses. It is very common for beginning photographers to get talked into these expensive and seldom-used items. Think about what you will actually use, because most camera equipment depreciates quickly.

- Don't get seduced by long lenses. Long lenses and zoom lenses are great accessories, but they can be expensive. Ask yourself how often you would use them. A big drawback of long lenses and zooms is that they aren't as fast as fixed-focal-length lenses, meaning that their maximum aperture will not be as great as those available on fixed-focal-length lenses. Slower lenses force you to use a flash under low light conditions when ambient light might make a better picture.
- Beware those tiny built-in flashes. They are okay for casual party shots or daytime flash fill, but they limit your control and creativity. If you buy a camera with a built-in flash, be sure it can also accommodate an external flash.

In short, I recommend you buy a camera with manual features or one on which the automatic features can be overridden.

## RECOGNIZE THE VALUE OF PROFESSIONAL-GRADE EQUIPMENT

Professional-grade cameras by the major manufacturers hold their value longer because of their superior workmanship, availability of accessories, and reputation for excellence. I have purchased equipment made by Nikon, Leitz, Hasselblad, and Mamiya that have all retained their value. When I was ready to buy something new, I was able to sell this excellent used equipment for a very good price and in a few cases, even more than I originally paid for it. The lesson here is that quality equipment is worth the extra money.

### Ask Yourself What You Need

The bottom line in buying new equipment is to educate yourself about what's available and to think about what your needs are. Don't try to get a camera that is all things to all people. Those models are made for amateurs who don't understand their creative options. Most of the great pictures in the world were made with basic equipment. So ask yourself what are your photographic needs? For all-purpose photography—portraits, landscapes, and snapshots—the Nikon FM10 comes with a 35mm to 70mm zoom lens and has a fully manual body. This camera sells for around $250 and can accommodate all of the brand's other lenses.

### Know Where to Go

Lastly, you may want to think about buying online or by phone or mail order from one of the large professional photography stores in New York, Chicago, or Los Angeles. I like to support my local stores, but I always check the pro shops' prices first. The savings can be dramatic.

## Choosing and Selecting Used Equipment

As great as buying new equipment is, buying used equipment can be even better. The biggest advantage to used equipment is that when done carefully, you can get a high-quality camera that is made of steel instead of plastic. An all-metal camera is obviously much more durable and, if taken care of, can last many lifetimes. Imagine handing down a great camera from one generation to the next, and how proud a young photographer will be to have the privilege to use his or her grandparent's quality camera!

Some of the new cameras are all metal, but very few. Being made of plastic makes them much lighter, which is fine, but if dropped, they break. Also, many new cameras have sophisticated electronics that, when broken, must

be sent back to the manufacturer for even minor repairs. This type of equipment is severely damaged if it accidentally becomes wet, which is less of a concern with all-metal manual cameras.

I have had very good experiences buying used equipment from both individuals as well as professional camera stores. If you are lucky enough to live in New York, Chicago, Los Angeles, or another major city, there are bound to be a few very good professional photography equipment stores that carry used equipment.

Used equipment can be a very economical way to go, getting you more of what you want for less money. Also, many photographic items become discontinued, so the only way to get them is to buy them used. Equipment that was excellent quality when purchased new can be repaired if necessary to work as well as the day it was bought.

Here are some tips for buying used equipment:

- Examine the equipment very carefully. This sounds pretty obvious, but do it anyway. Open the camera back and look for scratches that would indicate misuse or damage. Close the back and notice if it closed all the way to prevent light leaks. Does the equipment look well cared for?

- For lenses, go through the apertures and look closely at the diaphragm as it opens and closes. It should move smoothly without any sticking or jerky movements. Also, open the lens all the way and hold it up to the light. Is the glass smooth, free from scratches and imperfections? Is there dust inside the lens between the elements? Are there bubbles along the edge of the elements where they are glued into place? Is the aperture ring easy to rotate? Problems in these areas can mean trouble in a lens. If the aperture ring is hard to move it may only need a cleaning.

**PROCEED WITH CAUTION**

When buying used equipment, examine it thoroughly. Try all the lens apertures and shutter speeds. Look for misuse or odd sounds and hard-to-move parts. Though many malfunctions can be fixed or cleaned, it may cost you more in the long run.

- Try all the shutter speeds. Go through the full range and listen carefully. You should be able to hear the shutter speed increase and decrease as you adjust it. Open the back of the camera and try the shutter speeds with the lens removed so you can clearly see the shutter in action. All movements should be smooth and not make scratching or grinding

sounds. A shutter can be fixed but it is usually an expensive repair. I would not buy a camera with a broken shutter unless it was a good brand of camera and very, very inexpensive (under $40).

- Know whom you are buying equipment from if possible. You have no idea of what the equipment has gone through. Of course, there are want ads and Ebay where you need some trust. Check out the seller's profile and past sales history if possible. If a deal seems too good to be true, it probably is. I would never buy any equipment that I suspected was stolen, even if it was very cheap. The seller will disappear and the buyer could end up being charged with theft or receipt of stolen property.

**PROCEED WITH CAUTION**

Never buy equipment that you think has been stolen. You could become legally liable. When in doubt, buy from a reputable camera store. Even if something costs more, you have recourse if it breaks or is defective.

- Understand that cleanliness is a virtue in photography. Clean, well-cared-for equipment has a better chance of working well than dirty equipment. But remember that equipment can be cleaned and repaired by a camera professional, too.

- Know that exposure meters typically break on old cameras. They can be fixed, but you can also buy a good hand-held meter in its place. New cameras have very good built-in meters, while many older cameras had less reliable ones. Sometimes the old meter really isn't worth fixing when you can get a great hand-held meter that will perform better.

- Remember the bells and whistles I warned you about? They break and can cause other problems in used equipment. Stay away from overly complicated electronic used equipment. Manual cameras can last many lifetimes, which is rarely the case with electronic models.

## CARING FOR YOUR PHOTOGRAPHIC EQUIPMENT

As just stated, well-cared-for equipment can last a lifetime. Keep your camera and lenses clean, but don't go overboard. I recommend using a soft cloth to wipe down the camera body and lens barrel. I refrain from cleaning the glass of the lens unless it needs it. If needed, use only specially made lens cleaner and a lens tissue—a few drops of lens cleaner on lint-free lens tissue works fine. But it is best to keep it from getting dirty in the first place by using the clear filter.

The lens glass should be protected with a UV or skylight filter, and use your lens cap. If you have more than one lens, use a rear lens cap on all lenses not in use. This is a cap that attaches to the back of the lens for protection when not on the camera.

**JUST A MINUTE**

Keep your equipment clean. Wipe cameras with a soft cloth and use a UV or skylight filter over all of your lenses. When not on the camera, use the rear lens cap. Use a cap on the body when a lens is not on the camera.

Accumulations of dirt and greasy gunk on the camera body and lens barrel can be removed with alcohol and a Q-tip. Gunk has a tendency to gather around the focusing and aperture rings on the lens and around the film advance and shutter release on the body. Never pour alcohol directly onto the camera. Dab a small amount on a lint-free tissue for large areas and on a Q-tip for getting into small areas. Q-tips leave lint behind, so to blow lint away, use compressed air (available at all photo and office supply stores) or a bulb blower—a rubber ball with a nozzle that blows air when squeezed.

It is best to avoid cleaning inside the camera. Use a body cap if there is no lens on the camera. A body cap is a plastic cap that covers the hole where the lens attaches. Don't leave the camera back open unnecessarily.

If you are an active, busy photographer, keeping equipment clean during use is impractical, so before or after a shoot is a good time to wipe down the body and lenses. One of the best protections for your equipment is your camera bag. I have numerous bags for different occasions. I use a small canvas bag made by Domke when I don't need much equipment and mobility is important and a larger canvas Domke bag when I need access to more equipment.

Your camera bag should ideally have padded sections for extra lenses, an exposure meter, and film. Both of mine have outer canvas pockets for my flash and battery and a larger pocket for my notebook and bounce card. I keep the bag strap fairly tight so the bag stays close to my body, helping to prevent unnecessarily banging into walls and so on.

**JUST A MINUTE**

The best protection for your camera is a good camera bag. Cloth bags are lighter and easier to carry, whereas hard cases offer more protection but are heavier. Having a few bags really helps because they have different uses.

Some photographers also use soft cloths with Velcro tabs to wrap their lenses in. These are a nice idea for added protection of your lenses.

Electronic equipment must be protected from moisture. Some camera bags are waterproof and most are water-resistant for this purpose. Watch your batteries, too. Never leave batteries in equipment for long periods of time. If they leak, they can permanently damage your equipment and incur costly repairs. If they leak just a tiny bit, they could cause erratic performance in your equipment, ruining a shoot and causing you hours of trouble while shooting.

## IDENTIFYING SOME USEFUL ACCESSORIES

Once you have bought a camera you can begin considering the accessories that will expand your creative possibilities. First get a camera bag to carry and protect your equipment. Soft or hard cases are great. Soft cases are lighter and easier to carry, while hard cases offer the best protection. If you travel a lot, you might want to get the hard case and a smaller soft one. Use the hard case for travel and transfer equipment to the soft case when out shooting.

Here is a list of important and additional accessories and their uses:

- There are specialty bags such as backpacks for hikers and fanny packs for small cameras as well as conventional over-the-shoulder bags and hard-shelled cases for ultimate protection. The bag shown in the following figure is pretty small but has plenty of room for gear and makes things easy to get to quickly.

*This small camera bag is the best protection for your camera and flash. It fits comfortably under your arm and provides easy access to your equipment.*

*(Matthew Richardson)*

**JUST A MINUTE**

Camera accessories can greatly expand your picture-taking options. Camera flashes, creative filters, hand-held meters, and tripods are not only useful but are sometimes essential for good pictures.

- UV or skylight filters are needed for all your lenses.
- Front and rear lens caps and body caps are necessary for all your cameras. As seen atop the lens in the following figure, the cap is just a plastic cap but will save your lens from dirt and fingerprints.

*This little cap for the back of the lens is essential for avoiding fingerprints and dirt.*

*(Matthew Richardson)*

- An electronic flash is both a technical and creative tool. When light is too low for hand-held exposures, the flash will give the added illumination for just about any situation. And learning advanced flash techniques such as bounce and flash fill give your pictures a more professional look. Those little built-in camera flashes are okay for some purposes but are generally very limiting. The flash shown in the following figure is easy to use and will fit into any camera bag.

**GO TO** ▶
See Hour 5 for more on flashes.

*This Vivitar 283 flash is powerful, easy to use, and small enough to fit into your camera bag.*

*(Matthew Richardson)*

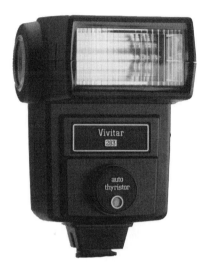

• Hand-held exposure meters can take incident readings that are more accurate than your camera's reflective reading. And like the one shown in the following figure, getting a unit that provides flash readings is a great asset that will come in handy.

*This hand-held flash meter is small and lightweight, and provides very accurate readings of both flash and ambient light.*

*(Matthew Richardson)*

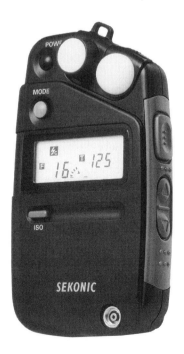

- Tripods are three-legged devices for holding your camera steady during exposure. They are typically used for slow shutter speeds when you cannot hold the camera without shaking it, but are also great for portraits, self-portraits, and when the exact composition is crucial or you want to make various exposures of the exact same scene.

  Tripods come in a large variety, and you often get what you pay for. Inexpensive tripods should be scrutinized for quality. Check the tripod head (where the camera is attached). It should be sturdy, and, when the screws are all locked, the head should not be able to wiggle or otherwise move. Also extend the legs and put weight on them. If they budge even a little bit, then the unit is not going to perform well.

  When choosing one, consider how heavy the unit is (see the following figure). Large, heavy units are necessary for large-format cameras. While a lighter, smaller unit may be fine for your purpose, weight equals stability—especially when photographing outdoors when it may be windy. Of course, if you do a lot of hiking with your camera and need a tripod, weight is a big consideration. Two excellent brands are Gitzo and Bogen, but you will be shocked at how much they cost. Remember, however, that one good tripod will last a lifetime.

**PROCEED WITH CAUTION**

Cheap tripods are often not a good investment. A tripod needs to be sturdy and stable to function properly. Check the unit before you buy it. Make sure the head will tighten completely and the legs will hold enough weight.

- A cable release is used to release the shutter without touching the camera. When using a tripod and slow shutter speeds, a cable release is an important item to prevent shaking the camera when releasing the shutter. Usually, a short cable release is sufficient, but for very long releases, get a bulb release as shown along side the traditional cable release in the second following figure. It has a squeeze bulb that when depressed will release the shutter. Bulb releases are very inexpensive and have very long cords, which are great for self-portraits.

*Here are two tripods that can handle just about any situation. The larger is very sturdy but heavy, and the smaller one (though lightweight and easy to carry), is sturdy for its size.*

*(Matthew Richardson)*

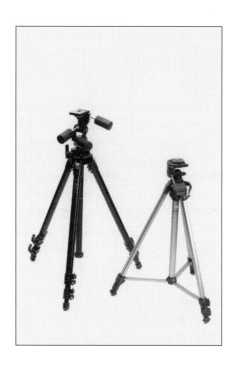

*The cable release has a wire running through it that activates the shutter without touching the camera, while the bulb release uses an air-powered plunger to do the same.*

*(Matthew Richardson)*

- Reflectors are used to shine light onto the subject and are great for use in the studio as well as in the field. They come in a variety of sizes and surfaces and have a spring steel outer ring that allows them to be twisted and folded into small carrying bags. A reflector is great when photographing a subject indoors near a window. Have the reflector opposite the window, reflecting light into the shadows on the subject. They give a nice soft light when the reflective surface is white and a harder light when the surface is metallic. There are also reflectors with a warm-color reflective surface such as gold. When using a gold reflector, the light becomes a warm golden color and is very attractive for portraiture. A reflector can be very large and require an assistant to hold it or be quite small, so the subject could hold it. There are attachments (as shown in the following figure) to hold reflectors on light stands for hands-free usage, too.

*The reflector is one of the best ways to gently enhance lighting on portraits and products. The light reflected is soft, and the reflector can be folded into a small carrying case.*

*(Matthew Richardson)*

- Creative filters for the lenses include the yellow filter to darken blue skies, the red filter to dramatically darken skies, and the polarizing filter to help control glare off of glass and water. There are also close-up filters that screw onto lenses, enabling a normal lens to focus very close. They are very reasonably priced, many times less than buying a macro lens.

**GO TO** ▶
For more on lens filters, see Hour 2.

- If you use a flash a lot, consider getting an external rechargeable battery. It enables the flash to recycle very quickly so you can take pictures with a motor drive in quick succession. They also give the flash a lot more stable power, ensuring more accurate exposure. The one shown in the following figure is a Quantum Turbo battery that can expose up to 10 rolls of film on a single charge.

**FYI** An external rechargeable battery is essential when using a motor drive or doing news photography.

*This Quantum Turbo battery holds a lot of power and lets the flash recycle very quickly, allowing you to shoot a lot of pictures in a short duration. But be careful not to fire the flash too quickly or the flash tube can burn out.*

*(Matthew Richardson)*

## INCREASING CREATIVITY WITH SPECIALTY CAMERAS

There are some specialty cameras that can add a lot to your creative choices. Panoramic cameras give a very wide angle of view and produce an image that is much wider than it is high. A normal 35mm negative's proportion is 1:1.5, meaning that it is one and a half times as wide as it is high. Panoramic cameras are much wider. The Noblex and Widelux cameras both use 35mm film and have lenses that rotate to give a super-wide, 140-degree vantage point. They produce 19 negatives on a 36-exposure roll, and the image's proportions are about 1:2.25. Hasselblad's Xpan camera is a dual-format camera that uses 35mm film and can make the standard 1:1.5 negative or switch to a 1:2.5 panoramic view. This camera's best feature is that you can switch in midroll, producing both normal and panoramic images on the same film.

While most cameras are suitable for most pictures, some manufacturers make cameras for very specific purposes such as ultra-wide panoramic cameras for landscape and water-tight cameras for underwater use. The larger camera stores rent this equipment, which is a great way for you to see whether their unique characteristics suit your picture taking needs.

Fuji makes a medium-format panoramic camera, the GX617, which produces a 6 cm × 17 cm negative, discussed in Hour 6. That is almost a 1:3 proportion and great for landscape photography or pictures of large groups of people.

Back in Hour 7 we discussed large-format cameras that are specialty models. 4 × 5 cameras are quite common but the 5 × 7, 8 × 10, and larger formats are more rare. The Speed Graphic is the old 4 × 5 camera made for news photographers in the 1930s to 1950s. It is a hand-held unit that can be accommodated with newer, faster lenses and electronic flashes.

There is a fairly new 5 × 7 and 8 × 10 hand-held camera called the HOBO. It has a wide fixed-focus lens. This is a great camera for landscapes and makes large-format photography the most spontaneous it has ever been.

There are cameras for underwater use such as the Nikon Nikonos, as well as plastic housings for using conventional cameras underwater. There are still a few ½-frame 35mm cameras, making negatives half the size of regular cameras, and super-tiny spy cameras. Minox makes the best-known spy camera that uses special tiny-format film. The camera is very high quality and has extras like a prism to put over the lens so it takes a picture at a 90-degree angle from the camera and a special close-up attachment for photographing documents!

As you have learned, there is a camera for every photographic need, and you now have the knowledge to sort through the myriad models to find the ones best suited to your needs. And remember that you don't have to buy something to use it, consider renting it over the weekend so that you can see whether it is right for you.

# HOUR 9

# Digital Black and White Photography

## CHAPTER SUMMARY

**LESSON PLAN:**

In this hour, I discuss the limitations and advantages of digital photography so you can make an informed decision.

- Know how a digital camera works
- Select a digital camera that is right for you
- Select the appropriate resolution for your pictures
- Understand how to scan and print digital images

Digital photography is one of the most important innovations in the field. It is quickly advancing on traditional film photography, and as the image and equipment quality rises, the prices are falling.

Digital photography is fundamentally different than traditional film-based photography. While they share many characteristics, such as depth of field and blur from slow shutter speeds, the way the image is captured is totally different. Understanding these differences and similarities will help you decide whether digital is the way you want to go when making black and white photographs.

The first thing to know is that resolution, or the quality of the image, is paramount. Those free cameras that come with software are pretty cool, but they will not give you the picture quality you have come to expect from traditional photography.

## UNDERSTANDING HOW DIGITAL WORKS

A digital camera is basically a computer with a lens. The image is formed by light falling onto a charged coupled device (CCD). The CCD converts the image into an electronic signal and the image is saved onto a memory card. The information on the memory card can then be transferred to your computer for manipulation, storage, sending via e-mail, and printing. The camera shown in the following figure has a pretty high resolution, many good features, and can accommodate high-capacity memory cards.

*This Nikon Coolpix digital camera has 3.4 megapixels, which means you can make a very good 8 × 10–inch print.*

*(Nikon USA)*

Obviously, there is no film to buy, and that is a big advantage. Most digital cameras have an LCD monitor on the back, so after each photograph, you can see what you got. This is another great advantage to digital. If you don't like the picture, you can immediately erase it. This is also great for studio and flash photography because you can see exactly how the lighting worked after each shot.

Many cameras let you choose an ISO rating for different creative effects as well as adjust the *white balance* of the camera to get good color balance under any lighting situation. White balance, which is used for color photography, is a function that enables you to point the camera at a white object in any type of light and have the camera record it accurately. This is important because different types of light have different colors. You have probably seen snapshots made indoor with household lamps on that have a strong orange cast. That cast is caused by the incandescent light, which has an orange cast. The white balance feature enables the camera to record the colors accurately under any type of light.

### STRICTLY DEFINED

**White balance** is the ability of the digital camera to make color-corrected images under any light source. Just point the camera at anything that is white and regardless of the color temperature of the light, the camera will record whites accurately.

Digital photography has some disadvantages as well, however. The high-quality cameras are expensive, and you will need a computer and software to download the images, manipulate, store, or print them. There is also the time it takes to learn how to use the equipment and software, but these are pretty much the same disadvantages of all new mediums. The good news is that as the market for digital expands, the quality continues to improve and the prices fall.

## HOW THE CCD CAPTURES THE IMAGE

The CCD has thousands of light-sensitive cells that record the brightness and color of the light falling on it. This is very similar to the way film works. The cells on the CCD are arranged in a grid pattern, and each one contains its own information. When combined, these cells form the whole photograph. This is just like film, in which the tiny grains of silver record the light and darkness of the scene and when put all together, create the final photograph.

**GO TO** ▶
For more on how film works, see Hour 3.

If you enlarge a digital image enough, you will see the tiny light and dark sources from the cells, called pixels. This is similar to enlarging film to see the grain. In the following figure, the small detail of the flower has been enlarged so that you can see the pixels.

*The image on the left shows where the enlargement is taken from. The image on the right shows that the pixels are blocks of light and dark gray.*

*(Matthew Richardson)*

The quality of your digital image is determined by the number of pixels and how much information each pixel holds. Each pixel has a number of bits, and more bits mean that each pixel has more information in it. Eight bits per pixel will give you very high quality black and white photographs but not very good quality color images. You need 24 bits per pixel to get millions of colors.

You don't have to shoot with a digital camera to get a digital photograph. You can *scan* or *digitize* a conventional negative or photograph, and the computer will convert the traditional photographic image into these pixels. The scanner shown in the following figure has a very high resolution and can scan from negatives or color slides.

**STRICTLY DEFINED**

**Scanning** or **digitizing** means to take a traditional negative, slide, or photograph and convert it into pixels. This is done with a device called a scanner, which is attached to a computer. The computer then stores the image as pixels that can be manipulated, saved, e-mailed, or printed.

*This scanner takes your traditional photographic negative and digitizes the image, converting it from a traditional photograph into a digital photograph that can be endlessly manipulated.*

*(Nikon USA)*

The images made with a digital camera are stored in the camera on a memory card. This card can be removed when it's full of pictures and another one inserted, or you can simply download the images from the card onto your computer, erase the card, and resume shooting. Memory cards come in different capacities designated by how many megabytes (MB) they can hold.

A typical good-resolution digital image might be around 1.5MB, so an 8MB card doesn't hold many pictures but a 96MB card does. Cameras come with memory cards, and you can buy cards that hold more megabytes for more pictures.

## CHOOSING A DIGITAL CAMERA

Just like choosing a film camera, choosing the right digital camera is a challenge. The choices are overwhelming, and the prices range from less than one hundred to many thousands of dollars.

The first thing to think about is how much *resolution* you want. Resolution is how much information the camera can capture. This is not the same thing as the amount of MB the memory card can hold. A low-resolution camera may be able to use a large memory card. The maximum camera resolution is determined by the number of *megapixels* it has. Most digital cameras will be partially identified by megapixels. Simply stated, the more megapixels, the more resolution. The more resolution allows for more detail and sharpness in a photograph as well as letting you enlarge the picture more. And as you might expect, the more megapixels, the more the camera will cost.

### STRICTLY DEFINED

**Resolution** is the amount of information a camera can capture and is measured in **megapixels,** the designation for one million pixels. (A camera with 3.4 megapixels, for example, has 3,400,000 pixels.) The more resolution, the better quality image you can get. A camera with 3.4 megapixels, such as the Nikon Coolpix 995, will capture enough information for a high-quality 8 × 10–inch photograph. Fewer mega-pixels means a lower-quality image or a smaller-sized photograph.

A 1.4-megapixel camera has pretty low resolution. You can make a good quality photographic print up to about 5 × 7 inches only. So if you want a digital camera that will let you make large prints, a much higher megapixel model is necessary. The Nikon Coolpix 995 (see the first figure in this hour) has 3.4 megapixels, allowing for a high quality 8 × 10–inch print.

Go to the web or a camera store and check out the prices. The 3.4-megapixel cameras cost quite a bit, around $700 right now. Professional models with 5 or 6 megapixels are in the thousands of dollars range. As with all digital technology, as the market expands, the quality is rising and the prices are falling. Think back to the price and power of a computer five years ago—those pricey models have been replaced by less expensive and more powerful units. The same is happening with digital cameras.

You do not need higher resolution if you are not making prints. If you are only interested in posting pictures on the web, the lower megapixel cameras are fine because a computer screen is not very high resolution. So those little free cameras are mostly okay for sending your friends pictures via e-mail or posting images on your website.

 **FYI** More resolution in your photograph equals a larger file size, measured in megabytes (MB). Files with high MB take longer to capture in the camera and take longer for a computer to process the information when manipulating images or printing. So more resolution creates larger files that may be harder or slower to work with, depending on how powerful your camera and computer are.

## CHOOSING THE RESOLUTION OF YOUR PICTURES

So the digital camera has a maximum resolution represented by the number of megapixels, and most cameras let you choose how much of that resolution power to use for any given picture. Why not use the maximum resolution for each picture? Because higher-resolution images take up more megabytes on the memory card. A 96MB card holds a few hundred low-resolution images, maybe only 60 high-resolution images, or maybe only 10 very high-resolution images. So your memory card will fill up faster with higher-resolution images, requiring you to download them to the computer more often or carry additional memory cards.

Also, high-resolution images take longer for the camera to record the information, and their larger file size takes more energy and time for manipulations in the computer and for printing. Before you take a digital picture, decide how much resolution versus how large of a file you want.

Your choice of resolution will be determined by how large you want your final print to be. As stated earlier, images on the web can be low resolution, but images to be printed need to have a minimum of 150 pixels per inch. The minimum pixels or dots per inch that will create a continuous-tone photograph is 150. For images on the screen, 72 is the maximum ppi required.

If you choose to photograph at a very high resolution and then change your mind, you can always dump the extra pixels, so a high-resolution image can be reduced. But a low-resolution image cannot be upgraded. You can artificially add ppi to an image, but it does not affect the picture quality; it only adds to your file size. So shoot at the resolution you need, more if you must, but definitely not less.

## USING A DIGITAL CAMERA

As with all photographic equipment, read your manual to know how your particular camera works. Most digital cameras allow you to shoot on automatic or manual modes. However, because you are learning how to control your camera functions, I recommend you use the manual mode.

You may be asked to set the ISO. Because digital cameras don't use film, the ISO setting is used as a way to make us film users feel comfortable. The ISO setting on digital cameras indicates how sensitive to light the CCD will be, with lower ISOs producing images with greater detail and less *noise*. This is similar to the way lower ISO films react—more detail in enlargements and finer film grain.

### STRICTLY DEFINED

**Noise** in digital photographs is the appearance of off-color pixels, especially in dark areas. This is similar to the grain that is apparent in higher ISO films. The higher the ISO setting on your digital camera, the more noise will be seen. Lower ISOs produce less noise.

Choose the ISO that is appropriate for your picture taking needs. Choose a higher ISO for low light situations and a lower ISO for higher light situations. Your choices are basically the same with films, with the huge exception that with films, you control a lot of the image characteristics through development, which you are unable to do with digital. Of course, digital has the huge advantage of being manipulated after the fact with the Photoshop program. As seen in the following figure, the ISO is changed by the clearly marked ISO button.

Now let's put the whole procedure into a set of steps:

1. Have a memory card in the camera and fresh batteries. If you are using single-use batteries, have plenty of extras. I use nickel hydride rechargeable batteries, which last a long time, and I have an extra set ready when one set is loosing power.

2. Choose the exposure mode (automatic or manual).

3. Choose the ISO.

4. Set the quality level to low, medium, high, or ultra (however your camera indicates these levels). In the preceding figure, the quality level is set with the QUAL button. Remember to choose a setting for the way you plan to use the image. Printed images need high resolution, web or e-mail pictures do not.

*This shows the back of the Nikon Coolpix with the display, ISO, image quality selector (QUAL), menu display, and other features.*

*(Nikon USA)*

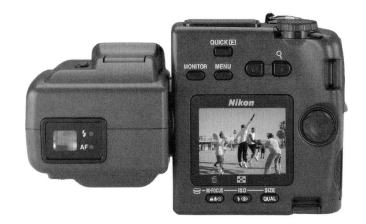

5. Set the shutter speed if you are shooting on manual mode or shutter priority mode. Digital cameras do not have a shutter, so just like calling the CCD sensitivity ISO to make us film users feel comfortable, the amount of time that the CCD is activated for is called the shutter speed. This activation has the same creative effect as a shutter. Longer activation times mean a moving object can blur and shorter times freeze action. Choose an appropriate shutter speed. When in doubt set to 1/60 for normal, hand-held pictures of stationary subjects.

6. Point the camera at your subject and press the shutter release partially. This activates the focus and produces an exposure reading. (If you are using manual mode, you may need to set the aperture—the auto modes will do this for you. Read your camera manual for the exact usage of your model.) The focus is activated by depressing the shutter halfway. Most cameras will focus on the subject in the center of the lens.

7. Once you have activated autofocus, you can recompose your picture, moving the subject to the side of the frame or otherwise changing your composition while the focus is locked at a certain distance.

8. Take your picture.

Depending on the picture quality level you have chosen, the camera may take a moment to process the information. This is an immediate disadvantage to many digital cameras, a delay just as you want to take the picture, in which time the subject may move or you may have missed a poignant moment. Better quality, more expensive cameras do this much more quickly than less expensive models. After the picture has been taken, there may be another pause, during which time you cannot take another picture. The camera is processing the information just received and you need to wait.

You can frame the pictures you want to make by looking through an optical viewfinder, just like on a film camera, or by looking at the LCD monitor on the camera back, as shown in the preceding figure. But the LCD doesn't work well in bright light and having it activated uses up your batteries quickly. I usually have my LCD off so that my batteries last longer and turn it on only when needed.

**PROCEED WITH CAUTION**

Digital cameras often have a delay just before and just after taking a picture. Never interrupt this process by turning the camera off or taking the batteries out. Let it process the information—and if you don't like the picture, you can erase it.

Now that you have taken a picture you can immediately view it. Depending on your camera, you may need to switch the camera to play mode or another way of viewing what you shot. The image will be displayed on the LCD screen on the camera back, and you can continue shooting or delete the image.

Many cameras allow you to select picture qualities from frame to frame. This is a great advantage over film cameras. You could conceivably change ISO from shot to shot, adjust for different lighting conditions using the white balance setting (discussed earlier), and even make adjustments for brightness and contrast of a scene.

## IDENTIFYING THE TYPES OF DIGITAL CAMERA LENSES

You will notice that the focal length of digital camera lenses does not conform to the focal lengths of film camera lenses. This is because the effect of a lens, whether it is wide, normal, or telephoto, is relative to the film or CCD size. CCDs are much smaller than a 35mm film frame, so the lenses used for digital photography are much smaller, too. The size of CCDs are not uniform either, so the normal lens on different digital cameras will vary. See the following chart.

**General Comparison Between Some Digital and 35mm Camera Lenses**

| 35mm Lens | Digital Lens | Effect |
|---|---|---|
| less than 20mm | less than 4.5 mm | ultra wide |
| 24mm to 35mm | 5mm to 8mm | moderate wide |
| 50mm | 10mm | normal |
| 80mm to 200mm | 15mm to 45mm | telephoto |

FYI Because digital photographic lenses have a shorter focal length than 35mm camera lenses, digital cameras have much more depth of field and are less capable of making pictures with shallow depth of field.

Zoom lenses on film cameras give a range in mm, e.g., 35mm to 70mm, but digital camera lenses give it according to the amount of magnification, such as 3×, 5×, or 10×, meaning that the lens can zoom 3, 5, or 10 times from widest angle. A digital lens that is 5mm with a 10× could zoom to a 50mm lens, which would be a very long telephoto effect.

Because these digital lenses have a shorter focal length than 35mm lenses, you will find that they have much greater depth of field. The downside is that it is difficult to take pictures with shallow depth of field, even shooting with the lens wide open. For best results for getting shallow depth of field, zoom the lens to its maximum length and then open to the widest aperture.

Digital zoom lenses can create telephoto effects either optically or digitally. An optical zoom means that the lens actually moves for higher magnification. Digital zoom means the pixels in the image are enlarged. The net effect is that optical zoom gives you a much higher resolution image than the false zoom effect created by digitally enlarging the pixel. If your image is going to be viewed on a monitor, digital zoom is fine, but for prints that require higher resolution, an optical zoom is necessary.

## Downloading Your Images

Downloading means to bring something into your computer. Once you have taken your digital pictures, you will want to download them onto your computer. The digital camera has an easy way to do this. Basically, you attach a cord to the camera that plugs into your computer. Many digital models come with the little USB port plug that works with most current computers.

Once plugged into your computer, the image will, depending on your camera, automatically be downloaded onto your computer desktop and appear as an icon. For the Nikon Coolpix 995, a Nikon icon appears on the computer screen with the images ready to be opened. The images downloaded then need to be opened through digital imaging software to manipulate and save them. In the following figure, the computer is downloading images from the Coolpix camera.

*Here is what a computer screen looks like when downloading digital images from the Nikon Coolpix camera.*

*(Matthew Richardson)*

## Understanding Basic Photoshop Manipulation

I use a software program called Adobe Photoshop to open my digital pictures. Photoshop is used to manipulate photographic images and has an amazing array of features that enable you do just about anything you can to an image, from replacing elements in the scene, to changing colors, to adding text, and much more. To do this, I go to the menu bar across the top of the screen, click File, and then scroll down to Open. You can choose which file to open (Nikon Coolpix), and then which picture from that file you want to view.

When opened, I check the image size and resolution. To do this, go to Image on the menu bar and scroll down to Image Size. A dialog box will appear with the size of the image in inches or pixels (which you can view either way) and its resolution, indicated as pixels per inch. Remember that 150 ppi is the minimum for continuous-tone printed photographs and 72 the correct ppi for images viewed on a monitor.

**FYI** Images for use on the computer screen don't need resolution of more than 72 pixels per inch (ppi). If you are e-mailing images to friends, be sure to drop the resolution to 72 ppi; this will make the file smaller and quicker to send—and quicker and easier for the recipient to open.

When shooting with the Nikon Coolpix 995 at high resolution, the downloaded images start out as 20 × 24 inches with 72 ppi. If I want to put the picture onto a website or e-mail it, I just reduce the image size and leave the

ppi at 72. The larger the picture's dimensions and the higher the ppi, the larger the file size, which in turn takes more time for the computer to store and send it and takes more time for the computer receiving the picture. Typically, I reduce the size to 3 × 4 inches so that my friends with slower computers can open the pictures without waiting a long time.

For images I plan on printing, I increase the ppi to between 150 and 300 and, consequently, the size of the image decreases. Let me explain this more fully. A high-resolution image from my Coolpix camera comes into my computer as a large-size, low-resolution image. As I increase the resolution, the pixels are moved closer together, creating more pixels per inch. As they move closer together, the picture becomes smaller, reducing the image's dimensions.

In the dialog box for Image Size, I uncheck Resample Image. This creates a linkage between the picture's dimensions and its resolution. As I increase the resolution and the pixels move closer together, the dimension of the picture automatically reduces, too.

Earlier I stated that you cannot increase the resolution of a picture by simply increasing the ppi, which is basically true. The difference with my digital photograph is that the resolution and dimensions are linked, so I am not just artificially increasing the pixels, but using the existing pixels and moving them closer and therefore reducing the dimensions of the picture. If the size and resolution are linked, then you can increase resolution. If the size and resolution were unlinked, the increase in ppi would have done no good and would only be artificially adding ppi and increasing the file size (MB) without adding any more actual resolution to the image.

Once I have adjusted the size and resolution, I save and name the picture, and either save it on my computer hard drive or onto a CD or Zip disc. CDs hold up to 650MB of information and are the safest storage device. Zips, depending on which you get, hold from 100MB to 250MB of information but are magnetic, like old floppy discs, and are susceptible to corruption from magnetic fields.

Once the picture has been downloaded and saved, you can manipulate it. For instance, in Photoshop, do the following:

1. Select Image
2. Choose Adjust
3. Scroll down and click Brightness/Contrast. A dialog box will open and allow you to instantly change the brightness and contrast of the image.

As you make changes, the image on the screen will change. Once it looks good, you can save it or revert back to the original.

Because we are talking about black and white photography, you can discard the color information in a photograph. If you want to have an image in both color and black and white, I recommend you make a copy of the picture and save one in color and change the other. To make a copy, choose Edit and select Save a Copy. You will be asked to give it a name, and it will be saved when you click Save. To convert a color image to black and white, choose Image, then select Mode, and click Grayscale. You will be asked if you want to discard the color information, and you click Yes. Your image is now black and white and you can adjust the brightness and contrast as mentioned previously.

Photoshop is an amazing program that allows a skilled user to do practically anything. This is a very sophisticated program and takes a while to get good at, but basic manipulations are quickly learned.

**FYI** Adobe Photoshop is a very sophisticated program but you can teach yourself by using *The Complete Idiot's Guide to Adobe Photoshop 6.* You will need to have Photoshop already installed on your computer. If you read this book, you will be a Photoshop Wiz.

## SCANNING NEGATIVES, SLIDES, AND PRINTS

You don't have to use a digital camera to produce a digital photograph; you can scan a conventional film negative, slide, or print. To do so, you will need a computer with a scanner and digital imaging software such as Adobe Photoshop. Scanner quality varies from model to model, and like digital cameras, the inexpensive ones are okay for web images but may not capture enough resolution for high-quality prints. Also, there are flatbed scanners to use with flat artwork such as photographs and film scanners for negatives and slides. Some flatbed scanners can also do film, but for the most part they offer less resolution than those made specifically for film.

The bottom line is that scanning is similar to shooting film. You need to capture as much information as possible or the print will not be up to your expectations. You can always dump extra pixels or information you don't need but you cannot create something where there is nothing, so the quality of the scan is paramount.

To scan using the Photoshop software, follow these steps:

1. Choose File on the menu bar.
2. Select Import.

3. Click the file that works for your scanner. I use a Nikon scanner, so the file under Import is titled Nikon.

4. A dialog box will open and depending on your scanner software, you will be able to choose a few options. You can select whether you are scanning from flat art, a negative, or a slide. For flat art, the type of scan is called reflective, meaning the light will be reflected off the art. Scans from film are called *transmissive*, meaning the light goes through it. Transmissive scans can be chosen to produce a positive image from either a film negative or a film positive (a slide).

**FYI** Scanning is similar to exposing film in that you need to capture enough information for the image quality to be high enough. A poor scan is like a poor negative: You can do a lot of things to fix it up but it will always be inferior to a higher-quality scan.

5. Select the scale of the scan. Do you want it to be 100% or larger or smaller?

6. Select the resolution. Remember that 150 is the very minimum ppi for a continuous-tone photograph. It is generally recommended to scan at twice this minimum, so I scan at 300 ppi. The exception is when you want to enlarge something, like a negative. We previously discussed how resolution and image size are linked, so if you want to blow up a negative to 6 inches × 9 inches, you will want to scan at a high ppi and then increase the dimensions, while maintaining resolution of at least 300 ppi.

Depending on your scanner software, you may be able to indicate the output size, that is, the size you want to print at, and the scanner will automatically tell you how much resolution is needed for that size. It is not uncommon to scan 35mm negatives at 1200 ppi or more so they can be significantly enlarged and still have the minimum resolution.

If you are not sure how much resolution you need for a given enlargement, you can go to Image and scroll down to Image Size and enter some numbers. (The following figure shows the Image Size dialog box.) Enter the size you would like the image to be and then enter the ppi you want (300 ppi is recommended). Then with the size and resolution linked as in the following picture, drop the image size to that of your original. A 35mm negative is about 1 inch high × 1½ inches wide. Because the resolution is linked to the size, the resolution will dramatically increase when you do this. This is now the resolution you want to scan at.

7. Once you have set the resolution, scan the image, and it will open in Photoshop and allow you to manipulate and print the photograph.

*In the Image Size dialog box shown, notice that the width and height and resolution of the image are all linked, indicated by the chain link symbol on the right. When one factor is changed, the others change accordingly.*

## PRINTING DIGITAL IMAGES

When you are ready to print your digital photograph, you will need a high-resolution printer. These printers have become very affordable, and many brands offer excellent quality at very reasonable prices. I use an Epson printer that has 1440 *dpi*. Dpi is just like ppi, it means dots per inch and indicates resolution.

To print, follow these steps:

1. Choose Edit.
2. Select Page Set Up.
3. Page Set Up will let you choose the paper size, the orientation (horizontal or vertical), and other options.
4. When you have made your choices, click OK.
5. Choose Edit again.
6. Select Print. This will open another box with more options before the print is actually made. These include standard and advanced settings. For printing photographs, click Advanced Settings. For print quality, choose 1440 dpi. Doing this will change the media type to *Photo quality inkjet paper*. You need to use photo quality inkjet paper to get a good photographic image with your inkjet printer. The paper is coated so it can accept much more ink and give you a rich, beautiful photographic image.

### STRICTLY DEFINED

**Photo quality inkjet paper** is designed to give you the true photo quality you expect from a photograph. The paper is specially made with a coated surface that can accept much more ink than regular paper. Whenever you choose 1440 dpi from your printer, the media setting will automatically switch to photo quality inkjet paper.

Also under Advanced Settings in the Print dialog box on my printer is something called Microweave. Microweave creates a smooth transition between tones so I check the Microweave box for Super.

7. You are now ready to print. If the print is too dark or light or has too much or not enough contrast, choose Image, select Adjust, click Brightness/Contrast, and make adjustments until the print looks good.

Inkjet prints are slightly wet when printed, so let them dry before storing.

Now you understand a lot about digital photography and cameras and can choose to shoot digital with good results. But don't think that digital can totally replace film. The results and look are quite different, and each is great for a different purpose. While digital photography will surely continue taking over the market, film and chemical-based photography will always have its niche.

# PART II
# Taking Pictures

# HOUR 10

# Photo Assignments: It's All About Light

**LESSON PLAN:**

Two of the biggest obstacles to making good black and white photographs are seeing the world in tones instead of color and becoming attuned to the quality of light. With a little practice and patience, you will start noticing scenes and lighting situations that will produce good photographs and be aware of problematic shooting situations.

- Identify the different types of light and their qualities
- Use various techniques to develop your own unique style
- Learn tips to help your pictures come out better
- Recognize the legal and ethical issues involved with taking pictures

Now you understand, at least theoretically, how your camera's functions work to control light, depth of field, and blur. Now let's move on to seeing the world in black and white, composing interesting images and techniques to help you make good pictures. You must be anxious to take pictures! So load your camera with film and let's get photographing.

## MAKING PICTURES ABOUT LIGHT

The word photography literally means light drawing. Photographic film and paper are light sensitive, so without light there is no photograph. Our first assignment is to make pictures about light, which is pretty easy because all photographs are in some way about light, so let's first discuss different qualities of light.

## DIRECT SUNLIGHT

Look at how direct sunlight affects objects. There are bright highlights and deep shadows. The difference in tonal values between the highlights and shadows are called *contrast,* and the more direct the sunlight, the more contrast the scene has. The opposite is true on overcast days. The light is softer, not as harsh as direct sunlight, and the shadows are softer too, not as dark. The tonal values between highlights and shadows are less; therefore, the scene has less contrast.

**Contrast** is the tonal difference between highlights and shadows. The greater the difference, the more contrast a scene has. Bright sunlight produces a lot of contrast, whereas overcast light has less.

When the sun is shining brightly, examine how the light affects things you might want to photograph. A landscape can look very good in bright sunlight because the deep shadows help define the scene through contrast. This, of course, depends on the scene you are looking at. A desert landscape tends to have less contrast and appears flatter than a wooded landscape where trees are casting shadows.

## OVERCAST LIGHT

Overcast light produces a scene with considerably less contrast than direct sunlight. The shadows are not as dark, and the highlights are not as bright. The effect in photographs is that there are many tones of gray with little pure white or pure black.

## OPEN SHADE

The shade in a scene with direct sunlight is called open shade and produces much less contrast than the direct light. Take something outside with you and hold it in the sun and notice the contrast, and then move to the shade and see the difference. These are the sorts of differences our film will record. Bright light offers contrast, overcast light is flat, and open shade is somewhere in between.

## PHOTOGRAPHIC EFFECTS

The effect in your photographs is profound. A given scene will look totally different under the different qualities of direct sunlight, overcast light, and open shade; and this is what you need to begin to look for when taking pictures. What kind of light will make your photograph look best? What kind of light will have the effect you are trying to achieve?

In the following figures, the same scene looks different from midday when the sun is overhead and the sky hazy than it looks in the evening when the sun is setting and there is more contrast.

*This photo was made during mid-day; you can see the unpleasant light and haze in the background.*

*(Matthew Richardson)*

*Just a few hours later and the scene looks a lot better when the sun is setting on the horizon, creating a more pleasant light with more contrast and longer shadows.*

*(Matthew Richardson)*

For your first black and white pictures, try to photograph under various lighting conditions so that you can begin to experience these different effects for yourself. When you see your pictures, you will immediately notice that film is not nearly as sensitive to light as your eyes are. Our eyes and minds allow us to see into shadows on very bright days, whereas film is so much less sensitive that those shadows may only be black. Overcast days can make some things look very good, but sometimes a photograph shot

under those conditions is very flat and gray. By experimenting with shooting film under various lighting conditions, you are training yourself to be attuned to the quality of light and are beginning to understand how film translates what we see into tones of gray.

**JUST A MINUTE**

If you need to photograph a person or object in the middle of a bright day, take them into the open shade to make the picture. Open shade is usually quite bright but has nice overall, even illuminations and soft shadows.

## The Golden Hour

You will notice that the quality of light changes over the course of the day. From early morning to midday to late afternoon to night, the light is constantly changing and those changes produce different effects in our photographs.

Many photographers prefer to shoot at what is fondly called the *golden hour*, or late afternoon, because the light is coming from a low angle, producing a very flattering light and good contrast. Early morning is also very good with most of these same qualities.

**STRICTLY DEFINED**

The **golden hour** is late afternoon when the sun is beginning to set and the light is a golden yellow.

Notice how the light changes as the sun rises. The low-angled, contrasty light of early morning gives way to a light that has less contrast and more glare. As the sun rises, the light becomes increasingly harsh, and the flattering low-angle light moves to a less attractive angle. As the day progresses, dust and pollution rise too, creating more haze, especially in the distance. The sun at 1:00 P.M. is high in the sky and the lighting is very unattractive for portraits, producing deep shadows on the eyes and under the nose and the chin with a bright, glaring light on the forehead.

**FYI**  Many photographers prefer to shoot during the early morning and late afternoon because the light at the beginning and end of the day comes from a low angle, which is flattering and produces long shadows with good contrast. As the sun rises, the light becomes flatter and harsher and has more glare. Also, distant scenes become hazy due to rising dirt and pollution. However, landscape photography can be an exception; some landscapes may look acceptable even during midday.

The various changes in the quality of light will have a major impact on your photographs; by attuning yourself to the differences, your pictures will turn out much more satisfying. An important characteristic of these various types of light is the mood they create in your images:

- Bright light is cheerier than overcast light.

- Dark, cloudy skies create a more somber atmosphere than clear, cloudless skies.

- The softer light of an overcast day can produce different effects depending on the subject matter that you use.

- Bright sunlight creates a mood all its own, depending on whether the photo was done in the morning, midday, or late afternoon.

We've all seen those wonderfully brilliant landscape photographs by Ansel Adams, whose high contrast and direct sunlight seems to suggest a majestic, spiritual presence. The same scene shot on an overcast day, while perhaps also beautiful, will have a different mood. The following figure shows the effect of high-contrast light.

*This photo shows how high-contrast light can affect your photograph.*

*(Matthew Richardson)*

The bottom line is to get a feel for how different light affects our pictures and how film translates the light we see into photographic images. Neither direct sunlight nor overcast light is better; it is just a matter of you making intelligent, creative choices.

## Seeing the World in Black and White

As you become accustomed to seeing the subtle and obvious characteristics of light, you can begin to look at the world as tones rather than colors. Color is extremely powerful, and for beginning photographers, a typical disappointment comes when something that is dramatically colored comes out as a boring photograph.

The usual example is a sunset. So dramatic and beautiful in color, the sunset is reduced to a few tones of gray in a black and white photograph! This challenge is overcome by experience and persistence but also by consciously looking at light, its highlights and shadows, and ignoring color. This is not easy to do, but once you start doing it consciously, you quickly become accustomed to it.

### JUST A MINUTE

Seeing the world in tones of black and white is a big challenge but doing so will help you get better pictures. Try to forget about the colors of things, which have a strong influence on how we feel. Look for brightness and darkness, with brighter objects being whiter and darker objects being shades of gray to black.

Bright objects are rendered white, dark objects are rendered black, and so on. Look around you and begin to see highlights and shadows. As you are photographing, seek out the bright things in the scene. Compositionally, bright things come forward and dark things recede. Various dark tones need some highlights to create contrast, or else the scene will be very low contrast and appear flat.

Red, one of the most powerful and emotional colors, is seen as a dark gray on black and white film. A portrait of a beautiful woman with red lipstick looks great in color, but in that same shot done in black and white, her lips look black! If this is the effect you want, great, but if you wanted a soft, gentle look, avoid the black lips.

**GO TO** ▶
See Hour 2 for more about using filters to correct tonal problems.

Black and white film is also overly sensitive to the color blue. This sensitivity often produces a white sky even though it was blue, making the picture different than what you remembered. To correct this, use a filter of the opposite color.

In general, any tone can be lightened in a black and white photograph by using a filter that is the same color as the object; using a filter that is the opposite color can darken it. Though you probably won't need to do this much, imagine photographing shades of green leaves in the woods. A green

filter will brighten the lightest of the leaves and give you more tonal separation and more contrast between the various tones of green.

## FRAMING YOUR IMAGES IN THE CAMERA

Look through your camera's viewfinder. The 35mm frame creates a horizontal hole through which you see the world. A great challenge is to fit what you think is important into that little rectangle. To be successful at this, I recommend that you shoot your pictures *full frame*.

---

**STRICTLY DEFINED**

Shooting **full frame** means that you are filling up the viewfinder with whatever you want to photograph.

---

Shooting full frame is one of the most important things you can do to get good photographs. Look at the top and the bottom and the side edges of the frame in your camera. Whatever it is you want to shoot, fill up this area. Novice photographers typically use the middle of their frames and basically ignore the edges, which leads to boring pictures with conventional compositions. Forget about cropping a picture in the darkroom later. If you want a close-up picture, move yourself closer to the subject. The following figure illustrates a photo filled with the composition.

Look closely at those frame edges. What's going on there? Are there interesting objects that can inform your subject? Are you cutting something off? Is there something just outside the frame that would make the picture more interesting? Move your camera around and remember that you can shoot both horizontal and vertical images.

When you are framing a subject, fill every inch of the frame. This is not to say you can't have *negative space* in a picture, which acts as a compositional balance. A large blank area in your picture is negative space, such as a blank sky or large solid-toned wall. Utilizing negative space can be a very effective way to add drama to a picture, such as putting the subject to one side of the frame and essentially filling the picture with one tone.

---

**STRICTLY DEFINED**

**Negative space** is an area that appears empty in an artwork but is actually an important compositional balance. The sky in a photograph my take up half of your picture and have nothing in it, but it may be an important compositional element, creating a mood or balance with other elements.

*This photograph uses the entire frame for its composition.*

*(Matthew Richardson)*

So when you hold the camera to your eye, fill up the frame and look closely at what is along the edges. Consciously take responsibility for what is in your picture. There are rarely accidents in your pictures, just things you have overlooked or didn't notice.

By shooting full frame you are utilizing the entire picture area, and this is one of the principles of good photography. Rules of composition dictate that the picture area be fully used. For beginners, I recommend getting close to your subject to fill the frame. By shooting from far away and cropping later in the darkroom, you are enlarging the negative and as you do so, you lose sharpness and detail.

## UTILIZING OFF-CENTER COMPOSITION

Setting the subject off center in your picture can be a good way to make your photograph more interesting. By plopping the subject in the center of the image, the composition becomes stagnant and puts a lot of pressure on the

subject to hold the viewer's attention. Try moving the subject off center when taking the picture. This gives the picture a more sophisticated look, grabbing the viewer's attention and holding it longer. Try this with all subjects in both horizontal and vertical formats as shown in the following figure. A picture of a rock in the desert when shifted to the side of the frame grabs our attention, and then lets our eyes wander into the background of the image. This has the effect of making the picture more complicated and more interesting, like the actual scene itself.

*Here the subject was moved out of the center of the frame and off to the side.*

*(Matthew Richardson)*

## TILTING THE FRAME

Tilting the frame is another way to help make your compositions more exciting. By gently tilting the camera you are creating a diagonal movement to the lines in the picture, which activates the scene. This can be an effective technique to add some movement to otherwise static pictures such as landscapes and portraits. Don't fall into the rut of never tilting the camera or always tilting the camera. Be spontaneous and try tilting the camera to varying degrees. Look closely in your viewfinder when composing the picture to see which scenes will look better with a tilted frame. In the following figure, the photographer tilted the frame to create diagonal lines from the beams in the ceiling and the airplane, creating a dynamic tension in the image.

*A tilt to the frame can help activate the picture plane and make a picture more interesting.*

*(Matthew Richardson)*

## Composing with a Foreground, Middle Ground, and Background

A real challenge to making pictures is how to convey the complexity and beauty of the world in the two-dimensional photograph. The preceding techniques of off-center compositions, tilt, and filling the frame can all help your picture. Another compositional device is to have a fore, middle, and background to your images. By this I mean that you compose your photograph in such a way that our eyes see something in the foreground, then our eyes move to the middle ground, and finally our eyes are led into the background, as in the following figure. This is not always possible or even desirable, but when it is done well it is an effective way to create dynamic and interesting imagery.

## Photographing from Various Vantage Points

Another technique is photographing from various viewpoints. By this I mean viewing your subject from below and above. Try squatting down when photographing and getting up above the subject as well. These different points of view can really help make a common subject more interesting. Many important photographs in the world have been created by showing us things from unusual angles. During the 1920s, innovative photographers were strongly influenced by ideas and trends in modern art, and the unusual point of view was an important technique that they adopted. The most mundane and common subject can be given new life simply by finding a way to look at it that others have not. The second figure demonstrates the low-angle perspective.

*Here the photographer has consciously set up a fore, middle, and background in the composition. The effect is that our eyes move deep into the photograph.*

*(Matthew Richardson)*

*A low angle can change the way we perceive something and lend a new way of looking at the world.*

*(Matthew Richardson)*

**JUST A MINUTE**

When taking pictures, try moving around the subject, photographing it from various vantage points such as from a low angle or high angle. By shooting a variety of pictures from different angles, you begin to discover more interesting ways of seeing the world and your subjects.

### PANNING

Panning is an advanced technique that you will want to try. It is used when the subject is moving, but when you want the subject to be clear and the background to be blurry. This has the effect of accenting the subject's movement. To pan, move the camera with the subject as you take the picture. For example, if you are photographing a person riding a bicycle, look through the viewfinder and move the camera with the subject. As you take the picture, the subject will be sharp, but because you are moving the camera, the background will be blurry. The idea is that the camera and subject are moving at the same speed, which minimizes the movement between the two, but the camera movement will blur the background as shown in the following figure. This is a very cool technique that makes your pictures of moving subjects very exciting.

*Panning is moving the camera along with a moving subject. It can help suggest movement by creating a blur in the background, as seen here.*

*(Matthew Richardson)*

These techniques are not meant as rules for you to slavishly follow, but only as suggestions for you to try out. As with any creative endeavor, the more you do it, the more comfortable you will be with various techniques and the better your work will be. I recommend that you shoot a variety of pictures of all subjects until you become more experienced. When taking a picture, shoot horizontal and vertical pictures, fill the frame, move the subject off center and utilize the fore, middle, and backgrounds to create new and exciting photographs. The use of odd, unusual, or unexpected angles can be a great way to explore your creative potential and make interesting photographs.

### PROCEED WITH CAUTION

Don't fall into a rut by using a formula for your composition. Techniques for pho-
tographing are not meant as hard-and-fast rules, only as suggestions to help you get
interesting photographs.

The bottom line with many good photographs is that they hold our attention.
Unlike many images that we see every day, the best photographs continue to
reveal things about the subject or stimulate us to look at them for long periods
of time. The greatest photographs made continue to be interesting for years
and years.

### JUST A MINUTE

Look closely at the top, bottom, and sides of your frame before you take the picture.
Good composition is often a result of paying attention to what is in front of you.

But how do they do that? One would think that knowing what a picture is
about or what the subject is would quickly cause one to lose interest. However,
we all know of powerful photographs that have kept our attention, and these
are generally ones that go beyond the mundane images that we see every
day. They are unusual pictures that have some complexity and suggest much
more than that of the subject matter—those that reveal the world or life
experiences with the complexity of real life.

### PROCEED WITH CAUTION

Making complex pictures is not the same as making confusing pictures. Complex
imagery can be simple, but there will be a nuance to the photograph that makes us
wonder about the situation and moves us by the beauty, horror, or profundity of the
moment.

## MAKING PICTURES

As you are making your first photographs, becoming attuned to the quality
of the light, and experimenting with various techniques, keep the following
tips in mind to help your picture come out:

- When you load your film, turn the rewind knob clockwise until the
  film is pulled taut. As you advance the film, the rewind knob will turn,
  indicating that you loaded your film properly.

- Be sure to set the ISO so that your exposure meter can give you accu-
  rate readings.

- Set your shutter to $\frac{1}{60}$, and when you see something to shoot, activate the meter and adjust the aperture for good exposure.

- Look closely at the quality of the light and how it affects the subject matter. Bright direct light will give you a higher-contrast picture, and overcast light will give you a lower-contrast picture. One is not better than the other; they just produce different effects in your pictures.

- Hold the camera steady when taking pictures.

- When your roll of film is finished, push the rewind release button on the bottom of the camera and rewind your film completely. Try to not let your film become hot, and definitely do not leave it in the direct sun or in a hot place like your car's glove compartment. Heat can ruin film.

- Develop the film soon after use for best results. Once film is exposed, it is more sensitive to ground radiation, which is a natural occurrence.

- Remember that the shutter can freeze movement or create blur. If your subject is moving, speed up the shutter speed beyond $\frac{1}{60}$ to freeze it, or pan the camera to capture your subject and blur the background. Blur can be a great creative effect, just like freezing a subject can.

- Remember that the aperture controls depth of field. The smaller the aperture (the larger the $f$-stop number), the more things from near to far will be in focus, and the larger the aperture (the smaller the $f$-stop number), the less things will be in focus.

- Shoot a variety of pictures of each subject. Get close, try different vantage points—both horizontal and vertical—and move around your subject. More is definitely better when learning photography.

## IDENTIFYING SOME LEGAL AND ETHICAL ISSUES

We live in the most photographed era of all time, and photographs serve countless purposes. Practically everyone has a camera and has taken a picture, and all colleges and universities have photography classes. With the influx of countless images and their various uses has come hostility toward photography in general and a suspicion of photographers.

**JUST A MINUTE**

If you like to photograph people, carry some model releases in your camera bag. Ask the person if you can photograph them and afterward ask whether he or she will sign the release so that you can use the picture for exhibitions and publications. I also offer to send a print as a thank-you gesture. Remember that minors cannot legally give permission.

You either have already or will shortly encounter some hostility or suspicion when making pictures. People have the right to refuse to be photographed or to ask you not to photograph on private property. And parents are very protective of strangers photographing their children. While their concerns are understandable, they are sometimes unnecessary and cause them to go so far as to violate the photographer's rights as well.

Here are a few tips to protect yourself:

- Ask people if you want to take their picture. Of course, if you are taking pictures of crowded areas, this is impossible, but when someone is alone or in a small group, courtesy naturally requires that you ask permission. If someone is in a public place, you can take their picture legally whether they agree to it or not, but ethically, you should ask yourself why you are doing so. You will be surprised at how often people will agree to being in your photograph if you ask and tell them why. A bit of flattery always helps. "You look so serene sitting in the park, and I think it would make a beautiful photograph." But be aware that if you plan on publishing or otherwise using the photograph, you need to tell the subject that. Don't be a coward and use long lenses to avoid asking for permission. It is very rude and creepy to feel that someone is watching you from afar. It is much better to be honest and talk to the subject you want to photograph. I often offer to send people a print, which helps convince them that my intentions are good.

**PROCEED WITH CAUTION**

You should not photograph children that you do not know without their parent's permission. People are very protective of their kids, and for better or worse, parents may be very suspicious of or hostile to you for photographing their children.

- Avoid photographing children you don't know. Parents are very concerned, sometimes for good reason, about the intentions of strangers around their children. Do yourself a favor and avoid photographing in playgrounds or schoolyards where children congregate. Of course, if you are a parent and can bring your children to a playground, talk to the other parents and you can probably get their permission.

- Avoid trespassing. Trespassing is illegal and you can be fined, or worse, for doing so. Find places to photograph where you are not on private property.

- Recognize that buildings are okay to photograph, but sometimes you will be told that you cannot do this. If you are on public property, you can legally photograph a building. What you might be restricted from doing is publishing the photograph if the image of the building is copyrighted. The Rock 'n' Roll Hall of Fame in Cleveland sued a photographer for publishing a poster of the copyrighted building. That was a rare case but one that may become more commonplace.

- Carry identification with you. If a police officer asks what you are doing, tell them. Carry an ID and a business card to prove that you are an innocent photographer just out to make interesting pictures.

- Carry model releases and business cards to give to people that you may want to photograph. I often ask permission and then give the person my business card. I tell them that I will send them a picture and ask if they will sign a model release so that I can use the picture. If they are skeptical, you can send the model release with the picture and have them mail it back to you. Business cards are easily made on your home computer. For releases, simply type out that the person signing is giving you the right to use the pictures in any way or with restrictions, which may include "for exhibition only" or "not for commercial purposes." Be sure they print their name, address, phone number, date of birth, and include their signature. Minors cannot give their permission. For business cards, you can get the correct size and weight paper at any stationary store, and your word processing program, such as Microsoft Word, will format your information to fit on the cards.

- Don't tell people you will send a print if you are not going to. I have had many bad experiences with people complaining that so-and-so never sent them a copy of a picture! Don't promise what you don't intend to do.

- When in doubt, call your local police department. They should be able to confirm that it is legal for you to photograph on public property. Of course, military and government facilities are very concerned about security since September 11, so be reasonable.

- Don't sweat it if you cannot make a certain photograph due to permission or restrictions. There are countless opportunities to make wonderful pictures. Your creativity is not dependent on any one picture or location.

Now you have completed your first assignment. The techniques described will be used over and over throughout your photographic career, and you will continually refine your style and techniques. The most important thing now is to make a lot of photographs and scrutinize each picture to decide what worked and what didn't.

# HOUR 11

# Photo Assignments:
# Portraits and Self-Portraits

## CHAPTER SUMMARY

**LESSON PLAN:**

In this hour, you take on the most difficult and, simultaneously, the most rewarding types of photographs: portraits.

- Considerations to make when taking portraits
- Different types of portraits
- Types of equipment and techniques to use for different portrait styles
- How to take self-portraits

Ever since the invention of photography in 1839, photographers have wanted to make portraits. It seems a natural inclination to picture our loved ones and ourselves. Because looking at a portrait can produce an array of emotions, photographing people continues to be one of the most provocative and challenging aspects of photography.

## PORTRAITS

Do you enjoy having your picture taken? There is a good chance that your answer is no. It's not that having a picture taken is painful (at least not physically), but it makes us self-conscious about how we look and reminds all of us that we have aspects of our appearance that we are unhappy with. "My smile is crooked, my nose is too big, my stomach is too fat," etc. These are the constant complaints heard by portrait photographers, and it is these complaints and the insecurities they underscore that are the biggest challenges to getting a good *portrait*.

### STRICTLY DEFINED

A **portrait** is a likeness of a person or animal. It normally shows us what the subject looks like physically, and, when done very well, may suggest aspects of the subject's personality that we may otherwise be unaware of.

Of course, what constitutes a good portrait is a matter of debate. The portrait studios in your local mall all do their

best to make pleasant, flattering portraits of everyone. They are trying to serve as many people as possible and to make everyone happy; and while this is a nearly impossible task, some photographers are very good at finding ways to make people look as good as possible in a photograph.

Not all of us are interested in making that kind of portrait. I prefer to make portraits that reveal something about the sitter (either physically or psychologically) that we might not otherwise know. Sometimes this means the photograph is not very flattering, but hopefully it's insightful or even profound. The following figure is a portrait of *Esquire* magazine editor Jay Woodruff, and with those deep eyes of his fixed on us, the photo suggests an intense personality. I find one the most exciting things about portraiture is a picture's power to stimulate an emotional response in the viewer, as in the portrait of Mr. Woodruff. It is as if the photograph is more than just a picture; instead, it's an emotive representation of the person. This is a lot to ask from a mere photograph, but when that happens, it is a deeply gratifying experience.

*This psychological portrait suggests an intense and engaging personality.*

*(Ian Spanier)*

## MAKING PORTRAITS

One of the first considerations in making a portrait is who to photograph. Choosing a person with an interesting face, who is comfortable with the

camera, and who smiles easily is great. But the reality for most of us is that we photograph people we know, and they may not always fit the bill of the perfect subject.

Photographing people you know can be even more difficult than photographing a stranger because of the feelings and history you share with the subject. And if he doesn't like the portrait, you are going to have to live with his criticism. But that said, our nearest and dearest are likely to be our first subjects.

## GETTING THE SUBJECT TO FEEL COMFORTABLE

Making your subject feel relaxed is a big part of making a portrait. This can be done by going to a serene environment like a park or the beach where the person can begin to relax. Another method is to photograph the subject in her own environment, home, or other place where she feels in control and knows the surroundings. Another technique, as illustrated in the following figure showing a bride on her wedding day, is to capture the person when she is expressing joy.

*This portrait of bride Karen Oh on her wedding day exudes the feelings of comfort and joy associated with such an event.*

*(Ian Spanier)*

If you are trying to get a pleasant portrait, a serene or comfortable environment is a good place to begin. As you are setting up your equipment or simply organizing what you brought, you can chat with the subject to get him to relax. This has the effect of drawing attention away from the formality of sitting for a portrait, which is unsettling for most people. If you don't know the person well, this is also a good chance for you to learn something about him, get a feel for his personality, and scout out where you want him to sit or stand.

### EXHIBITING CONFIDENCE BEGETS THEIR CONFIDENCE

When someone has her picture taken, you are the one in control. The subject is probably not a photographer and assumes (correctly we hope) that you know what you are doing and will tell her what to do to get a good portrait. This is a very important part of getting someone to feel comfortable. Your confidence makes her relax and feel confident in your ability. Do your best to project the attitude that you know what you are doing even when you do not. If you are having a problem or are unsure how to do something, don't let on to the subject.

**JUST A MINUTE**

When you project an air of confidence, the subject will feel confident in your ability, relax, and let you make your picture. If he thinks you don't know what you are doing, he will be nervous, think it is a waste of his time, and worry that the picture will make him appear unattractive.

The best way to insure that you, even a beginning photographer, know what you are doing is to test your equipment beforehand and to have some picture-taking ideas in mind. Always test your equipment before a shoot, just to make sure it is working properly, the batteries are fresh, and you have plenty of the right kind of film. Be sure all of your flashes and cords are compatible and operational. Then as you are setting up, you can comfortably chat with the subject and be sure that when you are ready, the equipment will be, too. Make a list the night before, if necessary, of what you need and your ideas for the shoot, and pack your camera bag.

## CANDID AND FORMAL PORTRAITS

Candid portraits are the most common and can be made anywhere. By definition, they are casual and may be spontaneous in contrast to the formal portrait, which is conceived in advance. Candid portraits can suggest many

aspects of a personality—such as a sense of humor, tastes in music, and popular culture—and may or may not be flattering. Formal portraiture is much more restrained and is more likely to suggest a narrow aspect of one's personality such as profession or social status.

Whether a portrait is casual or formal has as much to do with the photographer and his or her equipment as anything else. Setting up the large-format view camera, testing the lighting, and arranging a pose all lead to a formal portrait session, even if the final picture looks casual. Pulling out your 35mm and quickly shooting some pictures in a matter of moments, even in a professional photo studio, is pretty casual and the pictures will probably have that spontaneous feel. So the bottom line is that the photographer's attitude and the equipment chosen determine a lot about the picture.

## LOCATION

The location you choose to photograph in has a major impact on the portrait, so scout places out. Gnarly trees in the woods, cliffs with great views, little-used beachfronts, and rough industrial neighborhoods can all be great locations for portraiture. It all depends on what you are trying to convey about the person or people you are photographing. A tough-looking hip-hop group will probably look great on the city street or in a run-down industrial neighborhood, whereas a mother and newborn will look depressing in the same location.

**JUST A MINUTE**

Scout places out that might be good for future photographs, such as serene woods, rugged mountain cliffs and waterfalls, and funky industrial areas. I carry a notebook in my car to make notes when I see good locations.

### ENVIRONMENTAL PORTRAITS

The *environmental portrait* is a very popular genre in professional photography. An environmental portrait is one made in the sitter's home or work setting; it will necessarily show the surroundings that inform us about the subject. If you were photographing an auto mechanic, a good environmental portrait may show her in work clothes leaning on a car with the hood up, in the bay of a garage. The photograph would show some of the car and garage, and we would immediately know the subject's profession. This technique is used by every newspaper and magazine, and a good photographer should be ready and able to make an environmental portrait. In the following figure, Hal Hoverland is shown in his printmaking studio with his equipment.

An **environmental portrait** is one in which the location gives insight into the subject and his profession or personality. The background and any important props will be in the picture along with the subject, and a medium- to wide-angle lens is often used.

Try this with whomever you can photograph. Go to her job or home and look around for clues that can be incorporated into the picture. I am very nosy when I go to someone's home or office to make an environmental portrait. I ask if I can tour the location for good spots that may give some insight into who this person is, what she does, and perhaps even into her unique personality.

*Because of the environment in which he was photographed, there is no doubt that Hal Hoverland is an artist and printmaker.*

*(Matthew Richardson)*

## STUDIO PORTRAITS

A *studio portrait* is usually somewhat formal because it is done in a controlled environment with lighting and backdrops. Most people will come to a studio expecting a certain formality, so they will probably wear their best clothes and have their hair and makeup done. The biggest challenge in making studio portraits is getting the subject to relax and look comfortable. The earlier discussion of getting him to relax is very important in the studio where the subject is acutely aware that all the attention is on him. The artificial environment of the studio necessarily creates this tension and it takes good people skills to make the subject feel comfortable.

**STRICTLY DEFINED**

> A **studio portrait** is done in a controlled environment with a background and lighting. It does not have to be anything more than an extra room in your home or garage, but take the time to make it look neat and professional.

Again, the best way to relax your subject is to be very comfortable yourself, to project an air of being completely knowledgeable and experienced—whether it is true or not. I am not telling you to lie as much as to be highly sensitive to your subject's feelings of insecurity. Even if something obviously wrong happens, don't get upset or frustrated. Just acknowledge that a piece of equipment failed, but you have other options. You can sweat after the subject goes home!

GO TO ▶
For more on studio photography, see Hour 14.

In the following figure, the photographer has created a sense of old Hollywood glamour through lighting, carefully choosing the outfit, and by posing the subject.

*Here the photographer creates a sense of the glamour of old Hollywood movies through carefully controlling the lighting, costume, and posing of the subject.*

*(Stephanie Keith)*

## PORTRAIT TECHNIQUES AND EQUIPMENT

There are techniques that particularly apply to portraiture that will help you make flattering pictures. The first is choosing the right lens. As discussed in Hour 2, the lens you choose will have a dramatic effect on how the portrait

looks. Remember that wide-angle lenses fit more information into the picture, but in doing so they can create distortion. Distortion in an interior photograph or in a garden picture may be completely acceptable, but most people will not be too pleased with distortion in their portraits. Always keep in mind the subject's personal insecurities, real or imagined.

If you are making the environmental portrait, choose the lens that allows you to get enough of the location in the picture. If you are working in a small space you will need that wide-angle lens, and the wider the lens, the more distortion it will produce. The trick to using the wide-angle lens and making an acceptable portrait is to keep the subject far enough away from the camera that the distortion is minimized. Also, with enough of the environment included, our attention will not be closely focused on just the person. The rule about wide-angle lenses is the closer you get, the more distortion, and that distortion increases at the edge of the picture frame.

Generally speaking, a good portrait lens is 85mm or longer. Telephoto lenses compress space, and because you have to be farther from the subject, the proportions of the face are preserved. Being a bit farther from your subject also eases the pressure of your physical presence. We all have an invisible zone of comfort around us. When someone enters that zone, we are aware of her presence, and if that person is a stranger, we are on guard. By remaining outside of that zone, the subject is going to feel more relaxed and less like she is under a microscope. Of course, we photographers know better! The longer lens brings the subject up close, but the point is that she feels more comfortable with you farther away.

## Lighting

As discussed in Hour 10, lighting helps create mood in a photograph. Harsh lighting obviously creates a less flattering portrait, while softer lighting can hide skin flaws and is generally more pleasing.

If you are making a casual portrait outdoors, look for soft light. If it is a sunny day, take your subject into the shade. The soft light of the shade will give a nice overall brightness without the harshness of direct light that produces deep shadows and glaring highlights.

Another solution to portraits in bright light is the flash fill technique. With your shutter set to a flash synch speed, use your exposure meter to find the aperture. Then set your flash to put out the right amount of light for that

aperture. When you take the picture, the background will be well exposed and the portrait will, too, without those ugly deep shadows and harsh highlights.

Whether you are in the shade during a bright day or even during an overcast one, using a reflector can help produce brightly lit portraits without the harshness of direct light. As seen in the following figure, the photographer positions the reflector so that the light it reflects fills in the shadows under bright direct light. This technique also helps brighten the face and lighten shadows when shot in shade. On overcast days, portraits can look a bit gray, so the reflector can add just the right amount of illumination to give the picture some contrast and create a little *catch light* in the eyes. The figure on the next page shows that the subject is the one holding the reflector, which is nothing more than white cardboard.

**GO TO** ▶
For more on flash fill, see Hour 5.

**STRICTLY DEFINED**

**Catch light** is that little reflection of light in the eyes of a portrait subject. It makes the eyes glitter and adds a bit of brightness to dark eyes.

*Here a reflector was used to fill in the shadows normally present in a portrait done in bright light.*

*(Tony Maher)*

*In this case the sub-*
*ject was able to hold*
*the reflector and not*
*be seen doing so.*

*(Tony Maher)*

**FYI**  A reflector can be just the right accessory to use when making a portrait. The amount of light it bounces onto the subject may be perfect to lighten heavy shadows in direct light or to add a bit of illumination when photographing in shade or on overcast days.

Because flashes produce a strong light and lighting creates a mood, using your flash for a portrait can be very effective. Here are a few basic flash setup tips for making a portrait:

- Direct on-camera flash will cause a harsh light. Indoors I would avoid using a direct flash unless I wanted that look. But outdoors, the direct flash can be great. When the light is bright and you are shooting in direct sunlight, the direct-flash and flash-fill techniques are great for filling in those shadows and balancing the ambient and artificial light.

- Direct off-camera flash works great outside (just as the direct on-camera flash does), but it also allows you to create a directional shadow, which is interesting to look at and can be flattering as well. I use an inexpensive lighting stand with a mount to hold the flash unit. A synch cord attaches the flash and camera, and the flash can be used on automatic or manual mode.

- Bounce flash is really good indoors for most portraits. The light is soft-ened considerably and you can bounce the flash off the ceiling or wall. Just tilt the flash head up to the ceiling or to the wall and use on auto-matic or manual modes. I try to have my ambient *f*-stop light reading coordinated with the flash or maybe one stop under the flash output. Add a bounce card to this set up and you have a very nice light for por-traits. In the following figure, a portrait of monologist Spaulding Gray used a flash with a bounce card for a soft lighting effect.

*This portrait of Spaulding Gray was done with a bounce flash in a pretty dim hallway. The bounce effect illumi-nates the whole area but has a soft light-ing effect on the subject.*

*(Thomas McGovern)*

## COMPOSITION AND POSING

The following relates the techniques we have discussed to portraiture:

- Filling the frame is a great idea when making portraits. A close-up that uses the entire frame can be very dramatic and revealing.
- Using negative space to create a large, seemingly empty area in the picture can create a sense of mystery or introspection in the subject.

- Using off-center composition is a way to make your portrait more interesting and complicated, and is a very effective technique for environmental portraits.

- Tilting the frame in a portrait is tricky, and I would suggest being very careful when doing so. If you tilt the camera, be sure to make plenty with the camera not tilted, too, just in case the tilt ends up looking too weird.

- This is also true when trying different vantage points. Shooting a subject from down low can look cool, but I would be sure to do some head-on shots as well. Photographing from a moderately low angle can suggest a powerful or heroic subject. Getting too low ends up looking pretty odd but can also be effective. This is also true with getting up above the subject. This can be very good when photographing groups of people when sometimes the people in the back of the group get lost. Of course, high angles are odd and should also be done with the awareness that it may not always look good.

- Utilizing the foreground, middle ground, and background works well in portraits, especially the environmental portrait or when working with more than one person.

Many people want you to pose them for their portrait. I am not a big fan of posing because it often looks stiff, but when the subject wants the look of a formal portrait, posing is very important. And if the subject is very stiff or uncomfortable, telling him how to pose can reassure him that you will be getting a good picture.

Unless you are making mug shots for the police, you probably will not want the subject's body facing you directly. Angling the body up to 45 degrees from the camera gives a much more flattering look. The same goes for the shoulders. When the body is angled, one shoulder will be higher than the other. If sitting, try having the subject lean a bit to one side or the other along with angling the body. These two little positions will make the pictures more interesting and more flattering for most body types. Also have the subject lean a bit toward the camera whether sitting or standing. It helps make a more interesting composition and has her naturally tilt her head. If the subject is leaning back, the picture accents her stomach and we look up her nose—not a very flattering pose.

**JUST A MINUTE**

When posing people's faces, a slightly downward cast or else photographing from just above their eye level can be flattering. Shooting from above eye level puts our attention on their eyes, shooting from below puts our attention on their chins. Having their bodies lean into the camera is also flattering.

Tilt the head down slightly or try shooting from an angle slightly above eye level. This puts the picture's emphasis on the eyes, as in the following figure showing Andy Engelson, owner of the Stinger Club in New York. When the head is tilted back or you shoot from a low angle, the emphasis is on the chin, which is not very flattering. But if the subject is seated, having him lean toward the camera forces him to tilt his head back but keeps your camera angle higher than his eyes. This also helps stretch out flabby neck skin.

*In this portrait of night club owner Andy Engelson, the photographer has positioned the camera slightly above the subject, thereby putting our attention on his eyes.*

*(Ian Spanier)*

Having the head angled also helps. Completely frontal shots of the body and head are not as flattering as angled shots are. So even a gentle twist to the head lets us see some of the jaw line in relation to the shoulders. When you are making tight head shots, having the subject seated and leaning toward you with the camera above the eyes is a good way to begin.

With full body shots, on the other hand, you have a lot more to worry about. Angling the body so it is not totally frontal helps make the picture more interesting and flatters the subject, but an unwanted side effect can be a bulging stomach. Unless your subject does crunches every day, she may have at least a little gut. Good posture immediately helps reduce this. Standing up straight with shoulders back (while still angled from the camera) and breathing into the chest instead of the stomach also help. Most folks will naturally suck their guts in, but you need to watch carefully that this is not obvious. It is much more flattering to have a paunch and look relaxed than a flat stomach that is obviously being sucked in. Loose-fitting clothes help as well as the all-purpose sports jacket. A nice jacket can hide a multitude of physical imperfections and so can a sweater.

Hands are almost always a problem with full-body and half-body shots. What do you do with them? The hand on the chin is used a lot and can look pretty corny, but when done well it is still an effective pose. The trick is to make it appear natural and not as a stagy gimmick. Arms folded across the chest, hand on the hips, and for the casual look, in the front or rear pocket, can all look good. Having a prop can be good, too, and as seen in the following figure, it gives the subject something to do with his hands.

### PROCEED WITH CAUTION

I would be careful about anything too obvious in a studio portrait. For example, a golf club is a natural when shooting out on a lawn, but against a blank background, it can look silly.

While your subject is posing, chat with him and watch carefully as he finds natural poses. Be attuned to his body language. See if you can get him to laugh a bit, even nervously, and watch to see what a natural expression is. Many people don't know when they look good, and if you watch closely, you may discover a facial expression or pose that they thought looked goofy, but in fact is very flattering.

Lastly, pets can be a great prop and really aid in getting the subject to relax and naturally find comfortable poses. However, it really depends on the animal and the location. A wildly energetic dog is not going to work well, unless you are photographing outside and can quickly move around the subject and shoot a lot of film to get a good shot. A docile cat can be a great prop in someone's lap while she sits in her favorite easy chair in the living room. I've photographed people with their pet birds and found them to be very good props. Some parakeets are real comedians and can keep the subject distracted and relaxed.

*Here the prop gives the man something to do with his hands other than putting them in his pockets.*

*(Matthew Richardson)*

## PHOTOGRAPHING MORE THAN ONE PERSON

It's a big challenge to photograph more than one person and make them all look good. Start by talking to find out who the more extroverted person is, and put attention on him. This lets the more introverted people feel protected from the glare of the camera and can help keep everyone relaxed. Try to position groups so they are not lined up in a row facing the camera, which produces a very static look. Arranging people so they form a wedge or crescent is better and utilizes the foreground, middle ground, background technique to add depth to the picture. When doing that, be sure to use a small aperture so that you have enough depth of field and everyone is in focus. Be careful about your lighting, too. You don't want a shadow from one person falling on another's face. Having a person or two sitting, either in chairs or on the floor while others are squatting, kneeling, or standing can help avoid an overly static composition.

## SELF-PORTRAITS

I love self-portraits and have my students make them every term. We all know how hard it is to make a picture of someone else, so putting yourself on the other side of the camera is twice as hard. And our own feelings of

insecurity about our looks are ever-present. Why would you want to make a self-portrait? It might just be a portrait that you can send your loved one or maybe something you need for an identification card, but the self-portrait is also a deeply psychological image that forces the photographer to confront possibly uncomfortable issues. I liken the process to being in therapy, and for those who have the courage to do it, self-portraits can be a revelatory art form. In the following figure of a self-portrait, the artist simultaneously suggests vulnerability and sensuality through her pose and strong directional lighting.

*In this studio self-portrait, the artist has used dramatic lighting to accent her willowy figure, and her downcast head and closed eyes seem to suggest her vulnerability.*

*(Stephanie Keith)*

Most of our discussions about portraiture have taken for granted that you want to make a flattering picture of someone, or perhaps you want to open a commercial photography studio. But the self-portrait is done more for purely artistic reasons and has a long tradition in historical and contemporary art. Whatever your intention in making photographs, I strongly recommend you make self-portraits from time to time. It is an uncomfortable but rewarding genre, and I have seen many young photographers make important aesthetic breakthroughs from the assignment.

**FYI** We take for granted that most good portraits are flattering, but many of the greatest ever made were not. We are inundated with superficial pictures of beautiful people, so it is only natural that some of us prefer pictures that forego beauty in favor of intensity. Beauty is in the eye of the beholder, and some of us prefer the uniquely odd.

The techniques for self-portraiture are pretty simple. Here are a few to help you get started:

- Use a tripod and either your camera's self-timer or a bulb release. Place something where you plan to stand, focus on it, and take a light reading. Activate the self-timer and go stand in the picture or push the bulb release.

- Extend your hand and focus on it. Then hold the camera at arm's length and push the shutter. You have to guess at the framing and composition. By giving up so much control, odd things can happen. You can do this with friends, too. Put your heads close together and take the picture. Some very interesting pictures can be made this way.

- Try these techniques nude. If you thought the regular self-portrait was difficult, the nude self-portrait will really upset you.

Why am I suggesting that you make a self-portrait? Because photography can be a deeply personal and emotional art form. By letting go of some control and delving deeply into your own appearance, you will become more empathetic when you make a picture of someone else. Also, you may discover new and interesting ways to make pictures and create photographs that go beyond the millions of basically mundane images that we see every day. Making art is not for everyone, but if you think it is for you, the self-portrait is a great place to start.

All of the same things about composition and posing may apply to the self-portrait, but for this kind of work I would suggest you begin by making pictures that are close-up and personal. Let go of your ideas of what you should look like and take a bunch of pictures. They may scare you a bit, but the more you do it, the more you end up knowing about yourself.

**FYI** Portraits don't have to represent the sitter. They can be of characters, and your sitters can be like actors playing a role. Asking someone to "just be herself" can be uncomfortable, but asking her to play act can be a lot of fun.

## PHOTOGRAPHY AND REPRESENTATION

We normally think of photography as showing us what things look like, and by that definition, photography is representational. But that is not always the case. There is a whole genre of portrait photography that is about fantasy and using the human form and face to comment on our social and political world. The most widely disseminated of these types of pictures are publicity and glamour photographs. In these works the images create a person who is only

real in the photographs, created by the makeup, lighting, and camera work of the photographer. Many artists have adopted those same techniques to comment on the roles of people in contemporary society, and you can, too.

*Here the subject is freed from trying to present her real self and is role-playing a seductive Holly-wood starlet from the 1940s.*

*(Stephanie Keith)*

**FYI** For further information on the portrait that is of a fictional character, see any book by the photographer Cindy Sherman. She uses herself in her photographs but never as the real Cindy Sherman, only as characters that comment on our society.

When you make a portrait or self-portrait, it does not have to be of the real you. You can dress up as a character or as an aspect of yourself or of someone you fear or love. You can take on role-playing or character acting, too. This is a great way to get people to be your models. In the preceding portrait, the photographer has the model pretend she's a 1940s Hollywood siren. This lets the subject play act instead of trying to be herself. The natural pressure in a portrait shoot comes from the model feeling that he must be the perfect representation of himself at that moment. But when you ask him to be an actor, he is free to be ugly or weird or anything else because it is not really him. Try this when you make your portraits and self-portraits, and you will be surprised how much fun you will have and how interesting the pictures can be.

# HOUR 12

# Photo Assignments: Landscape and Architecture

## CHAPTER SUMMARY

**LESSON PLAN:**

In this hour, I discuss photographing landscape and architecture.

- Techniques for landscape photography
- Choosing the best equipment for landscapes
- Techniques and considerations for architectural photography
- Motivations and ideas behind landscape and architectural photography
- Choosing the best equipment for architectural photography

These two important genres have preoccupied photographers since the invention of the medium and continue to excite photographers today. Though they may both seem pretty straightforward, landscape and architecture represent some of the most challenging subjects to photograph.

As you begin taking your own landscape and architectural photographs, you will quickly appreciate the difficulty of creating dynamic images of such immense and imposing subjects. But with a few good techniques and some sensitivity, you will find yourself able to tackle these timeless subjects.

## LANDSCAPE PHOTOGRAPHY

Landscape photography has been around since the invention of the medium and for good reason. Landscape is accessible, easy to find, and remains stationary, which was perfect for the very long exposures required of early photography. One might think that with such a long history, there would be no need for more landscape photographs, but image makers have continually found new and exciting uses for this perennial genre.

Continued interest is in part due to changing attitudes about the land. The eighteenth-century photographers who first went west with cameras were driven by economics, philosophy, and art. As the eastern cities of the United States were becoming increasingly crowded, the population was slowly migrating west. With that migration came

tales of beauty and romance that captured the imagination, and photography proved the perfect medium for exploiting scenic images for profit.

With the advent of the steam locomotive, the railroad barons envisioned a country connected by rails, but first they had to explore the rugged and undocumented terrain. Just after the Civil War, the U.S. government commissioned the first of many expeditions into the West to document the landscape, its minerals, terrain, and populations, and the photographs that came out of these studies provided ample justification for the expansion of the railroads and exploded popular interest in photography.

Although those early landscape photographs were done with a clear purpose in mind, they are remembered now for their striking beauty of the untamed West. This dual purpose, to document and explore and to present the findings as seductive and compelling artwork, lives on for photographers today.

## Techniques

Landscape is one of the most difficult of photographic subjects. It is just too big and complex to easily fit into a photograph, but there are some techniques you can use to help pare it down to a manageable, though still immense, subject.

First, ask yourself what you are trying to show. For most beginners this will be as simple as representing something beautiful. Next, find that beautiful landscape you want to photograph, which is a little harder to do. And even after you have found the ideal spot, you may need to wait for just the right moment to capture it at its best.

Light and composition take on extra importance in landscape photography. Lighting creates mood, and with such a huge subject as the land, you have to rely on natural light. In the following figure, the photographer wanted to show the castle posed precariously on the forbidding cliff with intense early morning light.

**FYI** We have all seen those amazing landscape photographs by Ansel Adams. He is famous for setting up his camera and just waiting until the light was just right. Not all of us are as patient as Adams, but his magnificent work points out that one of the basic premises of a good landscape is the quality of the light.

*The photographer took this shot in the early morning to capture this precariously positioned castle on the edge of a rocky cliff. The edge of the picture appears odd because he used Polaroid 55, an instant film that also produces a negative, and he chose to print the edge of the negative.*

*(Ian Spanier)*

The quality of the light may be bright direct sunlight or the mottled light of partly sunny days or the soft gray of overcast light. There is no correct light, only choices for you, the photographer, to make. Because you have already been out looking at the light in the previous two hours, you are probably getting a good feel for what light will make good photographs.

**JUST A MINUTE**

Landscape photography is dependent on natural light, so waiting for the light to be right is essential to taking a good photograph. Find your location and note the direction you want to face. Have your equipment ready and when the light is good and in the right direction, it's time to photograph your subject.

The golden hour (discussed in Hour 10) is widely used by landscape photographers. Going out very early and waiting for the sun to rise is almost a rite of passage for many. The glorious light of late afternoon with its long shadows and warm color is also a prime time to photograph, as shown in the following figure of an old cemetery in the late afternoon.

*The intense late-afternoon light is contrasted with the deep shadows, adding to the nostalgia in this cemetery photo.*

*(Phil Marquez)*

Depending on your landscape, watch carefully for what will be the highlights in your photograph. Pictures need highlights and shadows for contrast, and that can be a challenge with landscape. While there are few really white things in the land, the intensity of the sunlight will make many things white, such as rocks, tree trunks and glare from barren dirt. Look for these bright areas and include them in your composition.

## COMPOSITION

The three-pronged composition of utilizing foreground, middle ground, and background becomes very important with landscape. Far-off mountains and trees are great, but your picture will need things in the foreground or it risks being boring. Boredom is the deadliest enemy in landscape. When you are in the field it all looks great, but once reduced to the little photograph it can lose a lot. Therefore, you need to be acutely aware of the composition and how it will energize the picture and draw the viewer in to see what you are showing.

**FYI** Strong composition is essential to good landscape photography. The subject is too large to capture in a picture, so employing a strong foreground element, followed by a middle-ground element, and supported by the distant background element are necessary to create the illusion of depth and keep your viewer's attention.

Setting up the foreground with a strong element is a good start. The nearness of the element will give the viewer something to immediately see, and from the foreground, their eyes can wander deeper and deeper into the image. By grabbing their attention, you are inviting them to take the time to look closely at all the details of this typically immense subject. In the following figure, the artist has set up a strong, dark foreground with an old fence.

*Here the photographer has set up a strong foreground, middle ground, and background composition. The fence brings us in, and our eyes then go deep into the picture to see the church steeple and contrasting power lines.*

*(Phil Marquez)*

The foreground in the preceding figure may only be on old fence, but that's okay. Rocks, crevices, ravines, and just about anything that produces some light and shadow will do. Just try to not let the bottom third of your picture be one continuous tone, which really kills most pictures. The foreground is

what people see first in your photograph, and if it's boring, you may lose the viewer before they've really considered the image.

The middle ground can be fences, more rocks, trees, or anything else that falls behind the foreground. These middle-ground objects help create the illusion of depth, which is so important when photographing a landscape. They force the eye to go deep into the image, and when done well, captivate the viewer and ensure that they look at all the picture's elements. In the preceding figure, the glowing white steeple immediately catches our attention and leads us into the background.

The background of a landscape may often take up the top third of the photograph and may include a lot of sky or mountains. This element of the composition concludes the illusion of depth and space. It can also be a primary device to suggest the spiritual aspect of nature, the things we feel but are impossible to touch, such as the distant mountains themselves. They can inspire awe in the viewer and inspire meditation on the image. In the preceding figure, the power lines in the background, in contrast with the church and broken fence, help make the image a complex commentary on the juxtaposition between nostalgia and contemporary life.

**JUST A MINUTE**

Just because most landscapes are horizontal does not mean all must be. Try framing the scene as a vertical, too. This can help accent the foreground for better composition, and because it's a bit unusual, you immediately get the viewer's attention.

## THE RULE OF THIRDS

The rule of thirds is a rudimentary plan for composition that has been suggested since ancient times. The rule states that the composition is most pleasing when broken into roughly equal thirds from top to bottom and left to right. While I discourage you from making this a hard-and-fast rule, you will find yourself naturally composing this way. We have all learned this method simply by looking at pictures, but we can help our compositions by consciously reinforcing this natural inclination. Your foreground, middle ground, and background may very well fall into these thirds.

## VANTAGE POINT

Many photographers believe that a good photograph is a function of vantage point, or where you stand. This is particularly evident in landscape photography, where the expanse of earth is seen best from elevated positions. The following figure, a night shot of Queens, New York, was done from an elevated position to give the expanse of the cityscape.

*Here the photographer has found the ideal location from which to photograph the borough of Queens, New York. This elevated vantage point allows the image to suggest the expansive city.*

*(Ian Spanier)*

We've all been to those scenic lookouts when travelling through the mountains. A good reason they are so popular is that they let us see the lay of the land, which is impossible from ground level, and they show us the terrain in a way that is unique. Finding these interesting vantage points is a great way to make good landscapes. Simply finding an elevated position helps, such as a rooftop or hill or bridge. Often these positions may not be accessible to us, but scouting out locations can lead to much better photographs.

**JUST A MINUTE**

Do some research on the places you are interested in photographing. Go to the library and search for information, publications, and the work of other photographers; you can search the Internet, too. By doing some homework, you may very well discover important facts that can be used to make your pictures more authoritative and more interesting.

## RESEARCH

For serious landscape photographers, this is probably the first step after deciding what or where to make pictures. Research is one of the most important aspects of great photography. Learn about your chosen subject: what its history is, who has photographed it before, what those photographs look like, and who has written on the subject. Research can reveal myriad aspects that are not self-evident and can lead you to richly rewarding picture-taking opportunities. By knowing your subject before or during your photographic expeditions, you are opening a lot more possibilities as to what the pictures will be about and important issues that can make your photographs much more than just pretty pictures.

Your research can lead to contacts that may help you get access to good locations, to knowledgeable experts, and to opportunities to get your work published and exhibited. So get to know your subject well, and your pictures will be more interesting and much smarter.

## EQUIPMENT

You can make landscape photography with any equipment, but some types of cameras, lenses, films, and filters can enhance your photography.

 **FYI** Most landscape photographers use medium- and large-format cameras, because the larger negatives provide greater detail and sharpness for all the tiny details in the landscape.

Because landscape contains so many tiny details, large and medium formats are often used. This allows for a great deal of information to be clearly seen in the images, and enhances the illusion of depth. In the following figure, the photographer used a 4 × 5 field camera to capture the intense detail of this forest scene. He also used a green filter to lighten the green foliage.

**GO TO** ▶
For more on filters, see Hour 2.

Medium-format cameras, those using 120 and 220 film, provide a lot of options for landscape photographers and are a good compromise between 35mm and large format. Most medium-format cameras are professional quality, so their lenses and mechanics will give you very good results. Because they are hand-held, they allow you to hike long distances without carrying a lot of equipment or even a tripod. This mobility is also great when trying to find unusual vantage points, such as up in a tree or perched on a high rock or cliff.

*By using a large-format camera, the photographer was able to render the intense detail of this forest scene. He also used a green filter to keep the greenery bright.*

*(Phil Marquez)*

However, the main advantage to a medium-format camera is the larger negative and the greater clarity and detail it provides. The larger negative means you have to enlarge the negative less than you would with 35mm, so the grain remains smaller and there are more bits of grain to define any tiny elements in the scene. All of this adds up to pictures with amazing sharpness that begin to suggest the details of the original scene.

Having said that, 35mm cameras work well, too. If you are looking for expressionistic imagery, that is, pictures that don't represent the landscape so much as act as metaphors, small-format film and even higher-speed, grainier films work well. But even if you want the crispness more often associated with medium and large format, you can do a few things to maximize your 35mm format. Here are a few tips for making better landscape pictures with a 35mm:

- Use a tripod. The tripod will hold the camera steady and allow you to precisely frame and focus your imagery.

- Use maximum depth of field. Shoot at your smallest aperture. This may require some slow shutter speeds but because you are using your tripod, that is not a problem. But be aware that wind can move the tripod-mounted camera during exposure and that the wind is moving trees and other flexible things in the landscape that may blur.

- Use film with a low ISO such as 100. The general rule of thumb is that the lower the ISO, the finer the film grain. Fine grain will give you more detail in faraway objects and help create the illusion of depth.

- Use foreground, middle-ground, and background compositions, as discussed earlier in this hour.

- Use a filter to help accent and separate tonal values. Remember that black and white film is overly sensitive to blue. A yellow filter helps give better detail to white clouds in the blue sky as well as helping to maintain clarity in the distant scene. Haze in the atmosphere is light blue, and without a filter the background of many landscapes would be fuzzy and gray. A yellow filter helps this some, but an orange filter does it even better. So does a red filter, but it makes the sky appear very dark.

- Shoot during the golden hours of early morning and late afternoon. The morning air is much cleaner and clearer than during the day or evening, so for those clear mountain views, go out early in the morning (and use a filter). The late-afternoon sky has a lot more dirt and pollution, but just like the morning, the light is coming from a strong angle for long shadows, producing good contrast that is needed in landscape pictures.

## WHICH LENS TO USE

Landscapes can be made with any focal length lens. Look through your camera and just see what looks best. Most photographers use the normal lens or a medium wide-angle lens, unless they are focusing on distant objects or those that they cannot get close to.

## ARCHITECTURAL PHOTOGRAPHY

Architectural photography shares many qualities with landscape photography. The subject has an abundance of detail, it remains stationary, and the lighting is paramount. Also, architecture has been a mainstay of photography since its inception.

The concepts of architectural photography are pretty clear. Most have been made as documentation of individual buildings and to show the juxtaposition of structures in the man-made environment. The more contemporary photograph may include the building as a metaphor, using architecture to plumb the social zeitgeist or to criticize urban development. The following

figure of an architectural photograph seems to be all about describing this abandoned early-twentieth-century building in a neglected urban neighborhood.

*The photographer approached the building as if it were a person sitting for a portrait. The tight framing and gentle overcast lighting helps keep our attention on the building facade.*

*(Thomas McGovern)*

**FYI** Like landscape photography, architectural photography is usually done with a medium-, or more often, large-format camera not only because of the need to capture great detail but also because they can correct for converging lines and maintain proper perspective.

In the nineteenth century, photographers who traveled made pictures of important buildings and monuments to bring home and sell for historical research or to sell to other travelers as tourist souvenirs. During the same period, photography in general and architectural photography in particular were used for artist's reference, for painters to use as a guide when making historical and decorative paintings.

## LIGHTING

As with landscape photography, the techniques for good architectural photography rely on natural light. This presents the photographer with some interesting choices that will strongly affect the pictures and, ultimately, what they mean.

Bright, direct sunlight produces intense highlights and deep shadows. This can look great on a building because the highlights seem to come forward in the picture and the shadows seem to recede. It creates a strong separation between things in relief (things that stick out) and those that are recessed. This type of lighting is often used when photographing architecture.

A problem with bright, direct light is that the shadows may have little or no information. If you want a picture that shows all the wonderful details of an ornate Corinthian column, you may prefer to shoot under overcast light. This will produce some soft shadows and only mild highlights but a completely visible range of details. Hard light or soft light both work well but will create vastly different pictures that may not always be appropriate for what you need. The hard light in the following figure of the Beechnut factory in Amsterdam, New York, works well to accent the structure and provide a good contrast with the sky, which was darkened with a yellow filter.

*The hard light on the white building makes a good contrast with the sky, which was darkened by using a yellow filter. The bright light helps accent the building's structure.*

*(Thomas McGovern)*

FYI    Lighting is always a major concern in architectural photography. It is possible to use flashes or other artificial light but more often than not you will need to wait for the natural light to be right to get the detail or illumination you need.

The direction of light is very important, too. When photographing architecture, you will probably want the light on the side of the building you are going to shoot. A building that faces east, then, must be shot in the morning, and a western-facing building in the evening. Southern-facing structures can be done during most of the day while northern-facing buildings need to be done during a very short period of time in the morning. I carry a notebook and record the location of the building I want to photograph and which direction it is facing so that I know what time of day to return.

## COMPOSITION

When photographing architecture, you can think of it as a portrait or landscape. If you think of it as a portrait, the building is going to be framed alone or with minimal surrounding. You would fill the frame and photograph it from a pretty straightforward position and would want the light to fall on the face of the structure.

If you think of it as a landscape, the building is part of the land and whatever surrounds it helps you understand its location and function. This method suggests a horizontal frame with elements of the building's lawn and other structures present. The light may or may not be illuminating the building, because it is only one part of a larger picture. You would probably pay close attention to the juxtaposition of other buildings and trees, and compose it so the picture represents the building in the context of its locale.

## FOREGROUND, MIDDLE GROUND, AND BACKGROUND

The compositional technique of foreground, middle ground, and background may or may not apply very well to your architectural photographs. If you are thinking of the structure as a portrait, it may be the only element in the picture, reducing it to a flat plane, which is fine. If you are thinking of it as a landscape, though, the landscape composition of fore, middle, and background will help make the picture more interesting and add to the contextualization of the building in the environment.

## JUXTAPOSITION

Particularly when photographing in a city, the juxtaposition of different structures can be beautiful. New skyscrapers behind a Victorian mansion for example, really demonstrates the growth and vitality of an urban setting. When you are composing your images, look to see whether there are other

man-made or natural elements that can be used to enhance the picture and accent the architecture. In the following figure showing the Carthay Circle neighborhood in Los Angeles, I was able to juxtapose the Spanish-style home from the 1930s with the modern skyscraper in the background.

*The skyscraper dwarfs the Spanish-style home of the 1930s but the house is still an important element because it is prominently placed in the foreground.*

*(Thomas McGovern)*

> **FYI** Think about the structure's surroundings when making architectural photographs. The street, other buildings, and context might be interesting and informative elements of the photograph.

## TWO VANTAGE POINTS

In the history of architecture, there are two basic views that are used repeatedly: the elevated frontal view and the perspective view. The elevated frontal is done from directly in front of the building from an elevated position or with the lens of the view camera raised. This shows the building in a fashion similar to a frontal architectural drawing.

The perspective view is done from a 45-degree angle and shows the front of the building and one side, which is also similar to an architect's perspective drawing. The two views combined give a good idea of what the building looks like.

## EQUIPMENT

Whereas landscape photography is often done with all formats, especially medium and large formats, architectural photography is really best suited to large-format cameras. Of course, you can take great pictures with your 35mm if you follow some of the tips I have suggested for landscape, but because of the nature of lens optics and the demands of architects, the view camera is especially well suited for this work. The bottom line is who is the picture for and for what purpose is it being taken.

### JUST A MINUTE

Keep the rear standard of the view or field camera parallel to a structure if you want to prevent converging lines. For very tall buildings, use the front rise and tilt the camera up if necessary, but then reposition the back to remain parallel.

Because most buildings have parallel sides and are perpendicular to the ground, architects prefer pictures of their buildings that do, too. Architecture is a combination of the science of engineering with the art of design, and architects and designers demand documentation that accurately represents the building's proportions and perspective.

**GO TO** ▶
For more on how view cameras work, see Hour 7.

The front standard of the view camera, where the lens is, can rise or fall. When it is raised, tall objects can be included in the picture that otherwise would have been cut off. When a building is very tall and the camera must be pointed up at it, there is the natural optical effect of converging lines. Converging lines happen because as something moves farther away, it appears smaller, so the top of a 20-story building appears much smaller than the ground floor. For accuracy of perspective and proportion, architectural photographers keep the rear standard, where the film is, parallel to the building they are photographing. They do this even when the camera is tilted up at a tall structure. By keeping the rear standard parallel to the building, the converging lines of the rising structure are eliminated.

In the following figure of a photo of an early skyscraper in Schenectady, New York, I had to work hard to avoid converging lines. The building does not have converging lines because I was able to keep the rear standard parallel to the building.

*This was a tough photograph to make. The street was quite narrow and I could not find a better spot to stand than immediately in front, so I used a wide-angle lens, raised the lens as far as I could (which shows where the lens falls off), and tilted the camera up.*

*(Thomas McGovern)*

Another reason for using large format is the large negative's great capacity for detail and sharpness, both of which are essential for accurate documentation.

## WHICH LENS TO USE

Architecture can be photographed with any lens, but just as the professional uses the large format to accurately represent the structure, he or she is probably using a lens that does that as well. Normal and long lenses will preserve proportions better than wide-angle lenses, but because of the constraints of locations, wide-angle lenses can be very useful for architecture. I have often found that standing across the street from a building was not far enough away to frame the picture, and I had to use a wide-angle lens. As long as you are careful to use a lens only as wide as necessary and to correct for perspective, this is usually acceptable to architects.

Getting farther away and using a longer lens is really best. Longer lenses more accurately represent proportions, and this is why they are preferred for portraiture, too. But in crowded cities, they are not always practical.

## FILMS AND FILTERS

Again, slower films (lower ISO) have less grain and generally offer more sharpness. I often use 400-speed film, but only make 8 × 10–inch enlargements from 4 × 5–inch negatives, so the faster film works fine.

Filters are used to help accent contrast and to produce a sky that otherwise would be white. The same rules apply that I outlined in the preceding discussion on landscape photography. Yellow helps render a blue sky, orange does so more, and red is very dramatic, producing a very dark sky and boosting contrast considerably. In general, orange and red filters are seldom used; a yellow filter is probably standard equipment for most photographers.

Landscape and architectural photography, along with portraiture, constitute the pillars of the photographic experience. The methods and techniques discussed here are applicable to practically any subject, and at the book's halfway point, you are well prepared to photograph just about anything.

# HOUR 13

# Photo Assignments: Night Photography

## CHAPTER SUMMARY

**LESSON PLAN:**

Because photographs are dependent on light, night photography poses some special problems. In this hour, I discuss how to make good photographs at night and some specific equipment and supplies that will help you.

- How to overcome exposure problems with night photography
- Learn techniques and the necessary equipment for night photography
- How to use flashes for night photography
- Compensating for reciprocity failure

Photographs made at night can be some of the most beautiful images you will make. The rich deep black of darkness can be wonderfully contrasted with the artificial lights of the city and with the ambient light from the moon and stars. To get good results, though, takes a bit of practice and patience.

## NIGHT PHOTOGRAPHY

Photography is dependent on light, but photographs made at night use a very small amount of it. Exposure meters sometimes have trouble detecting this small amount of light, so you need to be prepared to sometimes venture forth without the meter's usual help.

One of the major techniques to use when you are unsure what your exposure should be is called *bracketing*, photographing the same subject with various exposures, producing a series of negatives. For example, shooting the same subject at three different *f*-stops gives you three negatives of different densities. The idea is that you produce three shots and that one of them should give you a good print. Bracketing is a very common technique when photographers are unsure of the exact exposure or when the exposure meter is not giving them a reading.

### STRICTLY DEFINED

**Bracketing** is taking the same picture at numerous exposures so that at least one of them yields a good picture. This is typically done under odd or low lighting conditions, such as night or very contrasty situations.

## TECHNIQUES AND EQUIPMENT

When you photograph at night, there are a few techniques that can really help you get good photographs. The most obvious is to use fast film. Fast films are those rated at ISO 1600 and 3200.

### FAST FILM

I recommend Fuji Neopan 1600, Kodak TMAX 3200, and Ilford Delta 3200. All three are very good films that are flexible and produce clean, sharp photographs, depending on which film developer you use. I have used all three films with great success. Some of the advantages of these fast films are that they enable you to photograph without a flash and to use higher shutter speeds and smaller apertures.

GO TO ▷
For information on which film developers to use with the various fast films, see Hours 15 and 20.

Photographing at night under the available light can produce provocative and dramatic images. The world is visually transformed at night, and capturing the deep shadows and subtle highlights is a favorite of many fine photographers. Using fast film is the best way to show the nuance of light and shadow at night. This also enables you to photograph less obtrusively than if you were using a flash or tripod (which we discuss shortly). You can move around your subjects and shoot much as you do during the day. Also, fast film has a distinctive grain pattern that can be very interesting. The following figure demonstrates some of the advantages of fast film. It allows the photographer to move freely without a tripod, and the film has a definitely noticeable grain pattern.

*This photograph was done with Ilford Delta 3200 film. This fast film allowed the photographer to capture this night scene without a tripod, preserving the subtle and beautiful lighting in this portrait, which would have been altered if he had used a flash.*

*(Tony Maher)*

Fast films have a more noticeable grain pattern that I like very much, especially for night photography. There is a definite speckle pattern to the highlights and shadows, and night photographs typically have more contrast. The best part about using fast film is that it preserves the ambience of night scenes. Because light helps create a mood in your photographs, using the available light at night is best for suggesting the varied moods of night scenes.

## Fast Lenses

Along with fast film, *fast lenses* are another great tool to maintain the integrity of the night scene, and they enable you to move about freely while photographing. Fast lenses are those with wide apertures, typically *f/2* and *f/1.4* and even an astonishing *f/1.0*. For photographing at night, I use a 35mm *f/1.4* lens and a 50mm *f/1.2* lens. Remember that zoom lenses do not offer this degree of speed. The typical zoom lens may open to only *f/3.5*, which is about 2½ stops slower than my *f/1.4* lens. This is a very good reason to have a fast, fixed-focal-length lens at your disposal. If you love night photography like I do, the ability to shoot with available light (as was done in the following figure) is the best reason for spending the extra money for a fast lens.

### STRICTLY DEFINED

**Fast lenses** are those with apertures of *f/2* and larger (1.4, 1.2, and 1.0). They provide a lot of flexibility when photographing under low light conditions, enabling you shoot without a flash and with higher shutter speeds.

*Here the photographer was able to use an f/1.2 lens to make this picture under very a low light condition.*

*(Tony Maher)*

## PUSHING FILM

Pushing is not going to give you the same results that faster film would, but it can have some very interesting results that many photographers like. And if you need faster film and don't have any, it can be a useful solution.

GO TO ▶
See Hour 20 for more on pushing film.

When you push film, it is underexposed. This means that you are giving it less light than the manufacturer recommends. The practical effect is that the shadows, those areas that are already going to be dark in the picture, will have no detail at all. When you expose your film as recommended, there is usually some detail in the shadows, so pushing reduces the shadow detail a lot. When you develop the pushed film, you need to do so for a longer time than the manufacturer recommends. This overdevelopment of the under-exposed negative helps produce an image that is printable. During over-development, silver builds up in the highlights of the negative. When done properly, there will be enough silver built up to give you a good picture. A consequence of pushing film is that the shadows are inevitably black, without any detail, and the highlights are rather harsh and contrasty, due to the accumulation of silver. Because the shadows receive little or no exposure, no amount of overdevelopment will produce detail. This is why you get a high-contrast negative when film is pushed.

Try experimenting with shooting the same scene with fast film and then with slower film that is pushed. The differences are really pronounced, depending on how much you push the film. Pushing ISO 400 film one stop to ISO 800 usually works fine, but going further than that is really challenging the boundaries of what the film can do. In the following two figures, the picture with fast film has good shadow and highlights detail whereas there is a significant loss of shadow detail when ISO 400 film is pushed three stops.

Some newer films are made to be pushed, especially Kodak TMAX 3200 and Ilford Delta 3200. Both of these films were formulated with more flexibility for exposure and development and work very well when pushed. These films claim to be usable at ISOs as high as 64,000 for those really low light scenes or when you need to use a fast shutter or small aperture.

*In this image, the photographer used Ilford Delta 3200, rated at ISO 3200. The results are good shadow and high-light detail.*

*(Tony Maher)*

*In this image, the photographer used Ilford HP5, which has an ISO of 400, but he pushed the film three stops to ISO 3200. You can see the dramatic loss of shadow detail in the pushed film image.*

*(Tony Maher)*

## TRIPODS

If the type of night photography you plan on doing does not require you to move around spontaneously, a tripod may be your best tool. Using a tripod will let you shoot at very slow shutter speeds with any film. It also ensures that you have sharp pictures of inanimate objects. However, if you use a tripod, get yourself a cable or bulb release as well. Either of these will let you release the shutter without touching the camera, which could cause your picture to come out blurred if the shutter speed is very slow.

Tripod shots at night can look great. You can get the sharpness you hope for with the exposure that will give you a lot of detail. Try using a tripod with 400- or even 100-speed film, and you will be amazed at how great the pictures look. A tripod also forces you to carefully compose a picture, holding the camera for you while you check for all the details, look at the four edges of your frame, and check focus. The scene in the following figure was done with ISO 400 film and a tripod. It is sharp, well composed, and has less noticeable grain that if it had been shot with faster film.

*Here the tripod allowed the photographer to use Ilford HP5, rated at ISO 400, even though the light is pretty low.*

(Tony Maher)

## FLASH PHOTOGRAPHY AT NIGHT

Of course, you can make photographs at night using your flash, too. The flash can give you a bright picture in any lighting condition and enable you to use small apertures, maximizing your depth of field. Also, because the light from the flash is a very short burst of bright light, the flash freezes moving objects. This is a fun technique when photographing people dancing or other moving subjects.

**PROCEED WITH CAUTION**

A flash is a great tool but think about the effect before using it. Photographs done at night with fast film or a tripod will help preserve the interesting lighting and nuance of a scene that a flash would dramatically alter.

The problem with using a flash at night is that it overrides the existing light, which is often an interesting aspect of night photos, and the flash may be too bright, washing out your subjects. When a flash is too bright, it will overexpose your foreground and create a very dark background, which is fine if that is what you want. In the following figure, the photographer chose to use a flash to illuminate a nighttime scene.

*A flash was used for illumination in this photograph, brightening up an otherwise dim scene.*

*(Tony Maher)*

Use the open-flash technique for more background detail and to add a sense of depth to your photographs. And use an off-camera flash to create dramatic shadows and direct the light in creative and interesting ways.

Remember that when you use your flash, you need to have your 35mm camera's shutter set to a synch speed or your image will not be fully exposed by the flash. Most cameras synch at $\frac{1}{60}$.

One note on using a flash with high-speed film: Some of the high-speed black and white films such as Kodak TMAX 3200 do not react well with electronic flash. When used together, the film is very contrasty and I think it looks awful. I would recommend using flash with 400 ISO film or using the higher-speed film by itself—or pushing the high-speed film to an even higher ISO.

**GO TO ▶**
See Hour 5 for cool night flash techniques, especially the open-flash and off-camera techniques.

## LONG EXPOSURES

Photographing under low light conditions can be done with long exposures. You will probably want to use a tripod to prevent blur and shake, but those can be interesting creative effects, too.

A problem you will encounter with long exposures, however, is called *reciprocity failure*. Reciprocity means that you get a well-exposed picture through the combination of the intensity of the light and the time of exposure, and under normal conditions this is true. When you increase one, you decrease the other for good exposure. When making pictures under normal daytime situations, the combination of apertures and shutter speeds work together to give you a well-exposed negative. But with long shutter speeds of one second or more, this rule breaks down, and you need to compensate for reciprocity failure.

### STRICTLY DEFINED

**Reciprocity failure** occurs when the usual combination of aperture and shutter speed doesn't produce well-exposed negatives at a given ISO. The result is underexposed film.

Different films have different levels of reciprocity failure, and the latest Kodak TMAX and Ilford Delta films are designed to maintain reciprocity even at long exposures. When photographing at night, I recommend bracketing your shots. To do so, follow your meter and then make another two or three exposures, each with a ½ stop more light. This usually produces at least one good negative.

The general rules for avoiding reciprocity failure are as follows:

- If your exposure is 1 second, open the lens one stop, or double the exposure time and reduce your film developing time by 10 percent.
- If your exposure is 10 seconds, open the lens two stops or quadruple your shutter speed (slowing it down times 4), and reduce your film development time by about 20 percent.

Why do I recommend you reduce the development time while also increasing exposure? Because long exposures typically produce very high-contrast negatives. By reducing the development time, the highlights are prevented from becoming too overdeveloped, which would normally accompany the increase in exposure.

In the first of the following two figures, you can see that compensating for reciprocity failure gave the photographer a good negative that produced a good print. The second figure shows that by not compensating, the negative was thin; therefore, the print has less shadow detail.

*In this photo, the exposure meter indicated a one-second exposure, but the photographer used a two-second exposure to compensate for reciprocity failure. He used Ilford Delta 3200 film.*

*(Tony Maher)*

*Here the photographer followed his meter and the negative was underexposed due to reciprocity failure. He used Ilford Delta 3200 film.*

*(Tony Maher)*

The rule of overexposure and reduced development is different for the TMAX and Delta films because they have been designed especially for low light conditions. With a one-second exposure when using these films, open your lens ½ stop and develop normally. For a 10-second exposure, open the lens a full stop and develop normally. These are only very general starting points that I have found to be effective for me. You should bracket your exposures and do some testing with your film and film developer to get the best formula for how you shoot.

**GO TO** ▷
For more on controlling detail with exposure and highlight intensity with development, see Hour 20.

A very general rule about film exposure and development is to expose for the shadows and develop for the highlights. Basically, exposure controls the amount of shadow detail and development controls the intensity of highlights.

**JUST A MINUTE**

When you photograph using long shutter speeds of one second or more, you need to compensate for reciprocity failure. If your shutter speed is one second, open your lens one extra stop or double the shutter speed to two seconds to compensate for this. Also, reduce your film development by 10 percent to control contrast, unless you are using Ilford Delta 3200 or Kodak TMAX 3200, then develop normally.

## EXPOSURE READINGS AT NIGHT

Taking an exposure reading at night can be tricky because the scene you are shooting may be mostly dark with small areas of highlights. Of course, the first thing is to try your camera's built-in meter. If you can get a reading, follow it, but bracket your exposures, too, with a few shots overexposing and a few shots underexposing the scene. This will almost always give you at least one good negative to print from.

**GO TO** ▷
For more on using a gray card, see Hour 4.

However, if your meter does not provide a reading, you can try a few other techniques. One would be to use a gray card. Hold the card and take a reading from it. Again, though, I would do some bracketing to be on the safe side. If you don't have a gray card, use a white piece of paper or other light-toned object to try to get a reading under the available light.

**PROCEED WITH CAUTION**

Be careful with your light readings at night. Any bright light in the distance can activate your meter and fool you into thinking you are getting a well-exposed shot. To be on the safe side, bracket your night shots until you have the experience to make better exposure judgments.

Bracketing is a good idea under this tricky situation, but when each picture matters, such as during a news assignment, use your flash or fast film for best results.

### PROCEED WITH CAUTION

Watch out for being fooled into thinking you are getting a good exposure at night. This happens when there are some bright lights in the scene that will be throwing off your meter. The bright lights will activate the meter but you should look closely to see if your shadows are getting enough exposure, too. Night photos with shadow detail can look fabulous, but the same shot with no shadow detail can look flat and uninteresting. Because our eyes are so much more sensitive than film, we see these wonderful nighttime scenes, only to be disappointed by a high-contrast picture with no middle tones.

Night photography can produce beautiful, compelling photographs, but as you have learned, getting the exposure correct can be tricky. Don't let the variables keep you from trying it, though, just use the fast film and bracket your exposure. Once you've done this for a short time, you'll be able to make great night photographs.

# Hour 14
# Studio Photography

**LESSON PLAN:**

In this hour, I discuss the major components of studio photography so that you can begin to visualize and create images under this controlled situation.

- Studio lighting setups
- Portraiture and product photography
- Backgrounds and props
- Studio accessories

The photography studio is any place that has been set up specifically to make photographs. This usually entails controlled lighting, backgrounds, and props—all of which give the photographer the greatest amount of control possible. One of the most difficult aspects of studio photography is using this control to make the pictures you want. When done well, great studio photographs exude a seamless glamour or fantasy. When done poorly, they appear contrived, forced, and amateurish.

## Defining the Studio

You may have been in a professional photographer's studio and were impressed by all the equipment and gadgets or had your picture made in a smaller commercial portrait studio, surrounded by reflective umbrellas and various backgrounds to choose from. Or you may even have set up your own version in a spare bedroom with a flash or two and a blank white wall. These are all photography studios, and the important thing to remember is not how much equipment you own or how large your space is, but how good your pictures are.

## Using Studio Strobes

The most important aspect of any photography studio is the lighting and most studios use electronic *strobes*. Strobes are basically very powerful flashes with variable

power output. They can be used with umbrellas and large white *softboxes* for gentle lighting or used directly for harsher lighting.

---

**STRICTLY DEFINED**

**Strobes** are electronic flashes used for studio photography, but some have rechargeable batteries for outdoor use. Strobes are basically just like your camera flash except that they are much more powerful, heavy, and versatile. They are designed for use in a studio or on location when a high-powered lighting source is needed.

A **softbox** is a box with a translucent white material on the front. The box fits over the strobe head, and when fired, the light fills the box and is filtered through the white material to give a lovely soft, even lighting.

---

Depending on the manufacturer and model, a strobe can light a tiny object or an entire studio. Photographers generally use multiple flash heads that can be positioned around the studio to create interesting lighting effects. A great advantage of strobes is that you can use them with umbrellas to bounce the flash for a gentle, soft shadow and even lighting. Even more effective than using an umbrella is the use of a softbox. The following figure shows a professional studio strobe set made by Speedotron.

Each strobe head can be adjusted individually, too. This allows one light to be more intense than another and used for great creative effect that we will discuss shortly. And you can use three, four, or more flash heads simultaneously to really alter and control the light. Strobe heads can be used with metal reflectors to intensify and direct the light. Most manufacturers make small and large reflectors as well as barn doors, which are adjustable dark flaps that can be used to control the spread of the light.

## Creating Different Backgrounds

Studios use backgrounds to create abstract or innocuous backdrops for portraits and products. We've all seen those basic blue or blotchy backgrounds used in school portraits and at the photo studio at the local mall. Backgrounds can be wide paper on a long roll or cloth backgrounds that come in a huge selection of colors and styles. The paper backgrounds are very reasonably priced and come in either 4-foot widths or 9-foot widths with 30 feet of paper on a roll. Most studios have a stand that is specially made to hold the 9-foot rolls. The cloth backgrounds are great because they can be easily folded and stored, but they are much more expensive than the paper ones. I have used the 4-foot rolls in my home studio, hanging them on the wall with pushpins.

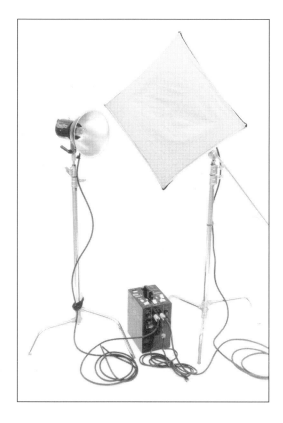

Here is a professional studio strobe setup. The main power pack plugs into the wall, and as many as eight strobe heads can be attached.

(Matthew Richardson)

**FYI** Portrait studio lighting is typically flattering but realistic enough to represent the subject. It is important in most cases for the light to come from a high angle to suggest the natural light of the sun. To look natural, there should only be one shadow, cast by the main lighting source.

## SETTING UP PORTRAIT LIGHTING

As you have already figured out by now, there are countless ways to light a portrait to create different moods or for creative effect. The setups discussed here all use four lights, but feel free to try them with three or even two lights. Sometimes a light can be removed and replaced by a white reflector to get the same effect. Here are the basic rules of lighting:

- There is only one main light. Other lights should be secondary to the main lighting source.
- The main light should come from a high angle, from 45 to 60 degrees above the subject, mimicking the angle and direction of the sun.

- There should be only one shadow. This shadow is cast by the main light. Because the other lights are secondary, they are usually not as intense as the main light, and therefore the main light is the one that casts the shadow.

- Shadows should have some detail. Our eyes detect shadow detail in practically all situations, except night, so studio portraiture should also have some detail throughout the photograph. This is usually done by using secondary lights, which add illumination to the darkest area in the picture.

- The subject's hair should be distinct from the background. If you are photographing a person with dark hair on a dark background, use a hair light or background light so the tone of the hair is separated from the backdrop.

The following are three of the most basic studio lighting setups which you can experiment with to learn the ones you like best.

## SHORT LIGHTING

Short lighting is the most often used portrait lighting setup and works well for most commercial photography. Position your subject so his or her face is at an angle to the camera. Looking straight into the camera is less flattering and looks like a mug shot. Basically tilt the head enough so that one ear is hidden. When the head is tilted like this, one side of the head and ear face the camera while the other side is only partially seen. This lighting technique is called short lighting because the main light is going to be illuminating the shorter side of the face, the side with the hidden ear.

GO TO ▶
For more on portraiture, see Hour 11.

**FYI** Short lighting places the main light toward the short side of the subject's face. This is a popular lighting technique that is flattering for most faces and used for most popular commercial portraiture.

The main light is positioned high to suggest the sun, at approximately a 45- to 60-degree angle, pointing at the short side of the face. There will be a distinct shadow raking across the wider side of the face that we will deal with next. You should be able to see the tiny catch light in the subject's eyes, too. The following figure shows you how to set up the lights for the short lighting technique.

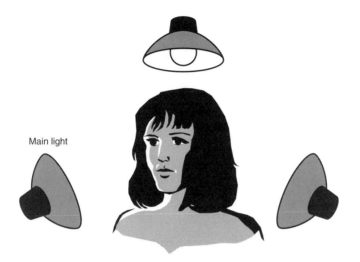

Main light

The second light is the fill light. The fill light gently illuminates the harsh shadow on the wider side of the face. This light is positioned on the side opposite the main light and at eye level or so. This light is typically about one or two stops less intense than the main light. The short lighting technique was used for the portrait in the following figure. Remember that the main light is the one that should cast a shadow, so keep it the strongest and have the fill light weaker. If you are doing this with strobes, use your flash meter to determine the intensity of the lights. If you are using photoflood lights, you can move the lights nearer or farther from the subject to adjust their intensity.

The third light is the hair light. A hair light puts a highlight on the top of the head and creates a visual separation between the background and subject. This also helps create the illusion of depth in the photograph and adds a more professional look. The hair light is positioned high and behind the subject, typically on the opposite side from the main light and shining toward the camera. Be careful that it does not shine into your lens or create a shadow on the face. The hair light is as bright or even a stop brighter than the main light to make the hair shine. A spotlight is often used for the hair light to contain the light and prevent shadows or unwanted light coming into the lens.

The fourth light is the background light. The background light is used to create a tonal variation on the background, further suggesting depth and separation between subject and backdrop. The background light is often placed low and behind the subject, pointing at the background.

*Using the short lighting technique, the narrower side of the face has the stronger light. This is good for making a wider face appear slender.*

*(Matthew Richardson)*

These four lights create the short lighting seen in the preceding figure that illustrates the ideal setup for this type of lighting technique.

## BROAD LIGHTING

Broad lighting is very similar to short lighting except the main light shines on the side of the head that is facing the camera, as seen in the following figure. Use the other three lights in the same manner as mentioned for short lighting. Broad lighting can be flattering for people with thin faces by giving them a wider look.

### PROCEED WITH CAUTION

The main light used in broad lighting can make the ear too bright.

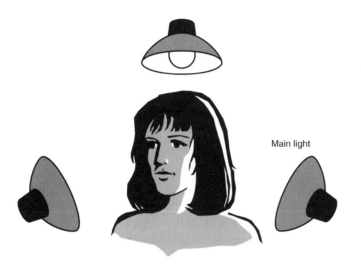

*This illustration shows the position of the lights for the broad lighting setup. Broad lighting is good for widening narrow faces.*

*(Mike Hollenbeck)*

## BUTTERFLY LIGHTING

Butterfly lighting is a little different from short and broad lighting, and is often used as a glamour lighting setup. Still using four lights, set the main light high but directly over the subject's head. In this case, the head is not angled as much as in the more conventional lighting techniques. The following figure illustrates the position of the lights.

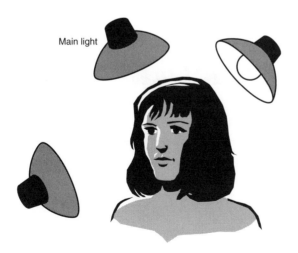

*This illustration shows the position of the lights for the butterfly lighting technique. The high main light should be positioned so the eyes are just out of the shadow.*

*(Mike Hollenbeck)*

The high main light should cast a symmetrical shadow under the nose and chin, but be careful that the eye sockets are not totally in shadow. Position the light so the eyes are lit but the eyebrows cast a shadow on the eyelid. The following figure shows the effect.

*Butterfly lighting places the main light high and directly overhead, creating a little "butterfly" shadow under the nose.*

*(Matthew Richardson)*

## OVERALL SOFT LIGHTING

One of the easiest and most popular lighting techniques uses an overall soft lighting. This is often done with two or more strobes and softboxes or umbrellas. The lights can be in practically any configuration, at 45-degree angles or one overhead and the other to the side, and so on. But one of the lights should be the main source, the stronger of the two lights that creates the soft shadow. Look at magazines and you will see a propensity for softly lit studio portraits. This soft lighting, as shown in the following figure, is very flattering, and natural and easy to set up, making it a popular technique.

*Two softboxes or umbrellas created this overall soft lighting effect. One light is slightly stronger than the other to direct the shadow.*

*(Matthew Richardson)*

## PHOTOGRAPHING PRODUCTS

Product photography is done mostly to create compelling photographs of a product. All of the photographs you see in advertisements and brochures are product photographs. Because it is essentially a type of publicity, the product must look great, convey some sense of the product or its function, or at the very least, be enticing.

Besides trying to make something look good, product photography shares other characteristics with commercial portraiture. The big challenge in product photography comes from the variety of products. Each different shape, texture, and material may require its own way of lighting to create interesting effects. For example, glass is obviously more difficult to photograph than something that is not shiny.

The field of product photography has seasoned masters who have acquired their skills after years of work. While I will give you a few shooting techniques, they are only the beginning. When you start working with these basic setups,

you will begin to have ideas about how you can alter them to create your own look in pictures. From now on, when you look at an advertisement or brochure, you will have a deeper appreciation for the skill of the product photographer.

Just like portrait photography, product photography has some basic rules that are good to follow:

- There should be a main light coming from a high angle, around 45 to 60 degrees. This high main light is essentially mimicking natural sunlight.
- There should be only one shadow coming from the main light. Two or more conflicting shadows are distracting and unreal.
- There should be some detail in all the shadows. Our eyes almost always detect shadow detail, and for a product photograph to look natural, the shadows should not be totally black.

There are many instances where you may want to break these rules, and that's fine. Look at product shots in magazines and brochures. See how the pros have done things and whether you can figure out their lighting techniques. One of the most common lighting techniques for products is the overall soft lighting discussed with portraiture. The same advantages of a natural and flattering light work well with some products, too.

## BACKLIGHTING

Backlighting is often used with products because it helps suggest the size and shape of an object and retains the sense of depth. This can be an important consideration when description is important in a photograph, and backlighting also creates an interesting dynamic in the image.

Set the main light so that it is high and coming from behind the object. Use other, less intense lights to fill in the shadows, preserving the forward cast shadow of the main light for depth, as in the following figure.

When you have a product to shoot, it is a good idea to try a few lighting setups until you get a feel for what works best for what shapes. I use photofloods and move them around the object to see where I want the shadow to fall, and whether I want the lighting to be hard or soft. After you have done this a bit, you will be able to visualize which technique works for which object. Frontal lighting is rarely the solution. Light coming from the front generally makes the object appear flat. Bounce lighting is not great for a box, either. It will light the top of the box okay but the sides will be the same tone, which does not enhance the shape.

*The backlighting technique gives this photo depth. Note that the front of the timer is also well lit from the fill light.*

*(Matthew Richardson)*

## BASIC PRODUCT LIGHTING SETUP

The following is a basic lighting setup for photographing a cube or small box using backlighting to suggest depth:

1. Position the box on a table that you can move around. Similarly to portraiture, don't face the box directly at the camera but position it at an angle. Set the main light so that it is high and behind the subject (but not directly in back of the object), because to create the illusion of depth, the shadow should be cast at an angle. This works best if the main light is a spotlight. If the main light is behind and to the right, the shadow will fall forward and to the left. This main light will illuminate the top of the box and cast the main shadow.

2. Because the box is at an angle to the camera, you will see the top, left, and right sides. Position the second light to fill in the shadow on right side. This light should be less intense than the main light by about one stop.

3. The third light is set up to gently illuminate the left side, where the main shadow is cast. This light should be about two stops less intense than the main light and one stop less intense than the second light.

Now you have a basic lighting set up for a cube or box product. The main light illuminates the top and casts the main shadow forward and at an angle to show depth. The second light illuminates the right side and is one stop less than the main light. The third light gently fills in the main shadow and

is two stops less than the main light. This gives you a good basic setup from which you can find the lighting that works best for your product. See the following two figures.

*Here is what the studio and lighting setup looked like for the following product shot.*

*(Matthew Richardson)*

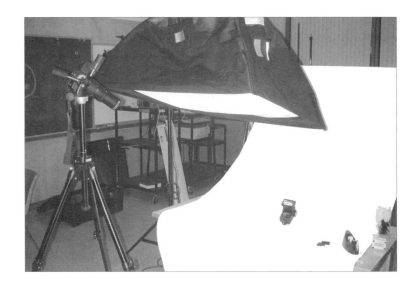

*Here is a well-lit product photograph.*

*(Matthew Richardson)*

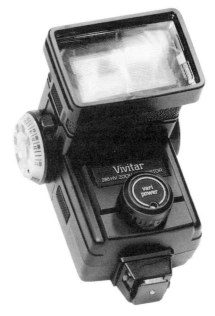

# IDENTIFYING OTHER STUDIO ACCESSORIES

The longer you work in a studio, the more gadgets and equipment you will accumulate. Some will be professional photography equipment but others will be homemade or originally designed for other uses. The following are a few goodies that you may want to think about as you are setting up or working in a studio.

## FAN

A fan is great for blowing long hair during a shoot. A person sitting motionless can be a boring subject, so many photographers, especially those who shoot fashion, use a fan to get the hair moving. A modest-sized fan with medium power is usually fine, unless you are trying to blow the hair of a crowd of people. I recommend you shop around the discount stores and find something on sale. As the fan blows the subject's hair, each shot will be different, and while some may be unusable due to hair in the eyes or mouth, the suggestion of movement from the hair blowing is a great look that can add some excitement to almost any portrait.

 **FYI** A lot of studio accessories can be found, made, or bought. A product designed specifically for use by photographers is typically overpriced. I try to find what I can in thrift and discount stores, such as fans, background cloth, and other props.

## DULLING SPRAY

Dulling spray should be purchased from a photo store. It is designed to take the shine off highly reflective objects and is an essential tool for most product photographers. For super-shiny objects, use dulling spray with a polarizing filter.

## MAKEUP

Cosmetics are an important part of any studio portrait. If you are a guy, you probably aren't all that experienced with using or applying makeup, but a little skill and knowledge about it can go a long way. Eyes are such a big part of a portrait that I suggest eye liner and mascara for women. This has the effect of adding contrast to the eyes and is particularly important when photographing someone with very fair skin and hair. For both men and women, some foundation of various hues and tones can help cover small blemishes,

discolorations, and pimples, and a light layer of powder is good for reducing the shine of oily skin. Lipstick can be great, but remember that black and white film records tones and not color. Red lipstick will come out looking black, but a light pink can look great.

## PROPS

If you are going to make a business out of portrait photography, go to the local junk and thrift stores to see what fun and interesting props you can get. Vintage clothes, hats, walking sticks, cool furniture, funny paintings, end tables, and vases can all be good props that you can use over and over. A good selection of props can inspire your subject to act or help them relax by giving them something to do with their hands.

## LIGHTING SNOOT

A snoot is a tube that attaches to your light, turning it into a spotlight. This is a great accessory for both strobes and hot lights, and can enable you to focus an intense beam of light onto a small area for accent, hair, and back-lighting.

## PRODUCT LIGHTING TABLE

If you are going to make product lighting a profession, you will want to invest in a product lighting table. This unit is a large frame on wheels onto which you mount a large piece of flexible plastic. With the plastic installed, the frame can lie out flat like a bed, or you can raise the back like a chair. This lets you create interesting backgrounds, and because the plastic is translucent, you can light objects from behind and underneath as well as overhead. Lighting from underneath is particularly great for glassware.

## COOKIE

A cookie is a piece of thin opaque board or wood with many irregularly shaped holes cut out. When a light is shined through it, the irregular cutouts create interesting shadows on the background or subject. The farther the cookie from the background, the less distinct the shadows, creating abstract lighting variations on plain backgrounds.

Now you have a good understanding of the complexity of studio photography. Whether it be portraiture or still life, attention to detail, composition, and precision lighting are primary elements of fine studio work. Don't worry about fancy equipment or elaborate studios, though. Later in the book I'll discuss some inexpensive ways to set up your own studio. The bottom line is not what equipment you use, but what your pictures look like.

# PART III
## Making the Print

# HOUR 15
# Developing Your Film

## CHAPTER SUMMARY

**LESSON PLAN:**

Having first discussed the mechanics of exposing film and then how to actually make pictures, you are ready to see what your exposed film looks like.

- The equipment, supplies, and chemicals needed to develop film
- How to mix developer
- How to determine the correct temperature and development time
- How to cut and store negatives

For me, this has been one of the most exciting aspects of photography since I began making pictures 25 years ago. To this day I am anxious and excited to see my freshly developed film, and I hope you are, too.

You will need some equipment for this procedure. Fortunately, it is not very expensive and when properly taken care of, will last for a long time.

It is important that you follow the procedures outlined here carefully until you fully understand the film-developing process. Doing something out of order will ruin your film, and as with most photographic procedures, it requires attention to detail. Because film developing is a chemical process, it is important that all chemicals be well mixed and stored properly, and that work areas be kept clean.

## NEEDED EQUIPMENT, SUPPLIES, AND CHEMICALS

Here is a list of the equipment and supplies you will need to develop your film (also see the following figure):

- Film-developing tank. This is a metal or plastic tank with one or two or more reels that the film is loaded onto. The tank is light tight but has a special top that lets you add and remove chemicals without removing the top. You can buy either the plastic or metal tank. Many beginning photographers find the plastic easier to load film onto, but plastic can break. Metal tanks and reels can last a

lifetime but cost more to purchase. I recommend you get the tank that holds two reels. A plastic tank with two reels costs about $30.

*Here is what you need to develop your film.*

*(Matthew Richardson)*

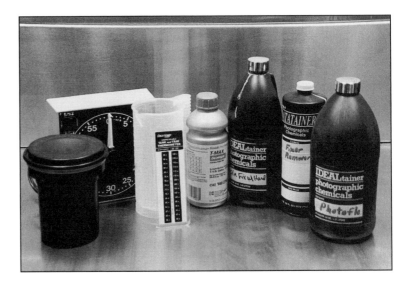

- A thermometer to check the film developer's temperature. Photo stores have thermometers made for this purpose for around $20. You need one that will read temperatures in the 60°F to 125°F range.

- A graduated beaker for measuring chemicals. I recommend you get a few of these in various sizes, particularly a one-quart size with ounces clearly marked on the side. Either plastic or metal is fine, but plastic ones are less expensive. A one-quart plastic beaker sells for around $8.

- Film-developing chart. This is information that comes with your film, usually printed on the inside of the box or on a separate piece of paper, that provides the film development times and temperatures. All the film manufacturers include this information with their film. Of course, they will recommend their own brand of developer, but the charts usually include developing times for other brands of developer as well. Get this information before you begin developing.

**PROCEED WITH CAUTION**

Use dark-colored containers with tightly fitting caps for storing photography chemicals. Many chemicals are sensitive to light and air, and go bad with exposure to light and oxidization.

- Four or more containers for storing chemicals. One of them should be dark because developer goes bad more quickly when exposed to light. I have often used household bottles and jars with resealable lids. If the mouths of the bottles are small, get yourself a funnel as well. You will be mixing chemicals and storing them in these bottles. Plastic bottles that are made for this purpose can be purchased at a good photo store for around $3 to $5 each.

**PROCEED WITH CAUTION**

Always clearly label any bottles with chemicals and never leave them where children or animals can get to them.

- A can opener or pliers for opening your film canister. A can opener should be the old-fashioned kind for opening bottle caps. Pliers work just fine.
- A timer of some sort to keep track of how long you are developing your film. You can use your watch but it is easy to lose track, and development time is crucial to good results. A kitchen timer is fine as long as it can keep track of minutes and seconds up to 20 minutes.
- Scissors to cut your film.
- Negative preservers are clear plastic sheets with sleeves to put your developed film in. They keep your negatives free from dust and fingerprints. They are available at any good photo supply store.
- Latex gloves to keep chemicals off your hands. I highly recommend using gloves. Photo chemistry is made to be low hazard, but different people have different levels of sensitivity. Also, chemical sensitivity builds up. You may be fine today but in 10 years you may develop some negative side effects. Be safe and always use gloves.
- Cloth rags to keep your hands dry.

**PROCEED WITH CAUTION**

Cleanliness is essential to good results when developing film. Always rinse your beakers and film developing equipment thoroughly to prevent cross contamination of chemicals.

Here is a list of chemicals you need to develop your film:

- Film developer. There are numerous film developers on the market, and most of them work well with just about any film. Although it is not a bad idea to use the same brand of film and developer, you may

want to experiment with different developers for different results after you have some experience with this process. If you used Ilford HP5 film, I suggest getting Ilford ID-11 film developer, which comes as a powder and needs to be mixed into a one-gallon container. You can buy liquid developers as well, such as Kodak TMAX developer that can be mixed right from the bottle for use. Powdered developer costs a lot less than liquid developer, but it must be mixed first.

**JUST A MINUTE**

When mixing powdered chemicals, follow the directions carefully. Start with water at the recommended temperature (usually around 125°F) and slowly add the powder and mix thoroughly with a stirring paddle. Let the mixed chemical sit for 15 minutes before using.

- Fixer. Fixer is a chemical that stops the developing process and removes the unused silver halides from film, making the film no longer light sensitive. You can buy either powdered or liquid fixers. Kodak Rapid Fixer comes as a liquid and is mixed with water to make one gallon and costs about $10. Fixer can be reused many times, so this is a pretty economical chemical. There are a few fixers that all work fine, but get one that has a hardener either already in it or one that can be mixed in. Film emulsion gets pretty delicate during developing and the hardener helps prevent scratching.

- Fixer Remover. It does just that: removes residual fixer from film and paper. This is important because residual fixer can stain and fade prints and film over time. Without this chemical, you need to wash your film and prints for a much longer time. Kodak Hypo Clearing Agent comes as a powder and sells for around $4, making one and a half gallons of reusable fixer remover.

- Photo Flo. Photo Flo is a wetting agent that applies a very thin coating on your film to help prevent water spots when drying. Remember the TV commercial about dishwasher spots on glasses? Photo Flo helps keep those spots off your film, which if not prevented leave ugly marks on your prints. A small bottle of Photo Flo goes a very long way and costs about $5.

- Hypo Check or Fixer Check. Your film and paper fixer can be reused many times, but you need to check that it is still good before use. Because you are just starting out, you can wait for this, but it is just a little bottle and costs only a few bucks. Just put a drop or two into your fixer, and if it turns white, the fixer is depleted.

## Preparing for Film Development

Once you have your equipment, supplies, and chemicals, you are ready to develop the film. The procedure for film processing is pretty simple and almost always done the same way every time. What changes is the amount of time you develop different films and the temperatures you use, all of which depend on the film you have shot, the developer you are using, and the results you want. What follows is the basic film-developing procedure using the materials outlined earlier in this hour.

### Load the Film onto the Reel

Load your film onto the film-developing reel as shown in the following figure. This must be done in total darkness. The first time you use a dark room to load film, sit for a few minutes in the dark to be sure the room has no light leaks. If it does, fix the leaks before opening your film. Loading film onto the reel can be a bit difficult at first. If you have an old roll of film or some strips of unwanted negatives, you can practice doing this in the light.

**JUST A MINUTE**

Loading film onto the developing tank reel can be tricky. A way to practice is to use an old roll or film or just waste one for this purpose. Try loading the film in daylight and get a feel for how the film and reel feel. This practice will be a big help when you actually do it.

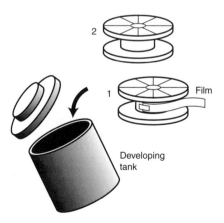

*Film is loaded onto the spiral developing reel as shown. Practice this with an old strip of negatives in daylight before attempting it in the dark.*

*(Mike Hollenbeck)*

Find a totally dark area and bring your film canister, can opener or pliers, and developing tank with reels. With the lights still on, open the film-developing tank and lay everything out. Examine your reels to see how the

film goes onto them. Turn the lights out. For the plastic reels, feed the film into the opening and twist the reel back and forth. The film will load itself onto the reel. For metal reels, you need to clip the film onto the reel and manually twist the reel, making sure the film goes smoothly into the spiral wire groove. This can be tricky to do in the dark the first few times. Be patient with this process. If the film crimps and won't go on all the way, remove it and start again. An old roll of film is great to practice this with.

Once you have loaded the film onto the reel, put it in the tank (with the second reel on top if you have a two reel tank), attach the lid securely, and turn on the lights.

## MIX THE DEVELOPER

GO TO ▷
For more on how developer works, see Hour 3.

Now that your film is loaded, you are ready to mix your developer. Developer is a chemical that accelerates the process of converting silver halides into metallic silver. If you have powdered developer, mix it thoroughly and let it sit for 15 minutes before using. If you are using a liquid developer, read the instructions on how to dilute it for use. Kodak TMAX developer is mixed 1:4 to make a *working solution*, this means one part developer is mixed with four parts water.

### STRICTLY DEFINED

A **working solution** is a chemical that is ready to use. A **stock solution** is a chemical that still needs to be mixed before using. Most liquid chemicals come as a stock solution that needs to be mixed with water to make a working solution.

For each roll of film to be developed, mix 10 ounces of working solution film developer. Unsure how to figure this out? If the mixing ratio is 1:4, add the two together to get 5. Divide the total amount you want by 5 and you get the factor that each of the ratio numbers are multiplied by. So 10 ounces of total developer divided by 5 gives us a factor of 2. Then, 2 × 1 gives me 2 ounces of developer and 2 × 4 gives me 8 ounces of water. Add them together to get 10 total ounces of working solution film developer.

## DETERMINE DEVELOPING TEMPERATURES AND DEVELOPING TIMES

As with all chemical processes, temperature affects how rapidly the process takes. Warmer temperatures make things happen at a much faster rate than cooler temperatures. The standard temperature that most films and developers are designed for is 68°F or 20°C. The manufacturer has tested the film and determined the optimum developing time based on developer that is 68°F.

The following information is a film-developing chart for some of the most popular films and developers. The chart indicates the number of minutes and seconds to develop a film for four different temperatures. Check your film and developer if they are not shown here.

| Ilford ID-11 Developer 1:1 | 68° | 70° | 72° | 75° |
|---|---|---|---|---|
| Ilford FP4 Plus | 11:00 | 10:00 | 09:00 | 07:30 |
| Ilford HP5 Plus | 13:00 | 11:45 | 10:30 | 09:00 |
| Ilford Delta 100 | 11:00 | 10:00 | 09:00 | 07:30 |
| Ilford Delta 400 | 14:00 | 12:30 | 11:15 | 09:45 |

| Kodak T-Max Developer 1:4 | 68° | 70° | 72° | 75° |
|---|---|---|---|---|
| Kodak T-Max 100 | 08:00 | 07:30 | 07:00 | 06:30 |
| Kodak T-Max 400 | 07:00 | 06:30 | 06:30 | 06:00 |
| Kodak T-Max 3200 | 11:30 | 11:00 | 10:30 | 09:30 |

(*Matthew Richardson*)

Look at the information inside the box your film came in; it will tell you how long to develop your film for your particular developer. If you don't have this information, find the film manufacturer online, and you can download it. You will notice that development times are given for temperatures other than 68°F as well, with the higher temperatures requiring less time than the lower temperatures. Although 68°F is considered optimal, two degrees one way or the other is okay to use.

I discourage beginning photographers from using higher or lower temperatures until they get used to the process. The times the manufacturers give are starting points and not necessarily the perfect time for your unique combination of circumstances. You may need to increase or decrease your development times as you gain experience. A major exception to the 68°F rule is Kodak TMAX 3200 film, which is designed for higher temperatures.

GO TO ▶
For information on using temperatures other than 68°F, see Hour 20.

## HOW TO GET THE TEMPERATURE RIGHT

Because most developers need to be mixed with water to get a working solution, bring the water temperature to 68°F first. Then when you add the right amount of developer and water, the temperature of the working solution will be very near 68°F. If you are using a developer that is used undiluted, try using a plastic sandwich bag with ice cubes or hot water to lower or raise the temperature.

If you are having trouble getting your developer temperature right, try using a plastic sandwich bag with ice to cool it down, or with hot water to warm it up.

## Developing Procedure

Now that you have loaded your film into the tank, mixed your developer and have it at 68°F, and determined the developing time, prepare the fixer and fixer remover, which should also be at or near 68°F. Then take the following steps:

1. Pre-soak. Begin by pre-soaking the film. Do this by pouring plain tap water at 68°F into the developing tank. (The top is securely attached to the tank but the lid pops off to add and dump liquid.) This is an optional step but helps the film develop evenly. This step lets the film emulsion absorb water so that when the developer is added, the process begins smoothly. Pre-soak the film for 1 minute. This time is not crucial, it could be 30 seconds or 2 minutes. Remove the lid and dump the water down the sink. Don't worry if it has a color cast, this is normal.

2. Developer. Pour the developer into the tank, replace the lid, and set the timer for the development time. *Agitate* the film by inverting the tank once a second for the entire first minute, then for the final 15 seconds of each consecutive minute until the developing time is reached (see the following figure). Do this gently, as you are only trying to keep fresh chemicals flowing over the film for even development. Agitation creates tiny air bubbles that will adhere to the film and must be dislodged or they will leave marks on your film. To prevent this, be sure to tap the tank after each agitation cycle. Once you have completed the developing time, remove the lid and discard the used developer.

**STRICTLY DEFINED**

**Agitation** means inverting the developing tank to keep fresh chemicals flowing over the film.

3. Stop bath. After the development cycle, add fresh 68°F water to the tank. Fill the tank and dump it three times, or let water run into the tank for one minute. This removes any residual developer and halts the developing process. There is a chemical you can use for this called stop bath, but I do not recommend you use it. Chemical stop bath is acetic acid, and if it is too strong it can burn tiny holes in your film emulsion, causing tiny black specks on your print. Plain water works fine.

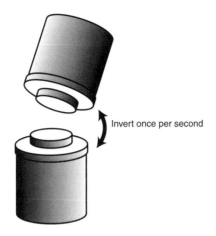

Invert once per second

*Proper agitation is done by inverting the tank once a second. Remember to tap the tank after each agitation cycle to dislodge air bubbles.*

*(Mike Hollenbeck)*

4. Fixer. Pour the 68°F fixer into the tank and agitate every 30 seconds for the duration of the fixing time. Five minutes is usually sufficient, but check the information with your fixer to find the manufacturer's recommended fixing time. Fixer is a chemical that removes the unused light-sensitive silver halides and makes the film no longer sensitive to light.

**JUST A MINUTE**

Fixer can be reused but will eventually go bad. You can use a chemical called Hypo Check or Fixer Check to know when to mix fresh fixer. Just add a drop or two to the fixer and if it turns white, discard and mix fresh.

5. Rinse. Rinse the film in 68°F, fresh running water for one minute, or add fresh water and dump three times. This helps rinse the fixer off the film. At this point your film is no longer light sensitive, and you can remove the developing tank top and look at your freshly developed negatives! Be careful, though: They are wet and easily scratched, and you still need to wash them. I recommend just taking a little peek to see if the film came out okay. Don't remove the film from the reel until you are ready to dry the film.

6. Fixer Remover. Pour fixer remover into the tank and agitate continuously for one minute. Read the manufacturer's recommendation for this, as each one may be a bit different. Fixer remover helps remove the residual fixer that, if left on the film, can cause the film to stain and fade over time.

Fixer remover can be reused but will eventually go bad. Check the manufacturer's recommendation for when to discard.

7. Final Wash. Wash the film in running water at 68°F for five minutes. You can get specially designed film washers for this. They attach to the sink and wash the film efficiently. If you just let the tap water run into the tank, it is a good idea to manually dump the tank every few minutes to ensure a good wash.

8. Photo Flo. Mix the Photo Flo while you are doing the final wash, if you haven't already. Photo Flo is a wetting agent that helps prevent water spots as the film dries. This is an important step, especially if you have hard water. (I mix a quart at a time.) Gently pour it into the developing tank and let the film soak for 30 seconds. Photo Flo can be used many times, so keep it in a reusable container.

9. Dry the film by removing it from the Photo Flo solution and hang it to dry in a clean location with no wind. Any dust that is blowing around the room can stick to your film and dry on it. Dust that dries on your film will become white spots on your final photographs.

The developer step is the most crucial with regard to time and temperature, and should be carefully followed. The subsequent steps should also be carefully followed, but the times and temperatures are not as important. If you gave the film a longer stop bath, rinse, or final wash, it really wouldn't matter. If the temperatures of the water or fixer were a little higher, that, too, would not drastically affect your results.

## Cutting and Storing Your Negatives

Once your film has dried, you can cut the roll into strips and store them in clear plastic negative sleeves or negative preservers. These are plastic sheets with sleeves that hold from five to seven frames of pictures. These sleeves are designed for you to see your negatives and to protect them from fingerprints, dust, and dirt. Always keep your negatives in negative sleeves when not in use. (See the following figure.)

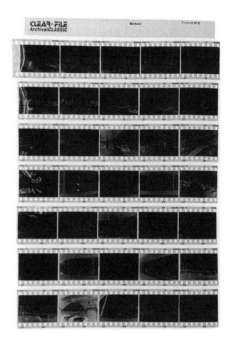

So how did your film come out? Hopefully you have a full range of density on your negatives from a dark gray to almost clear. Don't worry if your film didn't come out perfect. Film developing takes a bit of practice, but after a few tries you'll be doing it like a pro. You are now ready to print and see what your pictures look like.

# Hour 16

## Setting Up a Home Darkroom

### Chapter Summary

**LESSON PLAN:**

Now that you have developed your first roll of film, you will want to set up your darkroom so you can begin making prints. A home darkroom can be anything from a closet with minimal equipment to an entire room with running water—I have had both that worked just fine.

- Space and equipment needs to set up your darkroom
- Necessary chemicals to print black and white pictures
- Hints on organizing an in-home darkroom
- Suggestions on how to ventilate your darkroom

Just as with the purchase of camera equipment, don't get caught up with the fanciest models or the latest gadgets when buying darkroom equipment, either. They will run you a lot more money, and you will soon realize that printing photographs is a lot like shooting pictures: The quality and intensity of your vision is what makes photography interesting, not fancy equipment. And just as with buying new camera equipment, once you have made a purchase, the resale value drops substantially. Therefore, I continue to recommend looking at used darkroom equipment and accessories and considering a modest purchase before making a major investment.

## Space Requirements

Because you are just starting out, begin small and work your way up. An extra bathroom, closet, part of the garage, or even bedroom can be turned into a successful black and white darkroom. Your space requirement will be based on how large you want to make your prints, so let's assume you want to make 8 × 10–inch enlargements.

A closet that is 31 inches deep × 60 inches wide is very small, but workable. If you are going to use such a small area, organize it well. I suggest installing one sturdy work surface for the enlarger, and a shelf or two for the developing trays. The following figure shows how to organize such a small space.

Does the closet or area you want to use have a window? Although you will need to cover the window, it is a great advantage when you install your ventilation, which we will discuss shortly. (See the following figure.) To cover the window, simply use any totally opaque material. Corrugated cardboard works well as does ¼-inch plywood. There is specially made cloth for this purpose too, but it costs considerably more than the wood or cardboard, which can be scavenged. To seal the edges, use strips of cardboard and *gaffers tape*. If you use duct tape, be aware that it lets light through.

**STRICTLY DEFINED**

**Gaffers tape** is an opaque black tape used by photographers and filmmakers.

*This illustration shows a workable darkroom set up in a tiny closet. The window will be covered but is convenient for inserting an exhaust fan.*

*(Mike Hollenbeck)*

I would remove any carpeting, too. You are sure to spill chemicals, and wood, concrete, or tile floors are easy to clean. I have used a room with carpeting but covered it well to prevent soiling.

Once you have decided where the darkroom will be located, you can shop for equipment, because the size of your space will determine how much to get and how large your equipment can be.

**FYI**  Get your equipment list together and go to yard sales and junk stores. Many people have darkroom equipment they no longer use that can be had for a very small investment. But don't buy broken equipment unless it is a major brand for which you can buy replacement parts.

## NEEDED EQUIPMENT

Here is a list of basic equipment needed to make 8 × 10–inch prints, with details on each:

- Enlarger with 50mm lens and negative carrier
- Enlarging easel
- Grain focuser
- Timer
- Four 8 × 10–inch processing trays
- Graduated beaker(s). One is okay, but it is best to have separate and labeled beakers for each chemical.
- Safelight
- Tongs
- Contact printer or piece of heavy glass
- Multigrade filters
- Can of compressed air
- Anti-static cloth

### ENLARGER WITH 50MM LENS AND NEGATIVE CARRIER

The enlarger is basically a camera with its own light source and works a lot like a slide projector. (See the following figure.) The light inside the enlarger passes through your negative and is enlarged and focused by the lens onto the baseboard.

Enlargers come in every conceivable size and price range and will be a major part of your darkroom investment, but don't feel that you need a fancy model to get the job done. I have never bought a new enlarger; I've acquired them through yard sales, want ads, and used equipment photo stores.

**FYI** Your enlarger lens is what determines the optical quality of your print. If your enlarger comes with a poor quality lens or none at all, don't worry. You can buy an excellent quality lens at good camera stores. Money in a good lens is well spent.

The great thing about buying a used enlarger is that you can put your money into a new lens, which is the most important part of your enlarger. Super-sharp new lenses can be fitted to any old enlarger.

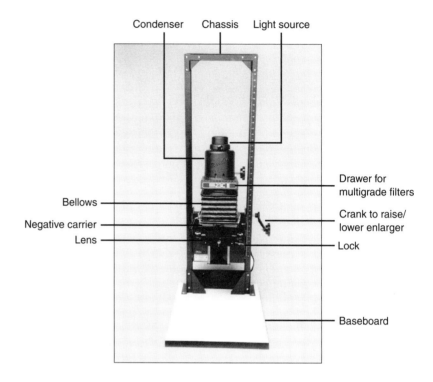

When shopping for a used enlarger, look carefully at the *bellows*. The bellows is the flexible accordion between the lens board and negative carrier. It needs to be capable of expanding and contracting for you to focus. The bellows must be light tight, so look for cracks or holes. A replacement bellows can be bought if necessary.

Also check the electrical components of the enlarger's lamp housing. Does the cord and socket seem to be in good shape? Of course, these can be replaced as well. Was the enlarger well cared for? Is it clean or can it be cleaned up? A nice feature on better models is an adjustable lens board. The lens rests on the lens board and must be parallel to the negative and paper planes. If the lens board has moved out of alignment, you can adjust it. If it is not adjustable, you can hope that it has remained aligned. The enlarger will be attached to a baseboard and should be securely mounted without wiggling. Measure the baseboard to be sure it will fit into your darkroom space.

Before buying an enlarger, make sure it has a negative carrier. If it is an off brand, you may not be able to find the correct one, and that will cause a lot of problems. If it is one of the major brands such as Beseler, Omega, Saunders,

Zone IV, or Leitz, you will be able to get replacement negative carriers and other parts.

The preceding recommendations may not be deal breakers but may be good points for negotiating a better price with the seller. As I said earlier, I have never bought a new enlarger and have found amazing deals on professional equipment in yard sales and junk stores. Also, some photo stores sell beginning enlargement kits that come with practically everything you need. The quality won't be the greatest, but it will certainly get you started.

## 50MM ENLARGING LENS

If your enlarger comes with a lens, that is great, but don't pass up a great deal just because it doesn't. All good camera stores sell enlarging lenses. Bring the lens board (into which the lens fits) to the store, and they will help you find one that fits. Remember that the 50mm lens is the normal lens for 35mm photography. It is also the same focal length for the enlarging lens, and larger negatives will require the normal lens for their format as well. But the camera lens and enlarging lens are not the same. While they both have an adjustable aperture with *f*-stops, they are fundamentally different, and the camera lens cannot be used on the enlarger (unless you have a special lens that can do both—Leitz makes just such a lens).

If you need to buy an enlarging lens, the major brands that make superior lenses are Schneider, Nikon, and Rodenstock. Because the lens is what determines the optical quality of your print, it is a good idea to invest in a quality lens.

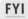 **FYI**  When buying a used enlarger lens, test it just as you would when buying a used camera lens. Open the aperture and look for bubbles, interior dirt, and scratches, and open and close the lens, watching for a sticky diaphragm. I do not recommend buying a broken lens.

## ENLARGING EASEL

An enlarging easel holds your photo paper flat during the printmaking exposure and probably has blades that will act as a mask for determining your picture's edges. Easels come in many models from very big ones for large prints to small ones with no moving parts. See the following figure.

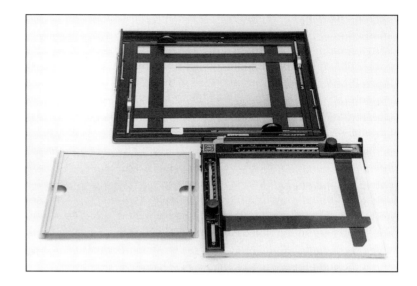

There are basically three types of easels: speed easels, two-blade easels, and four-blade easels.

Speed easels have a pre-cut mask under which you place your photo paper, often just a slit that you slide the paper into. They are very inexpensive, and you can find them at yard sales. Even new they only cost around $30. Speed easels work okay, but they are lightweight and sometimes slide on the enlarging base, blurring your print. A borderless easel is a type of speed easel that has no mask. Just lay the paper on it and expose.

Two-blade easels offer you more flexibility. They have two blades that are adjustable and two blades that are stationary. The two movable blades adjust to give you prints from 2 × 5 inches on up to a full 8 × 10–inch print. The problem with these easels is that because only two blades move, the image is not centered on your paper. You can cut your paper to create even borders, which look better. Until I could afford a four-blade easel, I used one of these. A basic two-blade easel sells for around $45.

Four-blade easels are the best and most versatile, and consequently cost more. The smallest model I could find takes up to 11 × 14–inch paper and sells for around $160. Four-blade easels enable you to make prints from 2 × 5 inches on up to 11 × 14 inches and to place the image in the center of the photo paper. This is a great feature because the centered image looks very professional and can be presented as is, without mounting or trimming. If you find a used four-blade easel, look carefully at the blades. They can be knocked out of alignment and parts could be missing which are not so easy to fix or replace.

## GRAIN FOCUSERS

Grain focusers help you get exact focus when making a print. You may get acceptable results just by focusing by eye, but the grain focuser makes this job exact and easy. A used grain focuser is great but harder to find, and new ones range from $22 to about $75.

## ENLARGING TIMER

You will need to use a timer when making photographic prints. The amount of time you expose the paper for will determine how dark or light your print is, so an accurate timer is important. You could do this task with a stopwatch, but your results may be inconsistent, which can cause a lot of frustration. An enlarger timer has outlets in which to plug the enlarger and safelight (discussed in a moment), and many have a repeatable function so each exposure time is exactly the same. See the following figure.

*Here are three widely available enlarging timers. The Time-O-Lite on the left, the GraLab in the center, and the electronic Beseler on the right.*

*(Matthew Richardson)*

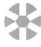

**PROCEED WITH CAUTION**

You can make do with a lot of household things instead of buying photographic supplies, but if you do, be sure to use them only for photography. A measuring cup or baking pan should never be used for food once it has had chemicals in it. Photo trays can be had very inexpensively at better photo stores.

## PROCESSING TRAYS

You will need four trays, three for your chemicals and one for your wash. Trays are very inexpensive and some stores sell them as a kit of four 8 × 10–inch trays for as little as $12. You can use metal or plastic, but if you use metal, they should be stainless steel or the chemicals will corrode them.

## GRADUATED BEAKERS

You can use the same beakers that you use for film developing. You will be mixing your paper developer with water and have to measure the chemicals.

## SAFELIGHT

Unlike film, which is sensitive to all light, photo paper can be handled under a reddish/brown safelight without affecting the paper. This lets you work in the darkroom with a dim light on so that you can see what you're doing. You need to get the correct safelight, which is available at any good photo store. It is called an OC and has an amber color. Yard sales are also good for finding used safelights, so check around before spending too much money.

## TONGS

Tongs are made from bamboo or metal and let you remove and add prints to chemicals without getting your hands contaminated. Do not put your hands into photographic chemicals unless necessary. Always avoid unnecessary contact between your skin and chemicals.

## CONTACT PRINTER OR PIECE OF HEAVY GLASS

A contact printer is a piece of heavy glass hinged to a foam-covered board. This is used to make a contact sheet. You can buy a contact printer, also called a proofer, at any good photo store. You can also use a piece of heavy glass. The contact printer or heavy glass is used to hold your developed negatives flat against a piece of photo paper. If you choose to get a piece of glass, get one that is rather heavy, at least ¼ inch, and have the glazier grind the edges smooth or tape them to prevent injury.

## MULTIGRADE FILTERS

Multigrade filters allow you to control contrast in your photograph. Contrast is the density of dark tones in your print and is a very important component to making a good photograph. Ilford makes multigrade filters that work very well with all brands of photo paper. Kodak makes them as well, and calls them polycontrast filters. You can get them to slide into a drawer that is available on many brands of enlargers, or you can get them to fit into a holder that is attached to the enlarger lens. If your enlarger has the drawer, I recommend the ones that go there, but the ones that attach to the lens work fine, too. See the following figure.

*Here are two kinds of Ilford multigrade filters. One set is inserted into a drawer between the light and negative, and the others are placed in front of the lens. A bracket is provided that is attached to the lens for this purpose.*

*(Matthew Richardson)*

## COMPRESSED AIR

A can of compressed air is used to blow dust off of your negatives. You will use this many times for each negative, so get a large can. This can be purchased at office supply and home improvement centers for a lower price than in photo stores.

**PROCEED WITH CAUTION**

Never shake or spray with the can inverted because the propellant can escape and burn your skin or ruin your negatives.

### ANTI-STATIC CLOTH

Ilford makes an anti-static cloth that is used to gently wipe negatives to remove dust and static electricity.

**PROCEED WITH CAUTION**

Be sure to clearly mark your photochemical containers—not only for safety reasons, but if you use the wrong developer or chemical your film or prints may be ruined.

## CHEMICALS FOR PRINTING BLACK AND WHITE PHOTOGRAPHS

You will need to get a few jugs or bottles for storing your printing chemicals, too. Of course, be sure to mark them so you don't get them confused with your film-developing chemicals. Here is a list of printing chemicals to buy:

- Paper developer. You can get powdered or liquid developer, and the same rules apply when mixing powders. Mix thoroughly until all of the powder is dissolved and let the mixture sit for 15 minutes before use. Kodak Dektol is a great developer and comes in powder form. It comes in packs to make a half or full gallon. Ilford's Universal paper developer is also very good and comes in a liquid that can be mixed directly into your tray. For convenience, I recommend the liquid developer.

- Stop bath. Stop bath is acetic acid that halts the development process on papers and films. It comes as a liquid, regardless of the brand, and must be handled with care. It is highly concentrated, so the acid can do real harm and the fumes are quite strong. Most stop baths have an orange color that turns purple when the chemical is exhausted. I recommend you get a jug and mix up a gallon at a time, which is reusable until it turns purple.

- Fixer. This is the exact same fixer used for film, but half the strength, so you will need a separate jug for film and paper fixers. Also, if you have a choice, don't use a hardener with your paper fixer. Hardener makes it more difficult to remove the residual fixer during the final wash.

- Fixer remover. This is the same chemical used in film developing and is used at the same dilution, so it is used for both film and paper.

Here are a few more little things that will make your life easier in the darkroom:

- Funnel for pouring leftover chemicals back into their jugs.

- Stirring paddle for mixing powdered chemicals.

- Large graduated beaker for mixing one-gallon portions of chemicals.
- Bamboo tongs for removing prints from the chemicals. These tongs are very cheap and available at any photo store. Get into the habit of keeping your hands out of the chemicals.
- Squeegee to remove excess water from your prints. This helps prevent water spots and reduces drying time.
- Drying screen or small line to hang your prints while they dry. Nylon window screen material is great to stretch over a frame and lay your prints on to dry. Or hang a little line where the prints can drip dry.

## How to Organize Your Darkroom

A darkroom has a wet side and a dry side. Obviously, the chemicals and trays are on the wet side, and the enlarger is on the dry side. Keep this in mind when organizing even the tiniest space. Because you are printing under a dim safelight, you will not be able to see splashes and damp surfaces that will ruin prints. Wherever the enlarger is should be the dry area.

In a tiny closet, I recommend setting up a sturdy shelf for the enlarger. See how much room you need for your enlarger and bring a tape measure with you when you are shopping for equipment. Mount things on the wall, too. Your timer could easily be wall-mounted as well as the safelight and other printing accessories. A set of shelves or a drawer under the enlarging table is great for storing your photo paper, negatives, and other accessories as well.

Also consider mounting the enlarger to the wall. This can be a good space-saving solution, too. Add an adjustable tabletop that can be moved up or down, and your tiny darkroom will be very versatile.

A separate set of shelves will do fine for the wet side. They can be one on top of the other if you don't have enough room for a long continuous shelf. You don't need much space to move around, just enough to turn around in.

## How to Block Out the Light

Depending on your specific needs, you may want to block out light so that you can work during the day or else just use your darkroom at night. As mentioned earlier, corrugated cardboard is a great material, cheap, and easy to find, cut, and throw away or replace. I have also used thick felt, found at most good fabric stores, to create light-blocking drapes for open doorways. Use two or three layers and hang them from the ceiling or doorway so they

overlap. You just part them to enter and exit. Try adding a section of metal chain in a sleeve along the bottom to keep the curtain from blowing open.

Many photographers have a nighttime-only darkroom that is not light tight during the day. I have had friends who used their kitchens and bathrooms that way with minimal protection over the windows and doors. Whatever works for you is great, and as I suggested earlier, start off modestly.

## SINKS AND MANAGING YOUR WATER NEEDS

I have had darkrooms with and without tap water. I suggest a five-gallon plastic bucket for bringing water back and forth and for dumping used chemicals. It is less convenient than a sink, but it works just fine. If you have running water, a great washing method is to use a clean processing tray with a siphon pump, as seen in the following figure. The siphon pump recycles the tray water and ensures an effective wash.

*This Kodak Siphon Pump is a great and inexpensive way to effectively wash your prints. The tray on the right has a siphon pump.*

*(Matthew Richardson)*

If you are lucky enough to have some space, you can really do it up. I have had entire rooms to use and turned them into extremely well-functioning darkrooms. If possible, consider installing or building a sink. A sink is a true luxury in the home darkroom. You can get inexpensive plastic custodial sinks at many hardware stores, but if you are going to have running water, go the extra step and get a sink that you can keep your trays of chemicals in. This makes the darkroom so much more efficient and clean.

Long sinks made of plastic are available from better photo supply stores. Freestyle Camera in Los Angeles sells a 48 × 24 × 5–inch sink for around $150. Try shopping in restaurant supply houses and salvage yards, too, but it will be hard to find a sink any cheaper than the plastic one. You can make a sink of wood and paint it with marine epoxy paint. This is an excellent solution for a custom-made sink. I had one custom made for a small 8 × 10–foot darkroom that had storage underneath and an extra shelf for an oversized wash tray. The marine paint is available from good paint stores and after drying for a few days becomes a hard, waterproof plastic. That was the best sink I ever used, and I miss it to this day!

**FYI**  You can buy very inexpensive plastic sinks made for a darkroom or you can make your own out of plywood and then coat it with marine epoxy paint. The wooden sink is great because you can customize it to your exact space requirement and darkroom needs.

Having a plumber run the water and waste lines was not very expensive and using such an efficient darkroom with a sink was a joy.

## VENTILATION

Ventilation can be a problem in home darkrooms. If your closet or space has a window, you can make something work. If it does not, you need to ask yourself whether you should proceed. I have used home darkrooms that did not have ventilation, and although I am not dead yet, there is no doubt that breathing chemicals is harmful to your health.

Assuming you have a window or can cut through a wall, you can use a bathroom vent for darkrooms. Go to your local hardware or home improvement store and check out the bathroom and kitchen vents. You want to get one that will exchange the air in the room in a few minutes. Each fan has a rating as to how much air it moves per minute. Measure your space for length, width, and height and ask for help to determine which fan can effectively ventilate your space.

Now that you have your home darkroom set up, you're ready to print. I love printing black and white photographs and find the time flies by when working in the darkroom. One of the great pleasures in photography is crafting a fine print of your favorite image in your own darkroom.

# Hour 17

# Black and White Photographic Paper

hotographic paper is essentially very similar to film, so a lot of our discussion will be familiar to you. Paper comes in a wide variety, and understanding how it works, its unique properties, and what's available will help you choose the paper to create the kind of pictures you want.

## Chapter Summary

**LESSON PLAN:**

Before you begin actually printing photographs from your negatives, let's discuss photographic papers.

- How photographic papers work
- The different types of photo paper
- The various surface types available
- How to test out-of-date or fogged paper to see if it's salvageable

## How Photographic Paper Works

Photographic paper consists of paper stock that is coated with a light-sensitive emulsion similar to that of film. The light-sensitive emulsion contains silver halides that convert to metallic silver when exposed to light. As with film, these tiny bits of silver appear black and accumulate to create the tones of your image.

The following figure gives you a good idea of a cross section of basic photographic paper with the emulsion, paper stock, and a thin resin coating that is used on many photo papers.

Because photo paper has an emulsion, you must expose the emulsion side when making prints. You can expose the backside, but because the light must travel through the paper, it would require a lot more light to make a print. Also, the image would be reversed, so words would appear backward.

The photographic emulsion (coated on the paper stock) is where the image resides. Although this is a very thin coating, well-printed images on fine papers appear to

have a bit of depth to them. I am not talking about the depth in the picture (the foreground, middle ground, or background), but an actual appearance of depth in the print itself. This is one of those qualities found in the finest photographic papers that make the best prints look so rich and deep.

Because there are tiny bits of silver in prints, there is also grain. However, the grain from paper is not noticeable because the paper is not enlarged, unlike film. When you see grain in a print, it is the grain of the film. Actually, it is not really the grain you are seeing, because the silver blocks light and remains white, so what you really see are the spaces between the film grain.

*This cross section shows the basic make up of RC photo paper.*

*(Mike Hollenbeck)*

RC photo paper

Emulsion with light-sensitive silver halides

Paper base

Resin coating

## Categories of Photographic Paper

Almost all the photographic paper on the market today is a type of *bromide paper*, a high-speed photographic paper used for making enlargements. High speed is just like film speed or ISO; it's how sensitive the paper is to light. Because enlargements are made with an artificial light source, and by definition the source is far from the paper, a fast-acting paper is required.

### STRICTLY DEFINED

**Bromide paper** is high-speed photographic enlarging paper, and most of the papers on the market today are a type of bromide paper. Bromide paper is commonly referred to as enlarging paper and uses silver bromide, a type of silver halide, to form the image.

There is only one of the old-fashioned *chloride papers* on the market today that I am aware of, Kodak's Azo paper. Chloride papers are slow speed, meaning they react slowly to light and were made for contact printing and not for enlarging. Chloride paper uses silver chloride, a type of silver halide, to form the image.

**STRICTLY DEFINED**

**Chloride papers** are a type of very slow-speed photographic paper used for making contact prints by placing the negative directly against the paper, rather than enlarging the negative. The only chloride paper I am aware of is Kodak's Azo.

Chloride papers are seldom used because faster-acting bromide paper can be used for both purposes. Chloride paper is one of the early types of photographic papers and was used when a photographer had a large negative that did not require enlarging, such as an 8 × 10–inch negative. Most photographic papers now are combinations of various types of silver halides and additives, but in general, they can be classified as bromide papers.

Although you will seldom encounter a choice between bromide and chloride papers, you will often have to choose between *resin coated* or *RC* paper and *fiber paper*.

**STRICTLY DEFINED**

**Resin coated** or **RC photo paper** has a thin plastic coating that prevents chemicals from being absorbed, which greatly reduces the required washing time, and it also has a chemical developer incorporated to speed up the development process.

**Fiber paper** has neither a resin coating nor a developer incorporated, so the development time is longer. It is a piece of smooth paper coated with an emulsion. The paper absorbs chemicals and water, so fiber prints must be washed thoroughly to remove residual chemicals.

## Resin Coated (RC) Paper

Resin coated paper, commonly referred to as RC paper, has a thin resin or plastic coating. This coating means that the paper base does not absorb water or chemicals. This lack of absorption is one of RC paper's strengths because it reduces the wash time.

RC papers are very common and widely available; I recommend you begin by using them. Besides a reduction in washing time, many or most RC papers have some chemicals incorporated into them. These incorporated chemicals make RC paper react much faster to developing than other papers.

Photography labs and commercial printers do not print black and white pictures using open trays of chemicals as you will be doing. They use processing machines that run the photo paper through series of baths that develop the

print. These machines typically develop, fix, and wash the print in about one minute. RC papers are especially designed for these short processing times, and the incorporated developers make this process possible.

Also, RC prints are very tough. Their plastic coating makes them very resistant to scratching and dimples. For publications, a big advantage is that you can write on the picture with a grease pencil, indicating where to crop a picture or the scale the image should be printed at. The grease pencil is then easily removed with acetone or film cleaner. RC prints are very good for many commercial applications (see the following figure) where the actual print is not going to be seen but only reproduced from.

*For a photograph such as this head-shot of actor Ian MacLeod, RC paper is a great choice. It processes and dries quickly, so it is well suited for commercial photography.*

*(Tony Maher)*

There are, however, some disadvantages to RC paper, too. The paper has limited capability to convey depth in the photographic print. Many photographers find that the RC coating inhibits their ability to see deeply into the print, and the coating can appear as a slight fog over the picture, especially in the deep black areas. This is a dulling of the shadow areas; it also reduces the overall contrast of the print, which is dissatisfying to many photographers.

But this is not universally so with all brands and surfaces of RC paper, and may be a result of water deposits from air-drying or the use of depleted chemicals. Ilford's Multigrade RC paper, especially the glossy surface, looks very good when run through a print dryer, but some other brands are not as satisfying.

My recommendation is for you to use RC paper until you are comfortable and familiar with the printing procedure. Then you can try other types of papers and you will have some experience to guide your judgments.

## FIBER PAPER

Unlike RC paper, fiber paper does not have a plastic coating. When you touch it, you will feel that the base is an actual piece of fiber paper coated with an emulsion. The emulsion in fiber paper does not have an incorporated developer. These two factors, a fiber-paper base and the absence of an incorporated developer, are the two major differences between fiber and RC papers. As stated before, the quality of the print on fiber paper is superior, and the image by artist Sant Khalsa in the following figure was done on fiber paper.

The fiber base naturally absorbs a lot of water and chemicals that must be thoroughly washed from the paper. Fiber paper typically requires an initial wash, followed by a fixer remover, and then a longer final wash. The initial wash can be around 5 minutes, followed by 5 minutes in fixer remover, and then at least 20 minutes of washing in fresh running water.

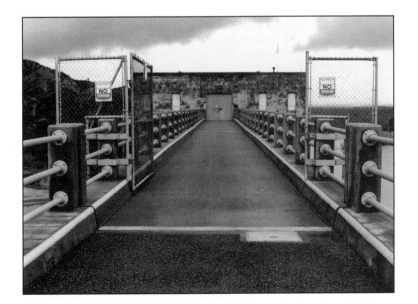

For fine art photography such as this landscape by Sant Khalsa, the richer tonality of fiber paper is a better choice than RC paper.

(Sant Khalsa)

The development time for fiber paper is longer, too. RC papers can be developed very quickly (even those that do not have an incorporated developer), but fiber papers should be in the developer for a minimum of 1½ minutes and up to 3 minutes. Most people develop their fiber prints for 2 minutes, as opposed to 45 seconds to 1 minute for RC papers.

Fiber paper is also much more delicate than RC paper. Once it has fully absorbed liquid, fiber paper is very soft and can be easily creased or bent. Depending on the brand and method of processing, the emulsion can become very soft, too. Some photographers have complained about fingerprints being impressed into the surface of wet fiber paper, so caution is needed.

The advantages of fiber paper outweigh the disadvantages, though. It is mostly the print quality that photographers like about fiber paper. Because it doesn't have the plastic coating, you can see the emulsion and image very clearly. There is nothing between you and the print, and when made well, fine fiber prints have a depth and richness that you won't find in RC prints.

For exhibitions, fiber prints are the best to use. They come in a wider variety of surfaces, types, and tones, and are able to accept toning and retouching better than RC prints. For artists, the photographic print is much more than just an image on a piece of paper. If it weren't, a good reproduction in a book would be fine art, which it is not. Charles Desmarais quotes the great photographic artist Robert Heinecken in *Proof: Los Angeles Art and the Photograph 1960–1980,* "The photograph is not just an image of something, it is an object about something." What Heinecken is telling us is that the fine art photograph does not just represent something in the world but is an art object in and of itself. Therefore the object, the piece of paper, the image, and the presentation are all-important aspects of the final artwork.

The emulsion on both RC and fiber paper contain light-sensitive silver halides, just like film. But fiber paper has more of this silver, which is primarily why the image quality appears richer, with more tonal variations and depth. Manufacturers have been fiddling with the amount of silver in paper for a long time, especially when the price of silver goes up. When I was a young photographer in the 1970s, some companies threatened to stop making fiber paper, thinking that RC was more economical and good enough. This was partially because fewer commercial photographers were making black and white pictures at the time. Fortunately, photographers complained, and since then there has been a resurgence of black and white photography in magazines and advertising.

 **FYI** Because fiber paper has no resin coating, there is nothing between the viewer and the image. This gives fiber prints a decisive edge in terms of clarity and depth of the image and is why fine art photographers use fiber for their exhibition prints.

## GRADED AND MULTIGRADE PAPERS

Another major category of photographic papers is how their contrast is controlled. When making prints, you control the lightness or darkness of the image by increasing or decreasing the intensity of the light falling on it. But you can also control the amount of contrast in the print. This is done in one of two ways depending on which category of paper you buy. The two types of paper are *multigrade paper* (also called variable contrast or polycontrast) and *graded paper*.

**STRICTLY DEFINED**

**Multigrade paper** uses colored filters to control the amount of contrast from print to print. **Graded paper** comes in specific grades, and you increase or decrease contrast by using a different grade of paper.

With multigrade, you control the amount of contrast—that is, the depth of the dark tones—by changing filters in the enlarger. With graded paper, you change contrast by using a different grade of paper.

Graded paper comes in various contrast grades from one for low contrast to five for high contrast, and was the standard photographic paper for fine art fiber-based photographs until the late 1970s. The problem was that you needed to have boxes of paper in each grade to print your photographs, increasing your expense and adding to the difficulty of making photographs.

Why do we need to adjust contrast in our pictures anyway? You will recall that different lighting conditions produce a different amount of contrast. The light on an overcast day has considerably less contrast than the light on a bright sunny day. Also, the way your film is developed helps determine how much contrast is in an individual negative. All of these factors create negatives of varying contrast ranges from shot to shot and from roll to roll of film. When you print, you need to determine the contrast level required for each image individually. So when using graded paper, you need a box of each grade to print the variety of negatives that you will have.

Multigrade paper has helped solve this problem by creating one product that can produce a wide range of contrast on a single type of paper. Multigrade

paper has emulsion layers that react to different colors of light, and by using colored filters, one piece of photo paper can be made to create images from high to medium to low contrast. This is obviously a tremendous advantage to darkroom technicians and photographers, saving a lot of money on paper and the inconvenience of having many grades of paper on hand.

Some photographers still feel that they get better results from graded rather than multigraded paper, but scientific tests seem to indicate that the maximum density, called D-Max, is just as great with multigrade papers as it is with traditional graded papers. But manufacturers still make graded papers, so you have the choice.

Because multigrade offers so much more convenience, you will find a greater variety of papers in this category. Almost all RC papers are multigrade, because ease and speed are their main attributes. Fiber papers are available in both multigrade and graded varieties. Increasingly, though, multigrade papers are taking over the market.

## PAPER SURFACES

Photographic paper is usually available in three different surfaces:

- Glossy (is shiny). Glossy surface is great for showing small details in photographs and is the standard that many photographers prefer. Glossy pictures are often synonymous with commercial photography, press, and publicity photographs. Actors' headshots are often referred to as "glossies." And images of theater or entertainment just seem to go naturally with glossy prints.

- Semi-matte (has a mild gloss). Semi-matte is good for hiding surface defects such as fingerprints and small imperfections.

- Matte (has no gloss at all). Matte has no sheen and therefore is great for viewing dark images because there is no glare. For a portrait of someone who is important, ill, or needs to be taken seriously, matte paper might be a good choice. The surface lets the viewer get close and see into the shadows without having to fight glare. The matte surface seems to suggest a seriousness that is very different from the glitz associated with glossy surfaces.

Semi-matte and matte have a slight surface stipple or texture that can impede your ability to see tiny details, such as fine print, but there are other considerations. For myself, the bigger consideration is the way the surface suggests something about the image being printed.

I recommend that you go to the photo store and look at examples of paper surfaces so that you can see which one you want to try first. When in doubt, get glossy. Because you are only buying 100 sheets or so at a time, don't worry if you don't like it. You will be buying many boxes of photo paper over time and can try them all.

## SIZES, QUANTITY, AND WEIGHT

Photographic paper comes in a variety of sizes. I recommend you buy a box of 100 sheets of 8 × 10–inch paper to start with. Paper can be purchased in 5 × 7–; 8 × 10–; 11 × 14–; 16 × 20–; and 20 × 24–inch cut sheets. There are also larger sizes, usually on rolls, available from large photo supply houses or by special order, such as 40 inches × 30 feet and 40 inches × 100 feet, and even wider rolls. Most of these wide rolls are available only in RC paper, but some manufacturers do make fiber paper in large rolls as well.

Packs and boxes of pre-cut paper come in various quantities, too. 5 × 7 and 8 × 10 paper come in packs of 25, 100, and 250 sheets. 11 × 14 and larger are available in 10-sheet packs and boxes of 50.

Photo paper also comes in different weights, that is, paper thicknesses. (See the following figure.) Most RC papers are a medium weight. Fiber paper is usually made in medium weight, but there are some papers available as very thin single weight as well as very thick double weight. I would avoid the single-weight paper, even though it costs less and you may be tempted to save a few dollars. It is very thin, and when it becomes wet in the developer, the paper tears easily. It can be quite difficult to handle, so I suggest you stick with medium-weight paper. Single weight is good when you need to adhere it to an irregular surface or paste it in a book. Double weight is good for exhibition prints. The added thickness makes the prints more durable, and the weight seems to suggest that the print is precious and valuable.

**FYI** Choosing the paper brand and surface that suits your needs is often a matter of experience and preference. You will use a lot of photo paper as you print, so don't be afraid to try something new. Most paper can be bought in small packs, too, so you can try different papers and find the ones you like best.

*Here are some different brands of the fine photo paper available today.*

*(Matthew Richardson)*

## TYPES AND BRANDS OF PAPERS

Here is a list of popular paper types and brands for you to consider:

- Ilford Multigrade Deluxe RC is a good all-purpose enlarging paper available in glossy, pearl, and satin surfaces.

- Ilford Multigrade Rapid RC has a developer incorporated into it, so it develops very fast and is used in automatic processors. It also works well with the tray development that you will be doing.

- Ilford Multigrade RC Warm Tone and Cold Tone papers produces a warm brownish-black tone or cool bluish-black tone, depending on which you buy.

- Ilford Multigrade FB is a fiber-based multigrade paper. I have used this a lot, and it is very good for your finest exhibition prints.

- Ilford Galerie FB is Ilford's top-of-the-line, heavy-weight, graded fiber-based paper for exhibition prints.

- Kodak Polycontrast RC is a good all-purpose enlarging paper available in glossy, semi-matte, and matte surfaces.

- Kodak Polymax Fine Art is a very good fiber-based multigrade paper for all purposes and exhibition prints.

- Kodak Azo is an old-fashioned silver chloride paper for making contact prints under full-spectrum light. This is not used for making enlargements under artificial light.

- Kodak P-Max RC has a double-matte surface so you hand-color your black and white prints. A matte surface is needed when applying pigment to prints.
- Kodak Panalure is specially made for black and white prints from color negatives. Because color negatives are made from multicolored dyes, this special paper is needed to get accurate tonal rendering from color negatives. This paper must be used in total darkness; no safelight is used.

Other major brands of fine photographic paper are made by Agfa, Forte, Oriental Seagull, and Luminos, among others.

## OUT-OF-DATE AND FOGGED PAPER

I would not recommend that you buy or even use paper that is old, past its sell-by date, or has been opened. You will see boxes of photo paper at yard sales, but because you have no idea how old it is or how it has been stored, I strongly suggest you avoid it. You will encounter many challenges printing on fresh photo paper, and using old or damaged paper only adds to your problems. If you have some old paper already, you can check to see if the paper is useable or should be discarded. If it is slightly damaged, there is a way to make it useable.

### PROCEED WITH CAUTION

I discourage you from using old paper given away or found at a yard sale. Paper has a definite shelf life and can be easily damaged from light, heat, humidity, and radiation. You will find printing enough of a challenge without wasting time having to test out-dated paper.

The sign that paper is old or is going bad is suppressed whites—that is, the whites are not white, but gray. You may not notice this if it is slight, but if you compare the print from older paper to fresh paper, the fresh paper will have a bright white base, whereas the older paper will have a definite beige cast or grayness. Here is how you can check to see if the grayness is from your paper or something else:

1. In a darkroom—set up as described in Hour 16—and in total darkness without your safelight on, take out a piece of paper and tear it in half.
2. On the back mark each piece so that you can tell them apart.

3. Put one directly into the fixer and the other into the developer for the recommended amount of time, then into the stop bath, and finally into the fixer.

4. Turn on the white light and examine the two pieces.

The one that went directly into the fixer should reveal the pure tone and color of the paper base. It has not been developed so no silver halides should have converted to metallic silver. This is your control strip. Compare the other strip that went through the developer to it. If the second strip is not the same tone, that is grayer or beiger, then the paper is damaged.

**TIME SAVER**

If you do have slightly damaged paper, you can still use it by adding a restrainer to the developer. Potassium bromide is a typical restrainer that is mixed into a 10 percent solution and added to the developer in small quantities to reduce slight paper fogging.

The graying of the paper is caused by unexposed silver halides being converted to metallic silver and could be caused by many things, particularly age, heat, humidity, or radiation. The paper can be salvaged—if the effect is not too great—by using a *restrainer*. A restrainer suppresses the conversion of silver halides slightly so the white of the paper should remain white but have no effect on the photographic image.

**STRICTLY DEFINED**

A **restrainer** is a chemical that is added to paper developer that slightly suppresses the conversion of silver halides into metallic silver. The effect is that the white of the paper stays a bright white.

A commonly used restrainer is potassium bromide (KBr), and it is added in small quantities to the developer. To use, mix a 10 percent solution of KBr, and add an ounce or two per quart of stock developer. Test the paper again, and if needed, add more restrainer until you get the desired result.

## Safelight Fog

Your darkroom safelight may be causing a similar problem that can also be tested for. To do this, follow these steps:

1. Do a series of tests to determine how much exposure is required to produce a slight gray tone on your photo paper.

2. Place a fresh sheet of paper under the enlarger, and with the safelight on, expose the paper.

3. Leave it in the easel, place a coin or other object on part of the paper, and leave it for three or four minutes.

4. Develop the paper, and if you can see where the coin was, then the safelight has caused some slight fogging on the paper.

To correct this problem, replace the lens in your safelight, reduce its brightness, and move it farther from the enlarger or replace it.

This has been a pretty detailed discussion of photo paper, so now you have a good idea of which paper to buy for your first prints. I encourage you to experiment with other types of paper and to ask your friends and photo store employees for their suggestions so that you find the perfect paper for your unique photographic needs.

# HOUR 18

# Basic Black and White Printing

## CHAPTER SUMMARY

**LESSON PLAN:**

Now that you have completed some photography assignments and developed your first rolls of film, you are ready to make your first photographic prints.

- How to develop and print a contact sheet
- How to make an enlargement
- How to wash and dry your prints
- Troubleshooting tips

Seeing just what those photographs you have taken look like is an exciting moment. As mentioned earlier, some of the challenges in photography are translating the world into a two-dimensional plane and seeing it in black and white. Your first photographs will show you how much of a challenge this actually is. Don't be discouraged if your first pictures are not as good as you hoped—and don't get too cocky if they are! Photography is an evolving skill that develops with persistence, and most of all, through practice.

## GETTING STARTED

At the end of Hour 15 you dried your freshly developed film and cut the roll into strips that you put into negative sleeves. From these negatives you will complete the following steps to make your first prints and a *contact sheet*. But first we will go over the needed chemicals and equipment, and then the actual printing procedure.

### STRICTLY DEFINED

A **contact sheet** or **proof sheet** is a print made from an entire roll of film that has been cut and put into negative sleeves. The print shows all 36 frames of film and lets you quickly review what you have shot so that you can choose the pictures you want to print.

**GO TO** ▶
To review the supplies needed for printing in your darkroom, see Hour 16.

1. Be sure to organize your four trays so that the first is for the developer, the second is for stop bath, the third is for fixer, and the fourth is for holding or washing your prints.

2. Mix your developer as per the instructions on your bottle or packet. If you are using a powder, mix it thoroughly at the proper temperature to make the stock solution, put it into a dark container, and let it sit for 15 minutes before using. If you are using liquid developer, you can mix it directly into a beaker and pour it into a tray.

3. The second tray is for your stop bath. Remember that stop bath is concentrated acetic acid and should always be handled carefully and with ventilation on. Mix according to instructions and pour into the second tray.

**PROCEED WITH CAUTION**

Always have your ventilation on when mixing chemicals—powdered or liquid. Powdered chemicals can be inhaled, and stop bath and fixer are both noxious-smelling acids. Always use gloves and eye protection when mixing chemicals.

4. Mix your fixer according to directions and pour it into the third tray.

5. Fill the fourth tray with water. Temperature is not crucial, but it should not be cold or hot, preferably room temperature.

6. Put a set of tongs by each tray. I recommend you mark the tongs and dedicate each for a single chemical so that one is used only for the developer, another for the stop, and another for the fixer.

7. Be sure your ventilation is on, and turn on your safelight.

You are now ready to print. We begin by making a contact sheet like that in the following figure.

## Printing a Contact Sheet

I'm sure you are anxious to see what your pictures look like, and I wish I could be there to see them, too! With your photo paper still in the sealed box, we begin the steps to making a contact sheet by testing your enlarger:

1. Turn the timer to the focus position. Focus means that the enlarger light will come on and stay on until you switch the timer from focus to time.

2. Raise or lower the enlarger so the light falling onto the baseboard can cover the contact printer or piece of heavy glass. You will be using this to hold your negative flat against the photo paper. If the negatives are not held flat, the proof sheet will not be in focus.

3. With the enlarger light still on, open the lens to the widest aperture. As you open and close the lens aperture, the light will brighten and dim. Open the lens so that the light is at its brightest level and be sure the light will cover the entire contact printer.

4. Switch the timer to the time position. This turns off the light.

5. Set the timer to five seconds. When you push the print button, the timer will activate the enlarger light for that amount of time.

6. Put a #2 multigrade filter into the enlarger or into a holder that is attached to the lens. If you are using graded paper, start out with grade 2 paper.

*Here is a contact sheet from a portrait shoot of actor Kevin Bacon. The contact sheet shows the 12 exposures from a roll of 120 medium-format film and lets me choose the best one to print.*

*(Thomas McGovern)*

**FYI** Multigrade filters come in a pack and are labeled from double zero to five. Grade double zero will produce the lowest contrast in your print and grade five the highest. Grade two is considered normal and should produce about the same amount of contrast as you would get if you used no filter at all.

7. Be sure that all the lights, except the safelight, are off and that your darkroom is light tight. Open your box of photo paper. The paper is wrapped in a plastic bag or paper. Take out one sheet of paper. Feel the paper carefully and determine which is the emulsion side. If you are unsure, tear off a piece and examine it in the light. Get familiar with feeling for the emulsion side of your paper.

8. Place the paper emulsion-side-up on the base of the contact printer.

9. Place your sheet of negatives on the paper with the emulsion down, against the paper emulsion. Unsure which side is emulsion? The negatives will curl toward the emulsion, and if you hold them up to the light, look for the brand name of the film printed above the film sprocket holes. If you can read the name, you are looking at the base side of the film, so the other side is the emulsion.

10. With the film and paper in contact, close the contact printer so that the glass is holding the film and paper together. They should be lying flat against each other. Push the print button on the timer, and the light will expose the paper for the time indicated, five seconds.

11. Remove the paper and put it into the developer. Watch the time or have a second timer with a sweeping second hand. Gently rock the tray so fresh developer washes over the paper. This is the same idea as agitating your film, but you don't need to tap the tray to remove air bubbles. If you are using RC paper as I have suggested, develop the print for one minute. Do you see the image appear?

12. After one minute, use your developer tongs and remove the print (see the following figure). Let it drain for a few seconds and then place it in the stop bath for 15 to 30 seconds. Developer is an alkali and the stop bath is an acid. Acid counteracts the action of the alkali. If you were to feel the developer, it would be slick, and the stop bath removes the slickness. The stop bath stops the action of the developer and removes it, leaving the residual developer in the stop bath. Gently agitate the print in the stop bath for 15 to 30 seconds.

*Using tongs, remove the print from the tray and let it drain for a moment before putting in the next one.*

*(Matthew Richardson)*

**JUST A MINUTE**

A contact sheet is an essential part of choosing which photographs you want to print. Because negatives are tonally reversed, you need the contact sheet to help you choose what to print. Go to the trouble to make good contact sheets and store them with the negatives for future reference.

13. Use your stop bath tongs to remove the print and let it drain for a few seconds. Then place it in the fixer and gently agitate the tray. The fixer will remove the unused silver halides, making the paper no longer light sensitive. Different fixers have different recommended fix times. Read the instructions with the fixer you have. Two to five minutes is the usual time, but the print can be viewed in white light for a few moments after one minute of agitation. But if you want to keep it, return it to the fixer for the full time recommended.

14. Once the print has been fixed, remove it with the tongs and rinse briefly. You can now view it under white light. If you are going to turn the light on in the darkroom, be sure that you have securely put your photo paper away.

Look at the contact sheet. It will show all of the pictures you took from that roll. Examine the print and determine whether it is too light, too dark, or just right. Look at the highlight tones in the print. If they are too light, increase the exposure time; if they are too dark, decrease the exposure time. Then look at the blacks. If they are too muddy, increase your multigrade filter

to a higher number. If they are too dark and intense, decrease the filter to a lower number. Do this until you have a good contact sheet.

 **FYI** In black and white printing, the exposure time controls the density of the highlights, and the multigrade filter controls the density of the shadows. Every time you examine a test print, look at the bright and dark areas and control them separately.

## MAKING THE ENLARGEMENT

Choose the first picture you want to enlarge. It helps if you have a loupe or magnifying glass so that you can see the images. I use a grease pencil to mark the pictures I want to print.

Once you have made a choice, you are ready to make your first enlargement:

1. Be sure your hands are dry and remove the strip of negatives with the frame you will print.

2. Put the strip in the enlarger's negative carrier. The negative carrier will hold the negative flat and mask it off from the others.

3. Put the negative carrier into the enlarger and be sure that it is lying flat and fully inserted.

4. Turn the enlarging timer to focus. The light comes on and projects your image onto the enlarger baseboard.

5. Get your easel and place it on the baseboard. Set the easel to the size you want your print to be. Because you are printing a 35mm negative on 8 × 10–inch paper, I suggest setting the easel to 6 × 9 inches. That will give you a nice large print that uses up most of the paper and has a good-looking white border. If you are not using a four-blade easel or are using a speed easel, you won't be able to do this, just print your picture in the center of the page.

6. With the lens wide open, focus the image onto the easel.

7. Once focused, raise or lower the enlarger until the image fills the picture area on the easel.

8. Focus again using the grain focuser. To do so, gently twist the focusing knob on your enlarger and look closely for the tiny specks of film grain. When you see them clearly, the negative is in focus.

**PROCEED WITH CAUTION**

Focus your negative carefully. Always use a grain focuser and have the lens wide open when doing so. Otherwise your print may be slightly out of focus.

9. Now you are ready to make a test print. Begin by closing the lens down two *f*-stops. This is important and if you do not, your print will probably not be in focus on the edges. Do not print with the lens wide open. I recommend that you close the lens two stops down from the maximum aperture for overall sharpness.

10. Switch the timer back to the time setting.

11. Put a multigrade filter in the enlarger just as you did when you made the contact print. I suggest you begin with a #2 filter.

12. With only the safelight on, take out a piece of photo paper and cut it into three or four test strips.

13. Put all but one away, and put that strip on the easel. Try to position it over part of the images that has some tonal variation or an important pictorial element. If the picture is a portrait, I would place the strip so it is over an eye.

14. Get yourself a piece of cardboard. Your box of photo paper probably has a piece inside. Cover three quarters of the test strip.

15. Set the timer to five seconds, and activate the timer.

16. When the light goes off, move the cardboard so it covers only ½ of the strip, and do this until you have made three or four exposures on the test strip. For good results, the strip must not move during this process. See the following figure.

**JUST A MINUTE**

Photo paper is just like film. The more exposure it gets, the more silver halides convert to metallic silver and the darker it gets. When making a test strip, if it is too dark, reduce the time, if it is too light, increase the time.

17. Develop the strip for the full minute and then place in the stop bath and then fixer. Once fixed, rinse and examine it in the light.

18. Look at the three for four exposures and choose the one that looks best. Look at the highlights to determine how much time to expose the next strip. Highlights are any light tones in the picture such as Caucasian skin, a white shirt, etc. Choose the time that looks best. If your strip has been exposed four times, ranging from 5 seconds to 20 seconds,

the strip will have four distinct tonal separations. The 5-second section will be lightest, and the 20-second one will be the darkest. If 5 seconds is too light and 10 seconds too dark, guess at how much time might be just right. If all of the sections are too dark, do another test strip but set your timer to a much lower number, maybe two seconds; or you can close your lens down farther, making the light dimmer and the test therefore lighter.

*Here is what a test print looks like. It has four different sections that correspond to the exposure times of 5, 10, 15, and 20 seconds. The more time, the darker the section. I recommend you start out using cut strips of paper, but I am showing a full piece of paper for clarity.*

*(Tony Maher)*

19. Once you have determined the best time on the test strip, go back and make another one for the time that looked best and examine it.

20. Your next test strip should look pretty good. Now look closely at the shadows or dark tones. Are they too dark, too light, or just right? Judging this takes some practice. If the dark tones are too dark, with no detail, remove the multigrade filter and replace it with lower value. If you were using a #2 and the shadows are too dark, replace it with a #1½ filter and do another test. See the following figure.

21. Once your test strip has what you determined to be good highlights and shadows, you are ready to make the print on a full sheet of paper. Take out a full piece of paper and expose for the time and filter that made the best test strip. After developing, stopping, and fixing, rinse and examine.

*This print does not have enough contrast; that is, there is no black tone. To correct this, reprint with a higher multigrade filter.*

*(Tony Maher)*

## WASHING AND DRYING YOUR PRINTS

After you are satisfied with the print and ready to move on to the next negative, do the following:

1. Put your fully fixed print into the wash tray. If you do not have running water, leave it until you are done printing for the day and wash all the prints at once. If you have running water, you can periodically fill the tray with water and dump, or better yet, get another tray and use one as a holding bath and the other as a continuous wash tray. Wash the RC prints for five minutes in running water.

2. Remove and gently squeegee the print to remove excess water, if possible, and hang to dry on a line or lay face up on a drying screen.

## EVALUATING YOUR PRINTS AND TROUBLESHOOTING TECHNIQUES

How does it look? Hopefully pretty good. Let's discuss some of the immediate problems you have encountered. The first is probably tiny white specks cause from dust or lint, as seen in the following figure. Dust is the photographer's enemy and will always plague you.

*This photo has a terrible dust problem. You can see all the white specks and lines that it has left. Correct this by using an anti-static cloth and blowing the negative with compressed air.*

*(Tony Maher)*

## DUST

First, keep your negatives as clean as possible. Dry them in a clean, dust- and wind-free place. Then store them in negative preservers. Before I put a negative into the negative carrier, I always gently wipe them with an anti-static cloth. But be gentle, as you can damage the negative.

Then use compressed air to remove dust. After the anti-static cloth has been used, blow the emulsion and base sides of the negative a few times. Always keep the can upright and never shake it. Doing so can release the chemical propellant that may freeze your skin or damage your negative permanently. When using compressed air, use short blasts instead of a long one. Short blasts are more powerful and effective.

Fingerprints and other marks, including stubborn lint and dust, can often be removed with film cleaner. Film cleaner is a solvent, so it removes greasy substances. I do not recommend using film cleaner unless necessary, as any excess rubbing on the negative can cause damage. If you have used your compressed air and anti-static cloth and there is still dust or marks, try film cleaner. Get a lint-free wipe and film cleaner from the photo store, and do the following:

1. Put a drop or two of the cleaner on the cloth and gently wipe the negative.
2. Reuse the anti-static cloth.

3. Blow the negative before replacing it in the negative carrier and print-ing again.

Hopefully that has taken care of the dust and fingerprints.

**GO TO** ▶
For information on hiding scratches, see Hour 19.

## TONALITY

Although dust is probably the first thing you see wrong with your first prints, the *tonality* of the print is much harder to control for beginning printers. By tonality I mean the highlights and shadows in your picture. Does the print appear crisp with rich shadows and brilliant highlights? Your first prints may not, but don't worry, you need to practice printing to get good at this.

Remember that judging your prints and test strips is a matter of looking carefully and making tests. Do not be impatient; this is a time-consuming task, and as you get more experience, you will become faster and better at making those judgments.

When printing, the exposure time controls the highlights and the multi-grade filter controls the shadows. Do the highlights look too light and washed out? Then increase the print time. Are the shadows muddy and gray? Then increase the filter. The great photographer and printer Ansel Adams reminded us that many really fine prints have a wide range of tones. While this is dependent upon how the negative was developed, quality of light in the scene, and exposure at the time the picture was made, you do have a lot of control in the printing process, too.

Look closely to see whether there is a pure black in the print. If not, increase the contrast and see whether you can achieve one without hurting the rest of the picture. Is there a bright white in the picture? If not, try dropping the time a little to enhance the highlights without hurting the overall print.

**GO TO** ▶
For more on meth-ods to control tones locally, see Hour 19.

## FOCUS

Is the picture in focus? This is often a problem when making your first pic-tures, too. Look closely and determine whether the lack of good focus is in the print or in the negative. When you made the picture, you focused the camera lens and therefore the image on the negative. When you made the print, again you had to focus the enlarger lens. To determine which was out of focus, look for the grain in the print. Remember that when you used the grain focuser, you were trying to make the grain appear sharp, and you should be able to see the tiny bits of grain in the print. Use a loupe or magnifying

glass to help you see. Sometimes the grain is just a little out of focus, which gives the picture a slightly fuzzy look. If you cannot see the grain because the print is out of focus, go back and make another print.

If you needed to use a long printing time, the negative may have been out of focus because it popped. This happens when the negative becomes hot and the polyester base expands under the heat. When you first put your negative in the enlarger and focused, the negative was cold, and the focus may have been fine. However, when the enlarger light has been on for 20 seconds or so, the negative becomes warm, causing it to pop up slightly, and taking it out of focus. When using printing times longer than 20 seconds, this can be a common occurrence. To solve this problem, let the negative warm up for 30 seconds or so before focusing, and let it warm up before putting your paper in the easel and printing. This usually solves the problem.

**JUST A MINUTE**

For a print to be in focus from edge to edge, the negative carrier, lens, and easel must all be parallel. Use a level to try to align your enlarger and do this whenever the enlarger is moved. Also, always print with the lens at least two stops down for edge-to-edge sharpness.

Another reason for the negative to be out of focus is that it is not lying totally flat in the negative carrier. This looks like a localized area is out of focus while the rest of the print is fine. Take the negative carrier out and examine to see whether the negative is lying flat. Some carriers have little pins that the film must slide under, and if not, it will not be flat.

A third reason may be that your enlarger is out of alignment or the easel is not aligned with the enlarger. For the print to be in focus across the picture surface, the easel must be parallel to the lens, and both must be parallel to the negative. On many enlargers, you can adjust the lens board or the place where the negative rests. Use a level and check these positions. The easel must also be checked and leveled.

If you are making small prints, you may not even notice that these things are not level, but the bigger the print, the more crucial the alignment. If this is only a minor problem, try closing the lens down farther than two stops. Just as with the camera lens when shooting pictures, the lens of the enlarger has more depth of field when used with smaller apertures.

Of course, if the print is in focus but the picture is not, the error occurred in the camera and you can do nothing about that except reshoot the picture, or if it is minor, try making a smaller print.

## PRINT BORDERS

Look closely at the borders of your print. Are they a sharp line or a little fuzzy? There is certainly no right way to make the borders, but I recommend that you make all four edges of the print consistent. Consistency signals that you have control, whereas inconsistency says that you do not. If you are using an easel with blades, enlarge the image enough that it slightly overlaps the blades. The blades will then mask the edges and make for a clean, sharp edge between the picture and the white border of the paper.

Is your picture in the center of the paper like the one in the following figure? Again, you can do what you want, but having the image placed in the center of the page looks much more professional and indicates you have control of the process. If you are using a four-blade easel, make sure that the blades are set up so the two horizontal blades are set to the same measurement as well as the two vertical blades. Four-blade easels are made so that if the blades are set properly, you just insert your paper into a slot on its baseboard and the image is printed in the center of the paper. This centered image looks very good as is, without trimming the paper.

*With the image printed in the center of the photo paper, it has a neat, clean look. It demonstrates that the photographer has control when printing and makes a nice presentation.*

*(Sant Khalsa)*

If you are using a speed easel, one that does not have blades, just try to put the image in the center. You will not have clean edges because there are no blades to mask the edges, so you may later want to trim the print.

Remember, I suggest you shoot your pictures full frame. I also suggest that you print your pictures full frame. I strongly discourage you from cropping pictures at first. By printing full frame, you will be learning exactly how you frame your pictures in the camera and can better develop your picture-taking skills. Refine your basic picture-taking skills and develop your photographic eye before moving on to more advanced techniques such as cropping.

You may want to print a black border around your pictures. There are a few ways to do this. If the hole in your negative carrier is slightly larger than the frame of your picture, it's easy. If you can see the clear area around your negative, you can print that clear line, and it will appear black. Unsure whether your carrier will work? Insert a negative and hold it to the light. If you can adjust the negative so that you can see clear all around the frame, your carrier will work. If your carrier does not allow this, simply use a metal file and gently enlarge the hole. Be sure to remove all burrs and clean the carrier well before putting your negative in it.

**FYI** A thin black line around pictures can look great and is popular with many professional photographers.

When you turn the enlarger on, you should be able to see the image and the bright, clear area around it. Adjust the enlarger and easel so that you get a thin clear area around the picture, and when printed, the clear area will be black. I like the neat look of the thin black line border seen in the following figure.

You can print a thick or uneven black border, too, which many photographers like. Simply do not let the easel blade mask the black line, and it will print however the carrier has been filed out, as seen in the second following figure. This is often a good way to print with a speed easel—one that has no blades.

I hope your first prints have come out well. Remember that printing is a series of testing for the best highlight and best contrast. Be patient about learning the process; photographers work for years to become great printers.

*Here a thin black line was created by using a filed-out negative carrier. The black line looks good and also tells us that the photo was printed full frame.*

*(Sant Khalsa)*

*This print also has a black line, but the photographer has moved the easel blades out so the full natural black line shows.*

*(Tony Maher)*

# HOUR 19

# Advanced Black and White Printing Techniques

## CHAPTER SUMMARY

**LESSON PLAN:**

You have probably noticed that your first prints are not the greatest and are now ready to learn more. In this hour, I discuss some advanced printing techniques that will enable you to continue to refine the printmaking process.

- Techniques to make isolated parts of your print darker or lighter
- How to hide scratches
- How to alter the contrast of your print when using graded paper
- How to produce black and white prints from color negatives

Now that you've made your first black and white prints, you have a pretty good feel for the procedure you will follow whether you are just starting out or are a seasoned professional. Now you will work on refining your technique, which is something that you do throughout your career; and just like shooting pictures, the more you do it and the more you think about it, the better you become.

## BURNING AND DODGING

You will have noticed that your negative, and consequently your print, does not always have an even tone across the surface. For example, one side is too dark while the other side it too light. If this is caused simply by too much or too little contrast, you already know how to correct it by raising the filter number to increase contrast or lowering it to reduce contrast. However, it is also very common for the contrast and exposure to be good while one or two areas of the print are still too light or dark. So how do we handle this? We correct this common problem by *burning* and *dodging*.

### STRICTLY DEFINED

**Burning** is adding exposure time to a localized area of a print, making just that area darker. **Dodging** is holding back time from a localized area of the print, making only that area lighter.

Remember that exposure time controls the overall lightness and darkness, and more time makes the print darker. This technique is commonly used when, for instance, the print looks good but the sky is too light. Imagine that everything else in the print looks great. It has good contrast, and the highlights, except the sky, look good. If you increase the exposure time, the whole print will become darker, so you add time to the sky area that is too light. In the first of two following figures, the print has areas that are too light. Increasing the exposure time would make the whole picture too dark, so burning is the solution, as seen in the second figure.

*This photo could use a burn to improve the areas that are too light.*

*(Tony Maher)*

*Burning made this print better, darkening the areas that were too light. If done well you should not be able to tell whether a print was burned.*

*(Tony Maher)*

A good print has a clearly defined edge. A pure white sky bleeds the image onto the white edge of the paper, having the effect of drawing our eyes away from the image because our eyes are attracted to bright tones. When the sky or another element on the edge of a print comes out totally white, you should burn that area. When done well, a sky or other white edge will become a soft gray and demarcate the edge of the image and the white border of the paper. If you want to keep the sky pure white, you can add a thin black border.

**GO TO** ▶
For more on borders, see Hour 18.

## HOW TO BURN A PRINT

To burn a print, follow these steps:

1. Get a piece of cardboard. (Your box of photo paper probably has a thin piece of opaque board that came with your paper.)

2. Produce the best possible print from the negative and then see what area appears too light. That is the area that needs to be burned.

3. When you have determined the best amount of time and the appropriate filter—for example, 10 seconds with a #2 filter—you are ready to burn. Expose your paper for the determined amount of time.

4. When the timer goes off, use your opaque cardboard to shield the part of the print that is good and turn on the timer, allowing the light to fall only on the part of the print that needs to become darker. During this exposure, it is very important to move the cardboard to create a gradual increase in density in the area being burned.

**PROCEED WITH CAUTION**

When burning a print, be sure to keep the burning tool (usually cardboard) moving during the burn exposure. This helps create a gradual, gradient effect. If you hold the board still, there will be a distinct line caused by the burn exposure.

5. For what length of time should you burn the print? You will need to test some strips to determine that. When you have done the burn, develop the print, and after fixing, evaluate your burn. If the area burned is still too light, make another print and burn the problem areas for a longer time. If the burned area becomes too dark, do it again for less time. As you have already discovered, photographic printing is a process of testing.

There are many areas of a print besides skies that you may need or want to burn. If they occur at the edge of the print, a flat piece of board often works well. But when you need to burn something in the middle of the print, you can cut a small hole in your cardboard. The perfect burn is one that you cannot tell was done, so being subtle and creating a smooth transition without any noticeable lines is what you want to achieve.

## How to Dodge

Dodging, the opposite of burning, is underexposing a localized area, making it lighter. When might you want or need to do this? One common example is a portrait in which the face is a bit too dark. If you reduce the exposure time, the whole print becomes too light, so you only want to reduce the exposure time for the person's face.

 **FYI**    You can make dodging tools easily or buy them at most photo stores. To make a dodging tool, use a piece of thin stiff wire and tape a round or oval piece of cardboard the size of a half dollar to the end. This works very well.

To dodge, follow these steps:

1. Do tests to determine the time and filter that makes your overall print look best.

2. Do tests to determine how much less exposure time is needed for the area that requires the dodge. Let's say that the overall print looks good at 10 seconds but a face in the foreground looks good at 7 seconds. Then you know that you need to dodge the face for 3 seconds.

3. Place a piece of paper in the easel and have a dodging tool ready. A set of dodging tools can be purchased at most photo stores. They consist of a thin but stiff wire with a series of opaque masks of different sizes and shapes that are attached to the wire, as in the following figure. Of course, you can make your own.

4. Activate the timer for 10 seconds, or whatever time you determined will give you a good overall print. During this time, use the dodging tool to block the light falling where the face is in the print. Again, be sure to keep the tool moving, or you will have a bright halo effect around the face.

5. When the 10 seconds are up, process the print normally and then evaluate the print. If the face is still too dark, repeat the procedure but dodge for more time. If the face is too light or has a halo, repeat the procedure for less time.

*This is a set of dodging tools available at most photo stores. The stiff wire handle can accommodate all the masks seen here.*

*(Matthew Richardson)*

As with burning, it is very important to keep the tool moving and to create a gradual, unnoticeable effect. The best burning and dodging are the ones only you know about. The following two figures demonstrate that dodging the face, which appears too dark in the first figure to follow, helps to brighten it without changing the overall tone of the photograph, as seen in the second figure.

*The man's face is too dark in this picture. Dodging would have helped.*

*(Tony Maher)*

*After dodging, the man's face is lighter, and the overall print looks much better.*

*(Tony Maher)*

## How to Burn with Different Multigrade Filters

Sometimes burning an area produces too much contrast, or sometimes you may want to increase or decrease the contrast in a localized area of a print. You can change multigrade filters when you burn to refine your print's tonal values. To do so, simply change the filter before you start the burning. I have often found that when burning a sky with trees, the trees get too dark. To help correct this, I will change to a lower-contrast filter before doing the burn, helping to keep the trees from looking too contrasty.

Sometimes you may only want the sky to be very pale, to have just enough tone to create a separation between it and the paper's border. For this effect it can be useful to change to a very low filter, such as a zero, when burning the sky. A zero filter affects the highlights much more than the darker tones of the print.

## Edge Burning

The great photographer Ansel Adams was also a great photographic technician. He conducted extensive tests on films, papers, chemicals, and equipment. One of the many things I learned from reading his technical books was edge burning. Edge burning is done to make the edges of a print darker than the interior of the print. As mentioned earlier, because our eyes are attracted to bright tones, if there are bright tones on the edges of a print, a viewer's eyes will want to wander away from the picture. Adams suggested

burning the edges of prints for about 10 percent of the exposure time, creating a very subtle tonal difference. This subtle difference is usually not even noticed unless you compare a burned print to one that has not been burned. However, the effect is very good—a strong print that helps keep the viewer focused on the image.

## HIDING SCRATCHES

Like dust, scratches are also a problem. Scratches can occur when the film is rewound into the camera, during the film processing procedure, and after the film has dried. Let's discuss how you can prevent them and how you can deal with them once they happen.

There are two kinds of scratches: those on the base and those in the emulsion. On your print, the ones on the base appear white, and those in the emulsion appear black. A scratch on the base often creates a V-like mark on the plastic base. During the printing exposure, the light passing through the scratch is slightly bent to conform to the V shape. The effect is that the light does not pass directly through the scratch on the negative and so leaves a thin line on the print where light did not land. A scratch in the emulsion, on the other hand, actually removes some of the emulsion, allowing more light to pass through the scratch on the negative, therefore making that area darker.

**TIME SAVER**

 Scratches that occur on the base of the film leave a white line on the print. They can be printed through if you apply a thin coating of Vaseline or a specially made liquid called No Scratch to the base side of the negative.

You can often correct the white line on your print from scratches in the base, but the black line from emulsion scratches cannot be corrected. A small amount of emulsion is actually gone and cannot be corrected in the traditional printing process.

To correct the base scratch, however, apply a thin coating of scratch remover, which can be purchased from a photo store. The thin coating fills in the V-shaped scratch in the base, and very often the white line in the print will disappear. The down side is that the negative becomes more susceptible to dust because the surface is made sticky.

## PRINTING WITH FIBER PAPER

GO TO ▶
For more information on fiber paper, see Hour 17.

*Here are six trays, the chemicals, and times for fiber paper development.*

*(Mike Hollenbeck)*

Once you have become used to printing on RC paper and used to burning and dodging, try printing on fiber paper. The following figure exhibits the items needed for fiber paper printing along with appropriate exposure times for each chemical.

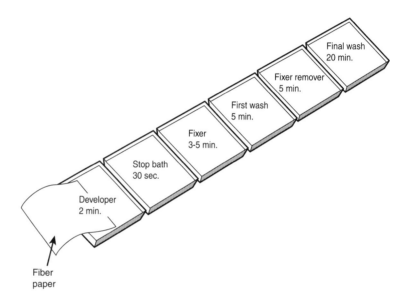

Developer 2 min.

Stop bath 30 sec.

Fixer 3-5 min.

First wash 5 min.

Fixer remover 5 min.

Final wash 20 min.

Fiber paper

To print with fiber paper, follow these steps:

1. I suggest a development time of two to three minutes, because development time for fiber paper is longer than for RC paper.

2. After development, the print should be placed in the stop bath for 30 seconds with agitation. The paper base absorbs the developer and you need to let the stop bath fully remove and neutralize the developer.

### PROCEED WITH CAUTION

 The base of fiber paper is highly absorbent so you need to wash the print very thoroughly, use fixer remover, and then wash again. Otherwise, residual chemicals will begin to destroy the paper and print over a period of time.

3. Your fiber prints need to be fixed for three to five minutes, depending on which fixer you use. It is important that your fixer is fresh and that you agitate the print in the fixer bath. Prints sitting in still fixer are not

getting fixed well. Remember that agitation keeps fresh chemicals moving around the print (or film).

4. The washing procedure is the biggest challenge with fiber prints. After the fixing is done, move your print to a holding bath until you are ready to wash all your prints. I would advise you to begin washing one hour before you need to leave the darkroom.

   When you are ready to begin, wash your prints in fresh running water for about five minutes. This is the initial wash. If you are using a tray with a siphon washer or running water into an open tray, you should flip the prints a few times during the initial wash. I suggest taking the print from the bottom of the tray and putting in on the top of the pile of washing prints. Continue doing this until you have moved all the prints from the bottom to the top and back again. Do this two or three times during the initial wash cycle.

5. Next, it is time to put the prints in a solution of fixer remover. Depending on the brand you buy, it may be called a Hypo Clearing Agent (Kodak), *Archival* Wash Aid (Ilford), or Perma Wash (Heico). They all do the same thing: help neutralize and remove any residual fixer left in the paper fibers. Leave the prints in the fixer remover for five minutes, flipping periodically to be sure that all the prints are getting fresh solution. Be careful to keep your fingers away from the image and handle the print only by the edges to prevent fingerprints.

**STRICTLY DEFINED**

You will often hear the term archival used in photography. **Archival processing** means that the print or film has been processed in such a way that no residual chemicals, especially acids, are present. This entails using fresh fixer and a fixer remover, and fully washing the material to remove all residual chemicals.

6. The prints are now ready for a final wash; use fresh running water for 20 minutes. There are some very good archival washers on the market for this purpose, but you can use an open tray with a siphon pump or just run water into an open tray. If you use an archival washer, 20 minutes should be fine. If you use a siphon pump, be sure to flip the prints every few minutes and wash for a bit more time, maybe 30 minutes. An open tray with water running into it is the least efficient method and should be closely monitored. I suggest flipping the prints every few minutes and washing for one hour.

I cannot overemphasize how important it is for you to wash fiber prints thoroughly. Fixer is an acid and residual acid in your print will eventually break down the paper, causing it to turn yellow and brittle, and will stain and fade your print over time.

7. Once you are done washing, remove the prints one by one and gently squeegee off excess water. Fiber prints curl when they dry, so removing the excess water helps reduce the curl and speeds up drying time. I recommend placing them face down on a nylon drying screen. You can also hang them on a line, but they usually curl a lot when dried this way. If hung on a line, clip two prints back to back to help prevent curling.

8. Fiber prints need to be flattened after they have dried. I use a dry mount press. A dry mount press provides pressure and heat. I put my fully dried prints in a 180°F press for 30 seconds, remove them and lay them face down, and put something smooth and heavy on top while they cool. Store fiber prints face to face, and they will remain very flat.

## Comparing Paper Surfaces

Glossy paper generally provides the best rendering of fine details because other surfaces such as "silk" and "pearl" have a slight tooth to the finish. Some photographers object to the glare from glossy papers but when air-dried, glossy paper has a very low gloss. However, any surface can give you excellent prints, so you should experiment and decide which you like best.

The surface is also affected by the way the paper is dried. Glossy paper run through a dryer has a shinier surface than when air-dried. There is also a technique that is rarely used anymore called *ferrotyping*, which uses a highly polished metal plate that creates a super high gloss on glossy papers. In the old days it was thought that ferrotyping helped make prints reproduce better, but the surface has such a high gloss as to really inhibit their viewing. This super high gloss is where the term "glossies" came from.

## Using the Two-Tray Split-Developing Technique with Graded Paper

If you use a graded paper, you can alter contrast by using two developers, one higher contrast and one lower contrast. You adjust contrast by the amount of time in each developer. This two-developer method is an excellent way to make very subtle changes to the contrast of multigrade papers as well.

For this two-bath method, I recommend using Kodak Dektol paper developer and Kodak Selectol Soft paper developer. Dektol is an excellent all-purpose developer that is normally diluted 1:1 or 1:2. Used undiluted, however, it acts as a much higher-contrast developer. Selectol Soft is a low-contrast developer and does not really produce much of a deep black. (There is another developer just called Selectol, so if you are going to use this method, be sure to get Selectol Soft.)

Follow these steps to use the two-developer bath method:

1. Fill your first developer tray with undiluted Dektol, put your print in this developer, and keep track of the time (usually about 30 seconds).

2. When the darkest tones of the print come up, put the print into the Selectol Soft bath (undiluted). This second developer will bring up the mid-tones and highlights. Leave the paper in the second developer for about two minutes. (See the following figure.)

After stop bath and fixer, evaluate the print. If you need more contrast, leave the print in the Dektol longer next time; if you need less contrast, take it out of the Dektol sooner. It is a good idea to keep the print in the Selectol Soft for a full two minutes; this is when the mid-tones and highlights are developing. If the highlights are too dark, drop your exposure time.

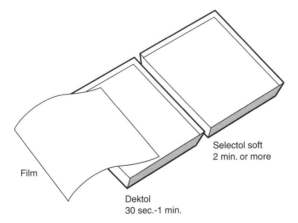

Selectol soft
2 min. or more

Film

Dektol
30 sec.-1 min.

*This illustration shows the two-tray, split-developing technique. The first tray of Dektol brings out the black tones, and the second tray of Selectol Soft brings out the highlight tones. Adjusting the amount of time in the first tray controls the contrast with graded paper.*

*(Mike Hollenbeck)*

## FLASHING

Flashing can work okay when you have a hot spot that is too intricate to burn or when there are very pale tones that need to be separated. This takes some testing to get right, and I do not suggest you do this for your fiber exhibition prints, except as a last resort. I have had very good luck flashing with RC paper that has an incorporated developer, though.

### STRICTLY DEFINED

**Flashing** means giving exposed photo paper a very small amount of light to slightly darken the highlights or create tone where there is none.

Flashing can be done a few different ways. The easiest is to expose the print, stop, put a piece of glassine over the lens, and expose the print a bit longer. The glassine diffuses the light and creates an overall soft light that slightly affects the highlights. You will need to test to find the right amount of exposure to produce only a slight tonality without turning the highlights gray.

The way I did it was to set up a second enlarger with the lens stopped all the way down and the timer set at about $\frac{1}{2}$ second. After I exposed the print on the first enlarger, I put the paper under the flashing enlarger and exposed it again. For bright tones on the edge of the print such as a white sky, you can even cover the rest of the print, thereby selectively adding the flash to the area needed and preventing unwanted suppression of the highlights. This worked very well with the RC prints I used to make at a commercial lab. You can also combine this with a burn for stubborn highlights. The interesting thing is that if done well, the white edge of the paper will not be affected, apparently because of the incorporated developer. When initially exposed, the developer starts to work, so when the flash exposure occurs, the already exposed part of the print has a head start on creating tone.

## BLEACHING

Bleaching can be done at the time of printing or any time later. (See the following figure.) Photographic bleach is the chemical potassium ferricyanide. This can be a tricky process but has worked very well for some photographers. The great photographer Eugene Smith, for example, is well known for his very dark, rich prints in which he enhanced highlights by bleaching.

### STRICTLY DEFINED

**Bleaching** removes metallic silver from a developed print.

*This photo was bleached with potassium ferricyanide. The bleach was applied to the trees and clouds to enhance the highlights after the print had been dried.*

*(Phil Marquez)*

If you want an overall lightening of the highlights of the entire print, follow these steps:

1. Mix up a solution of 1 tablespoon of potassium ferricyanide to 1 quart of water. (This formula is what worked for me, but you should cut up some prints and test to see whether it's too strong or too weak for you.)

2. Wet your print. The print must be very well washed and free of residual fixer or it will stain.

3. Submerge the print in the solution for maybe 10 seconds.

4. After 10 seconds take the print out and rinse it well. The bleach has a vivid orange color, and you need to fully rinse the color out.

5. Re-fix the print, and you will see the results. Prior to fixing, the results are very subtle, but once in the fixer, you will see the bleaching.

6. Rinse in running water for 5 minutes, use fixer remover for 5 minutes, and do a final wash of 20 minutes. Anytime you have put a print into fixer, you must go through the entire wash/fixer remover/final wash process.

If the action is too strong, try diluting the bleach more. If it is too weak, leave the print in the bleach longer.

You can also bleach specific areas to enhance the highlights. Wet the print so as not to produce a halo effect or abrupt tonal change, and use a cotton ball to locally bleach an area of the print. Then wash, re-fix, wash again, use fixer remover, and then a final wash after bleaching.

## Toning

Black and white prints have a subtle color that is determined by the paper and developer. Kodak papers are typically cool toned, meaning that the image is slightly on the bluish side. Agfa Portriga paper is famous for its slightly brown warm tone. However, prints can be toned after printing to alter the color of the image.

Toning after printing can dramatically change the color of a print, or the toning can be controlled to be very slight or even imperceptible. Many photographers use selenium toner, which is available at most photo stores. It can be mixed strong and produce a purplish tone or mixed very weak and be unseen. Many folks use a weak solution because it helps make fine fiber prints archival. Another interesting one is sepia toner, which produces a distinctive brown-orange. The company Berg makes very easy-to-use blue, gold, and yellow toners, all of which can dramatically change the color of your print.

## Producing Black and White Prints from Color Negatives

Now that you have your darkroom set up and understand the printing process, your friends will ask you to print pictures from their negatives. You will inevitably be asked to make a print from a color negative, and you can do it. See the following figure.

I have done it two different ways. One method is to use specially made photo paper. Kodak's Panalure is made for just this purpose. It is sensitive to all colors of light, so you must handle it in total darkness without a safelight. Expose and process it like any other black and white paper.

The other method is to use multigrade paper and two filters, numbers zero and five. Expose the print with the number five filter to get contrast; with the zero filter to create highlights. If you need more contrast, increase the exposure with the number five filter; if you need less contrast, reduce that exposure. The zero filter produces mid-tones and highlights, so more exposure makes the print darker and less makes it lighter. By using these two filters and separate exposures, you can get a pretty good black and white print from a color negative.

*This portrait of The Iron Warrior, professional wrestler, was from a color negative printed on Kodak Panalure paper. Panalure paper is specially made to accurately render the tones from a color negative into black and white. Unlike regular black and white paper, Panalure must be handled in total darkness.*

*(Thomas McGovern)*

Now you have learned a lot about making black and white photographs and how to alter the final prints. This is a continual learning process, so keep this book handy in the darkroom and refer back to it as needed.

# Advanced Film Exposure and Development

## CHAPTER SUMMARY

**LESSON PLAN:**

Now that you have a good grasp of basic film developing as well as basic and advanced printing techniques, let's discuss advanced film exposure and developing.

- How to use pre-visualization to set up a shot
- How to create a unique effect with reticulation
- Tips for using infrared film
- Tips for developing medium- and large-format film

Because film is what captures your image, the exposure and development of your film are two of the most crucial aspects of photography. While it is totally possible to be a great photographer even if you don't develop your own film, you would be missing out on an important area of control. Once you have the film-developing techniques mastered, you will begin to realize the depth of your control over the most subtle and refined aspect of your photography. And good film exposure and development will make your job of printing the finest photographs a lot easier.

## PRE-VISUALIZATION AND THE ZONE SYSTEM

Ansel Adams is credited with formalizing the *zone system* and of pre-visualizing a scene before making an exposure. I highly recommend that you consult his book *The Negative* (Little Brown, 1983) for a more detailed discussion of these concepts, but let me explain these important ideas and walk you through some of their practical uses.

**STRICTLY DEFINED**

The **zone system,** developed by Ansel Adams, is a method identifying 11 zones of tone, from pure white to pure black. By learning and using the zone system, you achieve greater control over your negatives and, consequently, the finished print.

Pre-visualization means visualizing how the tonality, brightness, and contrast of a final print will look while looking at the scene you want to photograph. (See the following figure.) Those who have never made their own prints and who then complain that their pictures don't look like the scene they originally saw often mistake photography for being a direct representation of reality. But those of us who develop and print our own pictures realize that film translates the color and tonality of a scene and that the print is a completely separate and highly subjective object. Photographs are not reality, and when you begin to acknowledge this you are free to be more creative and take more control of the art-making process. Our best photographs, even those that are very faithful to reality, are interpretations of it. Great artists are those who embrace the fact that we are in control of this process and that we are fabricating a picture.

*The artist has pre-visualized the scene, meaning that she is translating the color of the natural world into black and white and closely observing the tonal relationships. During exposure she is able to determine shadow details, and during development she is able to boost highlights and contrast.*

*(Sant Khalsa)*

When you pre-visualize a scene you are about to photograph, you are looking at all the compositional aspects such as foreground, middle ground, and background, where the highlights and shadows are, and the juxtaposition of elements in the picture. However, it also refers to the understanding that film has a limited pallet: It can only render so much tonality and has a definite limit to what it can record. With pre-visualization and by using the zone system, we can alter tones in a picture to enhance contrast, control shadow, and highlight details.

Remember that your exposure meter averages the light of a given scene to be middle gray, and that middle gray is 50 percent white and 50 percent black. If you take a reading from something that is white and follow your meter, the film will record white as middle gray. This is the foundation for our discussion.

The zone system is a method for placing tones from pure white to pure black on a scale that can be manipulated for creative effect. It has 11 zones from zone zero, which is pure black, to zone X, which is pure white. Zero and Roman numerals are used to refer to the 11 zones. (See the following figure.) Middle gray is zone V because it is half black and half white. Each f-stop over and under zone V is equal to a zone. If you take a reading and then close the lens one stop, you are effectively making the picture fall on zone IV instead of zone V. If you open the lens one stop, the picture tones will fall on zone VI. We'll go into more detail shortly.

X   IX   VIII   VII   VI   V   IV   III   II   I   0

*This chart shows the tonal relationship between zones zero to zone X. Zone V is middle gray, the combination of pure white and pure black. (Matthew Richardson)*

Let's go back to another rule we discussed earlier. Film exposure controls shadow details, and film development controls highlights and contrast, or to put it simply, expose for the shadows and develop for the highlights. What this means is that your initial exposure is what captures the details of a scene. Once exposed, film and paper have a latent image, unseen until development. Because shadows are dark and reflect less light than highlights, your film may not always record all of those details, especially if there are a lot of highlights that throw off your meter reading.

**FYI** An important rule to remember is that exposure controls the shadow details in a negative, and development controls the highlights and contrast.

For example, let's say you want to photograph a barren desert hillside with a small, dark cave. The overall scene is very bright and your meter is averaging the reflected light to middle gray. If you follow your meter, the hillside will be exposed well, but the dark cave entrance will be totally black. Remember this example; we will come back to it.

Film development converts the exposed silver halides into metallic silver. The latent image from exposure emerges during development, but the process is

more active in the highlights than in the shadows. As you develop your film, silver builds up quicker in the highlights. If you overdevelop your film, the shadows are not affected very much because there isn't a lot silver there to begin with; but the highlights continue to accumulate silver, making them denser, and therefore brighter in the print. If you overdevelop your film, you are making the highlights brighter and therefore increasing the contrast in your negative and print. Careful exposure and development was required for the following photograph, producing a long tonal range and excellent shadow detail.

*This photograph has a long tonal range, meaning that there are an abundance of tones from pure black to many grays to pure white. This is accomplished by scrutinizing the quality of light, pre-visualization, and careful development of the negative.*

*(Sant Khalsa)*

Let's return to the preceding example. You take an overall reading, and let's say it is $\frac{1}{60}$ at $f/22$. If you follow the meter, the overall scene—which is pretty bright—will be rendered at zone V, and middle gray and the cave will be black because it is much darker than the rest of the scene. If you pre-visualize the scene before shooting, you will know this.

Look closely at the cave, and ask yourself what zone (or tone) you want it to be. Zone V is middle gray, and each zone under that is one stop darker, each zone over that is one stop brighter. If you conclude that the cave should fall on zone II, take a reading of the light reflecting from the cave, and then close the lens three stops. Let's say the cave reading is $\frac{1}{60}$ at $f/5.6$. Close the

lens three stops to $f/16$, effectively rendering the cave entrance on zone II. Zone II is quite dark but has a small amount of detail. Now compare the overall reading of $\frac{1}{60}$ at $f/22$ with the cave entrance reading of $f/16$, and you see that the overall scene, if shot at $f/16$, will be one stop overexposed. To compensate for this overexposure, you will reduce the development time by one stop or about 20 percent. Because exposure controls the shadow detail, the cave will be exposed well. Because development controls the highlights, they will be good, too, because you have reduced the development to account for the overexposure. The rule of thumb is that exposure controls the shadows and development controls the highlights.

**JUST A MINUTE**

To learn the tones of the zone system, do a test. Expose 11 frames of an evenly lit, mildly textured surface. The middle exposure should be from your meter reading and represents zone V. The five over- and underexposed negatives represent the other zones.

For a visual reference so that you can tell the tones of each zone, shoot a series of tests. Follow these steps:

1. Photograph a textured surface, such as stucco or concrete, that is evenly illuminated. Take an exposure reading and make a picture. This negative will be rendered zone V.

2. Make 10 subsequent exposures, five at consecutively smaller apertures, and five at consecutively larger apertures. Each of the smaller apertures will represent zones IV, III, II, I, and zero. Each of the larger apertures will represent zones VI, VII, VIII, IX, and X.

3. Make a print from the first negative that represents zone V and match it to a gray card.

4. Expose the other negatives for the same time and each will accurately represent the 11 zones from zero for pure black to X for pure white.

In conclusion, pre-visualization means that you look at the scene you want to photograph and determine how you want the tonalities to be rendered. Sometimes the lighting is such that you simply follow your meter, and other times you will want to expose for a shadow and then adjust development for a highlight. Use your exposure meter to check the different illumination levels of shadow and highlight tones, and then determine which zone you want the shadow to be. Compare that reading with the highlights and then adjust your development to keep them from being too bright.

I know that this is a complicated idea, and photographers take a while to get comfortable using this system. However, it works very well to help you gain incredible control over your negatives and prints. Mark this section of the book, and when you feel comfortable with the picture-making process, reread it. By then you will understand this system better and be able to employ it.

GO TO ▷
To review push-pull processing, see Hour 3.

Now that we have explained the zone system, push-pull processing will make more sense, especially pulling film.

## Pre-Exposure

Pre-exposure is similar to flashing photo paper but is done before the film is exposed. This is useful when photographing a high-contrast subject, instead of pulling the film or reducing the development time. Sometimes the latter yields a negative in which the shadows are not contrasty enough. Pre-exposure can reduce the highlight value but help keep the contrast in the shadows. This is a tricky process that requires testing to achieve the desired results. Ansel Adams has a great suggestion for pre-exposing sheet film in his book *The Negative*. He suggests taking the following steps:

1. Find an evenly illuminated wall or surface with no shadows and little or no texture. A gray card is ideal.

2. Take a reading and reduce the exposure to expose the film on zone I or II.

3. Set the lens so that it is out of focus to create an even illumination that will record no detail, only a slight overall tone, and expose the film.

4. Label it as pre-exposed. You can now use it to photograph a high-contrast scene and the film will have great shadow detail with more contrast than if you simply pulled the film.

It sounds easy, but it takes a bit of practice to make this work!

## Reticulation

As you recall, the ideal development temperature for most films is 68°F, and your stop bath, fixer, and washes should ideally be at or very near 68°F as well. When there are sudden shifts in temperature, especially during development, *reticulation* is the result.

## STRICTLY DEFINED

**Reticulation** is the clumping of grains of silver, giving the picture a very interesting, heavily textured look.

Reticulation is generally considered an error, but some photographers love the weird look and do it on purpose. I think it can make for some very interesting patterns in the picture and have seen images that use the technique well. Ilford Delta films and Kodak TMAX films resist it, but Kodak Tri-X reacts very powerfully. To try this, all you have to do is shock the film with a drastic temperature change. One of my students recently did this by doing the following:

1. Pour the developer out after about two minutes.
2. Pour 100°F developer into the developing tank.
3. Agitate for a minute or so.
4. Put the 68°F developer back in.
5. Continue the process.

She did this a few times and got the wonderfully textured pattern seen in the following figure.

The artist has purposely "shocked" the film during development by suddenly changing the temperature of the developer.

(Leta Schmidt)

## INFRARED FILM

Infrared film is a unique type of film that records both visible light and invisible infrared light. The effect is an odd tonal rendering between things that normally have a fixed tonality. Things that reflect infrared light appear very light and things that do not, appear dark. Foliage is the typical example in that it comes out very bright with this film, as seen in the following figure. Skin tones are reproduced in an odd way with some deep shadows and glistening highlights. The blue sky comes out very dark with this film, and so it has some interesting uses, both creatively and scientifically. Aerial photographers use it because it does not see the haze in the air, producing very crisp shots of far-off mountains and of the land.

*Note the odd tonal relationships in this picture. The photographer used infrared film and a red filter on the lens.*

*(Stephanie Keith)*

Unlike regular black and white film, infrared film must be loaded and unloaded in total darkness. When you buy it, be sure it has been refrigerated, and only get it from a reputable dealer because it is very sensitive and can be easily fogged. You can shoot this film without a filter, but most folks use it for the odd effect and so expose it through a red #25 filter on the lens. With the red filter it records mostly infrared light. Exposure is tricky because infrared is not visible, so an exposure meter is not much help.

**FYI** Infrared film is used to detect forgeries of paintings and documents because it can detect things that have been altered or erased.

With infrared film, I recommend bracketing whatever you are shooting. You can set your meter to ISO 50 or so, but be sure to bracket. You can use this film with a flash, too. Use a red filter over the flash head or buy a special infrared flash unit. Also, infrared wavelengths are not the same as normal light and that effects focus. If you focus normally, the scene is going to be slightly soft. If you are working with the lens stopped down, there is no need to worry, but if your depth of field is shallow and focus is critical, you will need to compensate. To do so, see whether your lens has a tiny red dot next to the exact focus line. If so, focus your lens normally and then move exact focus to where the red dot it. This will make your point of exact focus slightly closer and gives you a well-focused picture with infrared film.

## BLACK AND WHITE SLIDE FILM

You can make slides with black and white film, too. Why would you want to do this? Slides are not as popular as they used to be because with digital technology a negative can be scanned and viewed as either a negative or positive. Slides used to be the standard for publication photography but are now used less and less because all images are now scanned. But slides are great for making presentations and are still very much used for presenting photographs to galleries and museums. Every photographer who wants to show his or her work to a gallery needs to be able to make excellent quality slides for this purpose. Many just shoot tungsten-balanced color slides film under tungsten lights, and that works very well, but black and white prints done that way often have a color cast. The color cast may be a slight blue or magenta and is annoying if you love black and white photography.

I have used two different methods to shoot black and white slides that both work well. The best is to use a specially made black and white slide film made by Agfa called Scala. You expose this film normally but need to send it out to a lab that does the special process needed. The resulting slides are gorgeous, with rich deep blacks and clear highlights. These are the best black and white slides, and of course, you can use this film to shoot copies of your work or to make original pictures.

The other method works well, too, but takes a little testing to get it right. Kodak makes a slide development kit for use with regular TMAX 100 film. The kit comes with a few chemicals that you need to mix and store, and you need to expose the film at a lower than normal ISO. But you develop the film yourself, and the processing is very similar to the normal black and

white film-developing procedure. The results are often very good. I have found that I need to boost the contrast to get a good black in the slide, and when I do this, the slides are excellent. This is a great process when you want large-format transparencies. A 4 × 5–inch transparency is really wonderful to look at, and galleries and museums appreciate the larger size.

## DEVELOPING MEDIUM-FORMAT FILMS

Development of medium-format films is the same process as that for 35mm films, but you may need to get a different reel to load it. If you are using steel reels and tanks, you will need to buy a separate reel for either the 120- or 220-length film. (Remember that 120 is the short roll and 220 is the long roll.) If you are using a plastic development tank, the reel probably is expandable. Simply hold one side of the reel steady in your right hand and twist the other side clockwise until it snaps apart. Look at the inside of the reel and you will see a few slots with which the reel can be reassembled at different widths. Snap the reel back together at the width for medium-format film and check with a ruler or piece of film that it is now at the correct width.

**PROCEED WITH CAUTION**

 The first few times you develop medium-format film be cautious when loading it. It is much wider and more flexible than 35mm film and it is very common to slightly crimp the film in the process, producing little crescent shapes in the picture.

There are a few films that are a bit different in medium and large format, though. When you buy Kodak Tri X in medium or large format it is called "professional" and has a slightly lower ISO rating (320 instead of 400) and should be exposed accordingly. Also, Tri X professional doesn't work well with all developers and times, so be sure to read the information packet with your film carefully.

## DEVELOPING LARGE-FORMAT FILMS

Because large-format films come in sheets instead of rolls, you cannot use your regular film-developing tank. I have developed this film two different ways that both work well. The first way is to use open trays in total darkness, and the second way is to use a tank with sheet film holders. Both work fine, but I happen to like the open tray best.

When developing with an open tray, be sure that the room you are doing it in is completely dark. Go inside and close the door and sit there for five minutes. Once your eyes have fully dilated, you should be able to see if there is any stray light coming into the room.

I suggest you get trays that are not too much bigger than your film because the film may slip out of your hands and be hard to find. Agitation is very important when developing all film, and time wasted trying to find your film can cause development problems. I use three 5 × 7–inch trays for developing 4 × 5–inch sheet film.

**FYI**  Pre-soaking is essential for open-tray development of sheet film. Film wants to stick together when it first gets wet, so the pre-soak lets each sheet of film absorb water and prevents it from sticking together in the developer.

Follow these steps for open-tray developing:

1. Set up the three trays.
2. Mix your chemicals and bring them to the proper temperature.
3. When you are ready, turn off all the lights including the safelight, and take out your film. Do not try to develop more than eight sheets at a time.
4. Cut a small edge off one piece of film. This will be the first film into the developer and the first one out to ensure that all the film is developed for the same time. See the following figure.

Cut corner

*When developing sheet film in an open tray, you need to keep track of which sheet went in first to accurately time the development. Do this by cutting the edge off a sheet of film as shown here. This will be the first sheet to go into the developer and the first sheet to come out.*

*(Mike Hollenbeck)*

5. Pre-soak the sheet film in 68°F water. A pre-soak is very important. Place one sheet at a time in water, emulsion side up. Remember that the notches in the upper-right corner indicate that the emulsion is toward you.

6. After all the film is in the water, take the piece from the bottom, gently slide it out, and place it on top. If the sheets stick together, gently peel them apart. Once the emulsion has absorbed water, the sheets will not stick together, which is the main reason for pre-soaking. Also, pre-soaking lets the developer absorb more evenly into the emulsion during short development times.

7. Locate the sheet with the cut edge, set your timer, put that sheet emulsion side up in the developer, and add the others until they are all in the tray.

8. Continually agitate the film by gently removing the one on the bottom and placing it on top. Do this continually for the duration of the development time.

*This figure shows the agitation procedure when developing sheet film in an open tray.*

*(Mike Hollenbeck)*

Agitate
continuously

9. When your time ends, take out the notched sheet first and then the others one at a time. This method insures that even though it takes time to remove the film, each piece should be getting the same amount of development.

10. Then do the same with the stop bath and fixers.

11. Rinse, use fixer remover, wash the same as with other films, and don't forget to use a wetting agent, such as Kodak's Photo Flo.

12. Hang to dry in a dust- and wind-free place.

The other method for developing large-format film is to use a small tank that has holders for individual pieces of film. The film is loaded into the holders and the tank has a lid so you can do the developing and agitation in the light. I prefer the open-tray technique because I have found the tank sometimes gives me uneven development.

Getting comfortable with film developing is important in achieving consistent results. As you have learned, there are a large number of factors that can affect the way your film looks and, consequently, the final print. Being good at developing your film and using pre-visualization will greatly improve your pictures.

# PART IV

# Final Presentation and Storage of Photographs

# HOUR 21
# Finishing Your Prints

## CHAPTER SUMMARY

**LESSON PLAN:**

Now that you have made both RC and fiber photographs, you will learn how to finish the prints. Once finished, you will be ready to mount and frame your pictures.

- Retouching spots
- Using collage and montage to alter a photograph
- Adding color to black and white photographs
- Storing your prints and negatives

Finishing is an important part of making your photographs presentable. Even a great print with good contrast and highlights may need some finishing work, such as covering dust spots or flattening. Without doing so, your photographs will not look as good as they can. Finishing helps give your photographs a professional look.

## RETOUCHING

Retouching can be major or minor, from covering a few little dust spots on the print to actually cutting out little black specks with a knife. The point of retouching is to eliminate or cover things that you overlooked when printing or things that you could do nothing about until after the print was made.

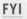 **FYI** Finishing is the last step before mounting or framing your photographs. During the finishing process you will scrutinize the print carefully and retouch spots and scratches that detract from the beauty of your work.

## RETOUCHING RC PRINTS

Because you are mostly using RC paper, let's talk about retouching these prints first. Dust is the most common and immediate problem with photographs. Any tiny speck, either on the negative or paper surface during printing, will leave a white speck that should be retouched.

**GO TO** ▶
For information on using Vaseline or No Scratch to repair scratches, see Hour 19.

During the printing process, look carefully for these annoying specks so that you can correct them before making your final print. Remember to use an anti-static cloth and compressed air every time you print to help fight dust. If you see a scratch use Vaseline or No Scratch.

## USING SPOTONE

Spotone is a brand name of liquid toner that is used to cover the white specks from dust and scratches (see the following figure). It is applied directly to the print surface. Spotone comes in three different tonalities so you can match it exactly to your print tone. As discussed earlier, black and white prints have a little tone to their images, ranging from a slight blue to a slight olive or brown. Most people will not really notice these tones but as you experiment with different papers and developers, these tonal differences will become apparent.

*Here are supplies for spotting prints, Spotone, sable-hair brush, spotting pens, dried Spotone, and a palette for mixing toner.*

*(Tony Maher)*

Spotone comes in cold tone (which is slightly blue), warm tone (which is slightly olive) and neutral (which is a balanced neutral gray). By mixing two or three of these tones together, you can match your print's exact tones. For RC prints I can often use the neutral Spotone with good results.

There are two ways of applying Spotone (see the following figure). The first and most obvious way is to use it straight from the bottle. Follow these steps:

1. Get a very fine brush to apply the toner. I suggest you go to a good art supply store and find a high-quality sable brush. A brush designated with three to five zeros has a very fine point that works well. Photo stores carry spot tone brushes, but I have never found one that was good enough. It seems that they are too thick, and the brush does not hold the toner well. As with any painting project, the quality of the brush is very important. I use a Grummbacher sable-hair brush that was rather expensive, but is excellent.

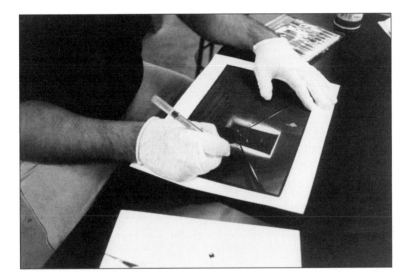

*Here is a photographer spotting dust marks on a final print. He wears cotton gloves to prevent smudging the toner and to keep handprints off the photograph.*

*(Tony Maher)*

2. Use only a tiny bit of toner. Turn the bottle upside down, take off the top, and use the residual toner in the top as your pallet. If you need to mix the toner for your paper, use an eyedropper and mix drop by drop. A little goes a long way.

3. Gently dab the brush in the toner and use a test piece of paper to test how dark the toner is. More toner is darker, and as you use the brush, the toner will become lighter and lighter.

4. Once you have the tone right, gently apply it to the spot on your print. I suggest a spotting action as opposed to trying to draw a line. Dab the spot once and see if it was enough. Repeat for darker spots. I begin by spotting the darker areas of the print first and work toward the lighter tones.

Because RC prints are plastic coated, the toner sits on the surface and needs to dry. When applying it, observe the following:

- Be careful not to smudge the toner during the process.
- Be sure to wear cotton gloves to protect the print from your finger and palm prints. Your skin oils will leave a mark and can even remove some of the toner you have just laid down.
- Do this process under strong light.
- Don't be too discouraged if you see a lot of spots. Be patient and spot them one at a time. I try to go after the most obvious ones first. I also take breaks to let my eyes rest. The more closely you examine the print, the more spots you will see. This is the natural outcome of such scrutiny and is good for reminding you to thoroughly clean and dust your negatives before printing.
- Don't wait for the last minute before an exhibition or presentation to do this. If you ruin a print, which is entirely possible, you will need to go back and reprint it.
- Some Spotone can be removed but there is usually a little bit left behind. Try re-washing the print or use some ammonia on a cloth to gently dab the toner away. In dark areas of the print, poor spotting is not so noticeable, but in a light tone such as a sky, it is very noticeable.

To repeat myself, look closely at your prints for spots when you are making them. You will save yourself a lot of grief by taking the time to make clean prints that don't need to be spotted. Spot toning is an important skill that you will need, so practice this process on bad prints.

## Using Spotone Dry

I do not use my Spotone wet. I dry it first and have found that to be a much better method. To use this method, do the following:

1. Put a drop of toner on the back of an RC print and let it dry completely. This will take overnight.
2. Once dry, the water-soluble toner is ready to use. Take your fine brush and get it damp or slightly wet. Keep the moisture to a minimum.
3. Dab the brush into the dry toner, and it will come off on the brush.
4. Dab the brush to see how dark the toner is and when good, apply to your print as described previously.

The beauty of this method is that the toner is almost dry and therefore sticks to your print and dries very quickly. This helps prevent smudging and lets you see how well it covered the spot. Also, when Spotone is wet, trying to apply more to darken a spot doesn't work well. The second attempt usually smears the first. The dry method lets you add layers of toner to increase the coverage of spots. Like burning and dodging, spotting should be something that only you know was done.

## Using Spotone Pens

Besides the liquid Spotone, there are also felt-tip pens. They come in a pack of 10, ranging from a very light gray to black, and are specially formulated for photographs. Do not use regular felt tips for spot toning; they will not match the color and cause damage to your prints. My students really like the convenience of the felt tips, but I don't think they work very well. Maybe I am just stuck on the old-fashioned way I learned, but it seems that the felt tips offer a lot less control and opacity than the liquid toner, especially when used dry as I described earlier.

Whichever method you use, practice and take it one spot at a time. Cover the big spots in dark areas first. As your toner lightens on the brush, move to the lighter areas. Very light gray skies are the hardest to fix.

**FYI** Try to make your prints as free from spots as possible, but don't avoid using Spotone when needed. Spots make your best prints look terrible. You will need to learn this technique because even the very best photographers have to spot their prints.

After you have spotted a print, take a break. When you return, you will be impressed. Close scrutiny of the print makes you see every tiny spot that most viewers will never notice consciously. Attention to detail is very important in photography, and once spotted your prints will look much better.

## Spotting Fiber Prints

Fiber prints spot the same way as RC prints but generally accept the toner better because the emulsion absorbs the liquid. Different surfaces react differently, too. A very glossy print has a smooth surface that resists holding toner until it is absorbed, and a matte surface has a slight "tooth" that grabs the toner and holds it better until dry. Any fiber print will hold the Spotone better than RC, but fiber prints usually require that you mix the toners to find the right color for effective toning.

## COVERING BLACK SPECKS

Dust on your negative blocks light from falling onto the print and therefore causes white spots, but sometimes you may get black spots as well. Black spots are usually caused by a tiny pinhole in the negative. The hole lets more light through the negative and therefore leaves a black speck.

Tiny pinholes in the negatives are sometimes caused by using an acid stop bath. I do not recommend using an acid stop bath with film, just water. The acid bath can etch the emulsion, creating a tiny hole that leaves a black speck on the print.

With large-format photography, a more common cause is dust on the negative during exposure. A piece of dust or lint on the emulsion blocks the light during exposure and leaves a clear mark that causes a black speck.

Knowing how these black specks are formed can help you prevent them in the future. But once you have them, here are a few ways to try to remove them.

### ETCHING THE PRINT

Etching the print is a very tricky process that can cause permanent damage to the print, and requires some skill and patience.

Using a sharp razor, gently slice the emulsion of the print where the speck is, as shown in the following figure. One bad slice and your print is ruined, but when done carefully, this can obliterate the speck. I have been able to remove small specks this way. I cut the speck out of the emulsion using very gentle slices. The less cutting the better. Once removed, the white of the paper shows through and needs to be spotted. If you are printing a picture and see a black speck that you want to remove by etching, make a few extras in case you ruin one. This will also give you a chance to practice this subtle skill.

### USING BLACK SPOT REMOVER OR BLEACH

Another way is to use black spot remover or bleach made for this purpose. They are both basically photo bleach, and you apply with a brush like Spotone. The print must be washed thoroughly after use. The bleach often leaves the area too light and then needs to be spotted.

*Etching is when you use a razor to gently cut away a black speck in a fiber print. Carefully remove the speck from the emulsion and then spot tone the area.*

*(Tony Maher)*

## APPLYING SPOTONE TO THE NEGATIVE

The third method is to apply Spotone directly to the negative. If you are working with a 4 × 5– or 8 × 10–inch negative, it is a bit easier than trying this on a 35mm negative, but dust and lint are tiny no matter how big or small the negative. To do this you will need a light table and perhaps a magnifying glass. Apply the Spotone directly to the emulsion side of the negative. The base is plastic and will not take the toner, but the emulsion will absorb it. Apply a little and let it dry. Examine it closely and see if it is enough. Apply more if necessary. See the following figure.

*A negative can be spotted to remove black specks caused by dust on the film during exposure. This is not easy and it helps if you are doing it to a large negative.*

*(Tony Maher)*

I would generally suggest you not do this, but it can work well. I have only had to do it once for an important photograph for a book of my photographs and the accompanying exhibition print. The black speck occurred in the light gray sky, was very noticeable, and really detracted from the photograph. The picture was very tightly composed and could not be cropped. I applied Spotone, and when I made the print, the black speck was gone. However, the Spotone created a small white area in the sky. I was able to then spot the print, and after a few ruined prints, I got one just right.

## MAKING MAJOR ALTERATIONS TO A PRINT

You may find it necessary or desirable to make major alterations to a print. While digital technology has made *collage* and *montage* seamless, old-fashioned photographers did this by cutting prints and pasting them back together and by printing from multiple negatives.

### STRICTLY DEFINED

**Collage** is when prints have been cut and pasted together for a special effect, such as adding a person to a landscape. Collage physically alters the print. **Montage** is when this effect is done in the enlarger, and the paper is not affected.

Collage is cutting and pasting something together, and montage is done by combining negatives. Collage and montage were popular back in the 1920s when modern art from Europe was about experimenting with new ways of seeing the world. Photographers cut up many photographs and reassembled them into one print with glue.

Montage is often done by printing different negatives onto the same piece of photographic paper. You can sandwich two negatives and print them simultaneously, or you can print each one onto the paper separately. Like collage, you can add other elements to your print by painting or drawing directly onto the print surface. You can present the print with the surface obviously altered, or to create a more subtle effect, you can rephotograph the altered image.

When making collages, and often when overpainting is done to obliterate something seamlessly, the altered image will be photographed again and printed. This rephotographing can hide a lot of alteration marks and seams where prints have been glued together, creating a single photograph.

Something that is now rarely done is to paint on the negative. I worked for a major photo archive that had negatives from the past 100 years and printed many old negatives that have been painted on. The paint was an opaquing fluid made for that purpose, and the results were usually very clumsy. The fluid resembles old-fashioned Liquid Paper.

It was used mostly to isolate a figure on a blank background, such as a boxer or actor. It seems certain that when done, the attempt was to create a seamless picture, which usually failed. But now that digital technology has made such things easier, the clumsy look of opaquing fluid has a certain charm and unique look. I predict that we will see more collage, montage, and other outdated techniques resurface in the near future.

Negatives can also be masked to remove elements and isolate figures by using ortho tape. Ortho tape is a deep red color and acts like a safelight. When the negative is masked, the light passing through it does not affect the print.

## HAND COLORING

Many photographers who print black and white enjoy the look of hand-colored prints. These by no means resemble color prints with their vivid color, but instead have a soft look that suggests old-fashioned photographs. For much of the nineteenth century, portrait photographers hand colored their prints. Red lips and cheeks are still seen on many old photographs found in antiques stores. Hand coloring has regained popularity and can be found on many greeting cards and in some galleries and books.

**FYI** Hand coloring black and white prints can be a great way to enhance your photographs. The process is quite easy to do and with some practice can be mastered. A kit of hand-coloring pencils can be purchased at most photo stores for around $20.

Hand coloring works best with matte surface prints because the color needs something to hold on to; glossy prints have a smooth surface and matte prints have a slight "tooth" to hold the color. I recommend using matte paper for the pictures you want to color, but you can also use a matte spray on glossy prints, which will help the color adhere. You can color either fiber or RC prints.

If you are using a glossy print, get matte spray or retouching spray made for this purpose. Apply a light but even coat to the print and let dry. This may take a full day.

There are pencils, felt-tip pens, and paints you can use to color your prints. The pencils are easiest to use but with some practice the paint is very good. The felt tips are also easy to use. Marshall is the company that makes these products, and they are available at most photo stores.

Once you have coated the glossy paper or have a matte print ready, you need to coat the surface with a preparation of linseed oil, which comes with the coloring kits. A very thin coating is all that is needed. This helps the colors blend more smoothly. Once coated, gently rub the pencil on the area to be colored. Then take a cotton swab or Q-Tip that has some of the linseed oil on it and blend the pencil marks. The lines of the pencil will blend smoothly into the print. You can add and mix many colors this way. Hand coloring looks best when you choose details or smaller elements to color, as opposed to trying to color everything in a picture. Once applied, let the print dry for a day or so, and the color will not smudge. You can always remove the color or add more or alter the print further by using the linseed oil mixture. To make this permanent, use a spray sealant.

## ALTERING THE SURFACE AND APPLYING SEALANT

You can use sprays to alter and seal the surfaces of your prints, too. There are sprays that block UV rays to help prevent fading and those to add a high-gloss surface or matte surface or seal the print. After hand coloring, use a spray sealant or fixative to protect and coat the surface. These sprays are usually permanent and cannot be removed, so choose carefully and always test them on trash prints before spraying on your finest exhibition prints.

## STORING YOUR PHOTOGRAPHS

Now that you have finished your prints, you should store them in a cool, dry place and keep them away from acids that will deteriorate the prints. Using the boxes that your photo paper came in is tempting but not recommended. Those boxes are not made for photographic storage and over time can damage your fine prints.

Remember that washing prints is to remove residual chemicals, especially acids from the fixer. Most paper products, like cardboard boxes, have acid in them unless they are called archival. If you use photo boxes, the acid from the cardboard leaches into your prints over time. This acid is what makes the paper brittle and can cause stains and fading of your prints.

It is worth your while to buy a few archival boxes from better photo stores or catalogues. Century is a company that makes very good boxes for storing photographs. An 8 × 10–inch box that is 2 inches deep costs around $15. That should be able to hold at least 100 prints.

Keep your photographs out of the light and heat. Keep your negatives in plastic negative preserver sleeves and also out of the light and heat. If you store prints or negatives in a filing cabinet, don't stuff them in too tightly—they need a little room to breathe. Remember that most office paper products, such as file jackets and folders, are not archival. Prolonged exposure to these products will harm your photographs.

So now you know that you can still correct imperfections or create new imagery even after the print has been made. Retouching with Spotone or bleaching out black specks make your prints look professional, and using hand coloring, collage, or montage really changes the photograph into another type of artwork.

# Hour 22

## Presenting Your Photographs

**CHAPTER SUMMARY**

**LESSON PLAN:**

Presentation is a critically important final step before you actually show your photographs. First impressions count, and just like dressing appropriately for a job interview, the presentation of your photographs sends an immediate signal to the viewer.

- How to use mat boards to mount your photos
- Different types of adhesives
- How to create an overmat
- Recommended methods to transport your photographs

Imagine having the most beautifully printed and impressive powerful-image photographs and showing up at a gallery or meeting with a photo editor with your pictures in a dirty paper bag. While any good curator or editor would overlook the bag, the truth is that many are not that open-minded. Besides, good photographs are not the only thing that they have to consider. They have to know that you are going to be reliable to work with and professional, and your presentation is primarily what that judgment will be based on.

Even if you have no aspirations beyond making pictures for your personal enjoyment, the presentation enhances your best work. In this hour we discuss and demonstrate the most popular and useful presentation methods to make you and your photographs look their best.

## USING MAT BOARDS

Because photographs are paper and can be easily damaged, many photographers mount their work to mat board. Mounting provides a stiff support for viewing and framing but also creates a formal presentation that tells the viewer you care about your work and deem it worthy of his or her attention.

Mounting can be done in a variety of ways, but your first consideration is what you are going to mount your photographs on. Mat board is the most commonly used mounting material and is available at art supply stores. However, there are many types of mat boards.

Because your photographs are going to be next to the board for a long time, it is essential that it be acid free. Acid in the board will eventually leach into the print, stain it, fade it, and make it brittle. The best acid-free board is called *museum board.*

**STRICTLY DEFINED**

> **Museum board** is high-quality, acid-free mat board and is the finest board to use for your mounting and matting. It comes in two-ply, four-ply, and eight-ply, and is available at better art supply stores.

Two-ply museum board is stiff but lightweight, four-ply is very rigid, and eight-ply is heavy weight. Each thickness is good for different types of presentations and effects. If you are mounting a photograph to the board, the thickness levels are for rigidity, so four-ply is best. Two-ply is just too flexible, and the board will bow and bend. All three of these plys are used for overmats, which will be discussed shortly.

Another important consideration is the color of the board. I recommend you use a white board or perhaps a black board for most presentations. Many people like colored mat board, though, and you should see what is available and find what you like best. But if you are interested in a career in photography, professionals almost never use a colored board.

Even white mat board, however, comes in different shades and tones of white, from cream to ecru to bright white. Because black and white photographs have a subtle color tone to their image, I suggest you take a photograph with you to the art supply store and hold it next to the various boards. This will help you find a board that looks good with your particular print tone. For example, if you are using a warm-toned paper, a bright white mat board may make the print look yellow and unpleasant whereas the cream board might compliment the print tone.

When you have found the mat board you are going to use, you will need to cut it. Most boards come in 32 × 40–inch sheets, but many good stores will cut it for you, and some even have pre-cut packets of board. Most photographers typically cut their board to the next biggest size photo paper from what their print is on. So if you have a print on 8 × 10–inch paper, try an 11 × 14–inch mat. The next larger sizes are 16 × 20 and 20 × 24. To cut mat board, use a utility knife with a sharp blade, and a steel straight-edged ruler for your guide. If the board is a full sheet, I recommend using a clamp to hold the ruler and board steady while cutting.

## Choosing Adhesives

To mount your photograph to the board, you can use spray mount, double-stick tape, repositionable mounting adhesive, or dry mounting. Spray mount is a spray adhesive, and 3M and Scotch make them specifically for photographs. These usually work well when you follow the directions. For heavier artwork, I suggest 3M's Super 77 spray mount, which is amazingly strong.

 **FYI**  When mounting photographs, choose an adhesive that fits your need. Permanent adhesion is done with spray mount and dry-mount tissue. Reversible adhesion is done with photo corners and linen tape.

## Spray Mount

I often discourage my students from using a spray mount because it is toxic and can be messy. If you are going to use it, be sure you do so in a well-ventilated place that is clean and wind-free. Using it outside is not a good idea because dirt almost always ends up on the freshly sprayed sticky side of the print. For large or heavy prints, spray both the back of the photo and the area of the board you are adhering to for a super strong bond.

To mount a photograph, follow these steps:

1. Buy or cut the board to be larger than the photograph.
2. If you are using spray mount, trim the print, spray it, and press it to the support.
3. Mount the picture so that it is positioned where you want it on the board. I position my pictures in the center, but others like it slightly above center.
4. Then place a protective sheet of paper or light board over the print and *burnish* with a spoon or other tool.

**STRICTLY DEFINED**

**Burnishing,** which means rubbing, makes the adhesion complete by removing air bubbles and forcing the print tightly against the mat board while the glue dries.

## Double-Stick Tape

Double-stick tape is the least desirable way to mount your print, and I only include this method because it may occur to you and because the tape is

readily available. For a good-looking mount, the picture should be totally flat against the board, and tape, unless you apply it to the entire back of the print, lets the print bow slightly. Also, tape is not archival so it will eventually leach acid into your print, dry out, and leave a nasty dried glue behind.

## REPOSITIONABLE MOUNTING ADHESIVE

Repositionable mounting adhesive is very popular and good to use. 3M's PMA is widely available and is archival. It comes in a roll, which you cut to fit your print. PMA is not sticky until you remove the protective sheets. To use it, follow these steps:

1. Don't cut your print until the adhesive has been applied because it can be very hard to get an exact fit. Peel off one sheet and apply it to your print.

2. Once it is on your print correctly, burnish it. It does not make a permanent adhesion until burnished. The material is named because you can reposition the adhesive and print until you get it where you want it.

3. Once applied, cut the print and PMA at the same time for a perfect fit.

4. Peel the second protective sheet and place the print on your board. You can move it as many times as necessary until it is just where you want it. Then burnish it, and you have a permanent seal.

## DRY MOUNTING

Dry mounting is what many photographers use. It is permanent, odor free, and can be archival when you buy the right dry-mounting tissue, which is available at most photo stores and resembles wax paper. The glue is activated by heat and pressure, and you need to use either an iron or a dry mount press—see the following figure.

To mount your print, follow these steps:

1. Place a piece of dry-mounting tissue against the back of the print and use a small tacking iron or conventional clothes iron to tack it in the center only. Only glue the center down and leave the edges unglued for now. A tacking iron is specially made for this and has a teflon coating to prevent the tissue from sticking. If you use a clothes iron, don't use it for clothes again, as it will undoubtedly have some glue stuck to it.

2. Now that the tissue is stuck to the back of the print, trim the print and tissue simultaneously so that they are the exact same size.

3. Position your print on the board and hold it there. (Because you will be touching the photograph, it is a good idea to wear cotton gloves to prevent fingerprints.) While holding the print in position, gently lift one edge. Because the adhesive is only stuck in the center, it will remain against the board. Use your tacking iron to attach the corner of the tissue to the board.

*Here the photographer is using a dry-mount press to mount a photograph. The print is attached to the board with dry-mounting tissue, which is activated in the press with heat and pressure.*

*(Tony Maher)*

**PROCEED WITH CAUTION**

You should test the dry-mounting procedure before using it with your best photographs.

4. You have now positioned the print where you want it and are ready to apply heat and pressure to create a permanent seal. It is best to use a dry-mounting press, but a clothes iron will do. Set the press to 180°F and let it warm up. Be sure the steam function of your clothes iron is off. Use dry heat only.

5. Use thin pieces of smooth mat board or release paper to protect the press plate from any oozing glue, and use heavy paper or thin mat board to protect the print from the clothes iron. A permanent seal will happen in the press after about one minute. Of course, do a few tests before mounting your best print so you know the temperature and time are good for your press and brand of mounting tissue. If you are using an iron, apply pressure and be sure the heat fully penetrates the protective sheet.

6. Remove the print from the press and let it cool under a heavy, smooth object such as a book.

Dry mounting can look very good and has been a popular way of mounting photographs for many years. If you have chosen a good-quality board whose color complements the print, trimmed and mounted carefully, this is a very professional presentation.

## OVERMATS

*Overmatting* creates an even nicer presentation than mat board does, and has often been used with dry mounting. Overmats are very often used when framing photographs because the overmat keeps the glass from touching the print. You never want the glass and print to be in contact because any moisture could cause them to stick together.

**STRICTLY DEFINED**

**Overmatting** uses two pieces of mat board: one with the print mounted to it and the other with a window laying over the print. The image appears in the window and the overmat protects the print. It is perfect for framing and formal presentations.

*This figure illustrates overmat and single-mat mounting presentations.*

*(Mike Hollenbeck)*

Overmats also have a timeless, elegant look that makes the photograph look very sophisticated and suggests that it is a precious object.

Overmats share many of the same considerations as dry mounting. You should choose a board that will complement the picture's tone and one that is stiff enough to provide protection and support. Because there is mat board

behind the print as well as over the print, you can use two-ply board that otherwise might be too thin for dry mounting. This is where the four-ply and eight-ply board also really make a difference. The overmat provides a window that you look through to see the print, so the thickness of the board is very evident. Many artists use the very thick eight-ply mat board when mounting for shows at museums and galleries because of the elegant look. Four-ply is very standard for overmats, but I have also used two-ply overmats. Because the board is thinner, the effect is less dramatic, but the overall weight is much less when I have to carry many prints. For overmats that I will be framing, I use four- and eight-ply board.

Once you have selected your board, cut the outside dimensions. For example, I print my 35mm negatives to 6 × 9 inches on 8 × 10–inch photo paper and overmat them to 11 × 14 inches. You will need two of these per photograph. To cut the window out of the overmat board, you will need a mat cutter. A mat cutter is often a large piece of equipment that holds the board and has a sliding handle with a sharp razor blade. (See the following figure.) These mat cutters are a bit expensive, and you probably won't have one in your home studio. You can, however, purchase a hand-held mat cutter that works well, but it takes more skill to use. Hand-held mat cutters are made by Dexter and Logan and cost around $20.

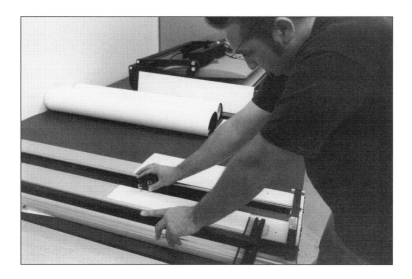

*Here the photographer is using a professional tabletop mat cutter. It holds the board still and provides a perfect straight or beveled cut for overmats.*

*(Tony Maher)*

The idea behind mat cutting is very simple, but doing it well can be difficult. This is an acquired skill that you should practice with cheap board before you attempt to cut expensive, high-quality board. Mat cutters have a razor that is either fixed or can be adjusted to a 45-degree angle. The idea is that you cut the overmat window so that you view the print with the 45-degree angle cuts showing. This angled cut illuminates your fine print without casting a shadow on it, which a 90-degree edge will do. It also looks very nice.

### PROCEED WITH CAUTION

Of all the rules of mat cutting, the most important is a sharp blade. Have plenty of blades on hand and change them often. A dull blade will only ruin your expensive museum board.

Here are a few tips for well-cut mats:

- Don't overuse the blade, keep replacing it.
- Have a piece of scrap board under the mat you are cutting. This gives the blade something to cut into after it passes through your board. Otherwise you may not get a clean cut.
- Overcut your lines just a bit, usually by about ¼ inch. Due to the 45-degree angle of the cut and the thickness of the board, an overcut is necessary or the very corner will not be cut.
- Keep a fresh blade handy. If you don't overcut enough, you can use the fresh blade to gently cut the board. Never tear mat board.
- Wear gloves to keep the board clean.
- If you get smudges of dirt on your board, use a gum eraser to remove them.
- If you get a rough cut with frayed edges, use an emery board to gently file down the rough edges.
- If you are using a hand-held cutter, get a long steel ruler and C clamps to hold the ruler and board still. Press the cutter into the board and cut with it sliding against the ruler edge.
- If you are using a tabletop mat cutter, don't feel you have to cut through the board in one cut—you can make several passes with the blade.

Let's assume you have a mat cutter or have practiced with a hand-held cutter and are ready to go. Follow these steps:

1. Draw a diagram on the back side of the front overmat to show where to make your cuts. Measure carefully. As they say on the home improvement shows, measure twice, cut once.

2. Decide where the window will be on the overmat. I put my window in dead center and like that look, but the more traditional method is to have the window slightly above center. The theory is that when something is in the center, it looks slightly below center. Also, if the bottom of the mat is a bit wider, the viewer knows exactly which end is up, which is not that easy if your picture is abstract. Let's use my $6 \times 9$–inch print on an $11 \times 14$–inch mat for an example.

3. Decide whether you want the window slightly smaller than the picture so the overmat overlaps or if you want the window slightly larger to show the entire print and edges. It is completely up to you and what you find appealing. Currently I cut the mat slightly smaller, but I have done both. If you sign your print on the front, you may want to cut the window larger to show your signature.

4. For this example, I would cut the window to be $5\frac{3}{4} \times 8\frac{3}{4}$–inch, leaving a $2\frac{5}{8}$-inch white boarder all around the window. If you want to make the bottom heavier, move the window up $\frac{5}{8}$ of an inch or so. Now that you have drawn a diagram of the window on the back of the overmat, carefully cut it out.

5. After you have cut the overmat, you need to attach the front and back boards. The best method is to use linen tape. (See the following figure.) Linen tape is acid-free cloth tape with an adhesive. The adhesive can be activated by moisture or by peeling off a release paper, depending on which you buy. I have not had good luck with the peel-off kind; the tape gave way after a few years, so I recommend the other.

**FYI** Linen tape is very useful for mounting, overmatting, and repairing torn artwork, photographs, and mats. It is acid free and has either a moisture-activated glue or peel-off backing. It can be found at any good art supply store.

6. Once you have the front window mat and the back support mat attached, mount the print so it fits into the window. You can dry mount it as discussed earlier, use linen tape to hinge it in place, or use photo corners. Linen tape is often used by professional framers. The tape can be folded over to form a loop or folded once to form a hinge. If the print must be removed, a gentle slice from a razor will free it. I prefer to use photo corners so that I can change the picture in the mat at will (see the following figure). Photo corners and linen tape are available at most good art supply stores.

*This illustration shows the linen tape and photo corner mounts for holding photographs in your mats. Both are great because they hold the prints securely but are reversible for reusing the mats later.*

*(Mike Hollenbeck)*

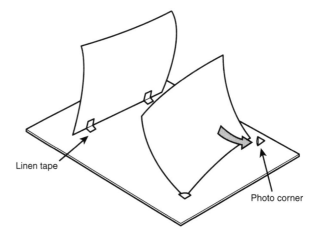

Linen tape

Photo corner

I like the flexibility of being able to use my mats for different pictures as my needs arise. That is one reason for cutting my overmat window so that it is in the center of the board. The window can then be used for horizontal or vertical images of pictures of the same size on the same size paper. So I have a lot of 11 × 14–inch mats with 6 × 9–inch windows. The pictures are mounted with photo corners so that I can use the mats with any pictures that size.

Again, museum board is the finest quality, not only because it is acid free but because of its texture, surface, and color. Moreover, cheaper board often has a slightly yellowish core, which is seen in the beveled cut. This yellowish core looks very bad and hurts the presentation of your work. Quality board is the same tone throughout and shows that you are concerned about the preservation and presentation of your work. It is well worth the extra cost.

## TRANSPORTING YOUR PHOTOGRAPHS

Presentation is not just the mats or mounting but also the containers you use to transport your work. This is especially true when you are bringing your work to galleries, museums, and magazines. Again, the presentation is sending signals about you, your work, and your professional attitude. It is not necessary to spend a lot of money, but then again, a good-quality case for your work will not only good great, but will last a long time.

When I was first showing my work around, I used a box that photo paper came in. The big orange Kodak box looks rather tacky for this purpose, so I simply spray painted it flat black. I first reinforced the corners with linen

tape and after spraying, I used a rag to rub the surface and remove excess paint. While I now have a much nicer box, the old photo box worked very well and had a professional, if modest, look.

Many good photo and art supply stores sell cases for carrying and shipping your work. When buying a case, consider what your needs are, what impression you want to make, and who you are planning on showing the work to. The following figure shows three popular carrying cases.

*Here are three types of cases for presenting and transporting your photographs. The presentation case with handle is great for matted prints. The shipping case is very strong and protects prints and mats. The third case has plastic sleeves for photographs and is ideal for commercial photography.*

*(Tony Maher)*

There are two basic presentation strategies—one is for fine art and the other is for commercial art. The fine art presentation is the overmat or the dry-mounted print on museum board. For transporting this work, a clamshell box is perfect. Clamshell means that the top is hinged and the box will open and lay flat. This enables a curator or gallerist to view the prints without taking them out of the box: He or she just slides them from one side to the other. Century boxes from good art supply stores are perfect for this and they are quite inexpensive. A bit more money but also more impressive is the box with a handle, and some are made of stronger material. This presentation is clean, elegant, and emphasizes the artistic quality of the work. It can work well for showing the work to magazines' art directors as well as galleries and museums.

The commercial presentation is less fussy and more utilitarian, especially for newspapers or less formal organizations. A zipper binder with clear pages

works well for this. It has a handle and an inside pocket for promotion and business cards or for sheets of slides. The plastic sheets protect the prints and tearsheets (pages from publications). A photo editor or art director can quickly go through the book without worrying about damaging your prints. The commercial sector is less concerned about your fine art prints and more concerned about the impact of your pictures and your experience as a photographer. This presentation is not good for curators or gallerists, who will take more time and scrutinize your prints as well as the imagery. These commercial binders are also available at good art and photo stores.

If you are shipping your work, you obviously need a much stronger case. I have separate cases for separate uses, from a commercial portfolio to a fine art portfolio to a hard shipping case. The shipping case I use is hard plastic with straps and a holder for the address card. You could stand on it if you wanted, and the pictures would not be damaged.

If you need a less expensive container, a photo box is okay, but be sure to securely bind the photographs in foam core and plastic to ensure their safety. I have had many prints damaged during shipping.

## STORING YOUR PHOTOGRAPHS

Again, photo boxes are not acid free and should not be used to store your photographs for a long period of time. An acid-free box is best, and there are inexpensive ones made for just this purpose. I save the plastic bags that my photo paper comes wrapped in and often reuse them if I need to store prints in photo boxes.

**JUST A MINUTE**

Store your photographs well so they will last a lifetime. Get acid-free boxes and store them out of direct sunlight and away from chemicals or where you cook. Proper storage means that your photographs will always be ready to be shown and prevent you from having to reprint them later.

**PROCEED WITH CAUTION**

Keep your photographs out of direct sunlight and away from moisture and chemicals. Be careful to avoid storing them near your kitchen where oils from cooking can contaminate them. Storing your fiber prints face-to-face helps flatten them, too.

Now you know how to present your photographs to make them look their best. Don't underestimate how important your presentation is; take the time to mount or overmat your photographs well, and find an appropriate case. A fine presentation will enhance every picture and maximize your career opportunities.

# PART V

# Photography as a Career

# Hour 23

# Careers in Photography

## Chapter Summary

**LESSON PLAN:**

Now that you are out photographing and making your own prints, you are probably having a lot of fun and wondering if you could make a living doing this. The good news is that there are many opportunities for photographers. The bad news is that finding those opportunities is not easy. In this hour you learn about the myriad career opportunities in photography, the necessary qualifications, and how to go about finding them.

- Exploring opportunities in commercial, editorial, and fine art photography as well a teaching career
- Assembling a job- or field-specific portfolio
- Getting started with an internship or apprenticeship
- Establish firm guidelines regarding your fees, when your work can be used, and how you are given credit

Because so many of us love photography, there are a lot of photographers out there trying to make it. Unlike many other fields, photography jobs are rarely listed in the newspaper want ads or other traditional venues for finding work. But the field is also very open to those with good skills and a willingness to work hard and seek out those who need photographs.

In our increasingly specialized world where advanced education is essential to succeed, photography is still one of those areas where someone with little or no formal education can be just as successful as someone with a graduate degree. But it is not easy and requires you to go out and sell yourself and your photographs, and to find those who want your services.

**FYI** Unlike many other fields, photography is one in which your images and hard work often count for more than your formal education. Consequently, the field of photography is quite open to young people. Great photographs and hard work are what will get you work.

## Commercial Photography

Commercial photography is just about any picture that is used to sell, promote, or display something. Besides our personal family pictures and those made for artistic gratification, most photographs that we see every day fall into this category.

Look around you and notice how many photographs are used. Billboards, magazines, newspapers, brochures, signs, greeting and post cards, posters, and even television and movies use still photographs. Someone has made each of those pictures and was paid for it.

So how can you get a piece of the action? First, you must educate yourself and have excellent technical and creative skills. You have taken the first step in buying this book, reading it, and following the advice. You must photograph a lot and work hard to make beautiful prints. Your first step to getting work as a photographer will be to assemble a *portfolio* that demonstrates your skills.

**STRICTLY DEFINED**

A **portfolio**—sometimes called a book—is a selection of your photographs. Depending on whom you are showing them to, your portfolio could be pictures from a single subject matter or a variety of pictures of many subjects. A portfolio usually has around 20 photographs and should be appropriate to the type of work you are looking for.

## How to Assemble a Portfolio

There is no right way to do a portfolio. Each working photographer has a different approach and idea of what makes a great portfolio, and with practice and experience, you will find what works best for you. A portfolio should show your strongest work and demonstrate your abilities. It could possibly have a lot of pictures of a broad variety of subjects or could be a small number of pictures of only one subject or idea. It could be a picture story or images that have no relationship other than the fact that you took them. Some people are generalists and others are specialists, and each type of photographer will have a different portfolio. (See the following figure.)

Ask yourself who your audience is. If you are interested in photographing products for catalogs, think of assembling a portfolio of this type of work. Look at catalogs and try to figure out how the photographer did the pictures and recreate them. It does not matter if the pictures in your portfolio were not done for a client as long as they look good. I suggest you show the kind of work you would like to do. If you want to do portraits, have a lot of them in your portfolio. Having an idea of the type of photography you would like to do is a big help. It is very hard to try to be all things to all people, and those who do usually end up being mediocre at everything and a master of nothing. I don't want to suggest you not try many things, which you must to improve your skills and gain experience; but as you learn, you will inevitably start to find some things you prefer to do over others.

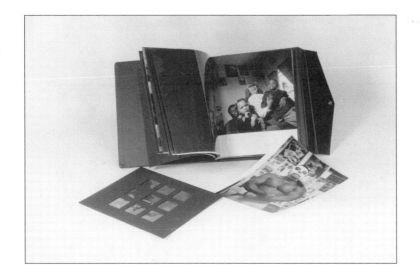

*Here is a typical portfolio for commercial photography. The plastic pages protect the prints, and the photographer's name is embossed on the front. Inside are sleeves for business cards, promotion cards, and additional material.*

*(Tony Maher)*

**FYI** Tailor your portfolio so that it is appropriate to the venue. A mainstream women's magazine is going to be interested in something different than a contemporary music magazine would be. Know your client by reading about it or visiting it often before showing your work.

Commercial portraiture and wedding photography are two major fields of photography, and both are quite specialized. They are not particularly difficult fields, but learning how others do them is important. Most clients of mall portrait studios are not looking for some work of amazing fine art—just pleasant, flattering pictures. (See the following figure.) Weddings are a lot more complicated, but if you look at wedding albums, you will see that there are certain setups and poses that seem to be used repeatedly. And there are more than a few books on the subject.

For commercial portraiture, I would suggest you see about getting a job at a studio. Many of my students have worked at a mall photo studio, and they learned very quickly the setups and poses. They also learned the valuable people skills and how to sell the images. Most of them left after a short time. The pay wasn't great, but it sure beat having to pay someone to teach them the same thing. They gained great experience.

Wedding photography is considerably more complicated, and there are excellent photographers who have honed their skills over many years. But they need assistants to carry bags, load film, hold lights, and help arrange poses. Being an assistant to a photographer is another valuable way of gaining experience that is hard to get elsewhere. To be an assistant, you will

need to demonstrate that you have good photographic skills, so put together your best pictures in a portfolio, and start knocking on doors and checking job listings.

*Here is a typical commercial portrait. The photograph is flattering, well lit, and was commissioned by the sitter.*

*(Matthew Richardson)*

## EDITORIAL PHOTOGRAPHY

Editorial photography is that done for magazines and newspapers and is a particularly open and exciting field. Most magazines and newspapers use freelance photographers, so there are many opportunities for ambitious and talented people. (See the following figure.) Freelance means, however, that you are not on staff and that you probably have no contract or any assurance of work. You are hired on the quality of your photography only. This is a highly competitive field but incredibly open to new and young people. It is hard work, and you are constantly judged on your work. But if you have the courage and determination, it is extremely rewarding and fun.

**FYI** Editorial photography is one of the most interesting and open areas of photography. Every magazine and newspaper uses editorial photography. To break into this field, you need to assemble a great portfolio of powerful images. Most will not care if you are young or old, educated or not. It is all about the pictures.

*This portrait of artist Andre Serrano was done on assignment for* The Village Voice *newspaper. The photograph accompanied a review of Mr. Serrano's art exhibition.*

*(Thomas McGovern)*

Open any magazine and look at the photographs. You can bet that most were done by freelance photographers. Now if you are looking at *Vogue, Time,* or *The New York Times Sunday Magazine,* those photographs are done by some of the best photographers in the world. However, look at some of the less prestigious magazines, and you will see work by a large group of photographers, many of whom may be just starting out.

How do you get your foot in the door? Assemble a strong portfolio and take it around to the magazines. New York City is where the vast majority of them are located, so if you don't live there, the job is immediately harder. But there are publications in every town and city that could use photographs.

Before approaching a magazine, look at it and read it for a few months. Familiarize yourself with the photographers and writers; look at the photo credits next to each picture. Look at the masthead in the front of the magazine to see who is on staff and who the art director and photo editor are. When you start to have a feel for the kind of work the magazine uses, you can tailor your portfolio to be appropriate. For example, if the magazine or newspaper is very proper and conservative, don't put kooky or weird pictures in your portfolio. Even if they are your best pictures, the magazine will not be impressed. If the magazine does a lot of picture stories, try to come up

with some ideas of your own to shoot. Your first assignment will probably be relatively simple, like the first job I did for *A&U Magazine,* as shown in the following figure.

**FYI** Most freelance photographers have story ideas that they have come up with themselves. These self-assigned stories often become their portfolios and are what get them published in the first place.

*This editorial spread using my portraits of actor Ron Dennis was done on assignment for A&U Magazine.*

(A&U Magazine)

In the world of editorial photography, photographers and writers generate a lot of stories, and it is a great way to get into the magazine. I photographed at two small African American churches for around six months and brought the pictures to the *New York Daily News Sunday Magazine.* They bought the story and published it as I submitted it. From then on I got more work from them. Many, if not most, photographers in photojournalism and editorial photography start this way. Come up with your own ideas for stories and individual pictures, do them, and then show them around. Obviously, this puts all the pressure on you, the photographer, and means that you are self-financing your work. I recommend you think of it as investing in your career. This is not like being an accountant where you go to school, learn a trade, and get an office job. Editorial photography is about you're ability to make great pictures and then get a publication to print them. From then on, you can get assignments from the publication.

**FYI** Once you have been working as a freelancer for a while you may want to find an agent. There are individual agents as well as agencies. The Associated Press is a huge news agency, and there are many smaller agencies that specifically represent photographers. When they find you work, they get a percentage of your fee.

There are agencies that many freelance and editorial photographers work with, but wait until you have a good portfolio and some work under your belt before trying to find an agent. They rarely take on someone with no track record.

The skills required for editorial or news photography are considerable. You must be able to use your flash very well. Flash-fill photography—using the flash outside to fill in the shadows—is a skill you must master. You must show strong compositions with foreground, middle-ground, and background elements, which make for interesting pictures. People skills are essential, too. You need to be able to meet and deal with many different kinds of people and not be shy. Assertiveness is a big asset. You also need to know current events and local news. Read your local and a good national newspaper every day and become familiar with the political and cultural issues of the moment.

## INTERNSHIPS

One way you can begin assembling a great portfolio and get to know the business is to be an intern. Internships vary from organization to organization, so there is no set rule as to what an internship will entail. How do you get an internship? Call your local newspapers, no matter how small or large, and speak to the photo editor or art director. For very small publications, you may end up talking directly to the editor.

Internships are the most direct access to the business and are invaluable learning experiences. One of the most difficult aspects of editorial and news photography is getting the chance to prove yourself, and that is exactly what an internship provides. Do not think of an internship as an unpaid job. Imagine getting the opportunity to go to the best school in the country on a scholarship; this is what an internship is. But be aware that internships are highly competitive, and you may get rejected a few times before you actually get one. As a college professor, I try to arrange for my best students to do internships each summer and have seen their work and careers bloom from the experience.

An apprenticeship is pretty much the same thing as an internship. Photographers may be willing to take you on and let you learn on the job. But again, there are no rules for what this might entail, and you would need to work out the details. Every commercial photographer uses assistants, too. A photo assistant does anything and everything, from loading cameras to carrying bags to making prints. Some of the busiest photographers employ groups of full-time assistants and have freelance assistants to call upon.

Assisting is a career in itself but is usually a fallback for those who are not able to make enough money directly from their photography. There is absolutely nothing wrong with that; many photographers don't make their living completely from their photographs. Those who do have built up a client base over many years, work very hard to maintain those clients, and are always seeking more.

 **FYI** What internships are to editorial photography, assistantships and apprenticeships are to commercial photography. Commercial photographers need assistants who have good photographic skills to help out on assignments, and this lets you get on-the-job training.

The following are skills needed as a photo assistant:

- Excellent technical skills
- Knowledge of lighting, and particularly studio strobes
- Working knowledge of how to use electronic light meters
- A willingness to work hard for long hours

How do you get an assistantship? Assemble a portfolio and then call photographers who might be able to use your services. Photo assistantships are sometimes listed in photo magazines. You can also post flyers at photography stores and labs that professionals use. New York's labs are full of these flyers from assistants seeking work.

## BUSINESS PRACTICES

Good business practices are essential in any field, and photography is no exception. Carefully managing your money, maintaining clear and accurate records, separating your business expenses from personal, and organizing your receipts are important. Being clear on your tax liability is essential, and you may want to consult with a tax professional, as everyone I know does, before taking deductions.

However, the photography business also has some unique practices and protocol. The following are some tips to help you when starting out.

## Negotiate Your Fee in Advance

Negotiate your fee and expenses in advance. Newspapers and magazines have set fees, either per assignment, per picture, or a day rate. So if you work for them, there is little room for negotiation unless you are on a long-term or special assignment. But you will need to do this for many clients. Your fee is separate from your expenses reimbursement, and you should always negotiate them separately. Expenses add up quickly so be clear on exactly what it costs you to make pictures. Some clients may require you to provide receipts for specific expenses, but most will let you just submit a bill for film, processing, and printing. I buy my film in bulk and need to keep the receipt for my business expenses. But if you rented equipment or hired an assistant, they may require the original receipt. I have worked for more and less money, depending on who the client was and how interested I was in the job. The bottom line is to be absolutely clear on what you are getting paid, when, and the terms of the arrangement.

### PROCEED WITH CAUTION

 Before you take on a photography job, be absolutely clear on the financial arrangement. Negotiate with the client to establish your fee and be clear that your expenses are separate from this. Expenses add up quickly so always have them paid separately.

## Usage and Limitations

Be clear on the usage and limitations. Publications who hire freelancers typically want one-time usage. This means they use your picture one time only for the fee paid. If they want to use it again, they need to get your permission, and you can (and should) be paid again. Depending on the client, be clear about the usage, whether it is for a single printing or reprints, national or international usage, and if they want to use it on the Internet. All of these things and more may be negotiated. Most publications will have a set list of their usage requirements that you will need to agree to. If you work for *Time* magazine, you don't get to dictate the terms of usage, but smaller organizations, those that don't hire photographers regularly, may not have set guidelines. You will need to be clear about the rules in advance.

## PHOTO CREDIT

Be clear on your photo credit. Your photo credit is the most valuable publicity tool you have. One good photograph in an important publication is worth countless dollars of publicity. (See the following figure.) By having an image in a major venue, you are immediately seen as legitimate and your work is deemed valuable. I insist that my name appear alongside my photograph and will fight for that. I will accept a lower payment before giving up my photo credit. I do not accept having my name in tiny print in the back of a publication where no one will see. Once your name starts appearing in print, you will get calls to reprint the work and for other photos from the shoot. These resales are an important means of income and extremely valuable, but if no one knows who took a picture, you won't get the resale. Also, the tear sheets from published work are an important part of your growing portfolio. Without your name on the picture, who knows if you really took the picture?

*Here is my photo credit for the annual report. Photo credits are invaluable promotion for your work. They are widely seen by photo editors and art directors who hire photographers, and prove that you are capable of working on assignment.*

*(AIDS Council of Northeastern New York)*

AIDS Council of
Northeastern New York
88 Fourth Avenue
Albany, NY 12202
(518) 434-4686
1-800-660-6886
FAX (518) 427-8184

Photography by Tom McGovern, Schenectady, NY

## CREATE AN INVOICE

Create an invoice that states the terms of the agreement. I was lucky enough to be mentored by the great Fred W. McDarrah at *The Village Voice* newspaper in New York. Fred is a master of the art of negotiating, and I owe him a debt of gratitude for his instruction on creating an invoice with the proper limitations and protections. At the bottom of your invoice, have the agreed-upon conditions of sale clearly spelled out:

- Photo credit must accompany print on the same page
- One-time use only permission for reproduction
- Prints must be returned in good condition after use
- Lost or damage prints billed at $150 each
- Omission of photo credit billed triple

These are the kinds of things you want on your invoice to protect your work and career.

# HOW TO PRICE YOUR PHOTOGRAPHS

How do I price my photographs? This is the first question usually asked by anyone who wants to sell work, and there is no right answer. The first question is: What is the purpose of the sale? Is the buyer getting a beautiful photograph that will be framed and hung as artwork? If so, it is entirely up to you and the buyer to decide on what is fair. I suggest you begin modestly. A good price for a photograph is $100, but that might be too much for some to charge. Ask yourself how important the sale is, who is the buyer, how much work was involved in the making of the photograph, and whether you have a track record to maintain. Whether negotiating a fee for a shoot or the price of a print, be reasonable. It has a lot do to with your experience and who the buyer is. If you have never sold a photo and your dentist wants to buy one, I would suggest coming up with a price, say $75, and asking if that sounds reasonable. You can always drop the price if you want to. Of course, the other side of this logic is that you can't increase the price, so once you get some experience, and depending on who the buyer is, you can start high and then reduce.

Remember that if you are negotiating a photo shoot, always have the expenses itemized separately. If it is for a print that you already have made, you can be more flexible. For the most part, you can always make another print. Of course, you can ask the buyer or client what they feel is appropriate first and then negotiate up.

## FINE ART PHOTOGRAPHY

The career of a fine art photographer is a lot more challenging but personally much more rewarding. The challenge is that there is a limited market for artwork, and you will need a gallery to show the work and conduct the sale. Just getting your work shown is a major accomplishment at which artists work years to achieve. Don't be seduced by the high auction prices you have read about and think your work will fly off the gallery walls. Collectors are a fickle and conservative bunch. Most are looking for good investments and may know very little about art, so a safe bet for them is a well-known, brand-name artist.

*This is an exhibition of fine art photography by Tony Maher. The photographs are overmatted and framed.*

*(Tony Maher)*

**FYI**  Fine art photography is the most difficult to succeed in but the most rewarding to do. Very few artists can support themselves solely from their photographs and so they often do freelance editorial work, teach, or work in galleries or unrelated fields. The reward is doing what you love and not having to reduce your vision to a commodity.

To have a career as an artist you need a body of work, the equivalent of a portfolio. But there is a big difference between artwork and commercial photography. Artwork is personal, reflects your unique point of view, and has content. By content, I mean that it has a message or idea beyond what is represented in the image. Artwork is made for yourself and requires you to scrutinize the meaning and appearance of the work and to understand contemporary art practices and the history of the medium.

Although you don't need to go to school to make artwork, criticism of your photography by those with more experience and a deeper understanding of contemporary artwork is invaluable. An important element to a career as an artist is to be aware of contemporary issues. This means you need to educate yourself by going to galleries and museums and reading books of photographs and those on theory and criticism. I should stress that you need to look at more than just photography, too. The contemporary art world is becoming less a divided community of separate mediums and style and increasingly a continuous field joined by issues more than style or mediums. Art magazines can be intimidating because the language that many art writers use is specialized, but don't let that discourage you. Just like science or any other field that people devote their lives to, art has specialists and experts who have developed language to express the complexity of the art experience.

## PROCEED WITH CAUTION

Before approaching a gallery with your photographs, take a few months to look at the shows they mount and go to their openings to meet people. Once you get a feel for what kind of work they exhibit, you can tell if your style and work will have any relationship to what they represent.

To educate yourself about issues in art, read. See the list of books and magazines in Appendix C. These publications will give you a good idea of the contemporary issues that many photographers are exploring. A particularly good and easy-to-read book is *The Photograph* by Graham Clarke. This book covers the history of photography, masters of the medium, and many important issues that resonate with artists today. It is very well written, so most people will be able to learn a lot from it. Two other great books on the impulse to make pictures are written by the great photographer Robert Adams, *Beauty in Photography* and *Why People Photograph*. Both are written from Adams's personal perspective on the act of making pictures and what they mean— and he is a master of taking profound ideas and expressing them clearly in nonspecialist terminology.

What do galleries and museums look for in a portfolio? The interest of curators and art dealers is as varied as the pictures they see, but a few things are certain. Fine-quality prints and strong imagery are clearly essential. Content, what the photographs are about, is too. I recommend your portfolio be of beautiful photographs that are overmatted and in a nice box. (See the following figure.) Be sure your pictures are as perfect as they can be. Many galleries and museums have specialties, and before you go out to show your work you need to educate yourself about the type of work they show. This is

the same advice I gave about approaching a magazine—get to know what they have done so you can judge if your work has any relationship to it. Also, you will to have need a tough skin and be willing to accept rejection, criticism, and sometimes insults.

*This is a typical fine art photography portfolio. The prints are overmatted and carried in a clam-shell box.*

*(Tony Maher)*

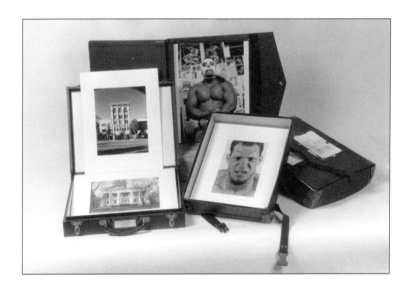

**JUST A MINUTE**

After you have a selection of strong photographs that you love, you can begin trying to get your work into exhibitions. Begin by looking in the back of some of the art magazines listed in Appendix C that have listings of galleries that are soliciting work. You will need to shoot slides of your prints for submission.

A good way to start your art career is to look for opportunities to show your work in the back of magazines. *Artweek*, *Afterimage*, and *Art Papers* magazines all have listings of galleries that are looking for work. You will need to have slides to send them. I shoot slides directly from my prints and send along an artist's statement, resumé, and always include an SASE—a self-addressed, stamped envelope for the return of your work.

## TEACHING

Once you have developed your skills as a photographer, teaching others may be an option. For most teaching jobs, a graduate degree is required, but you can teach workshops or at the high school level or at community art centers based solely on your professional experience.

Although this is a teach-yourself book, there are certainly limitations to this approach. The most obvious one is that you do not receive the criticism of professionals who know the medium, its history, and the field. Criticism is a major part of the academic experience and invaluable to a fuller understanding of your work. Every college and university has day and evening photography classes, and if you are fortunate enough to have a good community college system in your state, such as the one in California, you can take classes with excellent professionals for a very modest fee.

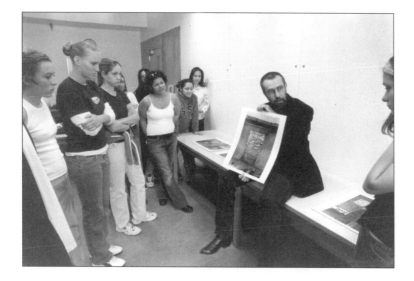

*Getting good criticism is invaluable, especially when you are just beginning to make photographs. Teachers and those who lead workshops routinely offer advice, suggestions, and criticism. The point of criticism is to give the photographer an honest, objective, and informed opinion of his or her work.*

*(Tony Maher)*

Here are some other great ways to get professional feedback: There are photography workshops and seminars that feature portfolio reviews, such as Fotofest in Houston, the annual conference of the Society for Photographic Education, among others.

If you wish to continue with your education and contemplate college teaching, you will need a graduate degree. There is the M.A., the Master of Art degree, and the M.F.A, the Master of Fine Arts degree. The M.F.A. is the terminal degree, meaning that it is the highest degree for studio arts, comparable to the Ph.D. for scholars. Many universities offer the M.A. and M.F.A. degrees, and you can find a good listing of those schools and their programs from the Society for Photographic Education and the College Art Association (see Appendix B).

As you progress as a photographer, the idea of a career in the field will certainly cross your mind. The preceding lesson will help you tackle the basics of getting started and discovering whether it is something you want to do. Truthfully, few working photographers that I know of consciously started out thinking they would have a career. Most got into it by working hard and accepting opportunities that arose, usually while they worked in other fields. Then one day they discovered that they were actually making enough to quit their "day jobs." I wish you luck with your career.

# HOUR 24

# Setting Up a Home Studio

Just like the home darkroom, the home studio can be set up in just about any space, temporarily or permanently; it really depends on your needs. If you want to make still-life photographs, a closet may do; but if you want to photograph people, you will need a bit more space.

Of course, your space requirements may dictate the kind of pictures you can make, but in this hour we go over some temporary solutions that will give you the most flexibility for whatever you plan on photographing.

## SPACE REQUIREMENTS

Photography studios can range from the entire floor of a building to a spare bedroom to a closet. For working professionals, the needs will dictate the space. But don't think that every professional photographer has a big studio. The overhead to operate one can be daunting even to busy working professionals. It has become very popular to rent studio space as needed. So if you are photographing a car, you rent the huge drive-in, ground floor studio. This expense is borne by the client who covers your expenses.

**FYI** A photo studio can be any space in your home or garage, even a closet, depending on what you are shooting and how much equipment you have.

This "have equipment, will travel" attitude is much more affordable and lets you take on jobs that might otherwise

be impossible. Look in your yellow pages and in photography magazines such as *Photo District News* for studio rentals. There are established studios that rent the equipment as well, further reducing your overhead.

It is important that the studio appear professional if you are having clients over. Don't kid yourself that it does not matter. People are paying money for your skills and services and as every good businessperson knows, they need to feel that they got their money's worth. This is often a matter of appearance as much as the product they receive so go the extra mile to make your studio, even a temporary one, professional looking. See the following figure.

*When you are just starting out, you do not need these swell studios. Most beginning photographers are probably going to be concentrating on local photographic needs such as weddings, anniversaries, and formal studio portraits of families, children, and pets. For this, a spare bedroom works well.*

*(Matthew Richardson)*

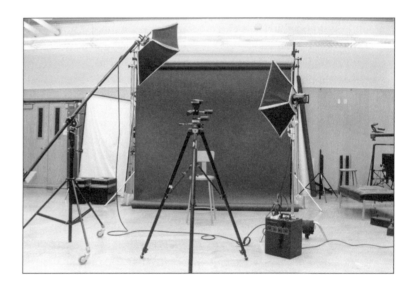

If you are using a bedroom, remove the bed before a client comes over. The space should appear to be devoted to the photography session, and a bed could obviously be sending some very uncomfortable messages to your client. At the very least, move the bed against a wall and lay out your equipment and maybe some photographs so that it appears as a work surface. You really need to think of the client and his or her reaction. This is why so many photographers have studios or rent them in the first place: to present a professional appearance that gives the client the confidence that you know what you are doing. Remember that his or her comfort and confidence is what will set him or her at ease and make your job of getting a good picture much easier.

So carefully consider your space. A part of your living room or dining room may be a better place for your studio than a cluttered bedroom that needs a lot of furniture moved out. The main thing is to have the space be flexible if it is not devoted to being a studio.

A large closet or any corner of a room can be a great studio if clients are not being photographed there. This works well for still-life photography, product photography, and food photography, as shown by the following figure.

*Eric Nelson creates these wonderfully elaborate and weird still lifes in his tiny home studio. Because no clients are there to be photographed, the appearance does not matter.*

*(Eric Nelson)*

## THE TEMPORARY STUDIO

A temporary studio is probably a lot more practical than a devoted space in your house or apartment. A temporary studio is one that can be stored in a closet and set up before the client arrives or can be taken on location. I use a temporary studio in addition to a fully equipped, dedicated studio. The difference has to do with the equipment. The temporary studio equipment is easily folded up and stored away, and can be transported as necessary.

 **FYI** There is nothing wrong with a temporary studio that you set up on an as-needed basis. Keep your equipment and lights in the closet until needed, and then move the furniture and set up before the client arrives.

## EQUIPMENT REQUIREMENTS

Here are the basic equipment requirements for a home studio:

- Two to four flash units. These can be as simple as good camera flashes or as sophisticated as studio strobes.
- Light stands and grips for the flashes. Grips are what hold the flash to the light stand.

**GO TO** ▶
For more on flashes and slaves, see Hour 5. For more on studio equipment, strobes, umbrellas, and light stands, see Hour 14.

- Slaves for the flashes not connected by synch cord to the camera.
- Synch cord.
- Umbrellas or softboxes for each flash.
- At least one reflector.
- Stand and grip for reflector.
- Background paper.
- Flash exposure meter.
- Camera.
- Tripod.
- Fan.

**PROCEED WITH CAUTION**

 Don't get caught up buying expensive equipment before you are ready. Check out used equipment and even yard sales. Also, remember that large camera stores rent equipment.

## HOW TO GET YOUR BUSINESS STARTED

Now that you've found the spot in your home to use as a studio and have gathered your equipment, you are ready for your first clients. But how do you find them?

Look around and remember that photography is everywhere and pictures have countless uses. You need to begin figuring out what kind of photography you want to do and then come up with a strategy for attracting the right clients.

If you are interested in weddings, there are a lot of options. But as with all of the photography professions, you need a portfolio to show prospective clients what you can do.

From there, some good marketing skills and ideas can be developed:

- Make business cards that you can hand out and leave at photo stores and other businesses. Cards give you some immediate stature as a professional.

- Join professional associations for the field you are interested in. Do Internet and phone book searches and ask other professionals about sources for equipment, supplies, and clients. While no one is going to give you their greatest client, I have been given clients that other photographers couldn't help or didn't want to work with.

- Create flyers that you can hand out at events, send out as mailings, and post at the supermarket or other places. One client will make up the cost of 1,000 flyers.

- Consider advertising. Having your business name out there is a huge advantage.

- Be versatile and don't turn jobs down. Every bit of experience is valuable. I regret turning down opportunities that I now realize could have been important learning experiences.

- Continue to educate yourself about photography and products. Know that you can rent equipment and that the client should pay the rental fee. I have turned down many jobs because I did not have the right lens or lighting equipment and didn't realize I could have rented them.

- Don't give up your day job. This may sound defeatist, but be realistic. It takes time to build any business and a steady income may take years to develop. Stay focused on your goal, be persistent, and you will succeed.

Your home studio is a great advantage to starting your photography business. Many jobs require a controlled environment, and if you have the equipment and know-how, you can serve the needs of more clients. Most photographers work for many different clients who have various needs, so being versatile and flexible is a great asset.

After reading this book, I hope you are enthusiastic and excited about making photographs. I began my career as a photographer by accident. I was planning on going to law school and took a photography class in college. After a short time, I discovered that I loved photography and decided to

devote my spare time to it. After a few years, I was getting enough small photography jobs that I was encouraged to pursue it full-time. But the point of this book is not to make you into a professional photographer—although that might be your goal. What I want you to come away with is an appreciation for this wonderful medium, how profound great photographs can be, and how much fun it is making them. Photography is one of the hardest but most rewarding things in my life, and I am grateful to my teachers and students for letting me live the life of a photographer. I hope you find photography as rewarding as I do.

# APPENDIX A
## Glossary

**agitation**   The process of inverting the developing tank to keep fresh chemicals flowing over the film.

**ambient light**   The continuous light existing in a given situation. Sunlight and artificial lights produce ambient light. Ambient light is what is read by your camera's light meter.

**aperture**   An adjustable hole in a lens that is opened (to make larger) or closed down (to make smaller) to control how much light comes into the camera (or passes through the enlarger).

**archival processing**   The print or film has been processed in such a way that no residual chemicals, especially acids, are present. This entails using fresh fixer and a fixer remover, and fully washing the material to remove all residual chemicals.

**backlighting**   A bright light behind the subject.

**bleaching**   A process that removes metallic silver from a developed print in order to enhance highlights.

**bracketing**   The same picture taken at numerous exposures so that at least one of them yields a good picture. This is typically done under odd or low lighting conditions, such as at night or in very contrasty situations.

**bromide paper**   High-speed photographic enlarging paper. Most papers on the market today are a type of bromide paper. Bromide paper is commonly referred to as enlarging paper and uses silver bromide, a type of silver halide, to form the image.

**burning**   Adding time to a localized area of a print, making just that area darker.

**burnishing**   Rubbing. It makes the adhesion of spray mount or pressure-sensitive mounting tissue complete by removing air bubbles and forcing the print tightly against the mat board while the glue dries.

**catch light**   A little reflection of light in the eyes of a portrait subject. It makes the eyes glitter and adds a bit of brightness to dark eyes.

**chloride papers**   Very slow-speed photographic papers used for making contact prints—prints in which the negative is not enlarged but made by placing the negative directly against the paper. The only chloride paper I am aware of is Kodak's Azo.

**collage**   Prints that have been cut and pasted together for a special effect, such as adding a person to a landscape. Collage physically alters the surface of the print.

**contact print**   Photograph made by placing the negative directly against the photographic paper. Because the negative is not enlarged, this produces a photograph exactly the same size as the negative, with excellent sharpness and detail.

**contact sheet (or proof sheet)**   A print made from an entire roll of film that has been cut and put into negative sleeves. With 35mm film, the print shows all 36 frames and lets you quickly review what you have shot so that you can choose the pictures you want to print.

**contrast**   The tonal difference between highlights and shadows. The greater the difference, the more contrast a scene has. Bright sunlight produces a lot of contrast, whereas overcast light has less contrast.

**density**   The level of silver present in a negative. A dense negative is one that is dark from a lot of silver, and a thin negative is one that is mostly clear, with very little silver.

**depth of field**   How much, from close to far away, is in focus in your photograph. Pictures taken with a large aperture have less depth of field than those taken with a small aperture, which have more depth of field.

**developer**   The chemical used to process film that converts a latent film image (made of silver halides) into metallic silver.

**distortion**  The unnatural perspective that affects objects seen through wide-angle lenses; the wider the angle, the more distortion. Also, the closer the object, the more pronounced the effect. Longer lenses have little or no distortion.

**dodging**  Holding back time from a localized area of the print, making just that area lighter.

**environmental portrait**  A portrait in which the location gives insight into the subject and his or her profession or personality. The background and any important props will be in the picture along with the subject, and the picture is often done with a wide-angle lens.

**exposure meter**  A meter built into a camera to read reflected light—the light bouncing off the subject and entering the camera. The meter gives a light reading, which indicates what aperture and shutter speed will produce a well-exposed negative.

**fast lenses**  Those with apertures of $f/2$ and larger (1.4, 1.2, and 1.0). They provide a lot of flexibility when photographing under low light conditions, enabling you to shoot without a flash and with higher shutter speeds.

**fiber paper**  Print paper without a resin coating. Fiber paper does not have a developer incorporated so the development time is longer than with RC.

**field cameras**  Large-format models that have fewer movements, are made to be lightweight and portable, and are designed for outdoor photography.

**film base**  A flexible support made from cellulose and polyester upon which a gelatin emulsion is coated. The film emulsion contains silver halides, also called silver salts, which become tiny particles of metallic silver when exposed to light and treated with a chemical developer.

**film speed**  The sensitivity any given film has to light, indicated by the ISO number. The higher the number, the more sensitive the film.

**flaring**  Occurs when a bright light near the lens or edge of the picture causes a washed-out area in the picture.

**flash**  The light produced by an electronic flash for a fraction of a second.

**flashing**  The process of giving exposed photo paper a very small amount of light to slightly darken the highlights or create tone where there is none.

**focal length**  Indicates a lens's angle of view. There are three types: wide-angle, normal, and telephoto. Zoom lenses are those with various focal lengths in one unit.

**full-frame shot**   Filling up the viewfinder with whatever you want to photograph.

**gaffers tape**   An opaque black tape used by photographers and filmmakers; can be used to help seal out light from an opening when creating a darkroom.

**golden hour**   Time in late afternoon when the sun is beginning to set and the light is a golden yellow.

**graded papers**   The type of photo papers on which you cannot adjust the contrast with filters, but on which you can make some adjustments by using a two-developer bath. Graded paper comes in separate grades of contrast.

**grain**   The tiny particles of metallic silver in your negative. In a print, it is the space between those particles that appear as tiny black specks.

**gray card**   A piece of cardboard with a middle gray, 18 percent reflective surface. All exposure meters are calibrated to give you a reading of this tone.

**guide numbers**   Indicate how powerful a flash is. The larger the number, the more light a unit can produce. A more powerful unit can illuminate a subject that is farther away.

**highlights**   Areas of the negative that are dark and therefore correspond to the bright areas in a photographic print.

**incident light reading**   A measure of the intensity of the light falling onto the subject; it is, therefore, more accurate than a reflective reading.

**large–format**   Cameras using 4 × 5–inch film, or larger. The cameras are the same basic design as those made 150 years ago. The large negative gives a very sharp and detailed photograph.

**leaf shutter**   Built into a lens, a leaf shutter opens from the center outward and allows synchronization with an electronic flash at all shutter speeds.

**lens speed**   The maximum aperture of a lens. Generally, a lens with $f/2$ or larger (smaller number) opening is considered fast.

**medium format**   Cameras using 120 and 220 film. 120 is a short roll, producing 12 to 15 exposures, depending on the width of the frame. 220 is twice as long, producing 24 to 30 exposures. Medium-format film and cameras are often referred to as 2¼ inch or 6 centimeter, which is the width of medium-format film.

**montage**   Multiple images done in the enlarger. The paper surface is not affected.

**multigrade paper**  Print paper using colored filters to control the amount of contrast from print to print.

**museum board**  High-quality, acid-free mat board used for mounting and matting.

**negative space**  An area that appears empty in an artwork but is actually an important compositional balance. The sky in a photograph my take up half of a picture and have nothing in it, but it may be an important compositional element, creating a mood or balance with other elements.

**noise**  The appearance of off-color pixels in digital photographs, especially in dark areas. It is similar to the grain that is apparent in higher ISO films. The higher the ISO setting on your digital camera, the more noise will be seen. Lower ISO settings produce less noise.

**overmatting**  Two pieces of mat board, one with the print mounted to it and the other with a window cut out laid over the print. The image appears in the window. Overmat protects the print and is perfect for framing and formal presentations.

**photo quality inkjet paper**  Paper designed to give the true photo quality expected from a photograph. The paper is specially made with a coated surface that can accept much more ink than regular paper.

**portfolio**  A selection of photographs. It could be pictures from a single subject matter or a variety of pictures of many subjects. A portfolio usually has around 20 photographs and should be appropriate to the type of work being sought.

**portrait**  A likeness of a person or animal. It normally shows us what they look like physically, and when done very well may suggest aspects of their personality that we may otherwise be unaware of.

**pulling**  Rating film at a lower ISO.

**pushing**  Rating film at a higher ISO, often resulting in reduced shadow details and enhanced grain.

**rangefinder**  A camera focusing system in which you look through a small window near the lens and align a semi-transparent "ghost" image with the object being focused on.

**reciprocity failure**  Occurs when the usual combination of aperture and shutter speed doesn't produce well-exposed negatives at a given ISO when

the shutter speed is one second or longer. When using shutter speeds over one second, the exposure needs to be increased to ensure a printable negative.

**reflected light reading**   A measure of the light bouncing off a subject. This reading can be in error because of the tone of things in the scene. (See the entry for incident light reading.)

**resin coated (RC) photo paper**   Print paper with a thin plastic coating that prevents chemicals from being absorbed, greatly reducing the required washing time. RC paper also has a chemical developer incorporated to speed up the developing process.

**resolution**   The amount of information a camera can capture. The more resolution, the better the image quality, and with digital cameras, this is measured in megapixels.

**reticulation**   The clumping of grains of sliver in the negative, giving the picture a very interesting, heavily textured look. By shocking the film during development with drastic temperature changes, reticulation can be created, but it is unpredictable.

**scan** (or **digitize**)   To convert a traditional negative, slide, or photograph into pixels with a device called a scanner attached to a computer. The computer then stores the image as pixels that can be manipulated, saved, e-mailed, or printed.

**Scheimpflug Principle**   When a lens and film are not parallel, neither will be parallel to the plane of focus. The plane of focus will be where the lens and film planes intersect, cutting through the image at an angle.

**shutter**   A curtain inside the camera that opens for an adjustable amount of time, letting light fall onto the film.

**single lens reflex (SLR)**   A focusing system enabling the photographer to focus through the camera lens.

**softbox**   A box with a translucent white material on the front. The box fits over the strobe head, and when fired, the light fills the box and is filtered through the white material to give a lovely soft, even lighting.

**standard**   The front or rear plate of a large-format camera. The front standard holds the lens and the rear (or back) standard holds the film. Each standard moves independently and they are connected by a flexible, light-tight bellows.

**stock solution**   A chemical used in film development that still needs to be mixed with water to make it a working solution.

**strobe**   An electronic flash used for studio photography. A strobe will often have an external A/C power pack, but some have rechargeable batteries for outdoor use. A strobe has a flash tube mounted in a small head that rests on a lighting stand and uses a cord to connect the head to a power pack with adjustable power output for greater control.

**studio portrait**   A portrait done in a controlled environment with a background and lighting.

**sun spot**   Those octagonal-shaped spots that appear in pictures when light falls directly on a lens.

**teleconverter**   A hollow tube attached between the lens and camera body that increases the focal length of a lens. They come in different magnifications and generally double or triple a lens's length. A 2× teleconverter on a 50mm lens increases the focal length to 100mm.

**view cameras**   Large-format models that have many camera movements allowing for a large degree of control of focus and perspective. They are made for studio photography.

**white balance**   The capability of the digital camera to make color-corrected images under any light source. By pointing the camera at anything that is white, regardless of the color temperature of the light, the camera will record whites accurately.

**working solution**   A chemical used in film development that is ready to use; no need to mix with water.

**zone system**   Developed by Ansel Adams, it is a method of identifying eleven zones of tone from pure white to pure black. By learning and using the zone system, greater control can be achieved over negatives and, consequently, the finished print.

**zoom lens**   A lens with variable focal lengths in one unit. For example, a 35mm to 70mm zoom lens is able to provide both wide angle and telephoto angles of view and everything in between. This is obviously a great advantage for many photographers and saves you from buying a lot of lenses. Older zoom lenses typically do not have great optics, but those made today are very good.

# APPENDIX B

# Photographic Equipment, Supplies, and Resources

## PHOTO STORES

Freestyle
5124 Sunset Blvd.
Los Angeles, CA 90027
1-888-205-8177
www.freestylecamera.com

Samy's Camera
431 S. Fairfax Avenue
Los Angeles, CA 90036
323-938-2420
www.samys.com

B&H
420 Ninth Ave.
New York, NY 10001
1-800-947-9970
www.bhphotovideo.com

Abbey Camera
1417-25 Melon St.
Philadelphia, PA 19130
1-800-252-2239
www.abbeycamera.com

Calumet
(stores around the country)
www.calumetphoto.com

## MOUNTING AND PRESENTATION SUPPLIES

Light Impressions
P.O. Box 787
Brea, CA 92822
1-800-828-6216 (call for a free catalog)
www.lightimpressionsdirect.com

Daniel Smith Art Supplies
4150 First Ave.
Seattle, WA 98124
1-800-426-6740
www.danielsmith.com

## PROFESSIONAL ORGANIZATIONS

College Art Association
275 Seventh Avenue
New York, NY 10001
212-691-1051
www.collegeart.org

Society for Photographic Education
110 Art Bldg., Miami University
Oxford, OH 45056-2486
513-529-8328
spenews@aol.com

Fotofest, Inc.
1113 Vine Street, Suite 101
Houston, TX 77002
Phone: 713-223-5522
Fax: 713-223-4411
www.fotofest.org

# APPENDIX C
# Further Reading

## BOOKS

Adams, Ansel. *The Camera*. Boston: Little Brown Publishing, 1983.

———. *The Negative*. Boston: Little Brown Publishing, 1983.

———. *The Print*. Boston: Little Brown Publishing, 1983.

Adams, Robert. *Beauty in Photography*. New York: Aperture, 1981.

———. *Why People Photograph*. New York: Aperture, 1994.

Clarke, Graham. *The Photograph*. Oxford: Oxford University Press, 1997.

Hirsch, Robert. *Seizing the Light*. Boston: McGraw Hill, 2000.

London, Barbara, and John Upton. *Photography*. Upper Saddle River, N.J.: Prentice Hall, 2000.

McDarrah, Fred W. *The Photography Encyclopedia*. New York: Schirmer Books, 1999.

Rosenblum, Naomi. *A World History of Photography*. 3rd ed. New York: Abbeville Press, 1997.

Stone, Jim. *A User's Guide to the View Camera*. New York: Harper Collins, 1987.

## Places for Fine Art Books and Hard to Find Titles

Art Resources Transfer
210 Eleventh Ave.
New York, NY 10001
212-691-5956
www.artretran.com

Hennessy & Ingalls
1254 3rd St. Promenade
Santa Monica, CA 90401
310-458-9074

Photoeye Bookstore
www.photoeye.com

## For Up-to-Date Photography Shows

Photography in New York
www.photography-guide.com

Art Scene (for exhibitions in Southern California)
www.artscenecal.com

## Magazines

*Afterimage* (reviews and listings for photo shows)
31 Prince St.
Rochester, NY 14607
585-442-8676
afterimage@vsw.org
afterimageonline.org

*Art Papers* (reviews and listings for photo shows)
1083 Austin Ave., NE
Suite 206
Atlanta, GA 30307
404-588-1837
subscribe@artpapers.org

*Artweek* (reviews and listings for photo shows)
930 Pershing Ave.
San Jose, CA 95159
408-288-7555

## OTHER FINE MAGAZINES AVAILABLE AT BETTER BOOKSTORES

*American Photo*

*Artforum*

*Art in America*

*Blind Spot*

*Contemporary Visual Arts*

*Doubletake*

# Index